Blumenfeld

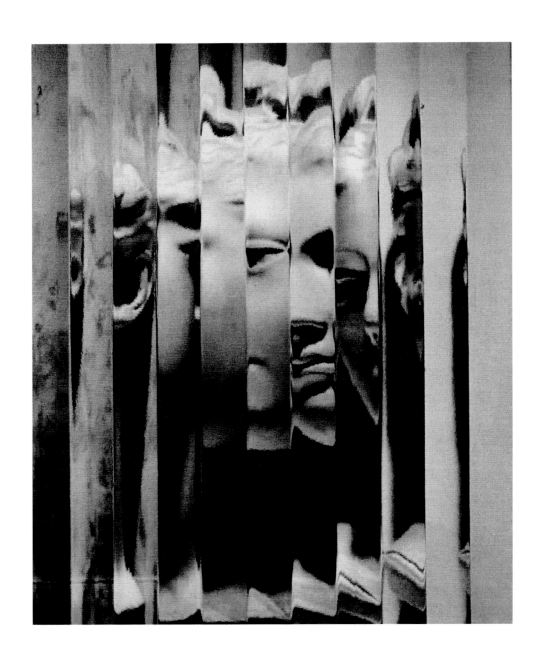

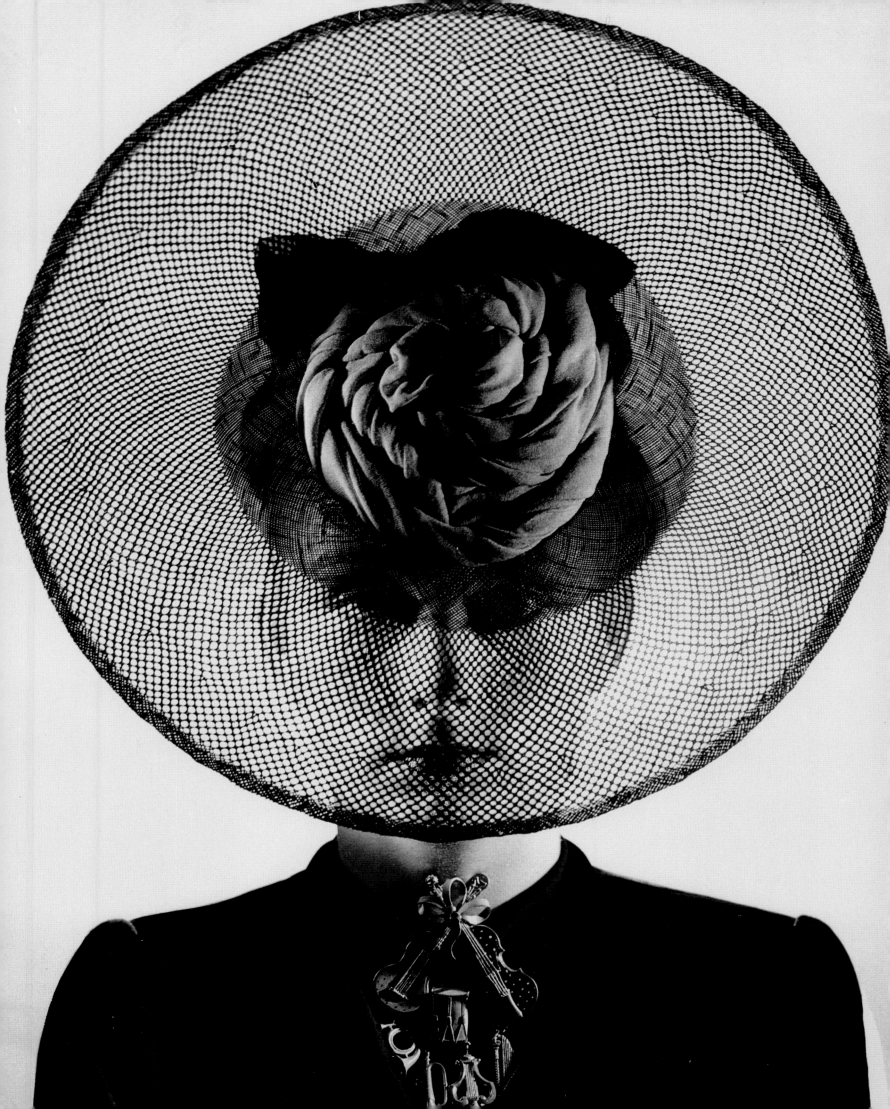

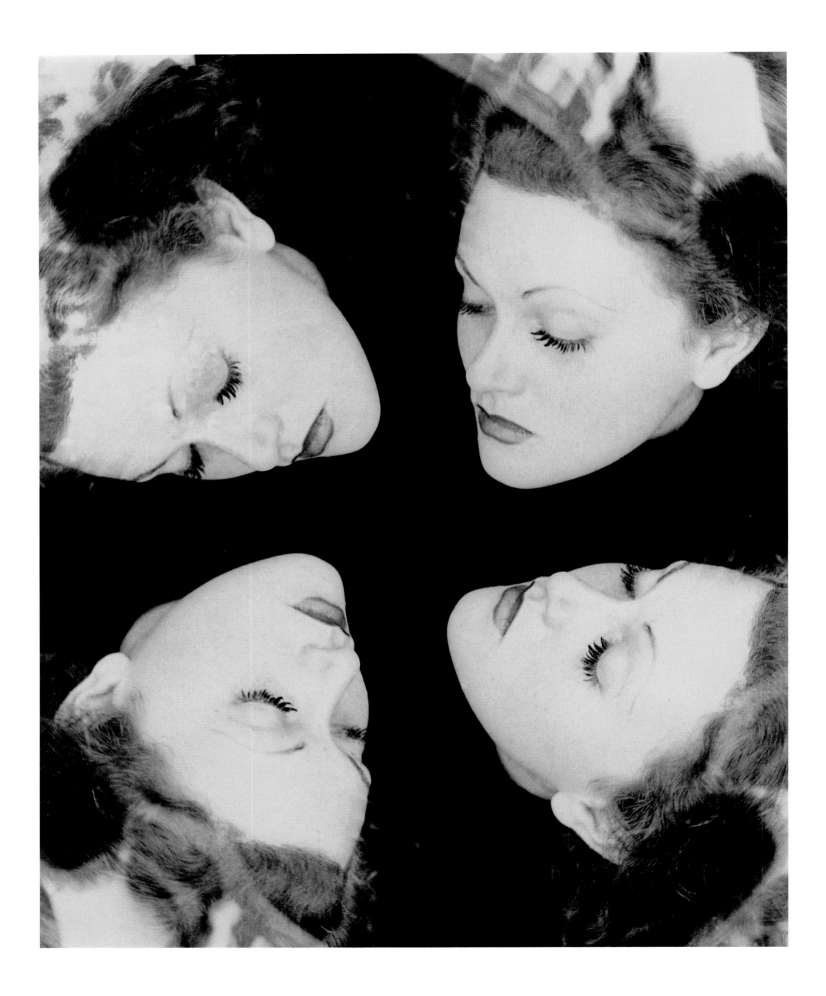

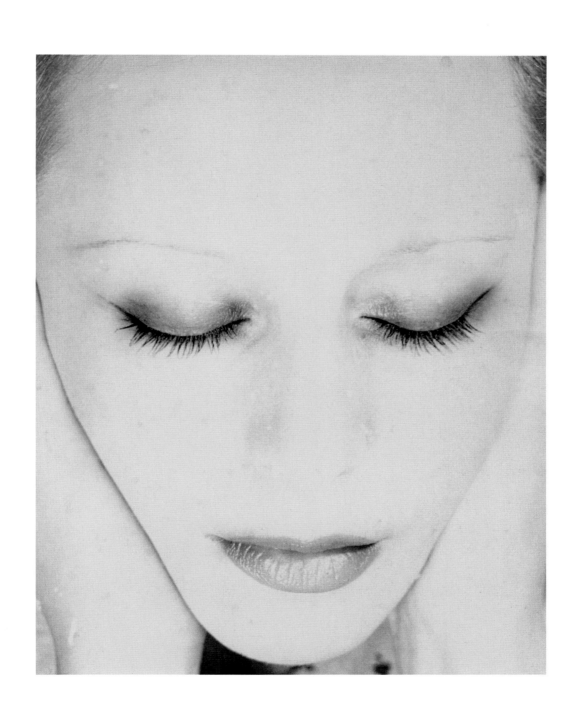

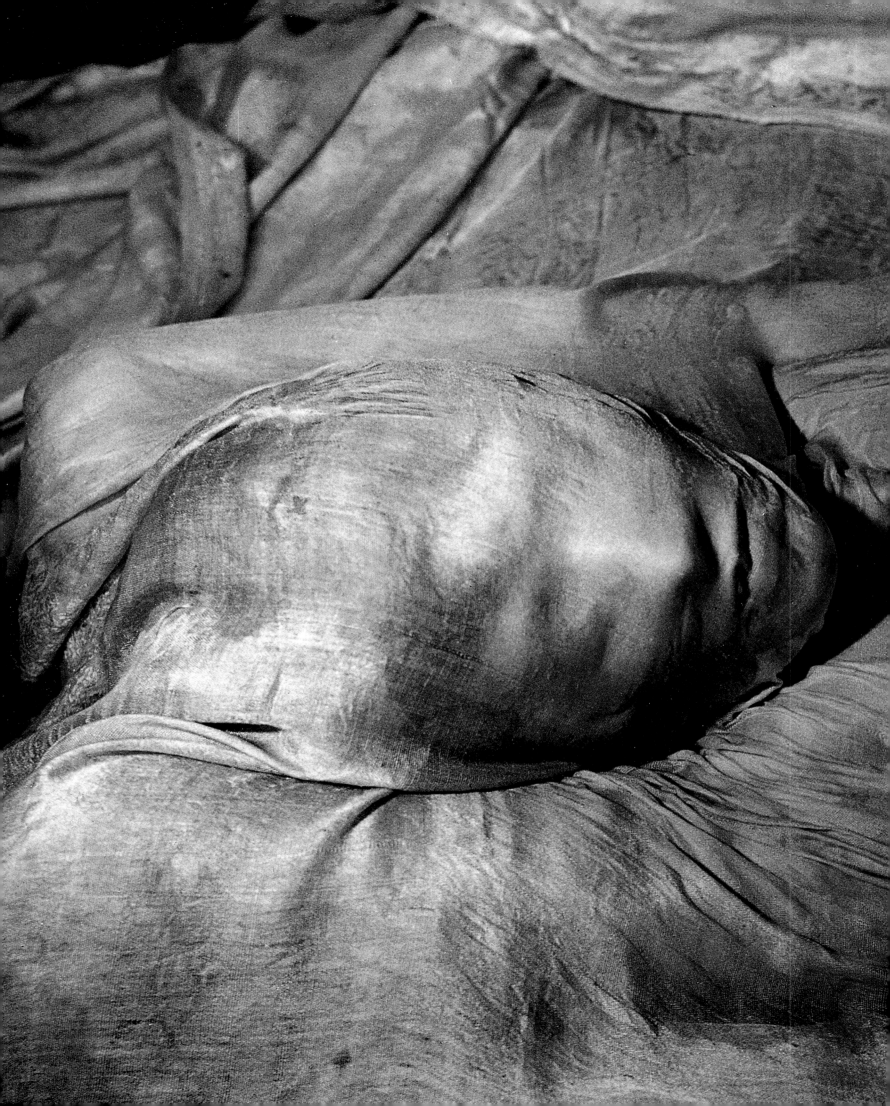

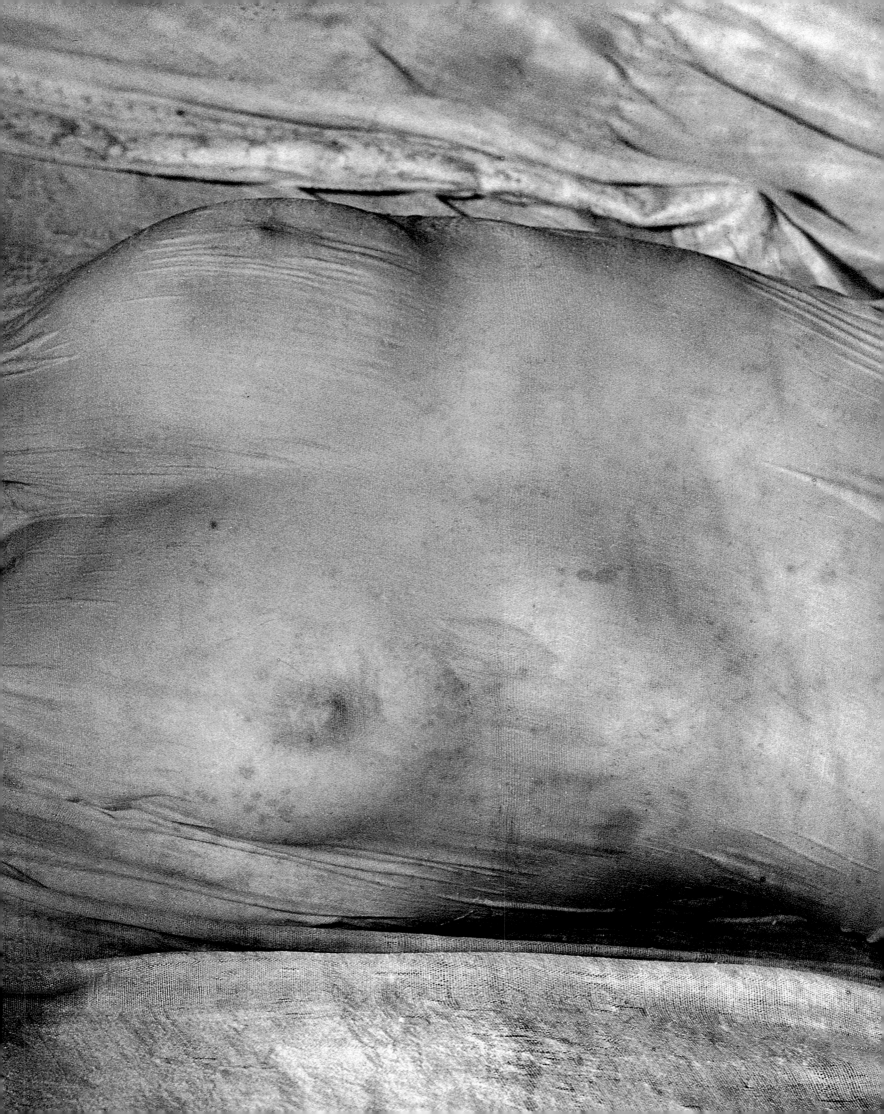

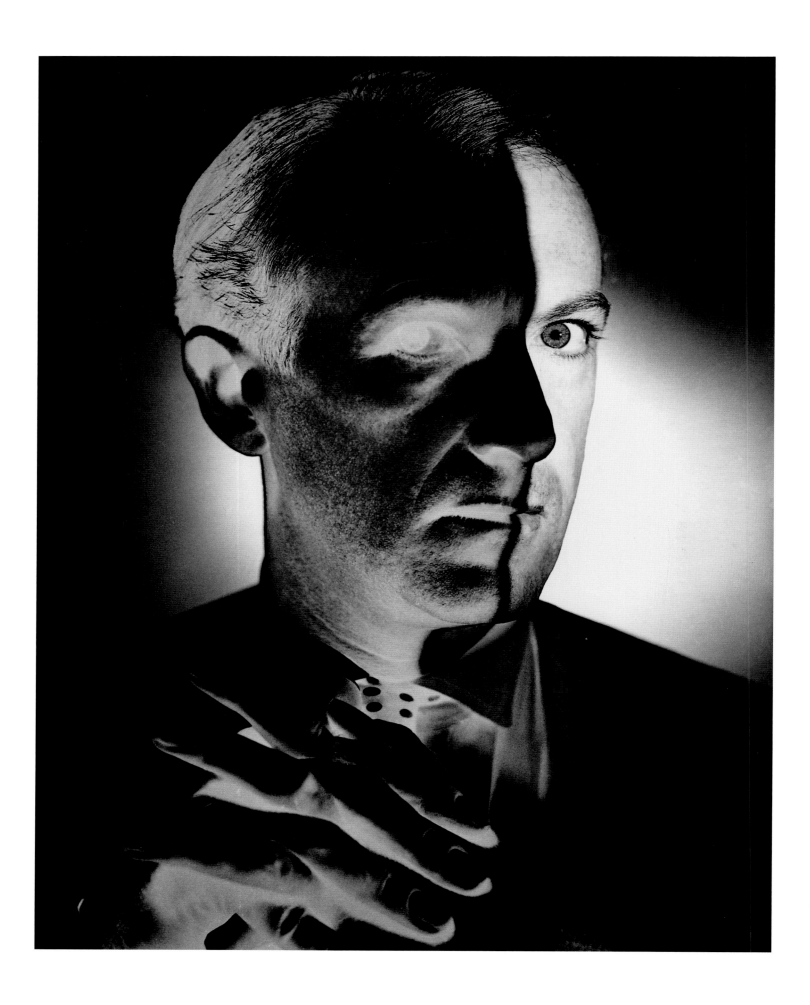

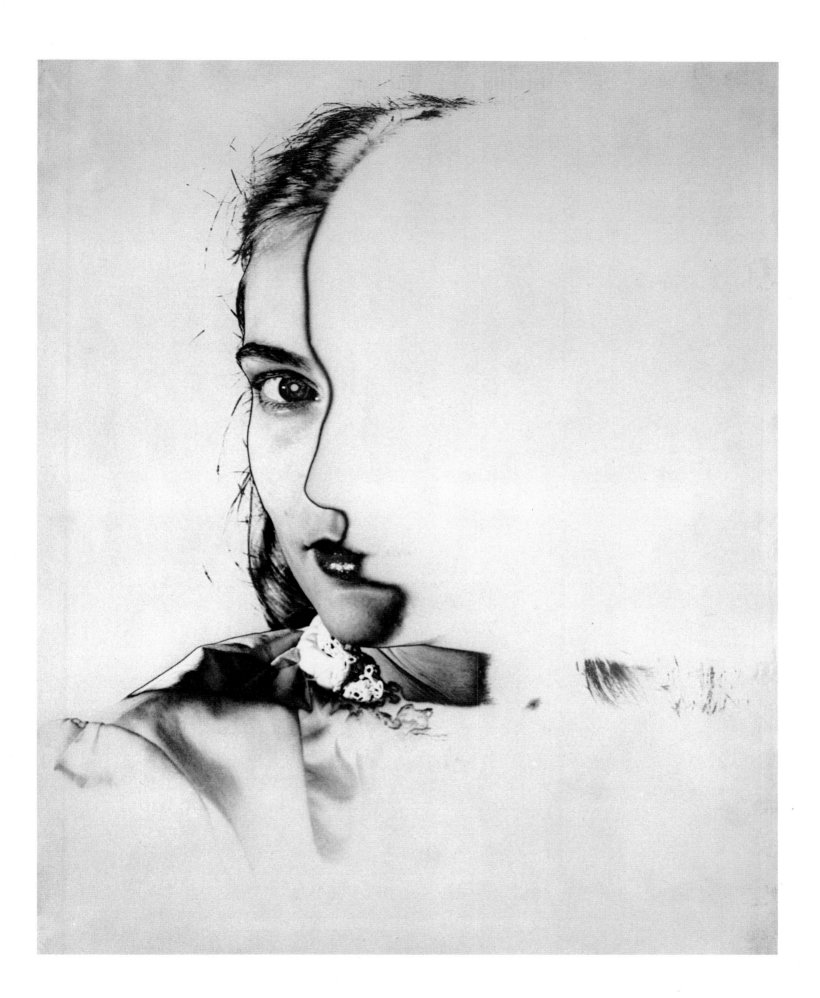

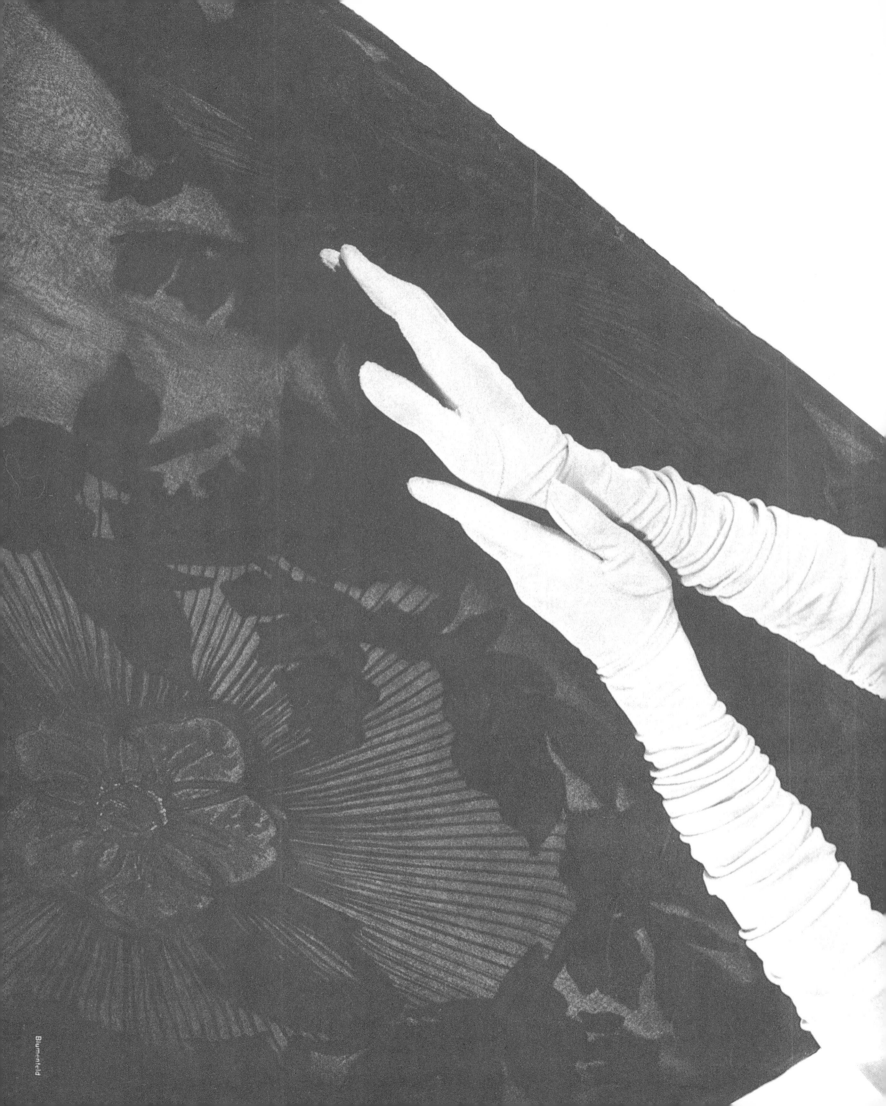

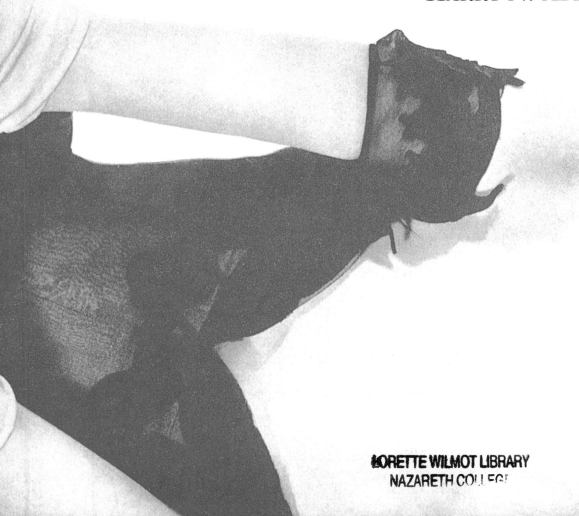

WILLIAM A. EWING
in collaboration with Marina Schinz

Blumenfeld

PHOTOGRAPHS

A PASSION FOR BEAUTY

HARRY N. ABRAMS, INC., PUBLISHERS

Preceding pages:

1 Self-portrait, New York, *c.* 1945

2 Untitled, New York, *c.* 1943

3 Untitled fashion photograph,
 possibly Schiaparelli, Paris, 1938

4 *Manina*, Paris, *c.* 1937

5 Untitled portrait, Paris, *c.* 1937

6 Untitled nude, variant of pl. 61
 (*Nude under Wet Silk*), Paris, 1937

7 *Cecil Beaton*, New York, *c.* 1947

8 Untitled portrait, New York, *c.* 1942

9 Evening dress by Harvey Berin for Dayton's
 Oval Room, Minneapolis, 1954

Quotes from Erwin Blumenfeld's autobiography are printed with permission from the English translation
made by Nora Hodges of *Durch tausendjährige Zeit* by Erwin Blumenfeld.
Nora Hodges's translation is copyright © 1989 by The Estate of Nora Hodges and Tenth Avenue Editions, Inc.

Library of Congress Catalog Card Number: 96–84385
ISBN 0–8109–3145–1

Published in 1996 by Harry N. Abrams, Incorporated, New York
A Times Mirror Company

Printed and bound in Singapore

Contents

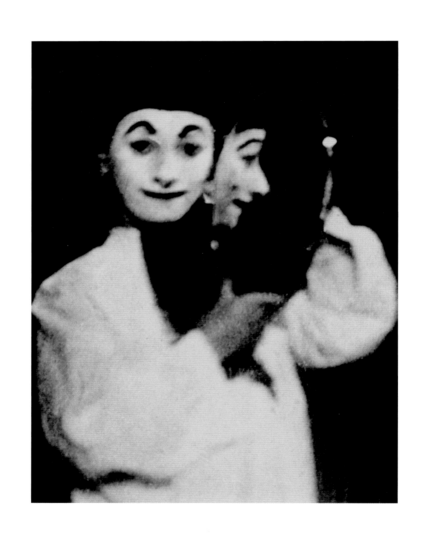

I: Dada and Daguerre

'A Coachman of Corpses'

On 17 March 1917, when the Great War in Europe, unlike the winter weather, showed few signs of thaw, and fallen soldiers lay rotting in no man's land because it was too dangerous to reclaim them – a twenty-year-old German-Jewish conscript was ordered to report to one of Berlin's key railway stations, the Anhalter Bahnhof. Although his eventual destination was unspecified, it must have been obvious to Erwin Blumenfeld that he was heading for the Western Front. He had, after all, been given rudimentary training as an ambulance driver assigned to a motorized division, and the war raging in France was exacting a high price in casualties.

Initially at least, signs at the railway station were auspicious: Blumenfeld and his fellow drivers were handed smart black leather uniforms and long greatcoats, and shown to their brand-new Mercedes ambulances. The men could be forgiven for thinking that they might just escape the worst of the situation, even if their destination was indeed the front. They had the protection of the Red Cross, and, moreover, some ambulance work was done well behind the lines. Besides, could what lay ahead be as abominable as life at the recruiting barracks at Zwickau in Saxonia, with its sadistic officers, ersatz meat and coffee, and unrelenting cold and filth? At the station, family and friends did their best to keep spirits high. Blumenfeld's beloved younger brother, Heinz, was there to see him off and bolster his confidence.

Four days later, however, as the train meandered westwards, any hopes of avoiding the worst evaporated: it soon became evident that they were to be in the thick of the fight, near Laon in Picardy. Moreover, on arrival, they were ignominiously stripped of both leather uniforms and Mercedes ambulances; these were shipped back to Berlin in an endless cycle intended to impress fresh troops with the Army's profound concern for their well-being. In their place the men were given 'lice-ridden grey rags' and heavy chain-driven trucks. Soon, Erwin Blumenfeld would find himself not an ambulance driver but 'a coachman of corpses'.[1]

Even as a boy Blumenfeld had questioned the integrity of adults, and over the years this was to harden into a stubborn antipathy towards authority in all its forms. Now, faced with this callous deception, any modicum of respect for his elders was extinguished. Further experiences of war merely confirmed his

Opposite: My First Self-portrait (14 years of age), 1911. The composite of a frontal and a profile view of the face was a motif which fascinated Blumenfeld throughout his life. He often spoke of 'the double'. By his own admission he was obsessed with mirrors, convinced that behind their smooth surfaces lay another reality.

worst fears about human nature. Years later, musing bitterly on 'this highly dangerous front of abysmal stupidity',[2] he wrote, 'We were drowned in lies.'[3]

Although there is always an element of black humour in Blumenfeld's description of his war experiences, the inhumane behaviour he witnessed at almost every turn would never cease to haunt him. The very darkest moments were to come at the end of the war, when he arrived back at the Anhalter Bahnhof in circumstances wholly different from those of his departure. He now had to burn part of the tattered remains of his uniform in order to stay warm, while petty thieves made off with his meagre belongings. But, blackest of all, his brother Heinz was not there to greet him – his corpse lay in the trenches of Verdun. He had died 'a hero's death', Blumenfeld noted bitterly in his autobiography, 'for the German Fatherland, Jewish family life, and the madness of the world'.[4]

Little wonder, then, that *junkers*, statesmen, generals and emperors would in future bear the brunt of Blumenfeld's ire; *his* heroes would be courageous thinkers like Voltaire, Strindberg and Wedekind, and especially those who wielded the weapons of wit and humour to attack pomp and pretension in all their forms – figures like the Marx Brothers and, above all, Charlie Chaplin. It is not surprising that the principled nonsense of Dada would prove such a compelling inspiration for him in the years immediately following the war.

'Exemplary Family Epistles'

Erwin Blumenfeld was born in Berlin on 26 January 1897, to upper-middle-class Jewish parents. As a child he was lucky in having a large extended family, including two sets of doting grandparents. On his father Albert's side, the family stretched back to seventeenth-century Bavaria, and proudly pointed to Heinrich Heine as its most illustrious ancestor. Albert's father, Matthias – Grandpa Moses to the children – was a Rabbi in Essen and known for his radical politics, for which, after the Revolution of 1848, he was briefly imprisoned. In Blumenfeld's memoirs he appears as a dignified but kindly figure, with a loving wife, proud of her matzo balls and shortbread.

Religious commitments were also characteristic of Blumenfeld's mother's side: her grandfather had been a rabbi on the Russo–East Prussian frontier, and her father had taught the Talmud at Hebrew school before opting for a secular life in America. Infected with the spirit of free enterprise and buoyed by a bit of capital accumulated in New York, he headed west, first striking it rich as the proprietor of a gambling den during the California goldrush, then wisely sinking his profits into a Salt Lake City department store. Tiring of the New World he then returned to the Old, marrying and buying a wine business near Stettin, where he prospered. Following his death, however, little was left of his fortune after it had been divided among fifteen grandchildren; what did remain

Blumenfeld, aged 3, with his parents and his sister, Annie, on the beach at Ahlbeck, Germany, 1900. Despite Blumenfeld's complaints in his memoirs that he had been raised in a stifling bourgeois household where much was 'totem and taboo', the children seem to have enjoyed a privileged upbringing. Photographer unknown.

was washed away by inflation and, noted Blumenfeld wryly, 'the exemplary business ineptitude of his sons'.[5] Of his two grandfathers, Erwin was closer to this more adventurous figure, from whom he inherited both a passion for climbing towers and superior skills in the fine art of nail-biting.

Erwin shared his grandparents with two siblings. His feelings towards his sister, Annie, were ambivalent. Though he looked up to her, he resented her dictatorial ways, as well as the fact that she, not he, was his father's favourite. He had no such reservations, however, about his love for his younger brother, Heinz, who was always willing to play the role of patient in Dr Erwin's operating theatre, never objecting to the torrents of red ink which served as blood.

The portrait Blumenfeld draws of his mother, Emma Cohn, is scathing. Bourgeois in every sense, she emerges as a creature of false pride, snobbery and self-righteousness, who looked down on her neighbours and on all foreigners, particularly Eastern European Jews.[6] Her highbrow pretensions convinced her that she was a letter writer of rare wit, whose 'exemplary family epistles would be read aloud from Stettin to Essen'.[7] Uncompromising opinions were freely dispensed. 'It is from her', noted Blumenfeld wryly, 'that I learned to condemn something quickly and smartly without knowing what it is about.'[8]

Blumenfeld's father comes across as a more sympathetic figure. Born in Essen in 1860, Albert Blumenfeld was a principal partner in the firm of Jordan & Blumenfeld, distinguished manufacturers of umbrellas and walking sticks. He seems to have been a kindly if somewhat inept businessman. Employees were regularly fired in fits of pique and then sheepishly rehired, so that 'every employee was thrown out on average twice a month, but worked at Jordan & Blumenfeld for at least the twenty-five years that yielded a silver watch or an umbrella with a silver handle.'[9]

Apprenticed to a haberdasher at the age of fourteen, he had lifelong regrets about not having gone to university and especially at having missed out on fraternity life. Although he was self-taught, he read a great deal of classical literature and devoured daily newspapers. Much of this was regurgitated in the form of quotations and aphorisms which missed the mark. He was, notes Blumenfeld, 'a *Reader's InDigest* come to life'.[10] Nevertheless, there were always books, newspapers and magazines around the house. One regular publication, the brilliant, savagely satirical *Simplicissimus*, served as Erwin's initiation into artful eroticism.

'Totem and Taboo'

Blumenfeld's sweeping statement that 'everything in the house was totem and taboo' does not quite square with his own account of home life, which suggests, rather, a privileged and happy childhood. There were painting and piano lessons, and no shortage of expensive toys, including a magic lantern and an

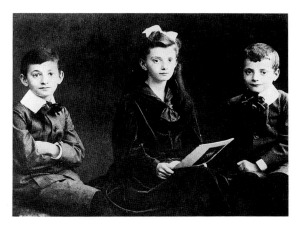

The Blumenfeld children at home in Berlin: Erwin, Annie and Heinz, *c.* 1906. Blumenfeld was extremely close to his siblings as a child, particularly to his younger brother, Heinz. Relations with his sister soured during her adolescence and never improved. Photographer unknown.

Erwin Blumenfeld at the age of five, Berlin, 1902.
Photographer unknown.

alcohol-driven steam engine. When he decided to treat his parents' most treasured objects as playthings, he does not seem to have incurred much in the way of chastisement, even on the occasion when his mother found her finest Parisian gown in shreds.

Other illicit activities went unpunished simply because they were not observed. His parents knew nothing of his surreptitious raids on the medicine cabinet, from which he would take poisons and acids and mix them to explosive effect, nor were they aware of his habit of sneaking into the off-limits drawing room, having pilfered the key. Stuffed with silk upholstery and paintings, drawings and figurines, this room was his first museum. On the almond-green, imitation silk moiré wallpaper hung prints by fashionable artists. A copperplate engraving of Böcklin's famed *Isle of the Dead* leant gravitas to the decor; nearby hung a Guido Reni lithograph and a coy nude by Jean-Jacques Henner. Anaemic portraits of Blumenfeld's parents, painted from photographs by a family friend, were proudly displayed in gold frames.

But the true wonder of the drawing room was a large mirror hung between the windows:

> Mama had taught me that eyes are the mirror of the soul. Eyeball to eyeball, I examined mine, sitting for hours on the colourfast Turkish rug in front of the drawing-room mirror and made faces in order to make myself mature, to look old, to discover my soul I am still convinced that behind that transparent glass there is a life in another world . . . [11]

Blumenfeld's fertile imagination found a stimulus in voracious reading. By his own account he read a book a day. The spoken word was also valued in the household: word games were played around the dinner table; riddles, too, were prized. Grimm's Fairy Tales, which had been a source of enchantment from an early age, kept Blumenfeld enthralled even into his teens. Max and Moritz, the mischievous figures from children's verse, would prove even longer lasting: they would remain heroes for life. Less enduring, though briefly intoxicating, were the epic struggles of the noble, if bloodthirsty, American Indians depicted in the books of Karl May, the immensely popular German novelist who had based his first-person narratives on translations of James Fenimore Cooper. Blumenfeld also loved mystery stories, particularly the work of Edgar Allan Poe. By the arrival of adolescence his interests had evolved into a passion for Wedekind, Strindberg and Dostoevsky. 'Without them', he admitted, 'I would have become a different person.' [12]

Language was always something vividly alive for Blumenfeld. He loved gossiping with the maids about his parents and vice versa, even if, in order to impress, he had to invent the occasional outrageous story. From street urchins

he picked up smutty songs – a further weapon with which to sabotage domestic tranquillity. But whether the word was read or spoken, sacred or profane, true or false, he learned to respect its evocative power.

'Chemical Magic'

The Blumenfeld children did not live unduly sheltered lives. In addition to the boys' toy soldiers, they had the real thing on daily parade outside the window: the First Guards Infantry Regiment in goose-step, followed by the mounted cuirassiers, silver helmets and swords glinting. The family doctor allowed the children to watch the great autumn and spring parades as they passed beneath his office, the Emperor and his sons riding at the head.

In winter there was ice-skating in the Tiergarten, and all year round the Philharmonic held Sunday afternoon concerts. If the boy grew weary of the city's ubiquitous military pageantry as he matured, there were other spectacles to take its place: the circus, and Berlin's renowned theatre and vaude-ville. 'I fell completely for the stage,' he admitted,

> It meant the world to me in the summer of 1905, after Max Reinhardt's 'Midsummer Night's Dream' had me lost in Shakespeare's enchanted forests, where dewy-eyed Gertrud Eysoldt's Puck and electric fireflies floated together in dreamy nights. I had to get to a revolving stage, I had to create little midsummernight-dreamlets myself. I had to write plays in which I alone would act and direct all the parts in self-designed costumes and sets. And then be the sarcastic critic who would pitilessly tear apart my own show.[13]

Small wonder that Blumenfeld would later discover, having been employed as a still photographer on Jacques Feyder's 1935 feature film *Pension Mimosas*, that he was wholly unsuited for creative teamwork.[14]

The art and artefacts found in most museums, he concluded, could not hold a candle to the living art of the theatre. Exceptions could be made for the gilded coaches at the Imperial Stables and the mummies and pre-Columbian gold marvels at the Ethnographic Museum but much of the fine art in the public galleries left him cold. The official taste was for German Romanticism, with its heroic battle scenes and stormy shipwrecks and its kitsch genre paintings. Far more to his liking were the few Impressionist works at the National Gallery, and certain of the old Masters, in particular, Bosch, Brueghel and Rembrandt. But the moment of epiphany came with his first visit to the Kaiser Friedrich Museum, where Botticelli and Cranach displayed their lightly veiled female flesh. It dawned on the awestruck boy that the naked body was 'made even more naked and impudent by transparent veils'.[15] The lesson was again driven home

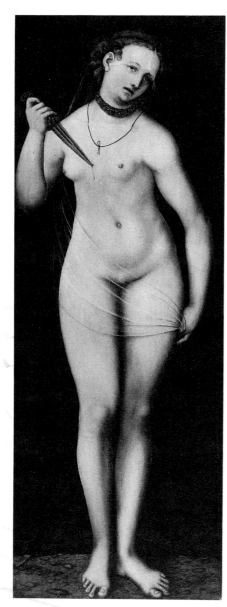

Lucretia, by Lucas Cranach the Elder, *c.* 1535. Oil on canvas. Blumenfeld credited Cranach's paintings of thinly veiled nudes with teaching him a fundamental lesson: that partially revealed flesh was infinitely more erotic than complete nakedness.

when, on a visit to an artist's studio with his governess, they almost caught a nude model unawares; though she had hastily thrown on a thin dress, her body was still visible against the light. It was, claimed Blumenfeld, what triggered his lifelong obsession with transparency.

One lesson learned early, then, that 'less is more', was borne out by Blumenfeld's own artistic experiments. More interesting than the actual images projected by the magic lantern were the mirages and veils thrown up by the oily smoke of the apparatus. Haunting shadows could also be conjured up by manipulating candlelight. Instruction of another order was provided by the keyhole to his parent's bedroom: the shadowy, shifting forms in the semi-darkness gave no more than tantalizing hints as to the nature of the secret activities within – the picture had to be filled in with the imagination. In a sense, these were early lessons in framing and suggestive imagery, lessons which would be put to good use in the future.

Eroticism was a component of Blumenfeld's art from the beginning, when at the age of ten he was given a camera, of 9 x 12 centimetre format, for having submitted to an appendicitis operation. From then on, he claimed, his erotic feelings were 'sublimely sublimated' by this marvellous apparatus, with its red rubber shutter bulb, tripod and metal carrying case.[16]

He soon realized, however, that in itself the camera represented only half the equation of photography; the other requirement was the darkroom, which he set up in his long-suffering parents' bathroom. 'My real life started with the discovery of chemical magic, games of light and shade, and the double-faced problems of positive/negative,' he recalled.[17] Now the ephemeral effects of flickering candles, oily smoke from the magic lantern, and drawing-room mirror reflections could be arrested and preserved. Blumenfeld's first picture was a still life:

Michelangelo's Moses, holding in its lap a half-peeled potato into which a toothbrush was inserted, was standing on an open deluxe edition of Gustave Doré's bible. On top of that, brother Heinz, wearing Mama's spectacles and Papa's moustache-curler, was leaning his hand on an upturned chamber pot and holding Mama's corset rolled up in his clenched fist.[18]

A trifle baroque, perhaps, but as Blumenfeld rightly notes in his memoirs, 'It was only a small step from that experiment to the advertising pictures for American companies that brought $2,500 apiece forty years later.'[19]

He shared his excitement about photography with his best friend, Paul Citroen, a Jewish Dutch boy whom he had met on their first day at school four years earlier. A joint self-portrait of 1910 commemorates their new passion and an early stage of what was to be a long friendship (*opposite*).

'Frisch, Froh, Fromm, Frei'

Blumenfeld claimed that his early quest for knowledge was dampened by the inflexible, militaristic and class-conscious regime at the Askanisch Gymnasium. Students were made to memorize Latin, Greek and history by rote, without much emphasis on real understanding. French was taught in a heavy Berlin accent, while English was frowned on as less than a true language – merely an idiom of trade. As Germans, Protestants and Berliners, pupils were encouraged to feel superior to those who were not so blessed, and the poorest students were never allowed to forget their misfortune. Peasants – in particular 'Austrian yokels' – were to be sneered at.

Blumenfeld also recalled marching about '. . . in brownish gym-suits, beltless monkey jackets and armbands with four gleaming F's: *Frisch, Froh, Fromm, Frei*' (fresh, happy, pious, free).[20] Years later he recognized the repressed homosexual current that had run through the school's physical activities, cloaked in an obsession with health and the Greek ideal of the body beautiful.

The militarism of the school gymnasium reflected larger social forces at work. Cultural historian Stephen Kern has explained how military prowess was entwined with cultural insecurity in the period following German unification; the widely popular physical culture movement, beyond its manifest claims concerning sound minds and sound bodies, was implicitly xenophobic, promoting military preparedness and the eradication of foreign elements which were seen to poison or pollute the body politic. The strong and disciplined German gymnast could contribute much to this ideal, and school was the perfect early training ground.[21]

It was made quite clear to all students just who those undesirable 'foreign' elements were. The teachers denigrated both Catholics and Jews. Jews were barred from becoming officer cadets and also from the rowing club – a particular hardship for Blumenfeld, who was keen on the sport. Most galling of all was that despite his excellence in gymnastics, he was not allowed to join the top team.

Jews were also singled out for criticism in academic activities. Although all other languages apart from German were despised, none was held in more contempt than Yiddish.

Blumenfeld sometimes came up against more virulent forms of anti-Semitic feeling than those he confronted at school. Once his parents' janitor showed him how to kill rats, 'splitting each animal expertly in half with the jolly remark: "This is the way those Jewish rats, the vermin of humanity, should be exterminated."' Blumenfeld recalls: 'I found this German virility fascinatingly revolting: my first insight into the sport of genocide.'[22]

Ironically, like many other German Jews, the Blumenfelds considered themselves Germans first and Jews second. Blumenfeld describes his grandfather in

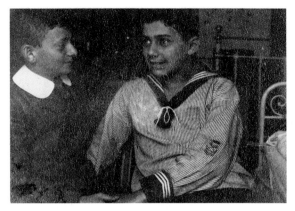

Erwin Blumenfeld with his 'best friend', Paul Citroen, whom he had met at school, commemorating their mutual passion for photography with a joint self-portrait, Berlin, 1910. They were to make two similar portraits in later years.

just such terms – 'a Teutonic, pan-Germanic Jew' – and casts his father in secular rather than religious terms: 'a liberal monarchist democrat, opting for the progressive centre, neither left nor right'.[23] The family felt they had more in common with most German non-Jews than with Jews from Eastern Europe. So, for example, Blumenfeld's mother wholeheartedly endorsed the physical culture movement her son so detested: like the cold baths she inflicted on her children in order to 'harden' them, she saw it as 'a decisive act of *German* culture' (my italics).[24]

While Blumenfeld's parents turned a blind eye to the evils of anti-Semitism, like most Germans of their class they embraced the idea of 'progress' enthusiastically and uncritically. 'Progress had almost assumed the force of a shibboleth for the middle class,' notes the historian Roy F. Allen, 'but it was understood to be a gradual and slow process, not a radical upheaval.'[25] This progress was technological, not social or political – evidenced in telegraphs, telephones, electric light, Count Zeppelin's dirigible, and such appliances as Papa's Gillette razor.

The period between 1870 and 1914 was one of relative serenity for the nation. Complacency prevailed. Military might was thought to be sufficient to deal with any major threats, external or domestic, and generally repressive cultural policies saw to it that radical ideas were held in check. Blumenfeld was speaking for all Germans when he observed that the Kaiser 'ruled everything, including my youth'.[26] As Roy F. Allen explains:

> There was a whole hierarchy of authority, beginning at the highest eche-lon with the Kaiser, followed by the military, the police and the courts, and concluding with the school and the father as head of the family circle. The last two named members had the major responsibility for inculcat-ing in the individual in his crucial formative years respect for authority.[27]

This, at least, was the theory. Judging from Erwin Blumenfeld's experiences at the hands of these authorities, the bedrock of the German nation was hardly secure. To his own mind, it was a system destined to produce either slaves or rebels.

'A Slight State of Siege'

Life experience would leave Blumenfeld with a deep distrust and dislike of Germans, whom he accused of betraying a magnificent language and culture. But he made exceptions for Berliners and their great metropolis: 'I was never a "German". I was really only a Berliner and have remained just that. Always just a Berliner. Specifically a Southwestberliner and Westwestberliner.'[28]

The Kaiser's Family, 1919. India ink and coloured crayon on paper. For Blumenfeld, the Kaiser represented everything that was inflexible and anachronistic in German life.

He was willing to overlook the authoritarian Berlin, the one peopled by strutting officers and ubiquitous mounted police – the city that the visiting poet Jules Laforgue described as under 'a slight of siege'[29] – because it was also a city which fostered urbanity, youth and modernity. At the turn of the century Berlin was truly one of the greatest cities in the world, centre of German commerce and industry, and capital of Prussia and the Reich. Like New York today the population was predominantly non-native and had been so for one hundred years. It made for a clash of customs and ideas, and seems to have bred a quintessential Berliner type – quickwitted, amusing and cynical. A nineteenth-century lexicon reported that 'the Berliner is always quick at repartee, always able to find a sharp, suggestive, witty formulation for every event and occurrence', but also had the tendency 'to find fault with anything greater or more profound that he encounters'.[30] By his own admission, it was a description that fitted Blumenfeld like a glove.

It was this cosmopolitan, irreverent Berlin which symbolized for Blumenfeld everything positive and hopeful, while the other imperial, pompous Berlin stood for bourgeois pretension, safe and innocuous opinions, blind faith in technology, submission to all forms of authority, hypocrisy and lies. And as he grew into adulthood he began to see his home life as a microcosm of the latter.

Although Blumenfeld's father nurtured high hopes for him – 'Papa determined to make a newspaperman of his son and heir so that he would impress the world every morning with his leading editorial'[31] – the sudden decline in 1912 of his father's health, due to syphilis (a fact kept from the children), and the increasingly perilous state of the family business forced Blumenfeld to abandon thoughts of higher education and contemplate the prospects of a job immediately following graduation. Thus, on 1 April 1913, thanks to a family connection, the sixteen year old turned up for the first day of an apprenticeship at Moses & Schlochauer, manufacturers of womenswear.

Albert Blumenfeld died in September of the same year, leaving only debts. The family escaped bankruptcy by a hair's breadth, but the business, houses and furniture had to be sold. When Emma's own health deteriorated she was sent to a TB sanatorium and the children moved in with an uncle.

With time Erwin grew accustomed to the garment trade, though there was little mystique or glamour to it. Extravagant dresses were bought in Paris and altered in Berlin to appeal to the German bourgeoisie. Much of the work was humdrum, but there were aspects of it which gave him valuable insights into the fashion business:

On the second day, I had to help Mr Wolfsberg squeeze five models into their over-tight white drill smocks. That was no child's play – it took the strength and skill of at least two strong men. Models did not starve

themselves the way they do today; there was no fashion photography, nor were there any reducing pills. The full figure was in style. It took real strength to lace those ladies into their corsets until the required hourglass figure was achieved.[32]

It was obvious to the amused young man that creating illusions of beauty was going to require heroic efforts. This was his first step on the long road which would lead within twenty years to the fashion capitals of the world.

As the months progressed, the apprentice found himself less and less enchanted with life in the garment trade. Luckily, there was relief from another quarter. For the past year or two he had been making friends with a number of young artists who were equally critical of established values and conventions. The Expressionists, much to Blumenfeld's delight, were opposed to all the dominant institutions of the day – schools, universities, the professions, the army, the Church and the family circle. Notes Peter Gay:

> Expressionist painters made inflammatory statements, exhibited outrageous pictures, published avant-garde little magazines Everywhere young artists broke away from the pomposity of academic art and sought to rise above the bombast of their surroundings to cultivate the inner life, articulate their religious yearning, and satisfy their dim longing for human cultural renewal The Expressionists were a band of outsiders, but they were determined and active.[33]

Prussianism was left behind in the territory of Bohemia, the poet, Walter Mehring recalled:

> [Here] the inhabitants spoke and wrote in foreign languages: Symbolism, neopathos, in the idiom of the English 'Georgians' and the Stefan George school, in the argot of theatrical dressing rooms and music halls, and in a silent speech and unwritten writing which only the initiate understood.[34]

If they were a band apart, they were still quintessentially German. The music of Wagner, the writings of Nietzsche and the imported plays of Strindberg gave articulate voice to their yearnings and inspired them to follow the rugged path of instinct rather than the smooth road of rationality. Images which sprang from mind and spirit were prized over those which presented themselves to the eye. Spurred on by Freud, they worshipped the unconscious.

At eighteen, Blumenfeld had arrived at an age at which he could appreciate the burning issues of art and felt a need to be intimately involved in the milieu. It was the moment when the Expressionists were coalescing into a well-

organized group. From 1910 Berlin saw a dramatic increase in new journals, recitals and forums for avant-garde art. The dynamic *Der Sturm* (a magazine devoted to contemporary art, complemented by a gallery and a bookstore) hosted events which attracted local artists as well as those of the international avant garde, such as the Italian Futurist Marinetti.[35] Paul Cassirer, an important art dealer and publisher, exhibited Matisse, Van Gogh and Cézanne, as well as German Impressionists who were challenging the reigning Realists.

Fauvist, Cubist and Futurist works were exhibited in Berlin from 1910 on, and their implications were debated in *Der Sturm* and *Die Aktion*, the most eagerly awaited weekly art journals. The group known as *Der Blaue Reiter* (The Blue Rider), founded by Franz Marc and Wassily Kandinsky in Munich, exhibited their bold canvases in Berlin beginning in 1911, simultaneously publishing an Almanach with work by Douanier Rousseau, Cézanne, Matisse, Van Gogh and other French innovators, along with work by the older *Die Brücke* group (The Bridge), which had set out, according to its leading member, Ernst Ludwig Kirchner, 'to wrest freedom for our actions and our lives from the older, comfortably established forces'.[36] Blumenfeld was impressed by the work of Kirchner and his colleagues, with their interests in eroticism, medieval German woodcuts, and African and Oceanic sculpture. He was also inspired by their use of violent colour schemes.

'The Emergency Exit'

Luckily, Blumenfeld was able to explore the Berlin art world with his old friend Paul Citroen. In 1915 Citroen had been introduced by fellow art student Georg Müche to Herwarth Walden, the publisher of *Sturm*. Consequently the two friends met many of the foremost artists of the time: the theatre director Erwin Piscator, the Dadaist musician George Brecht, the poet Walter Mehring, and Wieland Herzfelde and his brother Helmut, soon to be known as John Heartfield, photomonteur *par excellence*. When, two years later, Citroen was appointed manager of the Sturm bookstore, the close friends found themselves at the epicentre of the city's artistic life. Once again they commemorated their good fortune with a joint self-portrait.

Two eccentric and charismatic individuals had an immediate impact: Walden's first wife, the famous poet Else Lasker-Schüler – who decided that henceforth the young photographer should be known as 'the black-and-white magician' – and the writer Dr Salamo Friedländer, whose texts appeared in *Sturm* under the pseudonym Mynona. 'It was from his lips that I first heard the magic words psychoanalysis and relativity, and the name Montaigne,' acknowledged Blumenfeld, 'He showed me the emergency exit from my parental home through the Café Grossenwahn (Café des Westens) . . . So I tried my intellectual fortune in the café.'[37]

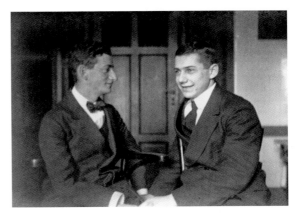

Erwin Blumenfeld and Paul Citroen, once again in a double self-portrait which consciously mimics the earlier one of 1910 (p. 23). Berlin, 1916. That year Blumenfeld would fall in love with Lena Citroen, Paul's cousin.

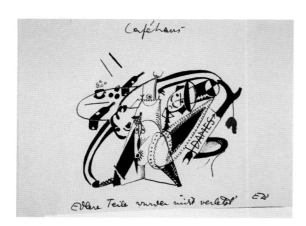

Caféhaus, c. 1921. India ink on paper. The inscription reads, 'Edlere Teile wurden nicht verletzt' (Nobler parts will not be injured). For many artists of the period, cafés represented freedom from bourgeois domesticity.

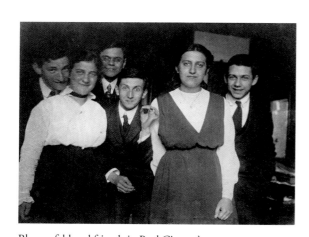

Blumenfeld and friends in Paul Citroen's room, Berlin, *c.* 1916. *Left to right:* Blumenfeld, Lena Citroen, Rudi Arnheim, Walter Mehring, Lotte Herzfelde (the sister of John Heartfield) and Paul Citroen. All were finding stimulation in avant-garde art. Photographer unknown.

The Café des Westens, dubbed the 'Café Megalomania' by the habitué Walter Mehring, was an Expressionist hothouse. Such cafés – and there were several in Berlin which welcomed artists – were, notes Roy Allen, 'the social institution of the era which combined convenience with a degree of freedom in manners, conversation and thought that the Expressionists required.'[38] Flamboyant dress and the flouting of social customs were calculated to outrage the bourgeoisie, and since the Café des Westens was located in Berlin's most fashionable thoroughfare, the Kurfürstendamm, the outrage was intensified.

The café fulfilled a number of vital functions for artists: it was an incubator of new ideas, a debating forum and a sounding board, a message centre, a source of the latest art news from abroad, a library where one could read the most recent issues of the Berlin art journals, and a magnet for visiting foreigners. Stefan Zweig called it 'our best place of education for what is new'.[39] In the mornings it also functioned as a studio – a place to actually *make* art. Artists sat at their favourite tables, writing or drawing alone. Socializing began at lunchtime. In addition to food and drink on the noisy ground floor, there were chess and billiards upstairs. Occasionally artists who had forgotten that the café was intended to be a business and not just a clubhouse were thrown out for not eating or drinking enough.

In a chapter of his memoirs entitled 'My Mount Olympus', Blumenfeld lists the great figures who had an impact on his life and art.[40] Some of these are included among names that had featured prominently in café conversation: Wilde, Strindberg, Baudelaire, Rimbaud, Wedekind, Whitman, Bergson, Nietzsche, Georg Simmel, Wilhelm Wildebrand, Jules Laforgue and Freud. It is not difficult to see the common thread: fierce individuality and disdain for the herd, sharp powers of observation, suspicion of excessive rationality, and recognition of the potency of sex and the importance of the unconscious.

Around the dynamic Lasker-Schüler were gathered a number of important artists: Mynona, Brecht, Mehring, the Herzfelde brothers, the pioneering Dadaist Richard Huelsenbeck, and the fiercely uncompromising painter George Grosz. Grosz had introduced himself to Blumenfeld in a most unorthodox way:

One night in 1915 I went, slightly merry, to the urinal on the Potsdamerplatz. A young dandy entered from the opposite side, put his monocle in his eye, opened his black-and-white checked pants and traced my profile in one fell swoop so masterfully on the wall that I could not help exclaiming in admiration. We became friends.'[41]

The attraction was obvious. As Henry Miller once remarked of Grosz, 'He saw in X-ray eyes, not only the flesh, but the mind and spirit as well . . .'[42] If the

young Blumenfeld had fancied himself the epitome of the cynical Berliner, he now discovered that in this remarkable eccentric he had more than met his match.

'A Future Blacker than Black!'

With the assassination of the Archduke Ferdinand at Sarajevo, Moses & Schlochauer was gripped with excitement. The boss foresaw war, and – in the best of all possible worlds – the conflict might well go on to 1944, ensuring massive profits for the firm from the mourning outfits women would be forced to buy again and again as they were widowed, re-married and re-widowed: 'I see the future as blacker than black!', Otto Moses proclaimed to his bemused apprentice.[43]

Like many Germans, however, Blumenfeld himself did not believe that the great powers would wage war, despite all the sloganizing and patriotic editorials. He felt confident that rationality would prevail. 'I felt superior and smiled at the grownups' childish worries,' he later confessed. 'Raised on the prejudices of morality, progress, civilization, I knew with absolute certainty until the very last hours of peace that war was an impossibility.'[44]

He was rudely disabused. Although he managed to avoid conscription for some time, March 1917 would find him as we have seen in the midst of the worst fighting on the Western Front, an ambulance driver with orders to drive his ungainly truck 'back and forth over impassable roads, without regard for men or materiel'.[45]

Between 1915 and 1917 the great opposing armies were essentially deadlocked, with minor shifts in the balance of power. While Blumenfeld was leaving Berlin for the front in March 1916, the Germans were beginning to fall back, but within a month they would halt a major French advance in the second battle of Aisne. Then, in May, another major reversal: fresh British attacks would break the Hindenberg line at Arras. Such shifts continued. Even with little territory changing hands, the casualty rates were staggering. In the first five months of Blumenfeld's service, both sides would lose half a million men.

He was often in the midst of carnage, and came close to death on several occasions. Of the great battle of the Chemin des Dames, which his comrades barely repulsed, he recalled:

> I stood there, sober, in the centre of one of the bloodiest battles in world history. Alone. Everything exploded. All life had crawled into the gashed bowels of forever violated mother nature Nailed upon the sky, motionless little clouds, angels of death In the splintered cinders of a tree dangled a hand[46]

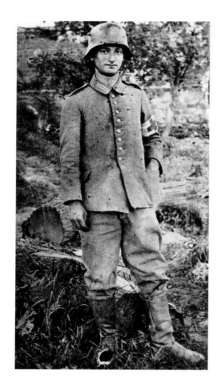

Private Blumenfeld, ambulance driver in the German army, 1917. Blumenfeld found it highly ironic that he had been conscripted as an ambulance driver despite the fact that he had never learned to drive. Photographer unknown.

Witnessing the behaviour of some of his comrades, the young soldier sometimes wondered who the real enemy was. Treatment of Russian prisoners-of-war was particularly repellent: at Easter 1917 Blumenfeld saw the German guards sitting on the edge of a quarry with their lunches in one hand, tossing what they laughingly called 'Easter eggs' – grenades – onto the helpless Russian prisoners below.

Blumenfeld learned that the dead could be profitable, too. A fellow soldier, offered cash by an officer for each body bagged for burial, worked out a way of doubling the money – by sawing the bodies in half and bagging them separately. Blumenfeld was therefore urged to 'rescue' corpses from the front, and to leave the wounded men behind, hanging on the barbed wire.

Indeed, some of his war experiences bear comparison with those of Jaroslav Hasek's hero, Svejk. For a short time Blumenfeld served as a bookkeeper for a German field brothel, where, as in childhood, glimpses through a peephole taught him volumes about human nature. He also briefly taught French to his sergeant, who needed to learn the language in order to become a Customs official. In return the sergeant arranged for Blumenfeld to 'win' the Iron Cross (Second Class) for bravery, though he never progressed beyond memorizing the first line of *Le Rouge et le noir*.

But there were moments of respite. Blumenfeld put *Le Rouge et le noir* to better use with a French nun, with whom he spent happy hours reading; later he shared Molière's *Les Femmes savantes* with a local schoolmistress. In spite of these female friendships, however, he remained faithful to his Dutch fiancée, Lena, a cousin of Paul Citroen's, whom he had met shortly before the war. He corresponded with her – in code – at every opportunity. Paul also regularly received postcards.

Blumenfeld came to love the pastoral landscapes behind the lines, and the tiny villages of Flanders and northern France. 'It was beautiful to dawdle through this lovely world, far from danger,' he recalled. The great cathedrals were a particular revelation: first Laon, 'my adored mistress of World War I . . . The oxen peeking from the highest windows of the tower won me over to gothic art'.[47] It seemed the perfect foil 'to the music of drumfire and the rattle of death'.[48]

The proximity to Holland and his beloved Lena tempted Blumenfeld to plan his desertion, but it was not to be. Letting his mother in on the plan led to his betrayal. Blind patriotism and the fact that her son was planning to marry a foreigner motivated her to inform a relative, who in a fit of spite notified the authorities. Blumenfeld was arrested, imprisoned and nearly shot. Only the chance intervention of an old business colleague, who happened to be a minor cog in the wheels of military justice, saved him. He was returned to the front in the dying weeks of the war.

'A Syphilization of Spirochetes'

That single, stupid act on the part of his mother – who compounded the offence by calling his fiancée a whore – goes a long way towards explaining the cruel treatment she receives in Blumenfeld's memoirs. On his balance sheet it was simply one misdeed too many. But both parents had a lot to answer for. Levelled at both were the general charges of shallowness, vanity and hypocrisy, though these are, after all, rather ordinary parental failings and, as their son admitted, were largely the consequence of his parents' social class.[49] More infuriating were their attempts during Blumenfeld's teenage years to discourage him from becoming an artist. 'A painter is a pauper,' he was admonished, even while the eternal truths of Art were praised to the heavens.

Later he was to discover that the real reason for his father's failing health and progressive insanity had been hidden from him; not until some months after Albert's death was the dreaded word syphilis whispered in his ear by a cousin. Henceforth the disease would be for Blumenfeld a metaphor for all the evils that had disrupted family life and devastated German culture and European civilization. Two world wars would prove that Europe had nurtured 'a syphilization of spirochetes'.[50]

'Complete Defeat'

With the fighting finally at an end, Blumenfeld made his way back to Berlin, arriving hungry and demoralized on 17 November 1918. However, the discovery of a cache of his parents' twenty-five-year-old wedding wine soon lifted his spirits. With fellow veteran George Grosz, he decided to invest the find in a night of debauchery. Brandishing a poster which promised a future in the movies to those who attended a party that very night, they trawled for young women on the Kurfürstendamm.

Eleven of their old male comrades arrived at Grosz's studio, among them former regulars of the Café des Westens: Mynona, Piscator, Huelsenbeck, Mehring and Wieland Herzfelde. To their delight more than fifty women showed up, and the men were forced to close the doors for fear of overcrowding. It did not take much coaxing to persuade the women to shed their clothes, and the night exceeded all expectations. Blumenfeld claims to have remembered little of what transpired, other than everyone having watched Grosz making love on a chaise-longue in the middle of the studio while clapping along with the rhythm. He awoke in Grosz's bathtub many hours later to find his clothes stolen. His host, meanwhile, complained that he had caught the clap.

The orgy not only marked the end of Blumenfeld's life in Berlin (the following day he enlisted the help of smugglers and crossed into Holland to be reunited with his fiancée), but also the end of his youth. Now he resolved to start a new life: marry, have children and make money.

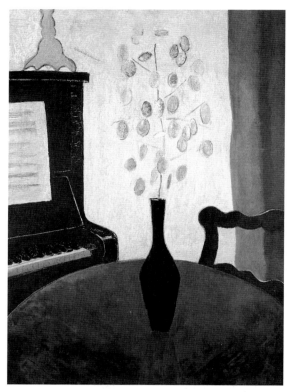

Untitled (Still life), 1930. Oil on canvas. In his memoirs Blumenfeld called himself a 'Sunday painter'. He found the activity a partial escape from the tedium of the garment trade. Curiously, the paintings have none of the violent expression displayed in the drawings and collages.

He was soon successful in all but the latter; the couple married in 1921, and in 1922 their first child, Lisette, was born. Henry would follow in 1925 and Yorick in 1932. But there was a high price to be paid for these achievements: the hated bourgeois existence. His struggle against it eventually ended, as he later confessed, in his complete defeat. Nor was he much of a success at adjusting to the rhythm of Dutch life; although he remained in Amsterdam for seventeen years, he never warmed to the city or its people, whom he regarded as dour, provincial and materialistic.

His first job in Holland was in a bookstore, where he tried to supplement his paltry pay by stealing pornographic plates from old books and selling them on with the connivance of Paul Citroen. When this was shown to make little difference to his finances, he joined Citroen in an art business set up by the latter in 1917:

> With the French I had acquired in the war, I wrote to the then unknown great masters whose work we knew from the *Blaue Reiter*, *Sturm*, and the *Ersten Deutschen Herbstsalon*: Léger, Braque, Juan Gris, Gleizes, Metzinger, Severini, and Carlo Carrà, requesting to be their sole agents in Holland. They all sent us drawings on commission Grosz also gave us his pictures.[51]

It did not take long to recognize the utter futility of this venture, or, as Blumenfeld savagely put it, 'the impossibility of selling Cubism to boors'.[52] Leaving Citroen to his own devices, he took the demoralizing step back into womenswear – to an antediluvian Jewish-German manufacturing and retailing enterprise: Gebroeder Gerzons. Here, by virtue of hard work, he was soon promoted to buyer of novelties for the firm's chain of department stores. But though he felt he was doing an admirable job and thereby securing his future, his employers seem to have thought otherwise: when in a moment of pique he offered his resignation, it was, much to his chagrin, immediately accepted.

'Jan Bloomfield'

It is more than likely that Blumenfeld's mind had not been entirely focused on his work. Ever since his arrival in the Netherlands – indeed, since he had fallen in love with Lena just prior to the war – he had been making art, partly to communicate this passion, partly as a release from the mundane pressures of daily life, and partly as a means of expressing his outrage over the war and the bankrupt values which, in his view, had brought it about.

It was also a way of keeping alive ties with Berlin – and not just with his art world friends and acquaintances. The underworld, with its whores, pimps and gangsters, also exerted a potent attraction for Blumenfeld, as it did for so many

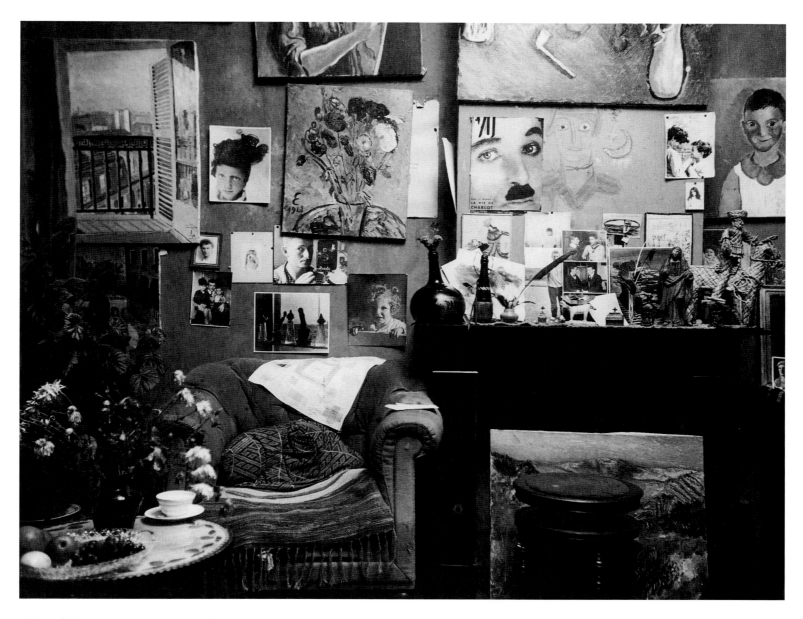

of his fellow artists. Here one found true defiance of the putrid moral order! Particularly heroic were the exploits of boxers, such as the heavyweight champion Jack Johnson (celebrated in collages by both Blumenfeld [p. 37 *bottom*] and Citroen). Although, by comparison, it was defiance of a different order, Blumenfeld was proud of his arrest on the beaches of Zandvoort, for having allowed the shoulder strap on his bathing suit to slip (a charge of indecency!) even if the offence had serious implications: later, when he applied for Dutch citizenship, his 'criminal record' would render him ineligible.[53]

Oddly, none of the underside of Berlin, or for that matter Amsterdam's famous red-light district, featured in Blumenfeld's oil paintings: for subject

The sitting room of the Blumenfeld house in Zandvoort, a village some twenty kilometres from Amsterdam, *c.* 1930. Photograph by Blumenfeld. On the walls are Blumenfeld's own paintings and photographs, along with an image of his hero, Charlie Chaplin. Note the portrait of his daughter Lisette (to the left of the still life of flowers), son Henry (far right) and his own self-portrait (below the still life of flowers).

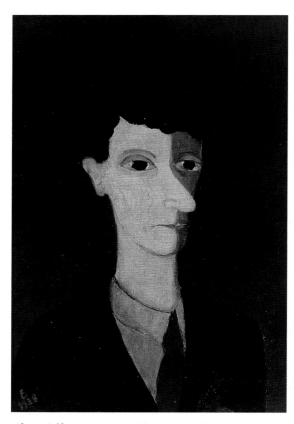

Above: Self-portrait, 1938. Oil on canvas. The self-portrait, whether drawn, painted, assembled in collage, or photographed, is a ubiquitous theme in Blumenfeld's *œuvre*.

Opposite: Charlie, 1921. Collage, india ink, watercolour and pencil on paper. Blumenfeld judged this his most accomplished and serious collage. It touched on a number of themes that often engaged his interest: life's tragic-comic dimension, war, religion and mysticism.

matter he contented himself with domestic scenes, still-lifes of fruit and flowers, and introspective portraits of self and family, executed for the most part in a subdued Impressionist style. By contrast, his collages and drawings (and sometimes hybrids of the two) were strident and anarchistic. These loosely structured works consisted of collaged elements of ephemera – fragments of photographs, maps, letters, segments of reproductions of paintings or engravings, product labels, cigarette wrappers, stamps, bits of text from newspapers and advertisements – to which might be added small drawings in ink, watercolour, crayon or pastel.

Baroque buildings and statues, nuns and saints, beautiful women, the Kaiser and his family, pompous generals and the massed ranks of men they deployed as cannon fodder, anthropomorphic animals and plants, astrological signs and symbols, his beloved wife, self-portraiture – Blumenfeld never tired of these subjects. Occasionally he made drawings without collage, or composed elaborate pages of handwriting, in a profusion of styles, as if by different hands. Indeed, he was fascinated by the individuality of handwriting and enjoyed inventing the 'autographs' of famous figures.

Despite the disparate subject matter, some themes recur: death and destruction through military misadventure; sexual desire; the vulnerability of the individual; the pomp and pageantry of the Catholic Church; the hubris of authority figures; martyrdom; and self-identity, whether as a split sexual persona, as a fraudulent lover, or as an unwilling 'chauffeur de camion' in the Kaiser's doomed army.

Significantly, these works are concerned with the detritus of the past, the collapse of the old order. Blumenfeld shied away from the brave new world of machines and skyscrapers that fellow artists Raoul Hausmann and Paul Citroen were depicting in their collages. It is curious, then, that Blumenfeld should use the term 'Futurist' when describing one of the two key elements of his style, considering that movement's faith in every technological marvel of the age; horses are the means of transport in a Blumenfeld collage, rather than Futurist automobiles and locomotives.

Although Cubist motifs make the occasional appearance in a Blumenfeld drawing, for the most part Expressionist colour and form are the inspiration. Certain of the images suggest the influence of Kirchner and other artists of the Die Brücke group, and the paintings of Emil Nolde and Oskar Kokoschka; the latter's 1923 *Sturm* exhibition catalogue cover was used as the ground for one of Blumenfeld's more sexually explicit depictions of himself and Lena (p. 38, *left*). But, specifically where the collages are concerned, Dada is the key.

Dada had originated in pre-war Expressionism, with which it shared many ideas, but it parted company with the latter over political issues: whereas Expressionists saw in the new German Republic the answer to their prayers, the

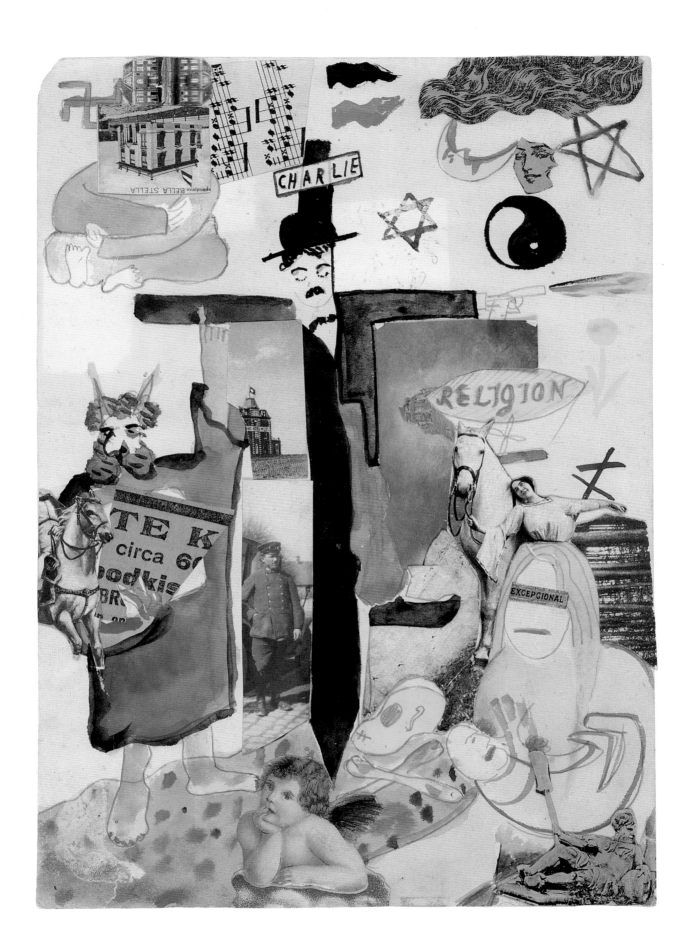

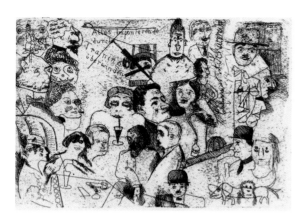

Café Megalomania, an etching from a drawing jointly executed by Erwin Blumenfeld, Paul Citroen and Walter Mehring, 1921. In this depiction of the hectic social scene at the Café des Westens, the newly married Blumenfeld appears twice: once in the centre and again (bottom right, in bowler hat) with his wife, Lena.

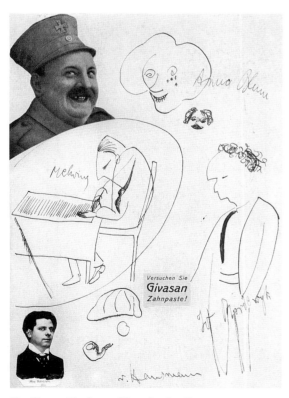

Try Givasan Toothpaste (Versuchen Sie Givasan Zähnpaste), 1921. *Clockwise from bottom left:* Max Reinhardt, Walter Mehring, an anonymous soldier, the fictional Anna Blum, Jo Nordewcyk and Raoul Hausmann. Collage and india ink on paper.

Dadaists saw in it only self-delusion. For a Dadaist, human nature was volatile and dangerous, and political solutions to social ills were a mirage. Hausmann spoke for Blumenfeld, too, when he raged, 'Weimar is nothing but a lie, a mask hiding Teutonic barbarism.'[54]

Blumenfeld was thoroughly familiar with Dada's tenets and with a number of its leading figures, whom he had met in pre-war Berlin. Both general and specific Dada influences can be discerned in his work – Tzara's 'calligrams', for instance, or Hausmann's phonetic poems and savage anti-Kaiser cartoons. With its nihilism, hostility to authority and tradition, and madcap humour, Dadaism corresponded perfectly to Blumenfeld's frame of mind in the aftermath of his surreal war experiences. Locked in the bosom of a bourgeois Dutch family and still trapped in the garment trade, he would seize any spare moment to wield a scalpel in the Dadaist spirit, defacing hated symbols of authority and musing on the absurdity of life. And why not a new persona to take credit for it? A certain 'Jan Bloomfield' stepped forward to claim authorship of the works.

'Chaplin Beat Rembrandt!'

Although somewhat isolated in Amsterdam, Blumenfeld was able to keep up with developments in Berlin through Citroen, who had established many contacts as an unofficial representative and 'propagandist' of *Sturm.* The two soon decided to compensate for their physical remoteness by running up the flag of Dada in Amsterdam. Richard Huelsenbeck agreed they should be co-presidents of the Amsterdam branch (and its only members), and accepted their contributions to his 1920 *Dada Almanach.*[55] Further Dadaist communiqués were sent via postcard to artists in Paris and Berlin.

Blumenfeld was also able to make occasional trips to Germany and France. In 1921, on his honeymoon, he and Lena met up with some of his old colleagues at the Café des Westens. In honour of the occasion he collaborated with Mehring and Citroen on an amusing sketch of café life (*above left*). Blumenfeld also flew with Lena to Paris, travelling in a tiny Fokker. There is no account of this stay, but one suspects that visits to galleries and museums must have been high on the agenda, and that Blumenfeld would certainly have been dismayed by the new Purist works of art then in vogue, with their mathematical precision and their emphasis on stability and harmony.

Back home, fellow artists sometimes featured in Blumenfeld's work: in *Try Givasan Toothpaste* (1921), for example (*left*), Walter Mehring and Raoul Hausmann rubbed shoulders with Blumenfeld's theatre hero Max Reinhardt. But way above all the creative people in Blumenfeld's universe loomed the tragicomic figure of Charlie Chaplin.

Whereas most of Blumenfeld's collages were generated spontaneously with materials at hand, the elaborate *Charlie,* of 1921 (p. 35), called for several

preparatory studies. This striking collage also employed india ink, watercolour and pencil. Around the crucified figure a chaotic universe unfolds, peopled by madonnas and angels, satyrs and soldiers. The face of a beautiful woman beams down on the scene; a musical score arcs overhead like telegraph wires; a pistol spews flame. Fragments of old buildings and landscapes are uprooted and tossed about, while a goat-man pronounces obscurely on Charlie's fate.

As the Swiss art historian Hendel Teicher reminds us, for many artists Chaplin was a perfect symbol for the persecuted Jew. Teicher recalls Hannah Arendt's analysis: 'The world Chaplin creates is very down-to-earth, grotesquely caricatured perhaps, but nonetheless starkly real. It is a world from which neither nature nor art offer an escape, in which humour is the only possible shield against all attacks and temptations.'[56] It enhanced Chaplin's status as anti-hero among Berlin's artists that his films had been banned there until 1921. All Dadaists agreed: 'Chaplin beat Rembrandt!'[57] As a personal token of respect, Blumenfeld announced in 1921 in a collage-postcard to Tristan Tzara that henceforth he was 'President Dada Chaplinist-Charlotin'. An accompanying letter staked his claim to being both 'erotic PRESIDENT of the DADA movement' and 'the inventor of orphic CHAPLINISM'.[58] The word was as important as the image in Blumenfeld's collages; in the best Dada tradition, the textual elements are bold, ironic, playful and enigmatic.

'The Corpse of Bleeding Fox'

Meanwhile, Blumenfeld had entered into a business partnership. On 1 June 1923, on the Kalverstraat, a fashionable shopping street, he opened the Fox Leather Company, an elegant leather goods store specializing in women's handbags. But he rapidly discovered that he had no talent for selling, and though he took great pains with both the internal design of the store and the window-dressing, few of the goods seemed to appeal to the women of Amsterdam. Nor was trade improved in 1932 by a move down the street to a new location, even though it featured his own strikingly modernistic shopfront design (p. 45).[59] Within three years the patience of his sleeping partner would evaporate and he would be forced to sell the business at a loss.

But, incredibly, 'the corpse of bleeding Fox' would yield salvation. Soon after moving to the new premises the hapless merchant discovered a darkroom, complete with Voigtlander camera with bellows, behind a barricaded door. Since childhood he had been taking pictures to record family and friends. Now, however, it was enthusiasm of a different order. Perhaps photographs of beautiful women – portraits and nudes of the very women who came into his shop to browse – could liven up his windows. The idea seemed to work: by day he took portraits, by night he toiled in the darkroom. In the shop window every morning a new face beamed among the forlorn leather goods.

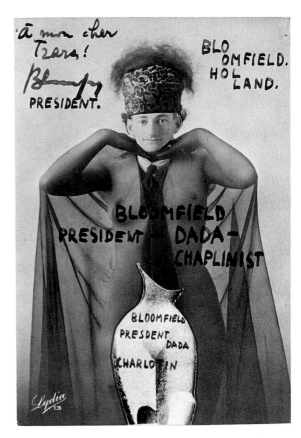

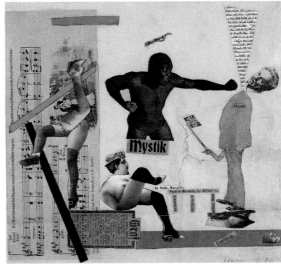

Top: In a collage postcard to Tristan Tzara, sent in 1921, Blumenfeld ('Jan Bloomfield') appoints himself 'President-Dada-Chaplinist'.

Above: Marquis de Sade, 1921. Collage. For both Blumenfeld and Citroen, the boxer was a figure to venerate.

Below: Oskar Kokoschka - Twenty Drawings, 1923. Collage, watercolour and crayon on cover of exhibition catalogue. Blumenfeld was a devotee of the work of the German Expressionists, and was particularly intrigued by their use of strident colour. Like so many of his collages, this work was a token of his love for Lena.

Right: Untitled, c. 1924. Collage with ink and crayon on stationery.

Opposite: Interieur und Liebe (Interior and love), *c.* 1919. India ink and coloured crayon on paper. In all likelihood this tender scene depicts Blumenfeld and Lena. In spite of his damning critique of his own upbringing, once in Amsterdam he set himself the goal of building a home and starting a family.

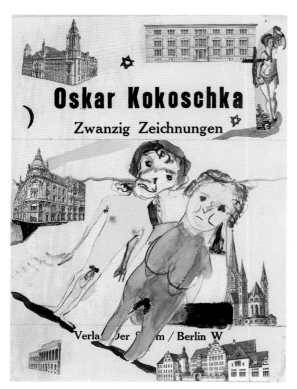

'A Dinosaurian Nebbisch'

Enraptured though he was with the avant garde during his formative years, Blumenfeld had paid little attention to the state of contemporary art photography, though he knew very well what the public thought of it:

A professional photographer was a pitiful dinosaurian nebbisch (like Hjalmar Edkal in Ibsen's *The Wild Duck*). Wearing a sleazy velvet jacket and a greasy Windsor tie, and harbouring dirty intentions, he would ponderously shift small window shades with a rod so as to regulate the light.

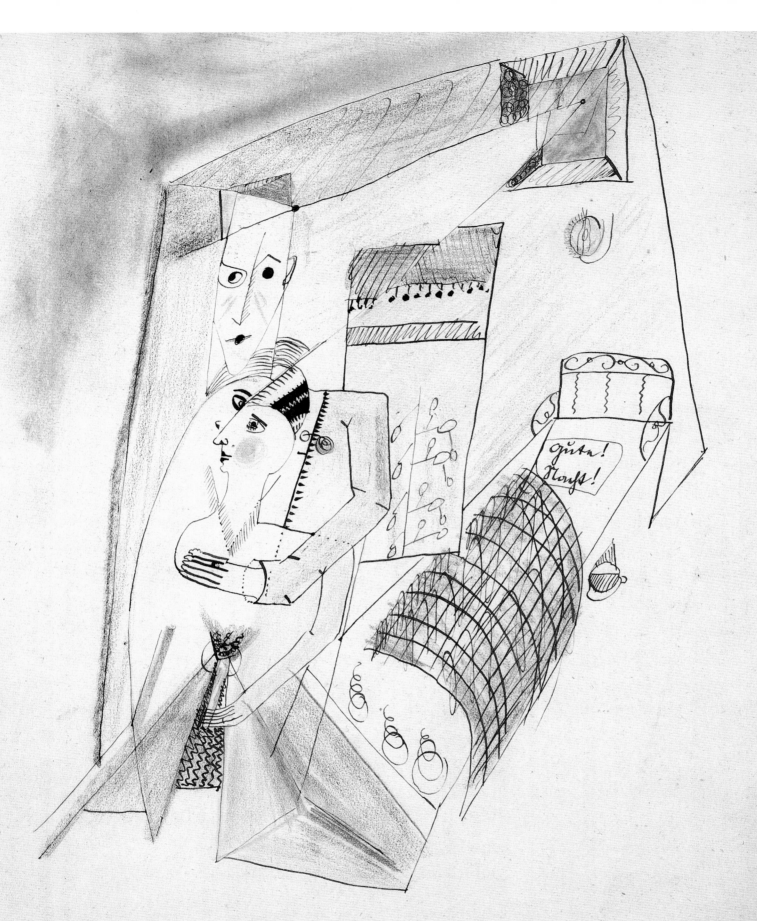

Interieur mit Liebe.

1919.

Der Menschenleeke Blo. H. 100.

With his clammy hands he would push your head this way and that, and finally wedge it in a clamp. When he then whined 'Now look for the little birdie,' all you could do was blink. Result: blurred pictures.[60]

Blumenfeld was actually providing a partly accurate description of run-of-the-mill *professional portraiture* as practised in the late nineteenth century (though no photographer would have remained long in business with blurred portraits). Creative, experimental photography of the kind which would have appealed to Blumenfeld *was* stagnant in this period. But what he failed to point out – and probably did not know – was that a handful of these same studio professionals had been the first to express their dissatisfaction with the status quo, devoting their free time to experiments with new subject matter and printing processes – and this a decade or so before Blumenfeld's birth.

In their attempts to overcome the formidable antipathy of their colleagues and the public – photohistorian Helmut Gernsheim tells us that 'the mere idea of a photographic exhibition in a leading art gallery seemed as incongruous as holding a scientific congress in a church'[61] – and to prove photography's worthiness as an art, the innovators were inclined to be overzealous. Thanks to elaborate new printing processes, photographic landscapes, nudes and portraits now began to look more and more like oil paintings, charcoal drawings and etchings; in fact, the less a photograph looked like a photograph the more it was admired.

Amateur photographers joined the ranks of these 'Pictorialists' in droves. In Germany, the photographers of Hamburg took the lead, showing no fewer than six thousand pictures at their very first exhibition of 1893. Other German cities followed in quick succession, with Berliners demonstrating particular enthusiasm. By 1899 even Berlin's Royal Academy had sanctioned photography as an art.[62]

Thus, if the young Blumenfeld had felt inclined, he could have looked for inspiration to a number of superbly illustrated photography magazines which had begun to appear in the early 1900s, journals such as the monthly *Photographisches Zentralblat* and the annual *Die Photographische Kunst*.[63] He would then have seen that the new artistic impulse was not and had not been confined to drab portraiture, nor to Germany, but had taken hold in France, England, Belgium, Italy and as far away as North America. And the finest of these photographers – Austria's Heinrich Kühn, France's Robert DeMachy and America's Edward Stieglitz, to name only a few, had indeed done much to demonstrate the unique aesthetic potential of the new art form.

For all its burning sense of mission, however, Pictorialism had in fact turned to a vision of the past for accreditation, and photographers of Blumenfeld's

generation dismissed it as reactionary and bourgeois. They could appreciate photography for what it was, not for its pretensions to high art. The nineteenth-century motion studies of Muybridge and Marey or even Röntgen's X-Rays were deemed far more relevant than the misty landscapes and sentimental genre scenes of the Pictorialists. Press photography also had staggering implications. Noting that his birth coincided with that of photojournalism, Blumenfeld wrote: 'Up to that time, daily events were sketched by clever artists and published many weeks later in *Die Woche*. Suddenly the *Illustrierte* reported the Emperor almost at the same moment, alive though blurred, eclipsing everything that had previously mattered.'[64]

'The New Vision'

In the mid- to late 1920s when Blumenfeld opened one of his favourite magazines – perhaps Berlin's *Der Querschnitt* or Brussels's *Variétés* – his eye fell on a new style of photography, and one much to his liking: vertiginous views from high bridges, steel towers and skyscrapers, often shot at odd angles, geometric studies of striking new modernist offices and factories and the gleaming machinery inside, fragmented close-ups of human and animal faces, cityscapes and landscapes where bold shadows had as much substance as concrete. Minimal still-lifes were composed of modern materials like glass and steel rather than the standard fruit and flowers of convention, while Cubist and Constructivist motifs brought new life to fashion images. Sudden, almost surreal conjunctions of events on city streets were caught by photographers armed with tiny cameras and superhuman reflexes.[65]

There was just as much innovation in the darkroom. Negative printing, solarization, double and multiple exposures, mirror distortions, high-key printing, photomontage and cameraless imagery were new darkroom strategies which promised the imagemaker a means of escape from the medium's stifling realism.

The leading exponents of 'the new vision', as Moholy-Nagy called it, became familiar to Blumenfeld: Germaine Krull, Herbert Bayer, Maurice Tabard, André Kertész, Florence Henri, Man Ray, Albert Renger-Patzsch The editors of new photography magazines, foremost among them the Parisian *Arts et métiers graphiques* and its sister publication *Photographie*, opened their doors to inventive photography anywhere, including anonymous work, whether it was views from the known reaches of the cosmos or the latest microphotography or X-rays of insects and flowers.[66]

Taken together, the new subject matter, the novel ways of depicting it, and a new generation of photographers added up to nothing less than a revolutionary way of seeing and perceiving the world. It all made perfect sense to Blumenfeld, who took to it like a duck to water.

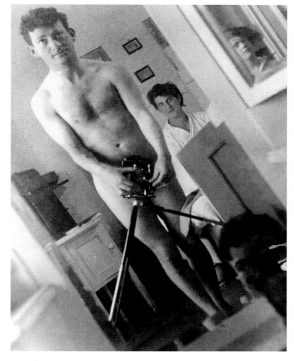

Family portrait, at home in Zandvoort, *c.* 1930.
Left to right: Erwin, Lena, Lisette (in mirror), Henry (bottom right). Although he did not devote himself fully to photography until his fortuitous discovery of an equipped darkroom in 1932, Blumenfeld remained an impassioned and resourceful amateur throughout the twenties.

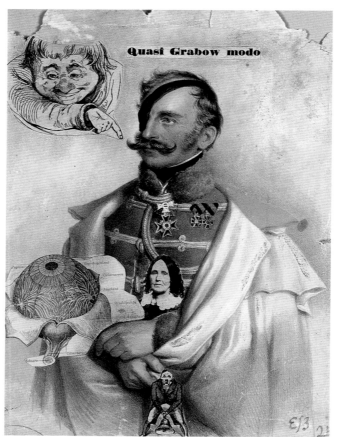

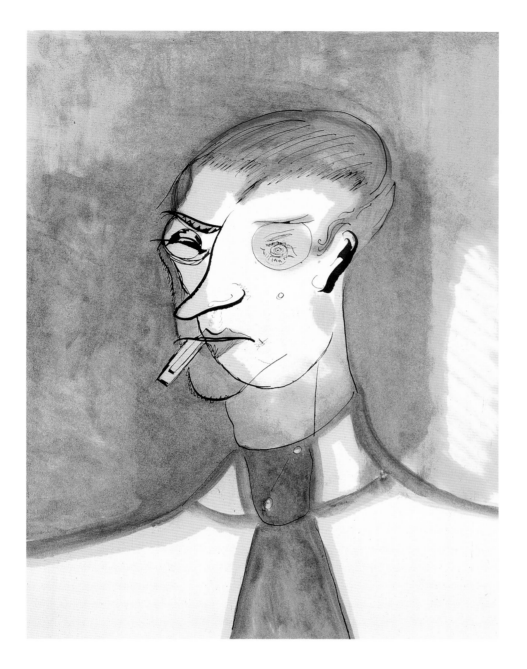

'The Fetishes of My Life'

Although his fortuitous discovery of the darkroom would set Blumenfeld on the long road to fame and fortune as a professional photographer, he had in fact been practising photography on and off since his boyhood. The earliest of his Dutch photographs are those of his immediate circle of family and friends. His wife Lena was a prominent subject (pl. 43), patiently allowing her husband to hone his skills and indulge in his manifold experiments with light and shade. Photographs of the children were also plentiful. Whether indoors or out, Lisette and Henry remember the sessions as playful and inventive, though Yorick, the youngest of the three, recalls that their father was very much the director and left the children little scope for their own creativity.[67]

Opposite, top: La Baionnette (The Bayonet), *c.* 1921-25. Collage and watercolour on paper.

Opposite, bottom: Quasi Grabow Modo, 1924. Collage, india ink and pencil on paper.

Above: Portrait (thought to be of Sylvia von Harden, a journalist and an habitué of the Café des Westens), 1926. India ink and watercolour on paper.

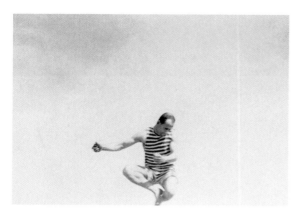

Paul Citroen on the beach at Zandvoort, near the Blumenfeld house, August 1929.

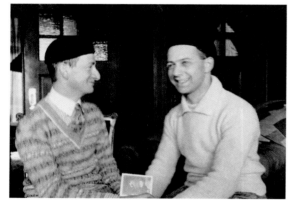

The third and last of the identically posed joint self-portraits produced by Blumenfeld and Citroen, Amsterdam, 1926. (Note the 1916 photograph in Blumenfeld's right hand.) The closeness of the relationship may be partly explained by their feelings of distance from Dada colleagues in Berlin.

Of the various friends who sat for Blumenfeld or performed for his camera, foremost was Paul Citroen. Blumenfeld captured him in an exuberant mood on the beach in Zandvoort so that he seems to dance on the bottom edge of the picture.

The sculptor John Raedecker (pl. 35), the painter Raoul Hynckes, and the art dealer Carel van Lier (pl. 42) and his assistant Lenie Spoor were other close friends and artworld acquaintances who posed informally for Blumenfeld in this period.

Throughout the twenties Blumenfeld dabbled in a range of other subjects: parks and gardens, the facades and interiors of baroque churches, house interiors (possibly as commissions) and street scenes. For the most part these subjects seem to have been less interesting to the photographer in themselves than for their volumes, forms and textures, and the patterns of light and shade that enlivened them: a swatch of tweed seen in almost microscopic close-up or the shadows of trees caressing a rolling landscape (pl. 29).

There are a small number of nudes from this early period as well, which prefigure the work Blumenfeld would pursue in earnest in Paris and New York (pls. 13, 27). Most of his efforts, however, were concentrated on photographing the faces and heads of women. 'Portraiture' is not quite the right word for these pictures, inasmuch as portraits strive either to reflect a unique personality or character or to depict the sitter as a social being, with a certain standing, professional status, class, and so on. Blumenfeld, it seems, had another agenda: *his* 'obsession' was with *woman* in general rather than with specific individuals and specific personalities. This is not to say that he meant to disavow individualism, or represent some kind of ideal woman (as did, for example, the fashion photographer George Hoyningen-Huene with a template from Classical Greece); on the contrary, what is striking about these pictures is how individualized these women are, even if, some seventy years later, we know little or nothing about them, not even, for the most part, their names. Blumenfeld *himself* saw as his aim the celebration of 'the eternal feminine . . . the fetishes of my life: eyes, hair, breasts, mouth'.[68]

The shop-cum-studio in the Kalverstraat was therefore ideal: customers drifted in, and if he found them of interest they would be invited into the private office to pose. Some sittings were paid for, but for the most part the women were there at Blumenfeld's invitation. Either way, the session was on his terms. These women had probably never experienced a portrait sitting, or studio, quite like this one: they might be asked to stand in a corner, the photographer perched on a ladder above them, or to hold their hands and arms in unorthodox configurations – or to close their eyes and hide their faces from the lens. Some were coaxed into posing in the nude (pl. 27), while one allowed herself to be wrapped up as an Egyptian mummy (pl. 23). There were exceptions to the rule

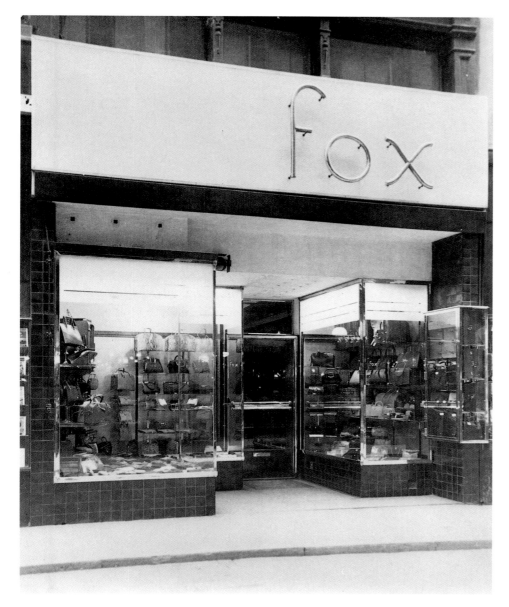

The Fox Leather Company premises on the Kalverstraat, Amsterdam, with shopfront design by Blumenfeld, c. 1932. Behind a barricaded door inside the shop, he discovered a fully operational darkroom, which he immediately put to good use.

of anonymity: the actress Charlotte Kohler (pl. 41); the photographer Marianne Breslauer, the socialite Eva Penninck (pl. 11) and one or two others who were part of his circle. These, too, entered into the collaborative spirit of the game.

Only the most perceptive of his sitters, men or women, could have had any idea of the transformations their negative might be subjected to in Blumenfeld's darkroom, thanks to partial solarizations (pl. 20), negative prints and a raft of innovative techniques with which he was then experimenting. Nor did they have any guarantee that whatever print emerged would not be exhibited upside down, or cut into fragments and recombined (pl. 18).

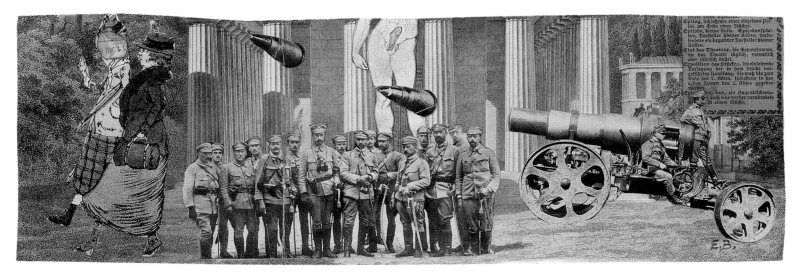

Above: Big Bertha, 1923. Collage on paper. Big Bertha was a gun made by Krupps of Essen, which could fire a shell from the German front line to Paris.

Opposite page, top: Hitler, 1933. Combination print with coloured ink.

Opposite page, bottom: Self-portrait, c. 1933. The inscription reads 'Met de hartelijke groeten mit het gedachten concentratie kamp', which loosely translates as 'With cordial greetings, thinking of the concentration camp'.

'Worthless Snapshots'

Carel van Lier gave Blumenfeld his first solo show at the Kunstzaal van Lier gallery in Amsterdam's Rokin street in 1932.[69] No record remains of any sales made, but there were reviews.[70] The photography had little in common with the style then in vogue in the Netherlands – a rather insipid and decidedly second-rate Pictorialism – and the critics were appalled. 'We rushed there full of interest, but were profoundly disappointed,' wrote the *Bedrijfsfotografie*,

> The maker of these photos would no doubt be able to make something of himself if he spent five years learning to photograph properly. But at the moment he hardly understands the simplest thing about the business of photography. The result is a collection of work, which, from a technical point of view, can be called nothing other than a set of enlarged and worthless snapshots by an amateur who has owned a camera for a few weeks. It is really utterly deplorable that such work should be exhibited in an art gallery.[71]

The severity of the judgment did not unduly faze Blumenfeld. Nor did the negative assessment of his work by the magazine picture editors at Ullstein Verlag in Berlin to whom he had submitted examples; they bluntly advised him that he had no future in photography. Van Lier, at least, remained a faithful supporter, arranging a further show, Cinquante Têtes des Femmes, in 1934.[72] In the same year Blumenfeld staged this exhibition at a gallery in The Hague.[73] The French title was telling: it made explicit the subject matter – heads, not portraits; it expressed his low opinion of the Dutch language (and implicitly of the Dutch themselves); and it revealed his attraction to French attitudes towards both women and art. To his delight, it was a French publication, *Photographie,*

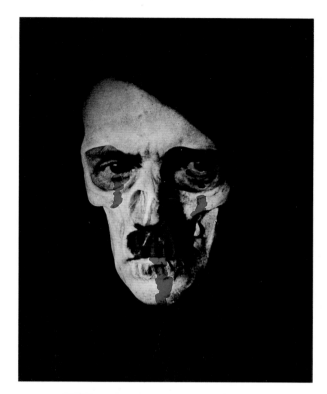

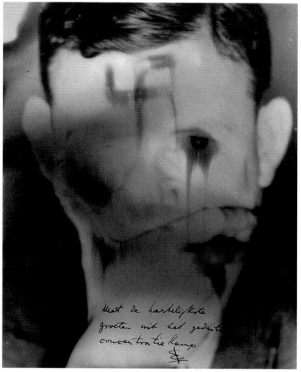

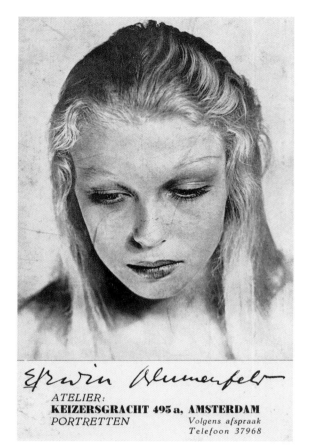

Blumenfeld's business card, with a portrait of Tara Twain, a Hollywood actress he had met in Amsterdam in 1935. This picture was the first Blumenfeld image to be published in a magazine.

which first published Blumenfeld photographs, a portrait of the Hollywood actress Tara Twain, *Momie vivante* (for a variant, see pl. 23) and a portrait of an anonymous woman. Within the year, he would be settled in Paris.

Throughout this period, as throughout his life, Blumenfeld continued to focus the camera on himself, often using mirrors so that he could include the tools of his trade in the image. A remarkable self-portrait of 1933 depicts the photographer as a victim of Nazism, branded with a swastika and weeping photochemical 'tears' (p. 47); it was sent to Van Lier with the chilling inscription: 'With cordial greetings, thinking of the concentration camp'.[74]

At this period, politics were beginning to drive a wedge between Citroen and Blumenfeld. Blumenfeld foresaw the horrific implications for the Jews in Hitler's coming to power, but felt that his friend, who Blumenfeld claimed was enamoured of the new Italian leader, Mussolini, was blind to the dangers.[75]

The self-portrait with swastika complemented a picture Blumenfeld had produced of Hitler on the very night of his election to power in 1933: prophetically it showed the demagogue as a living incarnation of death (p. 92).

As for the business, nothing could save it. Since Hitler's rise, Blumenfeld's Jewish leather dealer in Berlin had been unable to continue his business and another source could not be found. Fox was sold without a penny in profits. At home the gas and light were cut off and the piano impounded. It was to no avail that Blumenfeld, in a last magnificent Dadaist gesture, wrote to the Archbishop proposing that he buy the souls of the family for 500 Guilders – a sum well below the market price.[76] When this proposal came to nothing, the only alternative was to leave for greener pastures. Paris beckoned. There he would pursue his newfound dream of becoming a fashion photographer. Without money or passport, and leaving the family to follow later, he fled Amsterdam, with Voltaire's words in his ears: 'Adieux canaux, adieux canards, adieux canailles.'[77]

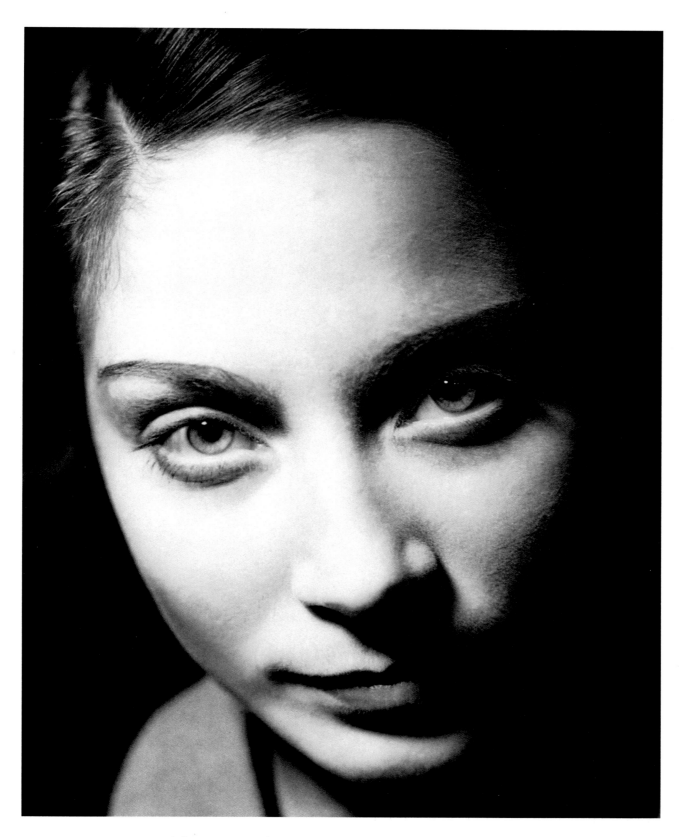

10 Untitled portrait, Amsterdam, *c.* 1932 (From the photographer's original contact sheets)

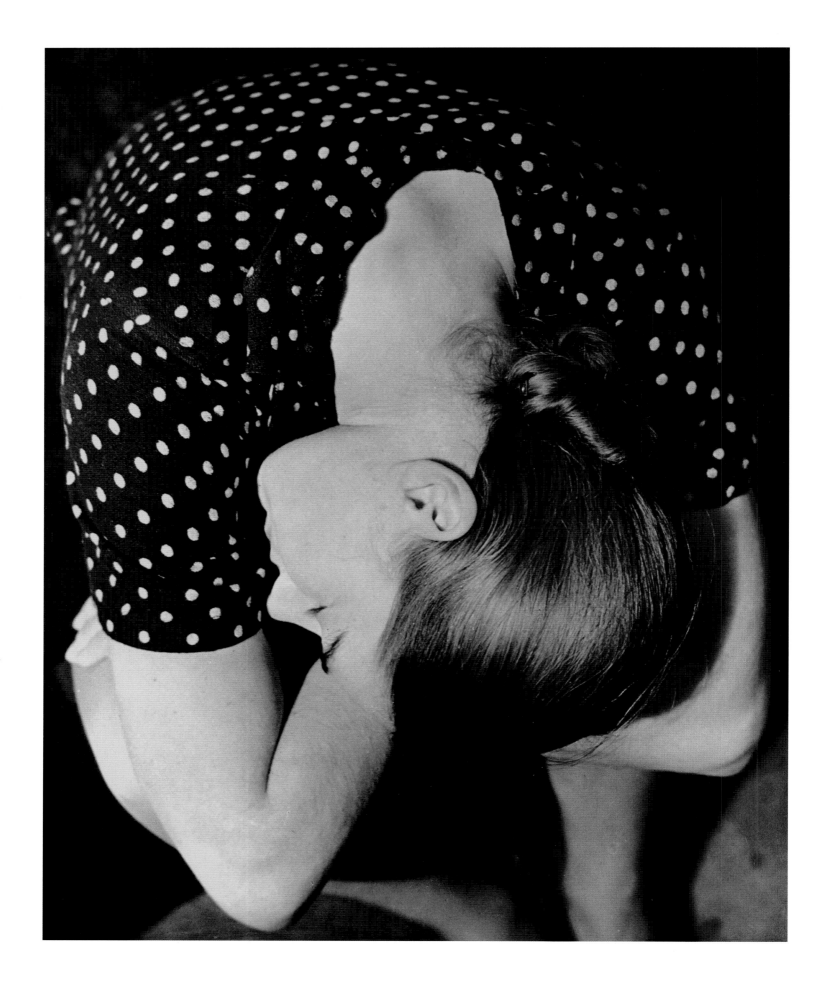

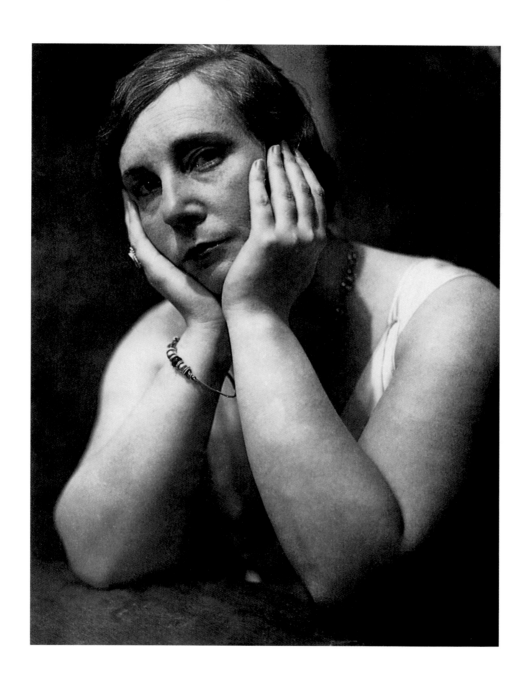

11 *Eva Penninck*, Amsterdam, *c.* 1932

12 Untitled portrait, Amsterdam, *c.* 1932 (From the photographer's original contact sheets)

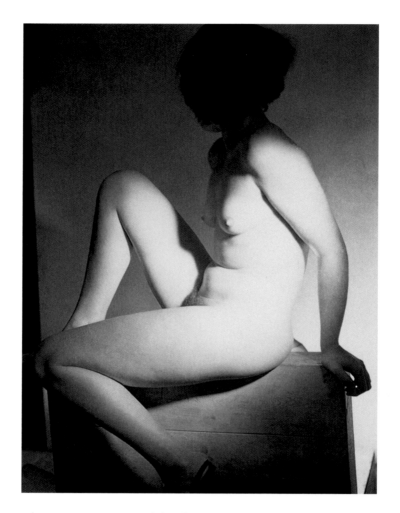

13 Untitled nude, Amsterdam, *c.* 1932
(From the photographer's original contact sheets)

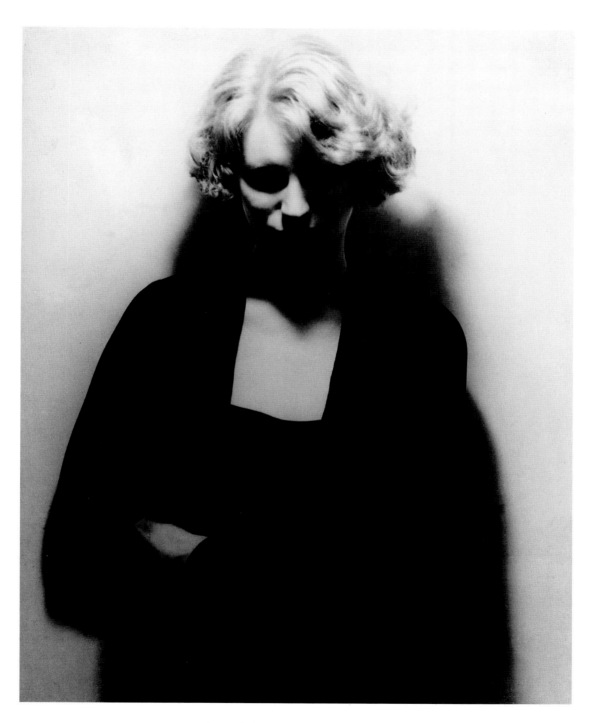

14 Untitled portrait, Amsterdam, *c.* 1932

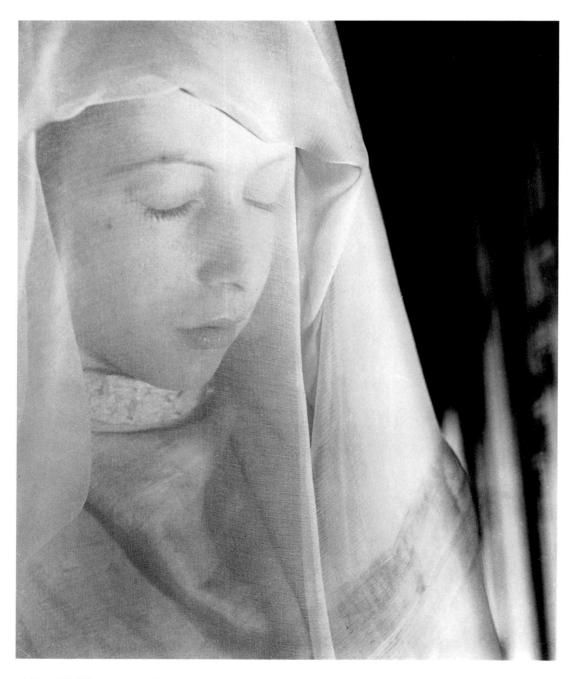

15 Untitled (After Roger van der Weyden), Amsterdam, *c.* 1932

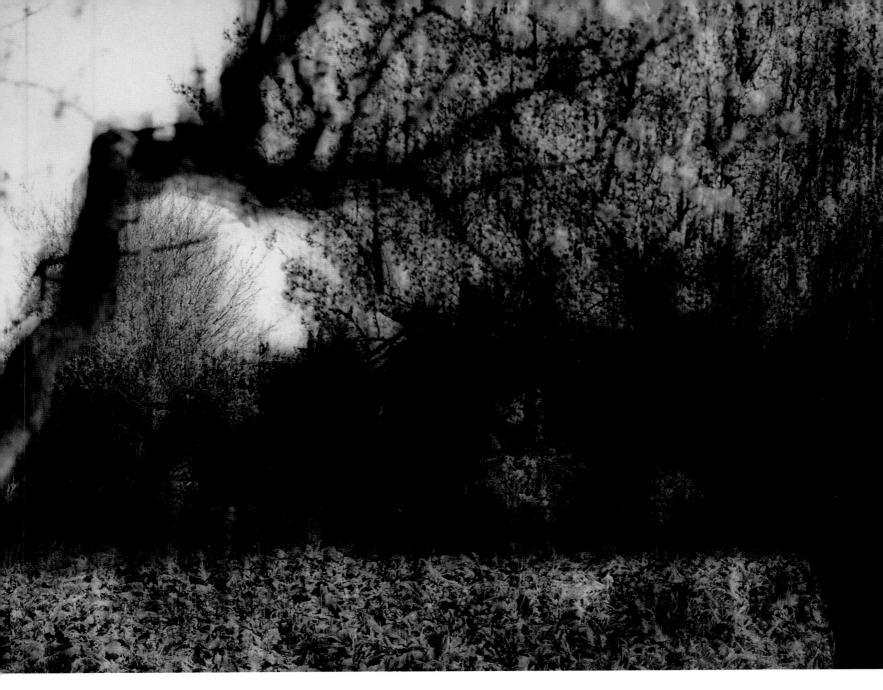

16 Untitled landscape (Northern Europe), *c.* 1932

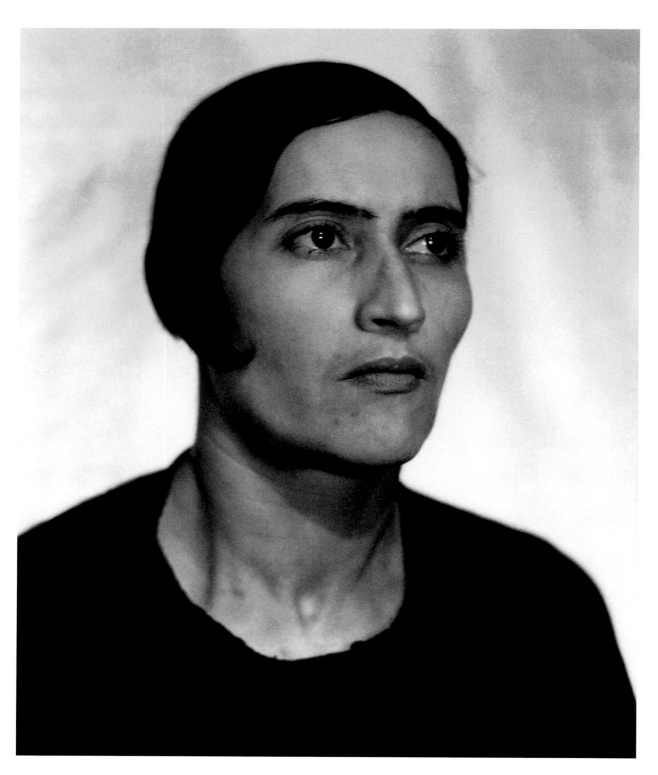

17 Untitled portrait, Amsterdam, *c.* 1932 (From the photographer's original contact sheets)

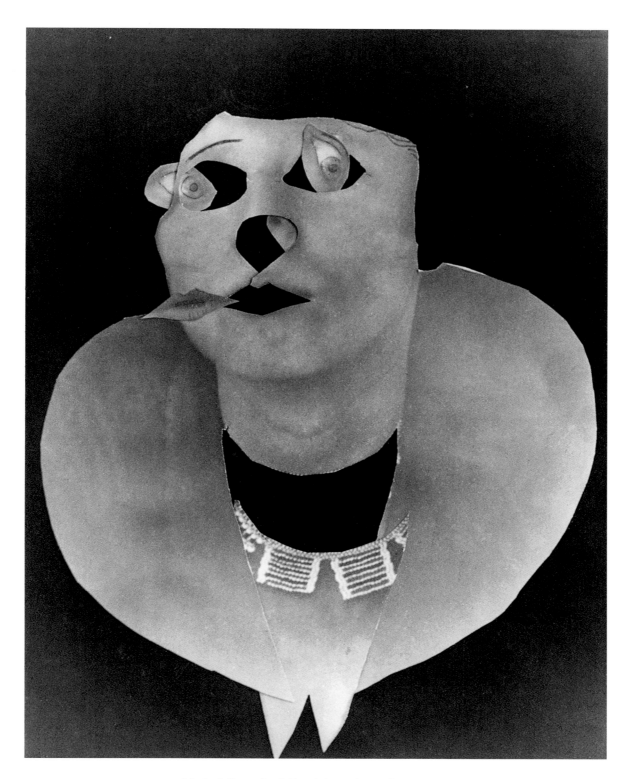

18 *Lenie Spoor, Art Gallery Assistant*, Amsterdam, *c.* 1932

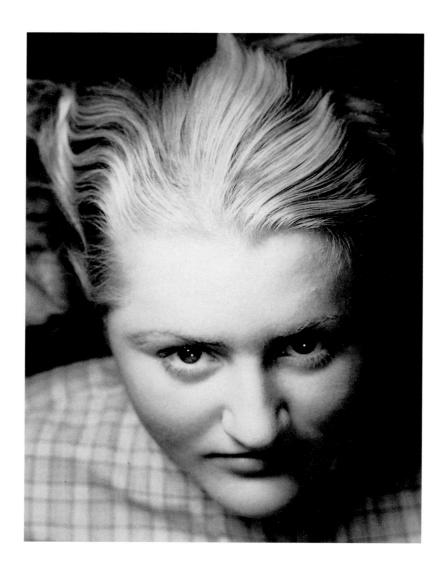

19 Untitled portrait, Amsterdam, *c.* 1932 (From the photographer's original contact sheets)

20 Untitled portrait, Amsterdam, *c.* 1932

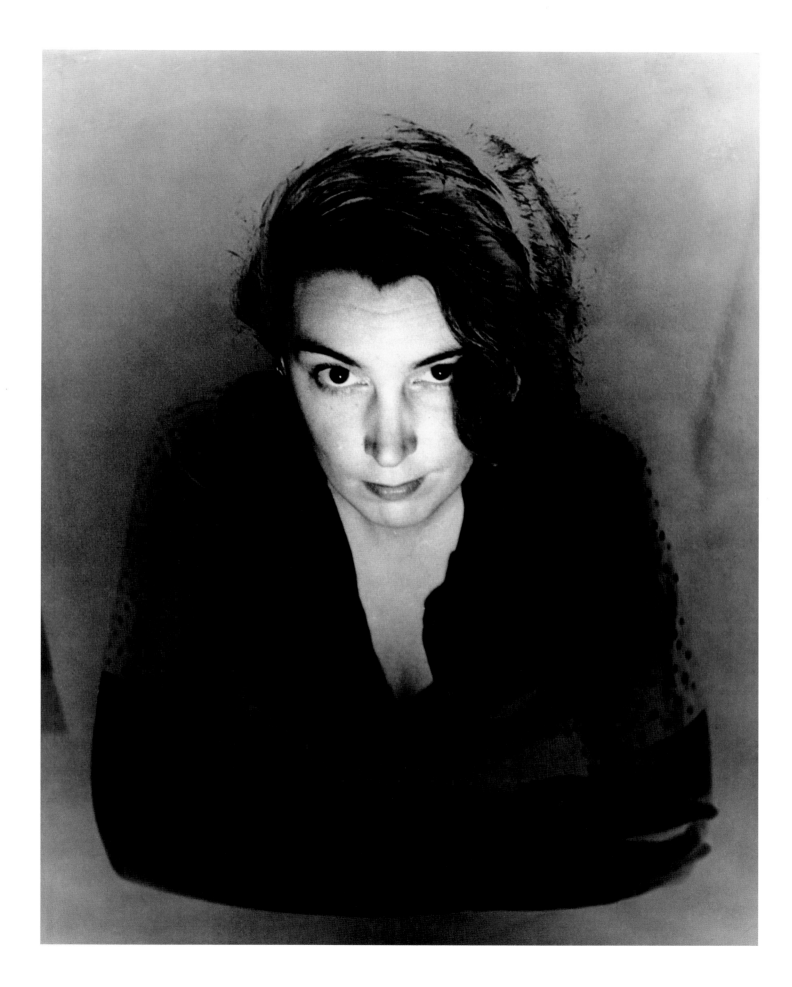

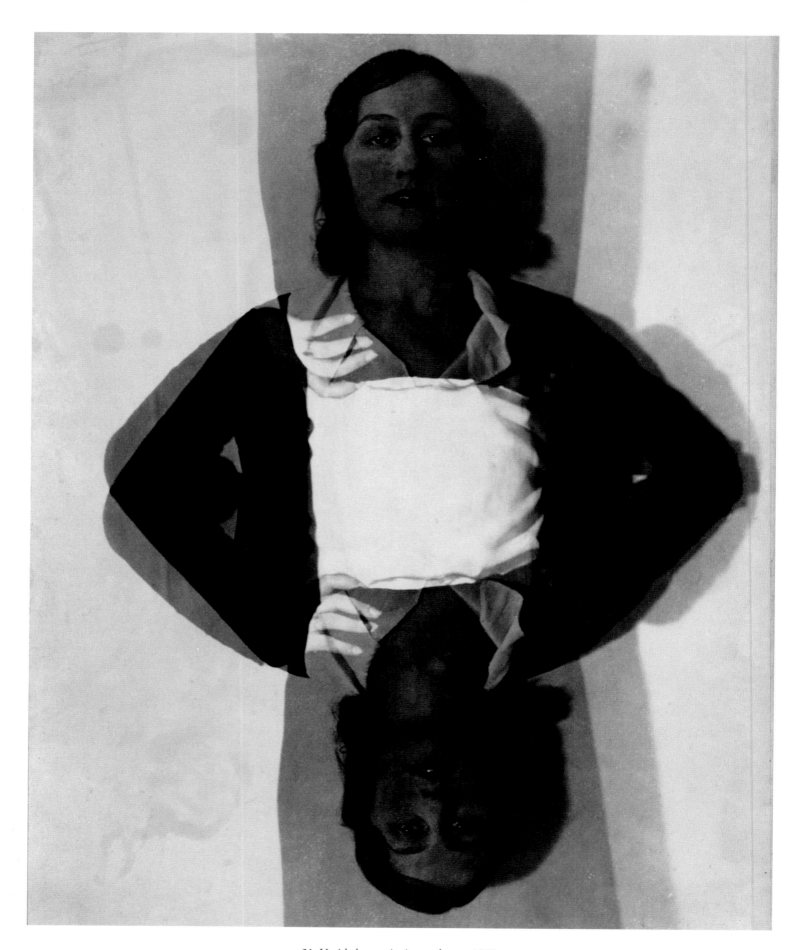

21 Untitled portrait, Amsterdam, *c.* 1932

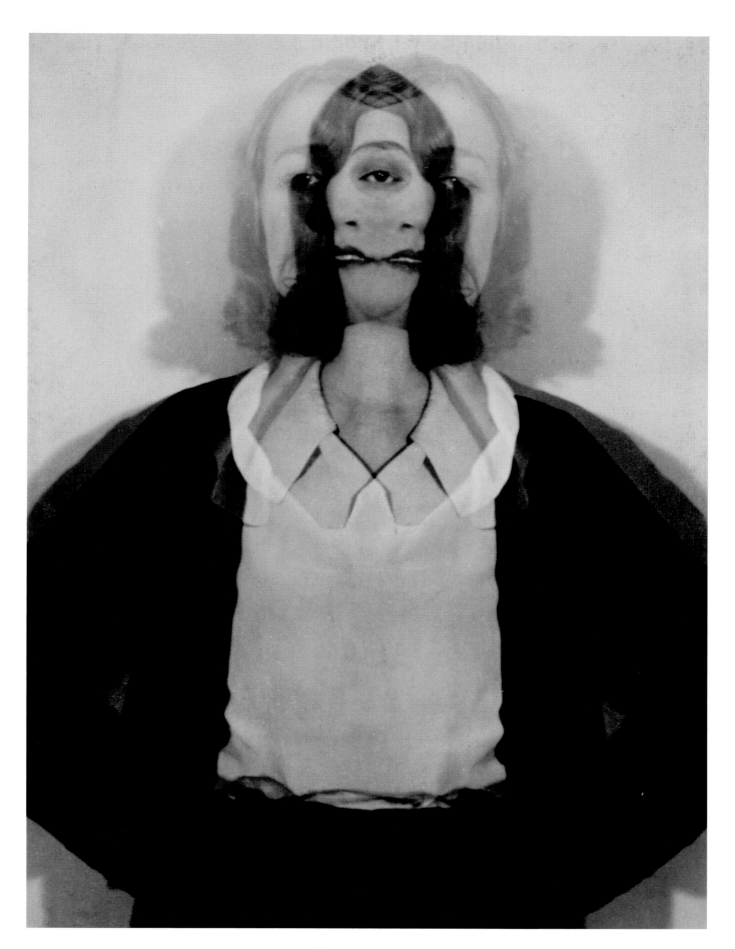

22 Untitled portrait, Amsterdam, *c.* 1932

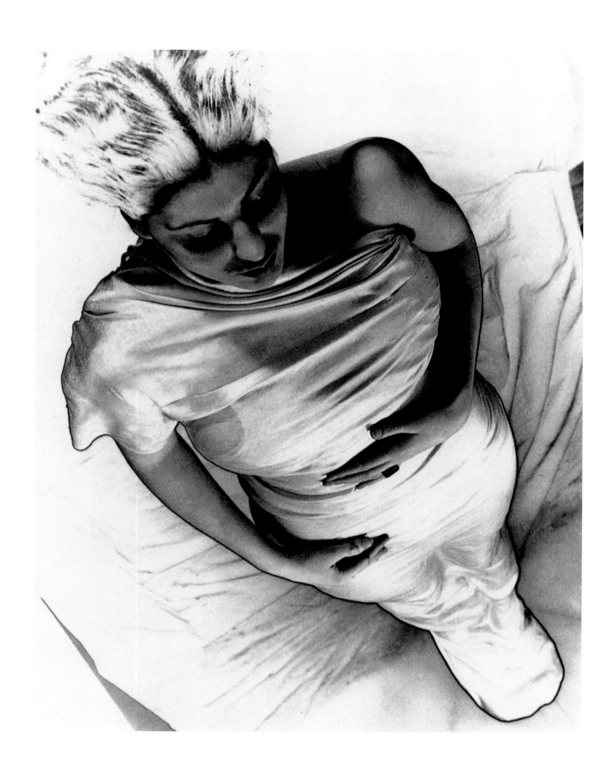

23 *Momie vivante* (Living Mummy), Amsterdam, *c.* 1932

24 *The Painter John Raedecker*, Amsterdam, *c.* 1932

25 Untitled, Amsterdam, *c.* 1932

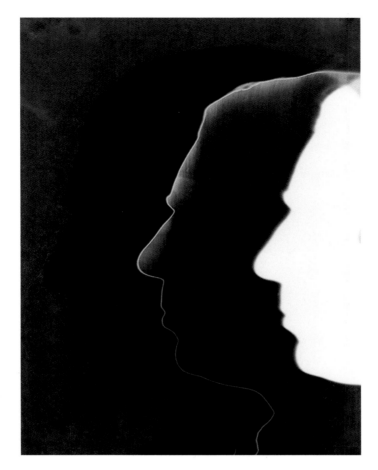

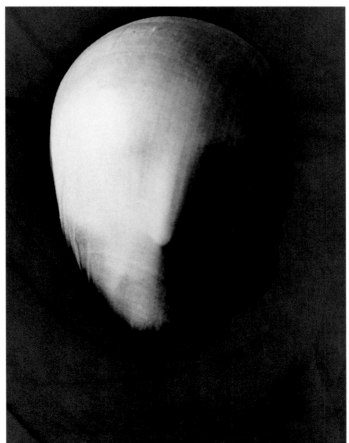

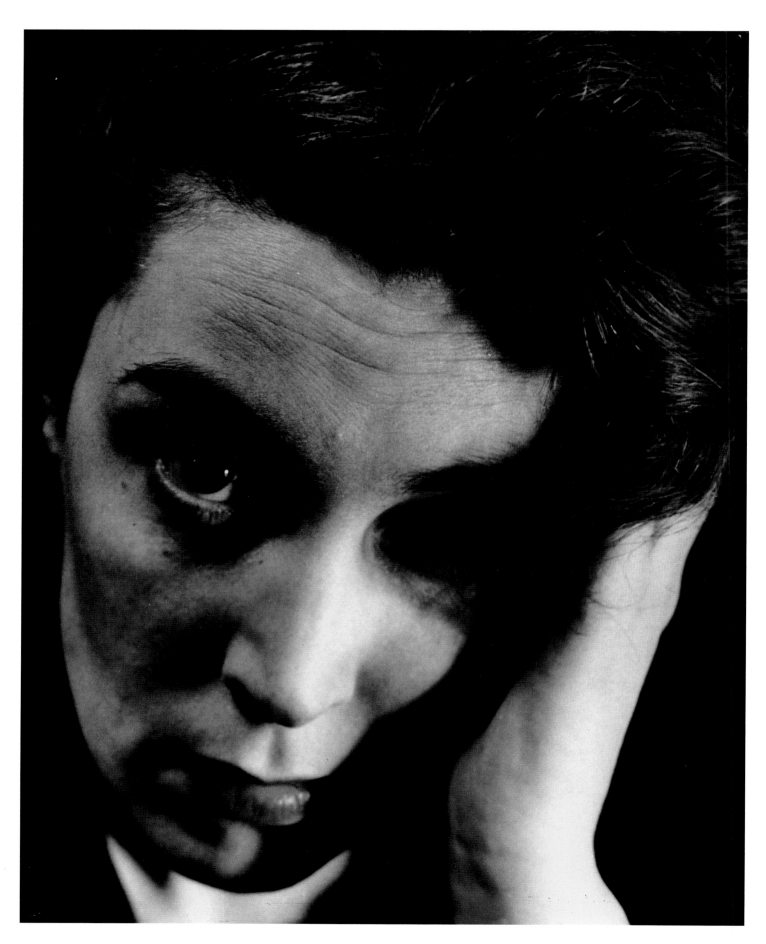

26 *Erika Mann*, Amsterdam, 1935

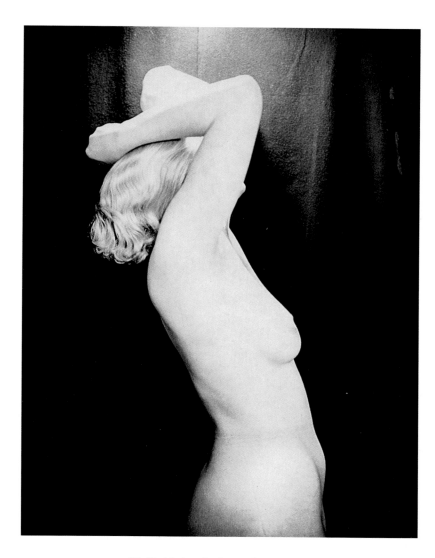

27 Untitled nude, Amsterdam, *c.* 1932
(From the photographer's original contact sheets)

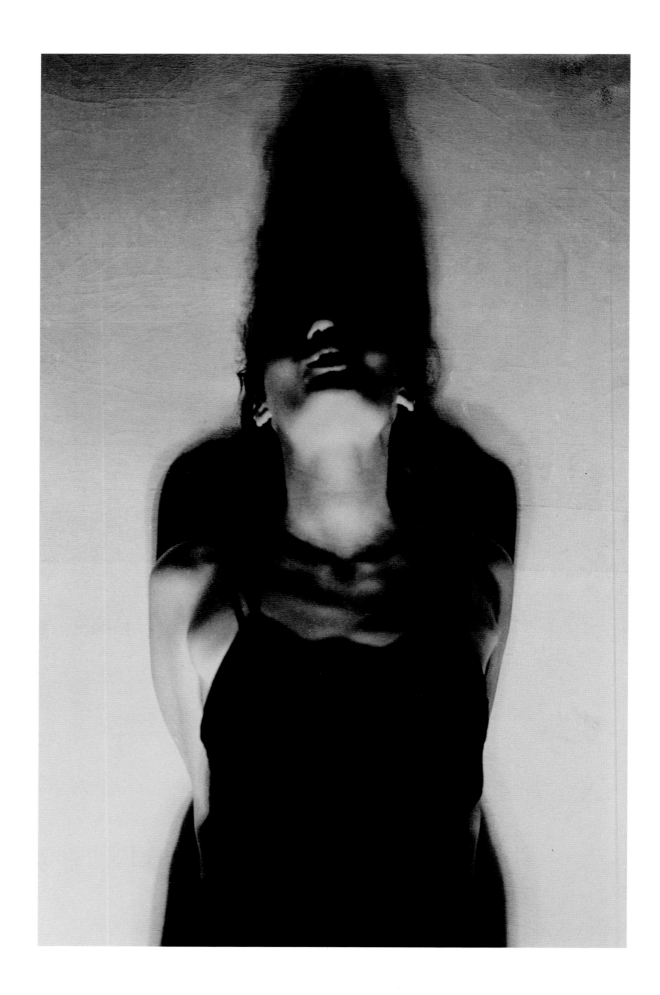

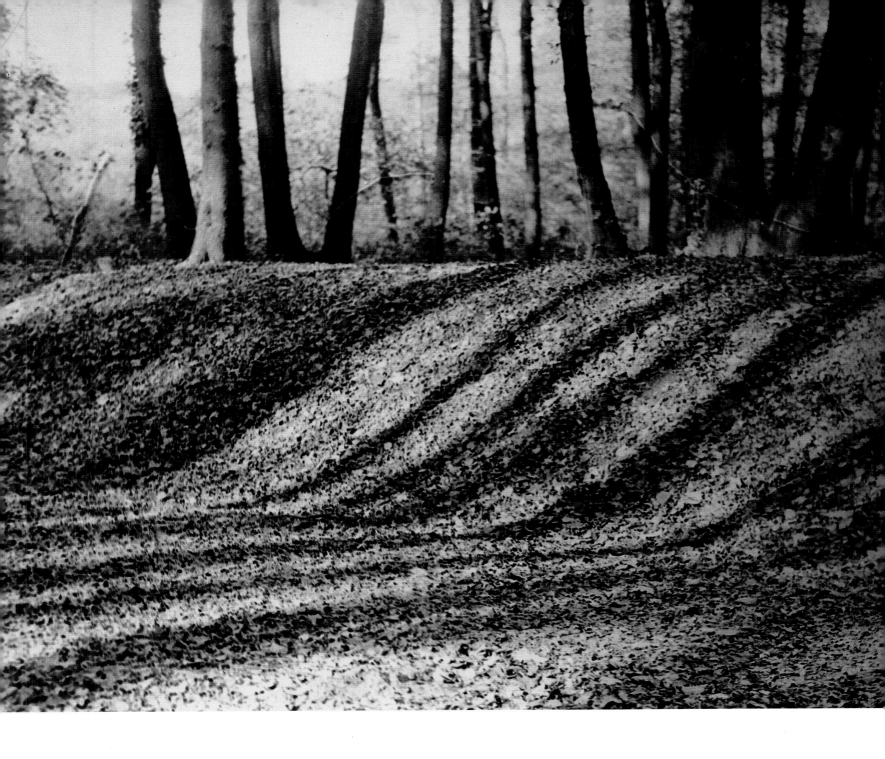

28 *The Dancer Chaja Goldstein*, Amsterdam, *c.* 1932

29 Untitled landscape (Northern Europe), *c.* 1932

30 *Church Effigy*, Amsterdam, *c.* 1932

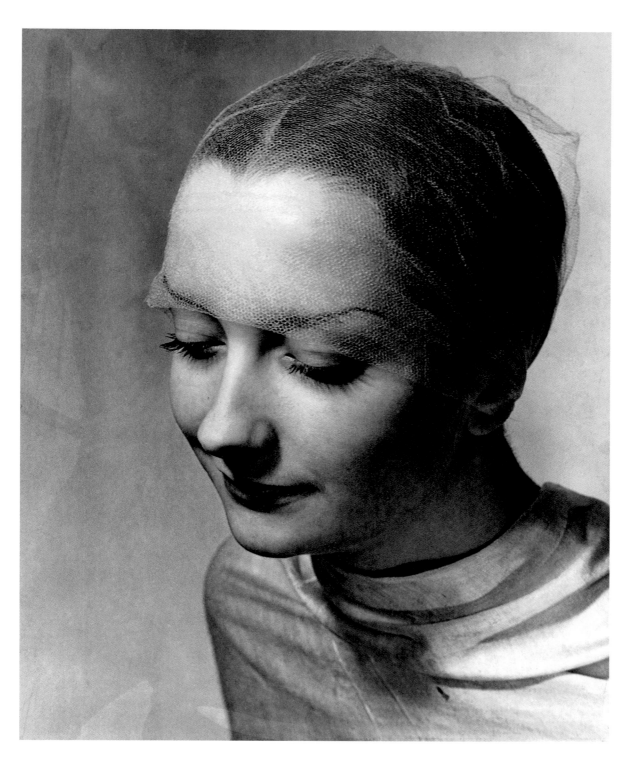

31 Untitled portrait, Amsterdam, *c.* 1932

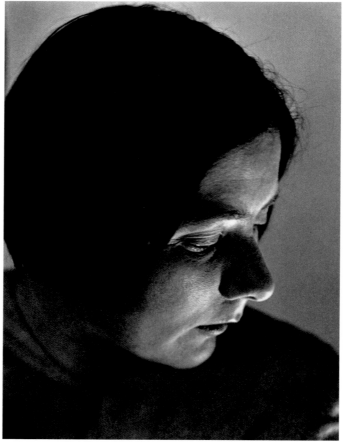

32, 33 Untitled portraits, Amsterdam, *c.* 1932 (From the photographer's original contact sheets)

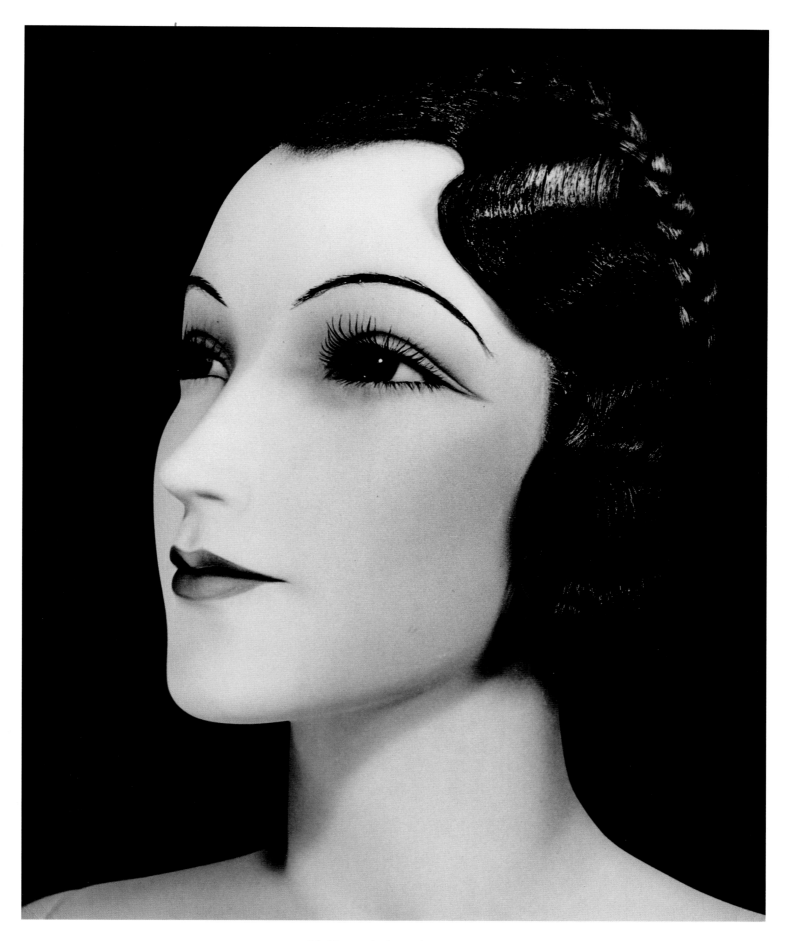

34 *Mannequin*, Amsterdam, *c.* 1932

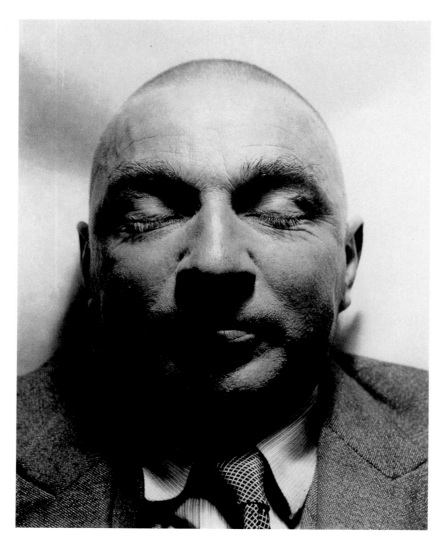

35 *The Painter John Raedecker*, Amsterdam, *c.* 1932
(From the photographer's original contact sheets)

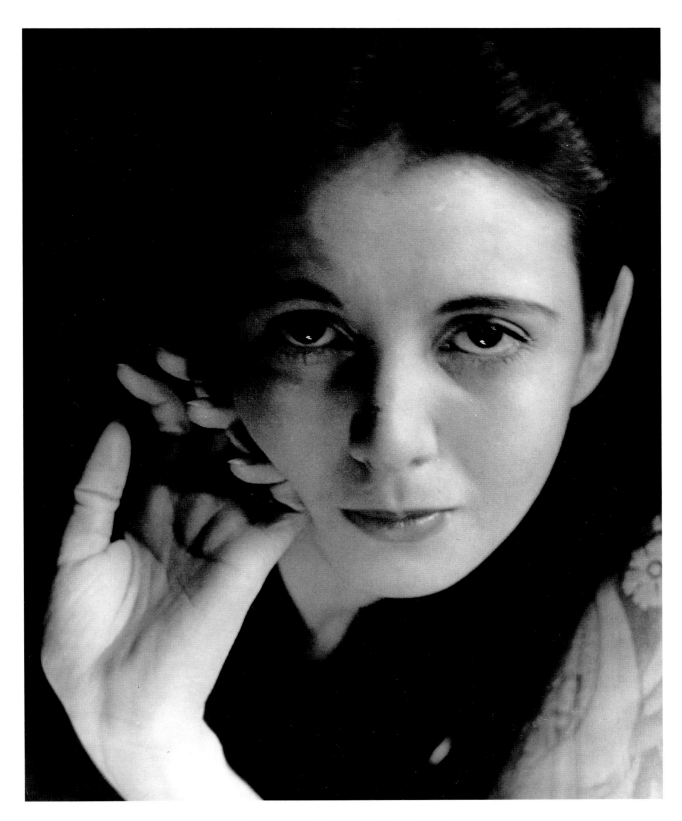

36 Untitled portrait, Amsterdam, *c.* 1932

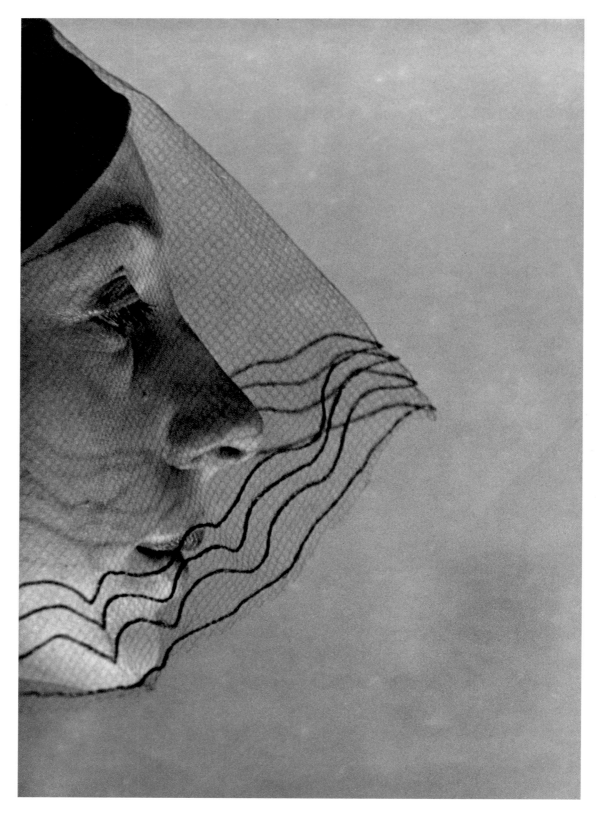

37　Untitled portrait, Amsterdam, *c.* 1932

38　Untitled portrait, Amsterdam, *c.* 1932

39　Untitled portrait, Amsterdam, *c.* 1932 (From the photographer's original contact sheets)

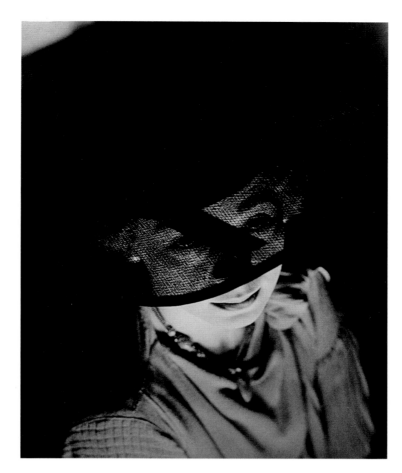

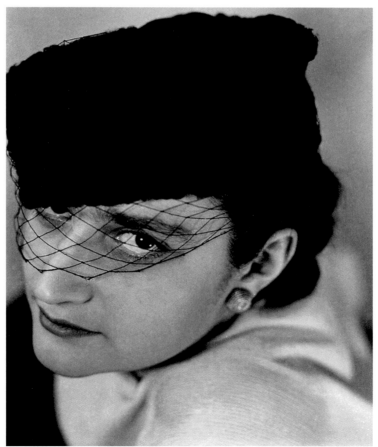

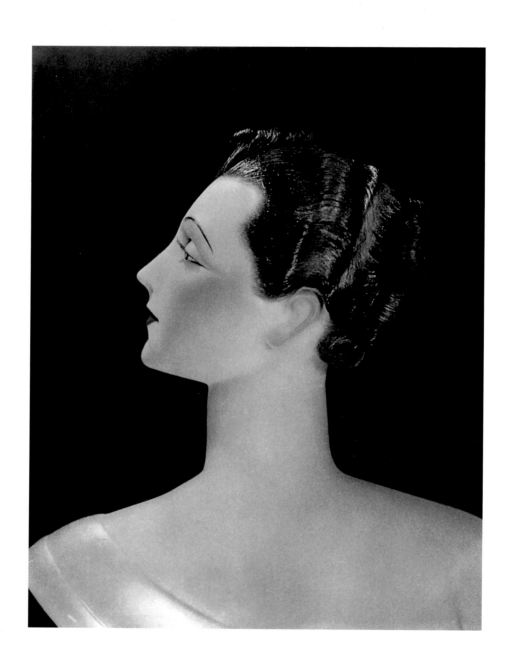

40 *Mannequin*, Amsterdam, *c.* 1932 (From the photographer's original contact sheets)

41 *The Actress Charlotte Kohler*, Amsterdam, *c.* 1932

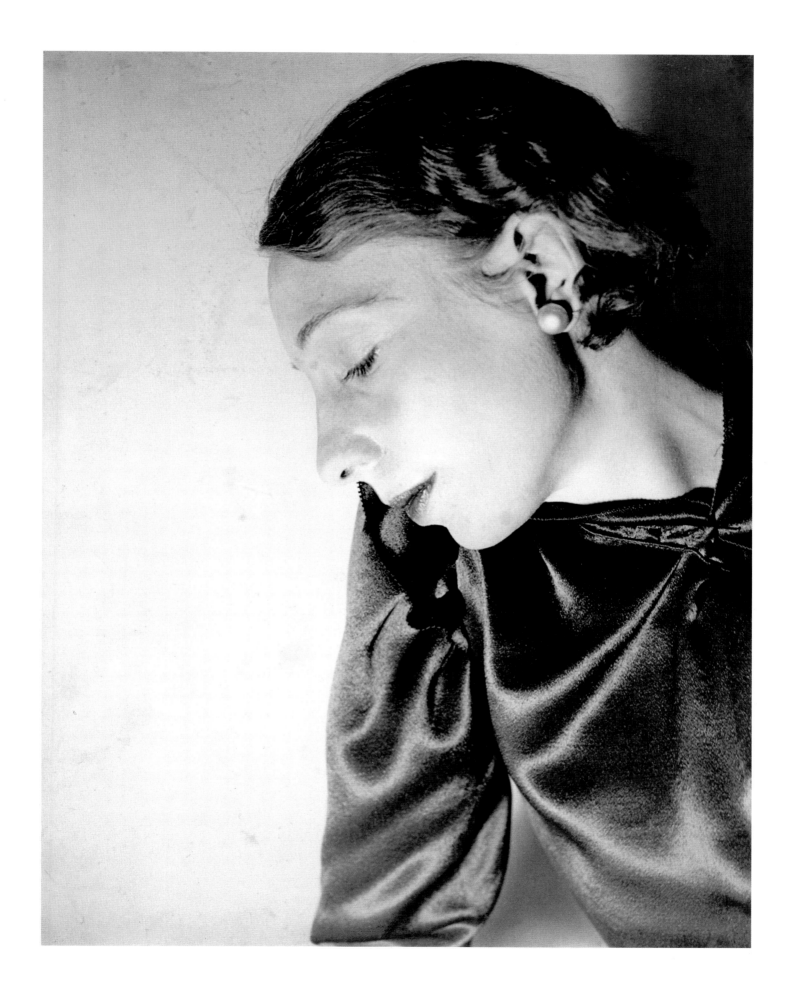

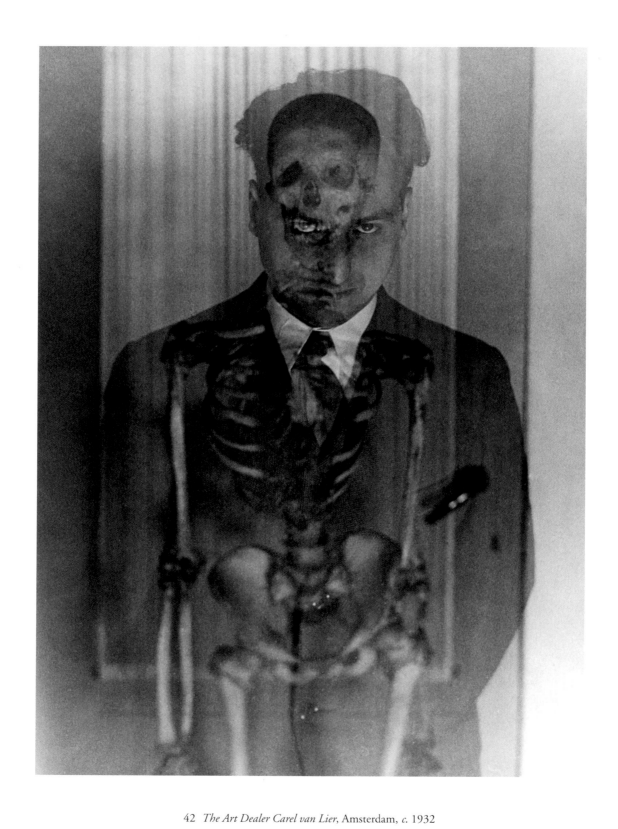

42 *The Art Dealer Carel van Lier*, Amsterdam, *c.* 1932

43 *Lena Blumenfeld* (with Blumenfeld's own 'self-portrait'), Amsterdam, *c.* 1932

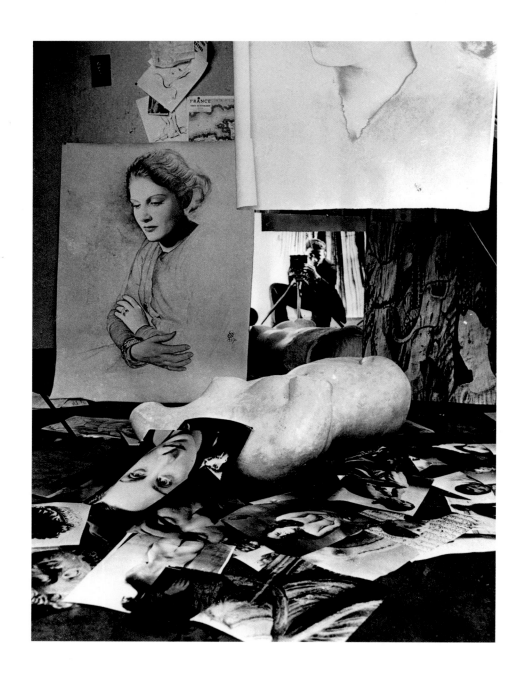

II: Passions and Patrons

'La Ville Lumière'

It was with mixed emotions that Blumenfeld arrived in Paris in January 1936. At almost forty he was no longer a young man, and there was an element of desperation to his quest. On the other hand, there were grounds for optimism. Paris was a photographer's mecca: it had drawn creative innovators from the four corners of the world – Man Ray from the United States, André Kertész and Brassaï from Hungary, Germaine Krull from Poland and Raoul Ubac from Belgium – to name only a few. Venues like the Galerie de la Pléiade and Galerie Billiet exhibited the latest experimental work; influential magazines embraced photography,[1] and it was even possible to conceive of a book consecrated to one's own pictures, like Roger Parry's *Banalités*, Man Ray's *Electricité* or Brassaï's *Paris de nuit*. As for those who nurtured the dream of becoming *fashion* photographers, this was the home of the leading fashion magazines, publications which reached a wide audience of men as well as women and provided an unequalled showcase for an ambitious photographer.[2]

In his search for success, Blumenfeld was betting with what he considered to be a strong hand: flair and imagination tempered with pragmatism and an insider's knowledge of the fashion industry.[3] But in fact the odds were stacked against him. He was destitute, barely articulate in French, and ever aware of his status as an illegal alien. Like scores of other foreigners who had gravitated to the world's cultural capital, he felt his presence there to be subject to the whim of the authorities. 'For fear of being noticed and deported', he recalled, 'we immigrants whispered with meaningfully closed mouths . . . because the passport had expired long ago, the *carte d'identité* was never *en règle*, you were working without a *permis de travail* . . .'[4]

Moreover, the pendulum was gradually swinging away from the experimental, avant-garde approach of 1920s-style photography to one of realism. Editors were beginning to favour politically committed documentary and reportage. The 'time of the aesthetes', as one critic put it, was coming to an end.[5]

But Blumenfeld did have one valuable asset. A year earlier, attracted by the unusual portraits in his Amsterdam shop window, a honeymooning visitor from Paris had requested a sitting. 'Genoveva', as the photographer would call her, was a dentist, and the daughter of the famous painter Georges Rouault. She was delighted with the portrait Blumenfeld made of her, and offered to exhibit his work in her waiting room on the avenue de l'Opéra in the hope of providing

Above: Geneviève Rouault, Paris, *c.* 1936. A visit by Geneviève Rouault to Blumenfeld's shop on the Kalverstraat led to a close friendship. The daughter of the painter Georges Rouault, she helped the photographer secure a foothold in Paris.

Opposite: Self-portrait of Blumenfeld in his Paris studio, a year or so after moving in, surrounded by photographs he had produced in both Paris and Amsterdam. The studio was located at 9, rue Delambre.

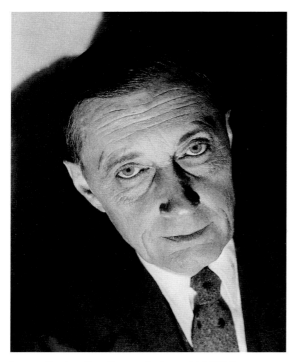

Jacques Feyder, film director, Paris, *c.* 1935. While living in Amsterdam, Blumenfeld had secured a job as a still photographer on Feyder's film *Pension Mimosas*, an experience which taught him that he was wholly unsuited to creative teamwork.

him with new clients. The admiration was mutual: 'Enchanted, and visualizing future paradises', Blumenfeld appointed her his Paris envoy.[6]

She was to prove her worth. On his arrival in Paris, a small number of influential clients were eagerly awaiting sittings. Some were distinguished society women, among them the Comtesse de Mun and the Vicomtesse de Noailles, the famous patron of modern art, with her daughters in tow. Although it soon became evident that few of his subjects had any intention of actually paying for the work, Blumenfeld remained patient. He understood that at this stage it was more important to build a reputation than to make money. It was a game he was willing to play wholeheartedly for a short time, even though it did not put food on the table or allow him to escape from his seedy lodgings – a room in an *hotel de passe* which had to be vacated for several hours each afternoon.

Geneviève Rouault's social standing also opened doors among the artistic elite. In due course Blumenfeld was introduced to her father, of whom he made a series of striking portraits (though Rouault later complained that he had been made to look like a convict [pls. 83, 84]).[7] François Mauriac was treated with equal candour; the great writer exudes a weary resignation (pl. 86). Another famous sitter, Henri Matisse, was equally perturbed when presented with a portrait which made no secret of his advancing years. Blumenfeld later claimed that both Rouault and Matisse had drawn rejuvenated self-portraits after having been presented with his photographs. But the Matisse images were hardly Blumenfeld at his best. A far more vigorous spirit is conveyed in his study of the conductor Bruno Walter, whom the photographer knew personally. The portrait of the film director, Jacques Feyder, with whom Blumenfeld had worked, is equally engaging, if more conventional – here again, the sitter was known to the photographer. Blumenfeld needed some degree of personal involvement with his male subjects before he could function creatively.

He consistently came alive, however, when his subjects were women. Eros could animate any image, from the young and beautiful to the old and decrepit. Some were simply the daughters of friends, who were models or aspiring models, like Manina Theorem (pl. 44), whose father was an Austrian painter, or Jo Sandberg Rigaldi (to whom Blumenfeld would always be indebted for saving his negatives during World War II). Others were personalities of their time: the German cabaret singer Valeska Gert (pl. 54); Carmen, the model who in her youth had posed for Rodin's *The Kiss* (pl. 76), or Yvette Guilbert, who had sat for Toulouse-Lautrec . . . all were handled sympathetically. Still others were accomplished artists, like the American singer Spivy, or the painter Léonor Fini, whose beauty seems to have captivated most of the Parisian male population. Fini was the focus of particularly intense and playful imagemaking (pls. 78, 81).

By the summer of his first year in Paris, Blumenfeld felt secure enough in his prospects to bring Lena and the children from Holland. By the autumn he had

also found a fine studio at 9, rue Delambre, just off the boulevard Montparnasse, thanks partly to the financial generosity of an old German friend, Marianne Feilchenfeldt. Other new acquaintances helped the struggling photographer in his search for clients and models. The fashion photographer Herman Landshoff brought Blumenfeld an extraordinarily photogenic young woman who went by the name of Muth (pls. 59, 77).[8] He was immediately smitten by this 'sleeping beauty' who was not disturbed 'by the heat of the lamps or the fury of work'.[9] When his luck eventually changed and he began to work as a fashion photographer, Muth remained his favourite model.

'La Photographie Psychologique'

In March, only two months after his arrival in Paris, and making liberal use of his best Amsterdam material, Blumenfeld mounted a show of fifty images at Pierre Worm's Galerie Billiet on the rue de la Boétie. Rouault, still apparently smarting over his unflattering portraits, rejected the photographer's request for a short statement of support, but Paul Valéry allowed a relevant quotation from his book *Idée fixe* to be printed on the invitation: 'What is deepest in man is his skin.'[10] To this Blumenfeld added what he thought was an equally perspicacious comment on his own quest: 'Through psychological photography one searches for the definitive portrait: as a consequence a new kind of beauty is discovered.'[11] It was his rejoinder to Rouault.

Although with the passing months he seemed to make no headway in his struggle to penetrate that bastion of fashion photography, *Vogue*, more and more of his work could be seen on the pages of the leading art and photography magazines. Even before arriving in Paris he had experienced the satisfaction of having three of his images published in Charles Peignot's prestigious *Photographie*, an annual publication of the monthly graphic design journal *Arts et métiers graphiques*. Now, as 1936 drew to a close and his fashion hopes failed to materialize, he approached E. Tériade, the publisher of the Surrealist magazine *Minotaure*. At the time Tériade was leaving the short-lived review to set up the deluxe quarterly art magazine *Verve*. Impressed with Blumenfeld's vision, he chose a number of his pictures for the first two issues. A year later (Winter 1937 and Spring 1938) Blumenfeld found himself in the select company of Man Ray, Brassaï, Ubac and Bravo, not to mention the Old Masters, whom he revered. Included in *Verve*'s selection were a number of Blumenfeld's strongest nudes, including the famous *Nude under Wet Silk* (pl. 61); a slanting, telescopic view of the tapestry *Bal des Sauvages* at Saumur (pl. 71); several heads of luxuriant hair; a view of Van Gogh's grave, and six interpretations of Aristide Maillol's sculpture *The Three Graces*. One of these was composed of multiple exposures which conveyed a sense of the sculpture in the round (pl. 75).

One cannot overstate how prestigious it was for a photographer to appear in this elegant, large-scale publication. A photograph usually filled an entire page, and reproduction was superb. Picking up his complimentary copies of the December issue, Blumenfeld must have felt that success was finally his.

But would prestige alone feed his family? He had profound doubts. He worried that there might be too much acclaim and too little cash. When, therefore, *Verve*'s editor arranged for the sale of fifty of Blumenfeld's images to the U.S. pocket magazine *Coronet*, at fifteen dollars a print (a substantial sum of money in 1937), there was cause for cautious optimism.

Photographie, too, continued to be a steadfast supporter, publishing one or two examples of his work (nudes, cathedral windows, portraits of women) in its 1937, 1938 and 1939 issues. Although he was only one photographer among many in these annual publications, the representation was important; *Verve* was respected in the Paris artworld, but *Photographie* reached an international audience eager to know who was who in the photographic firmament.

A 1937 group exhibition in which Blumenfeld was a participant brought the photographer a certain notoriety, according to the historian William L. Shirer.[12] The threats posed by Hitler and Fascism had tormented Blumenfeld since the dictator came to power in 1933. On the eve of Hitler's appointment as Chancellor, Blumenfeld had made a photomontage of Hitler and a skull (p. 92). In 1936 he produced *The Dictator*, a vitriolic comment on totalitarian leadership, showing the head of a calf mounted on a draped classical bust (pl. 87). Now, in 1937, he resurrected the earlier photomontage and put it on display. This ghoulish vision so outraged the German Ambassador that it had to be withdrawn from the show.[13]

'Arsedirectors'

Blumenfeld hoped that his exposure in magazines and galleries would lead to a dramatic increase in the number of clients for his portraiture, but he was profoundly disappointed. Even before his first year in Paris was over it was evident that the business was simply not viable. Although they wanted portraits, few Parisians could be induced to part with their money.

Blumenfeld's great goal of fashion photography was also remaining elusive. Even armed with letters of introduction from prominent people, he could not get through 'the hermetically sealed doors' of the fashion magazines.[14] He was therefore forced to consider another alternative. Although it meant subordinating his vision to the dictates of art directors (or 'arsedirectors' as he called them[15]), he turned his attention to advertising, with immediate reward. His first art director, the gifted but parsimonious André Guérin, put him to work on a campaign for toiletries; commissions for Mon Savon and for Dop Shampoo allowed for close focus on a favourite 'obsession': a thick, cascading head of hair.

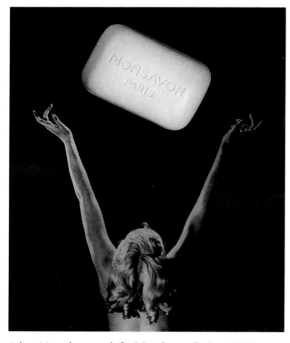

Advertising photograph for Mon Savon, Paris, *c.* 1937, one of Blumenfeld's first advertising commissions. He turned to advertising when fashion work failed to materialize.

André Girard, an art director who was rapidly developing into a close friend, managed to secure work for Blumenfeld on a few posters for Pathé-Marconi, among which was a photograph of Josephine Baker.[16]

Once he had equipped himself with a studio, Blumenfeld could concentrate on his highly experimental personal work. Whereas portraiture had been the primary concern in his Amsterdam years, in Paris the nude was paramount. Perhaps the initial six-month absence from his wife and his daily proximity to *filles de joie* in the Hotel Celtique stimulated his libido. Throughout his childhood he had heard his parents using French to veil erotic subjects; consequently he had never been able to shake the conviction that 'eroticism was a slippery secret, somehow connected like gel with Paris.'[17] Here in the French capital, in a hedonistic and artistic milieu, Blumenfeld could freely indulge the voyeuristic streak in his nature, and work towards moulding his own idiosyncratic vision of the feminine ideal.

As he himself recognized, this was nothing but an extension of childhood fantasy: 'I started life as a platonic erotomaniac. With all my love I loved only love, loved *all* women, not only *one*. As soon as it threatened to become personal, something went wrong. For fear of the little woman I took shelter in the Eternal Feminine.'[18]

Blumenfeld was well aware of the central importance of 'Woman' in the European intellectual cosmos. As Baudelaire had written, 'Woman is the being who throws the biggest shadow or the greatest light in our dreams.'[19] André Boiffard, Raoul Ubac, Emmanuel Sougez, Laure Albin-Guillot . . . the French photographers who were obsessed with 'Woman' were legion. But it was Man Ray, above all others, who had most dynamically translated Baudelaire's words into images. Like Blumenfeld, his approach had been nourished by Dada. And like Blumenfeld he revelled in the transformative powers of photography – his women were dreamlike apparitions who seemed to emerge from the very essence of the medium. Blumenfeld knew of these precedents and was inspired by them. Nor was the fact lost on him that Man Ray had also been able to achieve much of his superb imagery under the guise of fashion photography.

'Living Mummies/Momies Vivantes'

Blumenfeld wrote admiringly and often of beauty, but never explained precisely what he meant by it.[20] To him beauty was something profound, noble – even godly – but not immediately evident on the surface. The task of the artist was to discover or uncover it, and distill it in a work of art.

Veils, mirrors, models, mannequins, classical busts and modern sculptures were utilized in Blumenfeld's quest for beauty. Faces and bodies were stretched, squeezed, minimalized, multiplied, dematerialized, etherealized. The full panoply of his darkroom alchemy was brought to bear on the elusive subject.

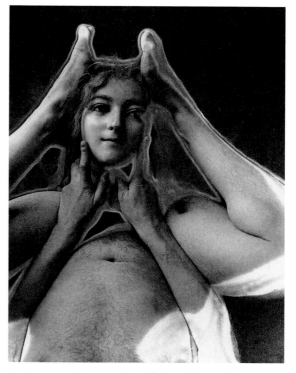

In this extraordinary – and psychologically revealing – self-portrait, Blumenfeld 'gives birth' to 'Woman': a vivid metaphor for his power as a photographer.

Negative/positive hybrids, reticulated negatives (obtained by freezing them when still wet), solarizations, multiple exposures and sandwiched negatives, the masking and bleaching of prints, even chemical blotches and blemishes were employed in order to bring his ideal to life.

Blumenfeld was careful never to allow pictorial effects to distract from the essence of the subject. As Maurice Bisset observed in his preface to Blumenfeld's posthumously published *My One Hundred Best Photos*:

> Blumenfeld was not trying to create a romantic blur or push that object [e.g., the nude] into a misty distance where it would lose its reality and its truth. His aim was to free the subject from the restrictions imposed on it by the geometry of the space in which it was set and replace the feeling of physical distance by one of subjective separation, imprecise, unstable and insurmountable, such as could be brought about by desire, recollection, dream or anguish. . .[21]

Since his Amsterdam years, sleep had been a common motif in Blumenfeld's imagery. It also recurs as a topic in his autobiography. Indeed, as the Swiss photohistorian Hendel Teicher observes, 'The theme of sleep is one of the indispensable keys to understanding Blumenfeld's work.'[22] It is tied to death, to the desire to escape *temporarily* from earthly constraints, and to sexual possession. For Blumenfeld, dreaming was the most marvellous of God's gifts. He claimed that his most inspired ideas came to him via dreams, and his darkest moments – the nights on the battlefields of World War I and in the concentration camps of World War II – were made bearable only by sleep and its partner, dream.

Photography therefore was a magical device through which dreams could be captured and preserved – and, where Woman was concerned, symbolically possessed. In this regard, Blumenfeld's *Momie vivante* (pl. 23) is a telling image: photography was modern man's technique of mummification.

This process also allowed the 'preservation' to be undertaken when the model was young and beautiful. Blumenfeld was distressed by the ravaging effects of ageing. Ever since seeing Cranach's *The Fountain of Youth* as a boy, he had been fascinated by the fleeting nature of female beauty. His nude portrait of Carmen, the model for Rodin's famous sculpture *The Kiss* (pl. 76) was his attempt at coming to terms with this.

'This Exclusive Enterprise'

Although Blumenfeld yearned for a place in the world of fashion photography, he was not overawed by the fashion industry. Hands-on experience in various aspects of the dressmaking business had removed any traces of mystique. But he respected the art and craft of fine dressmaking and understood, too, how ideas

from architecture and the fine arts had made their way into clothing design and enriched the lives of all women, not just the few who could afford haute couture. He greatly admired the modernist tendencies in the design of women's clothes, and was impressed by the fact that the great couturiers were open to ideas from the avant garde. Alix, Vionnet, Schiaparelli, Chanel and Balenciaga were only the better known of many designers who found new principles governing dressmaking in Constructivist, Cubist and Surrealist works of art.

Blumenfeld knew that only two decades earlier Baron Adolf de Meyer, at Condé Nast's recently acquired *Vogue*, had established fashion photography as a credible profession, indeed, one of considerable chic. Earlier fashion photographs had, with rare exceptions, been lifeless documents showing dresses modelled stiffly on tailors' dummies or society women. De Meyer, a renowned English Pictorialist, brought his soft-focus lens, high-key printing and rear lighting to the task of creating images of radiant beauty. More to the point, as the shrewd Blumenfeld noted, 'De Meyer was seen as a genius and paid accordingly . . . I quickly grasped the artistic possibilities of this exclusive enterprise.'[23]

Blumenfeld was also aware that a brilliant art director ruled at Condé Nast. Dr Mehemed Fehmy Agha had shrewdly appropriated avant-garde motifs and styles for his layouts at *Vogue* and *Vanity Fair*. Photography was central to his vision, and he had welcomed the involvement of some of the most talented practitioners of the day, among them Edward Steichen, George Hoyningen-Huene, Horst and Cecil Beaton.

Blumenfeld could see that the versatile Steichen, chief photographer at Condé Nast, had performed a difficult balancing act, bringing fashion photography stylistically into line with contemporary European art while servicing the industry with images which were 'as realistic as possible' in order to give the readers of the magazine 'a very good idea of how that gown was put together and what it looked like'.[24] Following in his footsteps, others had specialized in a certain look or style: Hoyningen-Huene, for example, had introduced a neo-classical motif into his own work to great effect, while Beaton had stressed a flamboyant theatricality.

But there was no one, Blumenfeld believed, who could produce what *he* had in mind as fashion photography. This confidence drove him forward despite the fact that week after week his attempts to meet Michel de Brunhoff, *Vogue's* editor-in-chief, came to nothing. Instead he had to content himself with the occasional commission from the magazine *Votre Beauté*. He was nevertheless pleased when asked to produce a high-key black and white portrait (which was afterwards coloured by hand) for the cover of that magazine's February 1937 issue. It was a prestigious addition to his portfolio and would certainly be noticed at *Vogue*.

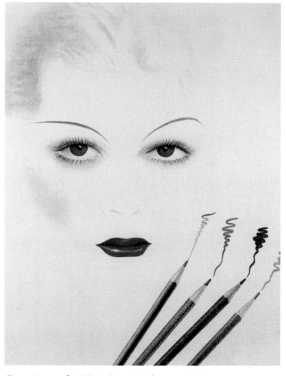

Cover image for *Votre Beauté*, February 1937.
The French beauty magazine used Blumenfeld photographs of faces and hair on several occasions. This particular cover may have encouraged the editors of *Vogue* to take him on.

The 'Portfolios de Vogue'

The odds of success shortened dramatically late one morning when Blumenfeld was woken from a deep sleep by the Celtique's concierge. Would he come down and take a telephone call? To his astonishment the half-asleep photographer heard his praises being sung on the other end of the line; the caller pronounced his portraits of the daughters of the Vicomtesse Marie-Laure de Noailles 'divine'. Blumenfeld realized that his strategy of photographing prominent figures had borne fruit. His admirer was none other than 'the Lord Byron of the camera, Prince of Geniusland and Court Photographer, *enfant gâté et terrible de Vogue*' – Cecil Beaton.[25]

A visit to the rue Delambre studio convinced Beaton of Blumenfeld's worth. After inspecting the fruits of the latter's Paris and Amsterdam labours, the Englishman confided to his diary:

> Here at last is someone who is not in any way influenced by the work of other photographers. Here is a fresh and clear mind He has done a series of nudes, women lying with wet draperies covering them, that are as beautiful as sculpted figures of the French Renaissance I came away with an assortment of pictures to send to *Vogue* and they will be fools in my eyes if they don't use him, but maybe they know their business end and there is never great profit in new art and this is something quite new and infinitely touching.[26]

To the delight of both men *Vogue* proved willing and, with much fanfare, Blumenfeld's work appeared in the October 1938 issue of the magazine. A picture of a hat by Rose Descat was followed by studies of African sculptures from the Musée de l'Homme and then the prestigious twenty-page 'Portfolio de *Vogue*'. This featured dresses by Alix, Patou, Revillon Frères, Callot Sœurs, Piguet, Maggy Rouff, Hermès, Rose Valois, Worth and Heim.

For the most part, Blumenfeld kept his wildest impulses in check: the majority of the images were shot in the conventional *Vogue* style: a demure pose, sitting or standing, with meticulous attention paid to the structure and design of the dress itself. To avoid distraction Blumenfeld used the simplest of studio props: the edge of a window frame, columns and a bench. Only one or two images employing rippled glass screens gave a hint of the tricks he was hiding up his sleeve.

The following month Blumenfeld was chosen to illustrate an article on evening dress for younger women.[27] To make the point – ('Voyez des robes mouvementées, ou le tissu semble vivant, animé déjà du souffle de la danse') – a circus theme was invoked, and the models, in dresses by four designers (Marcelle Dormoy, Vera Borea, Maggy Rouff and Bruyère) were laid prone, two

Gown by Chanel, for 'Le Portfolio de Vogue', *Vogue*, Paris, March 1939. Blumenfeld used an enlargement of one of his cathedral images as a backdrop.

at a time, across a large blow-up of Seurat's painting *Le Cirque* (pl. 57). One of the two images was reversed and both were then joined to extend the motif of the circus ring across the double spread.

Although French and British *Vogue* were pleased with the portfolio, American *Vogue* was critical. 'Last week Dr Agha (I could vomit) was here', Blumenfeld wrote to Beaton, 'and literally explained to me that I haven't a clue about photography.'[28] Perhaps Agha was wary of a nonconformist temperament like his own. In any event he withheld for several months the contract that would have given Blumenfeld peace of mind; when it did eventually materialize, it was binding for only one year. Blumenfeld sensed that the art directors remained uncertain as to how best to utilize his talents, and were therefore giving him accessories – jewelry, gloves, lingerie, stockings – and what he called the difficult cases: Mauriac, Yvette Guilbert, and the 'failed dresses' of Nina Ricci.[29]

Nevertheless, these assignments did not prevent him from producing striking imagery. For a jewelry article which appeared in February 1939, he combined the upper bodies of a living model and a mannequin to stunning effect.[30] The atmosphere of dream was also evoked in his advertisements for Lucien Lelong's perfume *Passionnément*, in which he used his trademark rippled glass.

A second 'Portfolio de *Vogue*' appeared in February 1939, this time focusing on fabrics. The assignment must have delighted the photographer as it allowed him freely to indulge his passion for transparencies. The final image in the series (pl. 51) is an intriguing precursor of the famous Eiffel Tower image, soon to follow (pl. 50).

March brought yet another 'Portfolio'. This time the presentation was more formal, each image centred on the page and surrounded by a frame of white, as if exhibited on a gallery wall. The photographer was now evidently more at ease with the work of the couturiers – Piguet, Lelong, Valois, Chanel, Paquin, and so on – and took more liberties, even borrowing images from his inventory of personal work to employ as dramatic backdrops. The issue also featured a bold double-page spread of corsetry which made brilliant use of shadow.[31]

April was a slow month for Blumenfeld, but in May the coveted twenty-page portfolio was once again his. The Eiffel Tower – then commemorating its 50th anniversary – was chosen as a setting for dresses or hats by Gaston, Valois, Balenciaga, Dormoy, Borea, Lelong, and several others. The portfolio opened with a vertiginous view from the top of the tower, the invisible structure making its presence felt by its distinctive shadow falling across the rooftops of the city. Inside (or more correctly, simultaneously inside *and* outside), the models perched precariously on railings or climbed vertical ladders and spiral stairs. For each image the photographer managed to find the perfect foil for the architecture of the dresses in the tower's railings, girders and bars. The spiral motif on a Balenciaga dress, for example, was accentuated by its framing within a

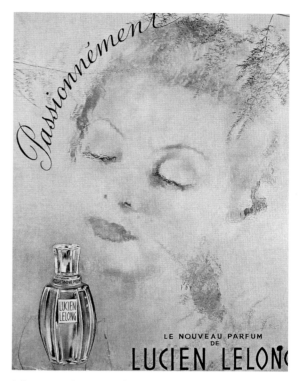

Advertising photograph for *Passionnément*, a perfume by the couturier Lucien Lelong. This appeared in French *Vogue* in March 1939.

spiral staircase (pl. 52) while a bird-like straw boater with veil by Rose Valois was all the more striking for its being caged within ironwork (pl. 49).

But the *pièce de résistance* of the series was Blumenfeld's now famous picture of the model Lisa Fonssagrives in a gown by Lucien Lelong perched high on the edge of the tower – a butterfly poised for flight. This beautiful creature seems to have metamorphosed out of the rigid iron structure itself (pl. 50).

The image is a brilliant orchestration of line: first, the overarching, protective span; then, in opposition to it, the arc formed by the model's body; next, the undulating hemline of the dress and the line of the garment flowing from the model's right hand to her waist: all three combine to balance the huge, overbearing arch which looms above.

Moreover, the model's diagonally straight arms play on the pattern of the iron bars and connect her to the structure, while the criss-crossing bars and their shadows seem to dissolve into the fluid stripes of the pattern itself. Then the gaze of the model, diagonally down across the frame to the lower lefthand corner: this 'line' acts as a counterweight to the structure. Finally, the rippling hemline begins to blur just at the point that Paris itself dissolves into the horizon.

In spite of this triumphal series of pictures, Blumenfeld's ego was still bruised by the fact that the April 'Portfolio' had been taken away from him and given to Arik Nepo. Ironically, his rivals had become more inventive due to his own example. To rub salt in the wound, the management was attempting to reduce Blumenfeld's fees and the British magazine had dropped him – he confided in a letter to Beaton – 'like a brick'.[32]

In fact, Dr Agha had made up his mind: at the end of May 1939 Blumenfeld was informed that his contract would not be renewed. It had taken less than a year for *Vogue* to put him on a pedestal and then to knock him off again.

The World of Tomorrow

Wisely, as it would turn out, Blumenfeld decided to investigate his prospects in New York, setting sail on the *Normandie* in early June. He had a letter of introduction in his pocket from Lucien Vogel, publisher of *Vu*, to his counterpart on *Life*, Henry Luce. On arrival, he discovered that the 1939 World's Fair was in full swing; its theme, 'The World of Tomorrow', augured well.

The visit to *Life* exceeded his expectations; Luce was absent, but his second-in-command, Alexander King, greeted Blumenfeld enthusiastically, introducing him to his colleagues as 'the greatest living photographer', and promised to feature his work prominently in the magazine. An equally friendly meeting with Carmel Snow, the editor of *Vogue*'s rival, *Harper's Bazaar*, resulted in an immediate and highly paid offer, which was gratefully accepted.

The *Harper's Bazaar* job would be Paris-based, much to Blumenfeld's delight. Although he noted that American designers were gaining confidence

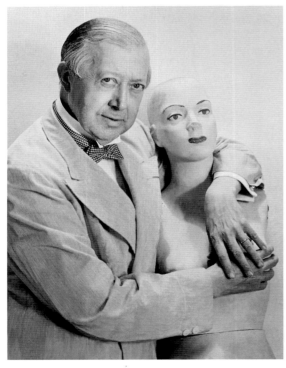

Lucien Vogel, publisher and founder of *Vu* magazine, Paris, *c.* 1936. Vogel championed innovative photographers and recommended Blumenfeld to Henry Luce, publisher of *Life*.

and that their clientele was growing, Paris was still the centre of couture and there was no reason to suspect it would not remain so indefinitely. Moreover, in his seven weeks in this 'Babel' of a New World city, this 'most lapidary expression of modern madness',[33] he had been impressed by the depth of technological achievement in America but shocked by the country's cultural shallowness. Returning to France with an American employer and a princely salary would mean a quantum leap in his standard of living. For the first time in his life he would be able to afford a proper home.

In fact he had had his eye on the perfect apartment in rue Verneuil, not far from his studio in rue Delambre. He was now prepared to buy it. But this time the cards did not come up trumps: war prevented the purchase. The next two years would not be spent, as he had expected, 'living like a god in France',[34] but incarcerated in French concentration camps. At first, he discounted the ominous signs around him; when he saw conscripted men marching off to the railway stations, he was sure it was bluff. And even if hostilities did break out, would not his status as an internationally known photographer, notoriously anti-Hitler, earn him the protection of the French? In the pit of his stomach, however, he knew that Europe was in for a repeat performance of 1914–1918, and that he would, once again, be caught up in war's insane machinery.

Alexander King, New York, *c.* 1942. King was *Life*'s 'ideas man'. From their first meeting he and Blumenfeld were close friends.

However, he stayed put, burying his nose in his fashion work. This was foolish – suicidal, even – because, though he had applied to be naturalized, he was *apartride* – without any nationality or passport – and stood to be interned. When he finally did decide late in the summer of 1939, he realized he had waited too long; the moment war broke out, escape was impossible. While Blumenfeld was in America his family had vacationed in the Alps, and in late August they all met up in Burgundy. Blumenfeld was about to be interned, but somehow he was able to arrange a kind of house arrest, first in Voutenay-sur-Cure, and then in Vezelay. For months the family were confined to a hotel, living in a state of dread, though Blumenfeld was sometimes able to lose himself in Montaigne or Ronsard.

In May of 1940 the situation took a turn for the worse; Blumenfeld was ordered to report to a French concentration camp at Montbard-Mernagne. Ironically, in retrospect, incarceration saved him; had he in fact stayed in Paris he would almost certainly not have survived: years later he learned that on the day the Germans entered the city, Gestapo agents arrived at *Vogue* to arrest him.

In his memoirs Blumenfeld tells in detail the awful story of his incarceration in a series of camps. There were episodes when the men were transported, standing in closed cattle trucks, for several days, constantly taunted by their gaolers with the fate that would be theirs when the Nazis finally caught up with them. As a last resort, Blumenfeld kept a razor hidden in his clothes. 'There was no hope any more', he wrote later, recalling those dark days, 'only

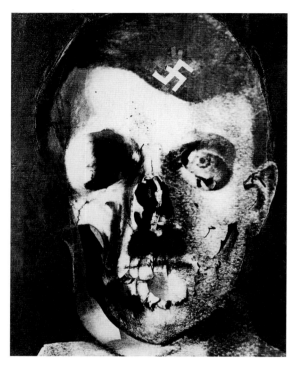

Hitler, 1933. Vintage gelatin silver print. Millions of copies of this image, made by Blumenfeld in 1933 on the eve of Hitler's coming to power, were dropped by the United States Air Force over German cities as part of a propaganda exercise in 1943.

fear . . . I thought I was the victim of a mass hallucination: neither France nor I could ever sink so low.'[35]

Confusion ruled. The men, all foreign nationals, were never quite sure of their status as actual internees. Were they 'soldier workers of the French army' or 'filthy foreigners' who had caused France's defeat? It ended in farce: during one of the transports between camps an officer turned up to announce that they had all been put into concentration camps by mistake! Suddenly Blumenfeld found himself reunited with his family.

Now the objective was to secure American visas as fast as possible. Using a press card he had been given on his visit to *Life*, he bluffed his way into the American Consulate in Marseilles, where he stumbled upon an official who was a great admirer of his photographs, Miles Standish. Visas soon materialized.

But fate was to deal one last, mean blow. The rickety ship that was to take Blumenfeld and his family to the United States in May was diverted to Morocco by Hitler's minions and once again they were placed in camps. Only the intervention of the Hebrew Aid Society saved them from the ovens. In July 1941 they left from Casablanca for New York.

'The Language of the Lens'

On his arrival Blumenfeld was immediately put to work on the next issue of *Harper's Bazaar* by the magazine's editor-in-chief, Carmel Snow. He was immensely relieved to have landed on his feet with a lucrative contract, and was equally fortunate in the fact that the tide of fashion had turned in his favour. The war had given American fashion an enormous boost. Many designers had left Paris: Molyneux, Paquin and Worth had fled to London, while other Europeans, like Schiaparelli, had gone to the United States, where they where joined by such returning Americans as Mainbocher and Charles James. Meanwhile, American designers were turning to their own culture for inspiration, supported by an industry increasingly dependent on American textiles and synthetic materials. In the hands of Claire McCardell, Clare Potter and Norman Norell, among others, American made-to-order and ready-to-wear fashions took root, nourished by an enormous market. The influential American magazines stopped genuflecting towards Paris and began exhorting women to buy the native product in order to support the war effort. They could report that the collections on their side of the Atlantic were now far more extensive than those of their European counterparts. American designers began to dominate the pages of the magazines.

Blumenfeld approved of the pragmatic approach of American fashion (what other nation could come up with a synthetic dress material known as Aralac, made from milk?). He admired those designers who could bridge the gap between French and American style: Norman Norell, for example, whose

allegiance to high fashion followed in the Parisian tradition of couture, yet was tempered with American practicality and functionality; Claire McCardell, so successfully styling her casual 'American look'; and Charles James for his superb architectonic sense. But the other side of the coin was that American fashions could, to the photographer's eye, look graceless. However, knowing womenswear as he did, Blumenfeld was able to judge each dress on its own merits, rather than on the reputation of its maker. Thus he could be critical of some of Ben Zuckerman's outfits, which he found stiff, as if 'nailed to the body',[36] while admiring others for their flair.

Cecil Beaton was delighted to hear of his friend's contract with *Harper's Bazaar*. He wrote, 'Je sais votre New York sera vraiment *votre* New York, as you are one of the few personalities strong enough to fight it.'[37] Writing from a besieged Britain, Beaton expressed his envy of Blumenfeld's freedom, and encouraged him to seek out the most talented people on the magazine: the two photographers he most admired, Louise Dahl-Wolfe and George Hoyningen-Huene, and *Bazaar's* fashion editor, the 'magnifique' Diana Vreeland.

The editors of *Harper's Bazaar* played the cultured-European-artist card to the hilt in Blumenfeld's debut issue of October 1941: 'Erwin Blumenfeld, who brings to photography the infinite absorption and love of craft that marks the ageless artist . . . speaks English diffidently but insists that in any case he is only at home in the language of the lens . . .'[38] In casual conversations, however, Blumenfeld began to hear his profession referred to in terms considerably less elevated: 'commercial photographer'. He found the label galling not only because he believed fashion to be a significant form of cultural expression but also because he felt that of *all* the professionals at work on any good fashion magazine, it was the photographer more than anyone else who was responsible for whatever 'art' appeared on its pages. The other key players were far more commercially minded: editors and art directors, he was sure, put business interests at the top of their agendas.[39]

Luckily for Blumenfeld, his first art director at *Harper's Bazaar* was someone he *could* respect: Alexey Brodovitch, the now legendary figure who had transformed the look of the magazine from one of staid elegance to one of graphic dynamism. From the moment Brodovitch arrived at the magazine in 1934, he imbued it with a new sense of vitality: an understanding of negative space, cropping, bleeding and montage. Brodovitch welcomed his fellow émigré with open arms, delighting in the photographer's original and striking sense of design which made his pages instantly recognizable. Unlike many other photographers, for whom the full frame of the negative was sacrosanct, and any degree of cropping a crime, Blumenfeld understood the image-enhancing aspect of cropping and bleeding images and often previsualized these treatments himself. Both men knew that the page (or indeed the double-page spread),

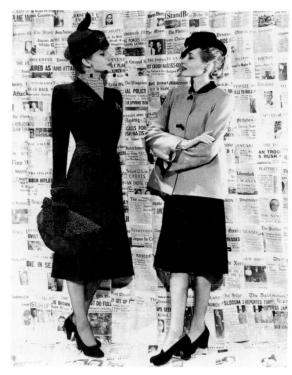

Molyneux fashions for *Harper's Bazaar,* 1943. On arrival in New York, Blumenfeld started work immediately on the Fall collections. Carmel Snow, the editor, wanted him to compensate for inadequate pages submitted by George Hoyningen-Huene. She greeted him with the words, 'Blumenfeld! Sent from heaven!'

with its synthesis of image and text, was, in magazine terms, the final artwork.

Blumenfeld joined a stable of illustrious fashion photographers put together by Snow and Brodovitch: Hoyningen-Huene, the brilliant but mercurial master of the neoclassical look; Dahl-Wolfe, whose romantic yet restrained use of colour was unequalled; Martin Munkacsi, who had cleverly appropriated a photojournalist's snapshot approach for his fashion photography; and Man Ray, whose quirky, enigmatic pictures often stole the show.

The American content of the magazine was interleaved with fashion imagery from Paris – Jean Moral and Herman Landshoff were frequent contributors – and non-fashion reportage by American and European photographers. Herbert Matter, Berenice Abbott, André Kertész and Lisette Model added a dash of social realism to the fantasy cocktail of fashion.

For almost two years Blumenfeld shared Munkacsi's East Side studio. Though their temperaments might have been expected to clash – both men had large egos – they seem to have enjoyed a warm relationship, possibly because their approaches to their work were poles apart. Nevertheless, when an ideal studio came on the market in midtown Manhattan – a high-ceilinged duplex with excellent light – Blumenfeld seized the opportunity and moved. 222 Central Park South would comfortably house his studio, darkroom and office for the rest of his life.

Blumenfeld's postwar work for the magazine showed his usual flair, though he was capable of lacklustre imagery as well, especially when he was required to photograph outdoors. Many of the fashions he was assigned were now American, and he set himself the task of depicting them in such a way that they appeared new, confident, and even patriotic – an important consideration for his editors during the war years (pl. 95).

In one sense, however, he picked up where he had left off. A 1941 cover image for *Harper's Bazaar* (pl. 96) was a reworking of – and notable improvement on – an image he had made for his last issue of French *Vogue*.[40]

Generally, however, he found that his American colleagues did not share his penchant for the more romantic genre, and especially his enthusiasm for veils and other transparent fabrics. As a result the fluidity and charm of his Parisian photographs is often missing – a defect that he put down to a lack of 'soul' in American women.

Blumenfeld tried – as he had at French *Vogue* before the war – to introduce into his assignments, when he could, the range of techniques he had developed and refined over the years. First, there were the studio techniques involving mirrors, veils, fluted or ground glass, a variety of means of distorting the figure with camera or lens (a favourite being elongation to make the figure appear more elegant), and backgrounds taken from famous paintings. Then came the optical and/or chemical manipulations in the darkroom, such as partial

solarization,[41] multiple exposures, negative reticulation,[42] controlled melting of the emulsion, and distortions of the figure by manipulation of the enlarger easel while printing. Lastly, the manifold manipulations of the print itself: bleaching, solarization, and so on. Up to sixty prints from one negative might be required to achieve the desired effect: thus his horror at hearing that Cecil Beaton did not do his own printing. How, he wanted to know, could one then take advantage of accident, so vital to creative work? Surely this was tantamount to relinquishing the most creative half of the image-making process? Beaton, amused by his friend's consternation, replied that he found *his* magic backstage in the theatre.[43]

To would-be photographers he gave the advice: disdain rules and conventions. *Popular Photography* reported:

> When Blumenfeld reads the 'directions for use' provided by the manufacturer (and he has a childishly passionate interest in such reading matter) the first thing he does is to forget the instructions. A glance at the cover picture, for instance, will disclose at once that it was made in violation of Eastman Kodak's exact and careful directions. Color-temperature theories were completely ignored.[44]

Blumenfeld had relinquished with great regret the European 9 x 12 centimetre format familiar to him since childhood, in favour of the American 8 x 10 inch format of the studio camera. However, the difficulty of visualizing in the new proportions was partly offset by his way of working, which was always to include a wider view of his subject in the negative than he would actually choose to print – that is, he always allowed himself a margin which could then be cropped precisely. In addition, shooting a wider field than was necessary had the advantage of giving more depth of field.

Harper's Bazaar was a brilliant showcase for the photographer's work, and Blumenfeld began to earn money from advertisers, many of whom had admired his treatment of their products in the editorial pages. Accounts like Richelieu Pearls and Elizabeth Arden were extremely lucrative. Blumenfeld's love of the female face and hair made him a natural choice for clients in the cosmetics industry, the most powerful group of advertisers in the fashion magazines (and the reason why the face was becoming the dominant image on magazine covers).

Unfortunately, advertising photographs were often the most frustrating of all assignments. The client was always accompanied by an art director, a breed which Blumenfeld had, since his Paris days, come to detest. 'They have very definite ideas of their own and they more or less impose their will on the artist,' he complained, 'They know their own business but usually they know very little

about art.'[45] But he was aware that the real conflict was in fact between his desire to express himself as an artist and the economic reality: the unfortunate art directors were simply convenient scapegoats.

Was there any way round the dilemma posed by art and commerce? Blumenfeld thought there was. The creative photographer had to give his allegiance to the *art* of photography, not the *business* of it, and the way to do this was to 'smuggle in art'[46]. The actual smuggling operation would be easy, since the client-barbarians would not even recognize the photographer's Trojan horse. Blumenfeld liked to tell the story of how his fashion photograph of a model in bare feet – 'smuggled in' as a means of evoking classical Greece – lost a fashion magazine (unidentified) 'about $50,000 in advertising accounts for shoe manufacturers'.[47]

This, at least, was the theory; in truth, art directors usually won out, as Blumenfeld was forced to admit: 'What's the photographer going to do? Say the hell with the instructions, here's the way to do it? Or is he going to remember his rent, his grocery bills, the instalment due on his car. If he's wise, he'll do it à la prescription.'[48]

In the end he seemed to get the balance right. Less than three years after his arrival in New York, the *New York Times* could report that he had become 'one of the highest paid photographers in the United States . . . an outstanding leader in imaginative photography.'[49] It quoted the master's advice appreciatively: 'Photographers must understand that they have to see with their own eyes and not with the eyes of other photographers The amateur's greatest fault is imitativeness.'[50]

That Blumenfeld had enhanced his considerable gifts since 1939 did not go unnoticed at *Vogue*, and in 1944 he responded to financial inducements and returned to the Condé Nast fold.

'The Most Graphic of All Photographers'

Blumenfeld's memoirs give the impression that he alone was responsible for his move to Condé Nast, but Cecil Beaton had once again been working tirelessly on his behalf. The British photographer had been with *Vogue* since 1928 so his opinions carried considerable weight. 'I have written several times to the *Vogue* people saying they are nuts not to bind you down to them,' he told his friend early in 1943, 'Perhaps it is very impertinent but I do feel they cannot afford to let you slip through their fingers.'[51]

Blumenfeld's arrival at Condé Nast was timely. American women were growing restive with the austere fashions of the war years (due partly to governmental restrictions on materials – not to be lifted until 1946) and yearned for clothes that offered them some escapism. It was for this reason that Christian Dior's 'New Look' of 1947 caused such a sensation. The 'New Look' was really

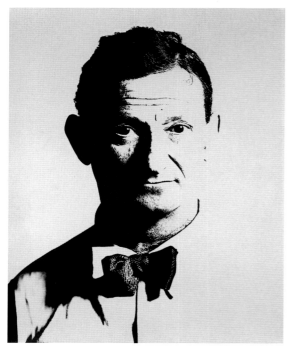

Self-portrait by means of the Kodalith process, whereby the image is comprised of pure black or white (no grey tones). New York, *c.* 1950. Blumenfeld's strong graphic sense made him attractive to art directors.

more news than 'new', but it triggered a great surge of buying, and boosted every sector of the industry. The demands of advertisers soared, and the fashion magazines prospered. Henceforth, haute couture would no longer be the preserve of wealthy women; store buyers and ready-to-wear manufacturers now moved into the field and fashion magazines found themselves in a position of considerable influence. A major publication like *Vogue* would select a particular couture gown to feature and provide the name of the manufacturer who had bought the toile or pattern to copy. In this way, notes fashion historian Jane Mulvagh, 'the choices of the editors to some extent determined which gowns would be mass-produced'.[52]

American manufacturers realized that the most effective sales strategy blended European chic and American practicality. Thus a caption for a Blumenfeld image of an American-made Dior dress reads: 'Uniquely American (the American pace demands it); ready-made fashion from designers of the couturier category; and smart in the international fashion sense,'[53] – an obvious attempt to reassure American women that they were indeed getting the best of both Old and New Worlds.

The increased expenditures of advertisers meant that more demands would be placed on those photographers who could be relied on to create the alluring ambience that would persuade readers to part with their hard-earned cash. Accordingly, photographers who contributed to the prestigious editorial pages found themselves increasingly well-paid. Moreover, if a manufacturer liked what he saw on these pages the photographer would be offered even more profitable advertising work. For the most part the editors of *Vogue* assigned American fashions and beauty products to Blumenfeld. Unlike his fellow photographers, Horst and Beaton, he did not like to work outside his studio and resisted attempts to send him to Paris to photograph the collections. The photographs he did make of Dior, Balenciaga and other European couture were produced when the garments were in New York.

The quality and style of Blumenfeld's work for the Condé Nast publications (which included on one or two occasions non-fashion imagery for *House & Garden)* was not substantially different from his earlier production for *Harper's Bazaar*. He was expected to cover the full range of womenswear and accessories. A Pauline Trigère coat, a Norman Norell evening gown, a Charles James jacket, a Christian Dior suit, a cloche hat by John Frederics, jewelry from Van Cleef & Arpels, eyeshadow by Elizabeth Arden, 'Bronze Beauty Balm' by Germaine Monteil, a coiffure by 'Michael of Helena Rubinstein' – these garments, accessories and beauty products were standard fare for Blumenfeld in the years to follow as he laboured under the tutelage of Edna Chase, *Vogue's* editorial mastermind, and Alexander Liberman, yet another gifted émigré who had replaced Dr Agha as Condé Nast's art director.

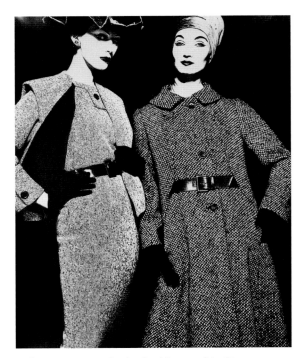

Fashion assignment for the Oval Room of the Dayton Company in Minneapolis, *c.* 1955. The Dayton account gave Blumenfeld an almost unimaginable degree of creative freedom.

Liberman recognized in Blumenfeld a talented if temperamental artist, 'the most graphic of all photographers, and the one who was most deeply rooted in the fine arts'.[54] Though, in his turn, Blumenfeld acknowledged the art director's brilliance, he nonetheless resented any attempt to curb his creative efforts. Liberman, to his credit, understood this and gave the star photographer considerable rein, though clashes were inevitable. Wary respect, rather than trust, seems to have been the basis of this fruitful relationship.[55]

Fashion accessories, jewelry and beauty products, when shown by themselves or on a mannequin, generally provided Blumenfeld with more creative leeway than did suits, dresses, gowns or coats, which required a real woman to wear them if they were to be brought to life. Jewelry could be better displayed on the idealized form of a mannequin, and gloves and stockings (with their delightful transparency!) could be artfully arranged as still lifes (pl. 134). He could also make use of his more experimental techniques to fabricate interesting backgrounds or frames for these articles; a hat could be enhanced, for example, with a background pattern of hallmark Blumenfeld whorls (pl. 92). As for beauty products, which called for the creation of an aura rather than the depiction of a specific product, even more scope was allowed: a beautifully made-up face could shimmer indistinctly behind a veil of smoke (pl. 110).

The experimental genre also suited occasions when what was needed was a general sense of a style or a 'look'. But when clear delineation of cut, texture and line was required, Blumenfeld was capable of dispensing with his darkroom alchemy and producing a straightforward document without embellishments. Here he relied on his innate feel (indeed his *liking*) for the clothes themselves, his fascination with the myriad ways they could transform the female body, and his strong graphic sense of design. In these often spartan images the full attention of the viewer is focused on the clothes and the woman wearing them. A simple gesture on the part of the model is all that is required to catch the eye – a hand placed just so on a hip, an odd tilt of the head, a slight twist of the body, a haughty gaze, a hint of a smile. Then, through the tightness of the photographer's cropping, the essential attributes of the dress are made clear while, simultaneously, the composition is enlivened by means of a playful geometry – beautifully orchestrated curves (hairline, shoulder, neckline), a well-placed counterpoint (the silhouette of a male back off to one side in the foreground), effectively used negative space (between an elbow and a hip). With these strategies Blumenfeld highlighted the originality of the garments and underlined the chic modernity of the women wearing them. His women seem utterly confident, utterly natural, utterly *right*, in their clothes.

Liberman was quick to realize that this formal economy would make for highly effective *Vogue* covers. The photographer relished these assignments, composing his elegant images with meticulous care. They were always made

with the typographic requirements in mind (the superimposition of the magazine's title, the date, the main features, and so on). For more than a decade Blumenfeld covers were a staple of the magazine; in one year alone as many as twelve were produced. At their best they were masterpieces of form and colour.

On his arrival in America, colour had posed a challenge to Blumenfeld. He had already seen Kodachromes in Europe and they had made a tremendous impression. Most of his work for *Harper's Bazaar* (most of *all* work for the magazine during the war years, with the exception of covers and one or two key pages per issue) was produced in black-and-white, but colour intrigued him and he determined to master this new language.[56]

That he did so stood him in good stead when he went to work for Condé Nast. *Vogue* liked to think of itself as a pioneer of colour photography and boasted of its photographers' achievements in this domain. The magazine was especially proud of having 'considerably surprised the photographic world in September, 1935, with Edward Steichen's double-page colour spread of the *corps de ballet* of Radio City Music Hall'.[57] Three years earlier Steichen had also produced the first photographic colour cover.

With *Vogue's* encouragement, therefore, Blumenfeld seized the chance of appropriating motifs and effects from painting, working them into his own pictures. The art of Manet, Van Gogh, Uccello and Vermeer provided particular inspiration; he spoke of the latter as 'the inventor of colour photography',[58] meaning that the range of colours on the Kodachrome plate was a close match to Vermeer's palette. 'Kodachrome has its special technique,' he explained, 'It never renders colours exactly as we see them. It acts best on transparent colours. The principal secret of Kodachrome is not to work with colours, but with coloured lights'.[59] He would therefore tape coloured cellophane over white light, or stick it to sheets of ground glass with the light source illuminating it from behind (pl. 111). Most ingeniously, he would cut the cellophane into thin strips and place it on the *inside* of the camera bellows to produce a subdued glow.

Blumenfeld took great pleasure in ignoring conventional rules of colour. He liked to shock *Vogue's* readers: a green rose was preferable to a red one (pl. 116); a red coat looked even redder against a red background (pl. 132), and so on. He could even appreciate accidental effects on transparencies resulting from imperfect film emulsion, faulty exposures, or inadequate development; of one such accident he wrote, 'The charm of this picture is due to the fact that the emulsion of the film was badly balanced, and too sensitive to blue.'[60] But he could not abide the abysmal standards of colour reproduction in the magazines, which he blamed not on inherent limitations in the technology but on the lack of aesthetic sensitivity on the part of the engravers.[61]

'Devious Devices'

A sitting for *Vogue* was a complicated affair involving a considerable number of people. It would begin with a briefing by the art director in his office, sometimes augmented by additional advice from one of the fashion editors; Blumenfeld was usually attentive to Liberman's requirements, but would studiously ignore the editor's suggestions.

He was similarly high-handed with the outfit in question. If it did not meet with his approval – that is, his *own* standards of design or workmanship – he might ask to see the complete line and select a more inspiring alternative. Such was his knowledge of dressmaking – and his self-confidence – that he was rarely challenged.

With the help of the model editor at *Vogue*, Blumenfeld would then choose the model and schedule her for a specific day. These were often women at the peak of their profession, like Jean Patchett, Teddy Thurman or Evelyn Tripp, but sometimes, to his credit, Blumenfeld might select what was referred to in the business as 'a new face': someone he had discovered while making test shots. He did this partly for the challenge of discovery – wanting to prove to *Vogue* that he had his finger on the pulse of popular culture – and partly as a gesture of kindness, since an aspiring model might gain a foothold on the ladder if she could show a set of Blumenfeld prints to a prospective client.

Blumenfeld found these new faces thanks to an open-house policy he had instituted on Tuesday mornings, when models, erstwhile photographers and would-be assistants paraded in to exhibit their portfolios and solicit the master's advice. As he took the time to listen to their problems, both professional or personal, he developed a reputation for sympathy and respect, otherwise rare in the business. He joked that he had become 'father confessor' to the young hopefuls. When, during a test sitting, one aspiring young model, Marella Caraciollo (later Agnelli), complained of boredom, he invited her to come round to the other side of the camera where the *real* excitement lay; the result was that she became his assistant, or, as she put it, the 'sorcerer's apprentice'.[62]

There was certainly an erotic element in his relationships with the young women who posed before his lens, but by all accounts their sexuality was not exploited for his own pleasure. Whatever desire stirred, it was, as he always said, 'sublimated by the lens'. *Popular Photography* hinted at the erotic component of a sitting when it wrote, 'By devious devices, directions, suggestions, or cajoling, Blumenfeld puts his model into the proper mood to express a wish, a desire, or an invitation.'[63] Kathleen Lévy-Barnett (now Blumenfeld), who had worked as *Vogue*'s model editor before becoming Blumenfeld's agent and subsequently his daughter-in-law in the mid-1950s, recalls more bluntly how, once behind the camera, he would flirt with the model, pleading with her in his heavily accented English, to 'love me for a moment' or, 'make love to the camera'.[64]

Blumenfeld prepared for his sittings meticulously, establishing a clear starting-point if not a precise end result. Whatever props or accessories might be required were brought to the studio in advance and placed in position before the models arrived, as were the lights, tripod and camera – an 8 x 10 inch Deardorff.

Less experienced models arriving at the studio would be required to apply their make-up and arrange their hair according to the photographer's precise instructions; sometimes Blumenfeld would even apply make-up himself or sketch in outlines directly on the face. On the other hand, some of the top models would arrive straight from the hairdresser with their hair and make-up in place. Jean Patchett recalls turning up ready for a session on her coiffure, but Blumenfeld, delighted with the 'doe-eye' make-up she had applied (an idea which had recently been introduced in Paris by the designer Robert Piguet) made *this* the central focus of what would become the most celebrated of his cover images (pl. 126) – not to mention the most copied.[65]

A sitting would typically begin at 9.00 or 10.00 a.m., sometimes lasting all day, sometimes only until lunchtime. A full day's work would usually cover two outfits, each requiring between ten and forty separate exposures before the photographer was satisfied. Once made-up, the models would be asked to assume precise poses, down to the position of their fingers and their facial expressions – under Blumenfeld's regime there was no room for spontaneous gestures.

Lighting in the pre-strobe era (for Blumenfeld this meant approximately before 1950) was not a simple matter. Moving some of the heavier lights required two men, and the heat from the lights took its toll on the composure of the models, not to mention the technical team. With the introduction of strobes this problem was resolved; Keg lights were used to set up the shot and focus the image, and the subsequent enormous pulses of light energy given off by the strobes lasted only 1/10,000 of a second.

Blumenfeld customized certain lights for specific tasks. One was equipped with a telescope, for example, allowing the photographer to project a very small beam. 'When this beam appears right down the centre of the face', Blumenfeld explained, 'it gives the illusion of a double exposure When the beam appears only on one side of the face, it appears to have a profile and full view effect – almost a negative and positive effect'.[66]

The studio could be a crowded place on the day of a sitting. A *Vogue* fashion editor, a hairdresser and a make-up artist might attend. As well as the men to move the lights, there were also one or two assistants. The first had an essentially technical role, helping with camera and lighting equipment, loading of the plate holders and the like; the second performed a variety of duties: making adjustments to the model's garments and hair, keeping track of the exposed film, and dealing as diplomatically as possible with the traffic in the studio.

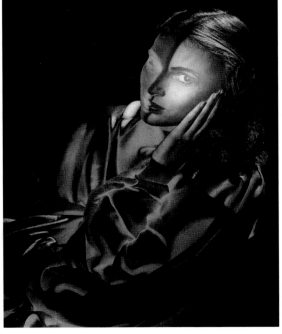

Untitled and undated fashion photograph showing all the trademark Blumenfeld effects.

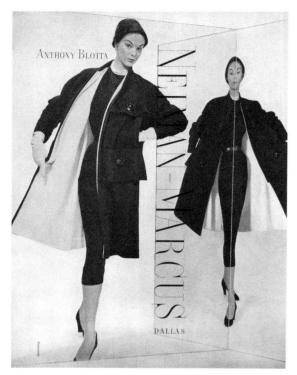

Above: Advertising photograph for Neiman Marcus, Dallas, Texas, *Vogue*, March 1954. Blumenfeld's editorial work for *Vogue* led to lucrative advertising commissions. By the early 1950s he was the highest paid fashion photographer in the world.

Opposite page, top: The playwright Eugene O'Neill, New York, 1947.

Opposite page, bottom: The singer Juliette Greco, photographed for a promotion for Columbia Records, New York, *c.* 1955. For this portrait Blumenfeld harked back to a motif he had developed in his Amsterdam period some twenty-five years earlier (see pl. 21).

Whether the session was for half a day or a full day, the photographer would rush off to his darkroom at midday to check the results (this in the case of black-and-white film; in the case of colour, the plates were sent off quickly to the lab). After the break, if the pictures were not judged satisfactory, the session would resume.

The total exhaustion of all parties was the usual state of affairs at the end of the day, especially during the steamy New York summers, but this did not stop Blumenfeld from cloistering himself in his beloved darkroom until the small hours. He always insisted on doing his own darkroom work, and his 'trusted assistants', as they ironically called themselves, were seldom trusted to do more than agitate the tanks during development or make contact prints under strict supervision. After development the negatives were contact-printed and studied, and the making of the prints begun. As with all his work, commercial or personal, this was the time he relished, making thirty, forty or even fifty variations on a single image before he was satisfied with the result. The fruit of these labours was usually three different photographs: the final choice would be left to the art department at *Vogue*.[67]

'The World's Most Famous Photographer of Women'

Blumenfeld managed to hold on to a number of advertising accounts from his *Harper's Bazaar* period, augmenting the list considerably while working for *Vogue*. To Richelieu Pearls, Elizabeth Arden and Helena Rubinstein were added Bryans, Lanvin and Dupont. The cover of *Vogue* was a virtual billboard for his talents, and a folding screen in his studio, entirely papered with covers, reminded clients that they were in the presence of a master, and could expect to be billed accordingly.

Despite the fact that advertising paid so highly, Blumenfeld still found it the least satisfying of his endeavours. Often a client's art director would want the work to conform too closely to a preconceived idea, which to the artist in Blumenfeld meant creative death. 'The great things always happen by accident,' he would argue, usually fruitlessly (and a bit hypocritically, too, as he himself had preconceived ideas that ruled out spontaneity on the part of the model).[68]

By 1950 Blumenfeld had achieved fame as one of the finest photographers of the age. He was also one of the best-paid – by some accounts the highest paid of all, which of course put him in even greater demand. Neiman Marcus, Seagram's, Ford, Van Cleef & Arpels, Haig Whisky and Seymour Fox (a manufacturer of women's clothing) were among his eager clients. 'We went after whisky, cars, you name it – we made a fortune,' recalled his agent, Kathleen Lévy-Barnett.[69]

Fortunately, one of his accounts gave him an almost unimaginable degree of creative freedom: Dayton's Department Store in Minneapolis hired him for

their designer boutique, the Oval Room. Stuart Wells, Dayton's vice-president of advertising, acted more like a patron than a client, allowing the photographer to choose the theme, dresses, models, decor, and even make the final cropping and layout decisions according to the various formats of the magazines targeted. The only 'given' was the designer or designers to be featured. At the end of the process, when the images were in position, Blumenfeld and Wells would place the tiny bylines (store and designer names) discreetly on the image. The results, with all double-page images laid horizontally, were striking. Blumenfeld's work for Dayton was the peak of his commercial endeavours (pls. 141, 142, 143).

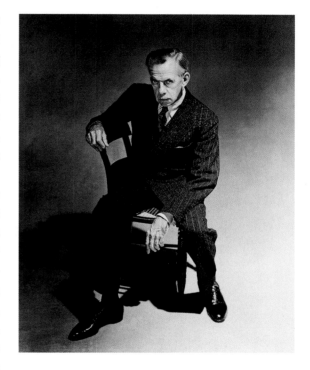

His fame as a photographer of fashion – and beautiful women – made him something of an oracle for amateurs, and his half-serious, half-tongue-in-cheek pronouncements concerning 'Woman' were eagerly reported, with a certain amount of poetic licence, by American photography magazines. *Popular Photography* intoned breathlessly: 'The women in America are the most beautiful in the world, according to Blumenfeld. Even in Paris he worked mainly with American models [This was not true]. The proportions of the American female, due largely to unknown but beneficent factors, are absolutely ideal. Blumenfeld's women are incarnations of femininity . . . masterpieces of rare charm – Solomon's songs presented in the metier of today – *photography*.'[70] The magazine's male readers were now armed with a heady justification for their enjoyment of its coy nudes. Blumenfeld's imagery graced the covers of half a dozen issues of this journal.

The photographer's privileged insights into the nature of woman also earned him the covers of *Collier's* (happy, wholesome wives and mothers) *Seventeen* (neatly dressed, perky young women), *Kaleidoscope* (new all-American fashions) and *Cosmopolitan* (the glamorous sophisticate). Pictorial features also appeared in the mass-market American picture magazines *Life, Look, Coronet* and *Pageant* ('Blumenfeld says faces from all the Old Masters can be found among today's American women if one knows how to look'[71]), while abroad, his work was published in French and British *Vogue*, the British magazines *Picture Post* and *Lilliput*, and the Swiss graphic design magazine *Graphis*, among dozens of other journals and newspapers. Inevitably, reference was made to 'the world's most highly paid photographer' and 'The world's most famous photographer of women'.[72]

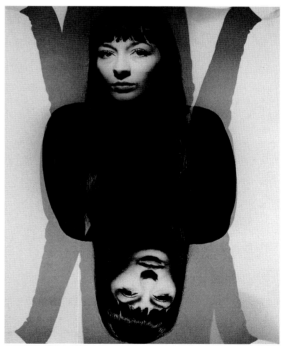

Some of his assignments for various magazines, and particularly for *Vogue*, included portraits of society women, celebrities and distinguished artists: the socialite Mrs Cushing Mortimer (Babe Paley), film-maker Robert Flaherty, writer Eugene O' Neill, film star Marlene Dietrich, singer Juliette Greco, comedian Jackie Gleason Typically his portraits of women were invested with feeling and elan, while his portraits of men, with a few notable exceptions, were flat and undistinguished. There was always a strong element of graphic design

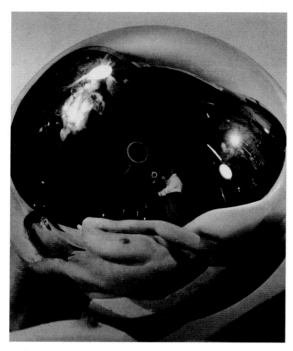

Self-portrait, with nude, taken at Blumenfeld's premises at 222 Central Park South, New York. He always photographed there, so that he could move easily back and forth between studio and darkroom.

in his female portraiture – a tight, sculptural unity of form (pl. 137); but he was unwilling to subordinate the men and their dull grey suits to these graphic schemes. This double standard was seen most dramatically in a feature for *Vogue* on Betty Parsons' Gallery in New York. Of the stable of artists depicted – Mark Rothko, Jackson Pollock, Ad Reinhardt, Clyfford Still and other leading Abstract Expressionists, only Richard Pousette-Dart's likeness had any vitality. And, characteristically, it is Betty Parsons' portrait that dominates the group. Recognizing this for the disappointment that it was, *Vogue* ran the images the size of postage-stamps.

When talking about his photography, Blumenfeld was always careful to distinguish between the work he did for magazines and advertisers and his personal work. The latter he managed to pursue throughout this period, mainly experimenting with nudes and portraiture, but occasionally photographing architecture, cityscapes and landscapes. 'I have no interest in taking these pictures but for my own pleasure and a certain goal of hunting for some elusive effect of the finished work,' he explained.[73]

Pride of place in this personal sphere went to the nude, a subject of which he never tired. The specialized techniques remained essentially those he had developed in Paris, but these were subjected to endless variations and refinements. The goal was always to reveal some aspect of femininity or womanliness lying beyond the outward form. As odd as it first sounds of a photographer who delighted in transformations, Blumenfeld maintained that his objective was to work 'without tricks or decorations'.[74] By this he meant that the transformations were not ends in themselves but a means of illuminating another reality. So projecting lines on the naked body, for example, was not a decorative device, but 'a modern art problem' – one more of Blumenfeld's attempts to 'transcend the simple mechanics of the camera'.[75]

Portraits *per se* were now less interesting to him than nudes; if he still could not resist a beautiful face it was only because it was part of a body (as opposed to a sign of personality or character), to be subjected to the same transformation. He had developed a special technique for his portraits: ideally he liked to start a sitting in the dark, turning on first one light and studying the effect, and then another, until the balance of light and shadow was exactly as he wanted it; only then would he decide where and at what distance from the subject to place the camera.

Conventional landscapes and cityscapes held no interest for him. When he found himself taking pictures on the streets of Manhattan or in the expanses of the American West, it was to record textures and objects which evoked *other things*, things he had seen and photographed years earlier in Paris, Amsterdam or Berlin. When he focused his camera on the Grand Canyon (pl. 149), or a mangrove swamp in Florida, or Manhattan skyscrapers (pl. 154), or even on

tyre tracks on a dirt road, it was to delight in the unity of the world, to see in the patterns and structures direct kinship with, say, Gothic cathedral architecture, or a woman's skin or hair (pls. 148, 149). Ultimately, he preferred to work within the studio, in close proximity to the darkroom.

Although Blumenfeld liked to give the impression that his commercial and personal work were entirely separate, in fact the genres merged. A prop or unusual piece of material left over from an assignment might be used for a nude; a veil for a nude might find its way into an advertising image. An experimental nude, even something made years earlier, might be utilized as a background for a commercial product; he found several of his partially solarized nudes and portraits perfect settings for displays of jewelry. Later in his life, when he planned the juxtapositions of images for his proposed book, *My One Hundred Best Photos*, landscapes and cityscapes were paired with images of women's faces or bodies, clearly demonstrating the extent to which, in his own mind, form had primacy over content.

Had Blumenfeld reached his prime some ten or fifteen years later than he did, he might well have managed a separate career as an 'art photographer', as his successors Richard Avedon and Irving Penn have so successfully done. But dedicated photography galleries and dealers, photography departments at museums, specialized journals, collectors and the like – what is usually called 'the support network' – existed in only the most rudimentary form in the 1950s and 1960s.

The few art galleries and museums that did make overtures were generally rebuffed, since Blumenfeld had precise ideas of his own as to how his work should be printed and displayed. This explains, for example, why the curator of 'Glamour Portraits', organized by the Museum of Modern Art in 1965, made the decision not to include Blumenfeld's work, even though the raison d'etre of the show – to exhibit photographers who had 'triumphed over their collaborators, and each discovered a woman that was largely his own invention' – seemed tailor-made for him.[76]

Only occasionally did his work find its way into important group exhibitions. In 1947 Edward Steichen chose six of his photographs for 'In and Out of Focus: A Survey of Today's Photography', which opened at the Museum of Modern Art in New York and subsequently travelled to nine American cities; Blumenfeld agreed to take part because he respected the show's designer, Herbert Matter. On the West Coast, Blumenfeld's work was included in 'Seventeen Photographers', organized by the Los Angeles Museum (now the Los Angeles County Museum of Art) in 1948. It is telling that in his memoirs Blumenfeld makes no mention of his exhibitions (with the exception of his first Paris show); he seems to have set little store by this aspect of his career.

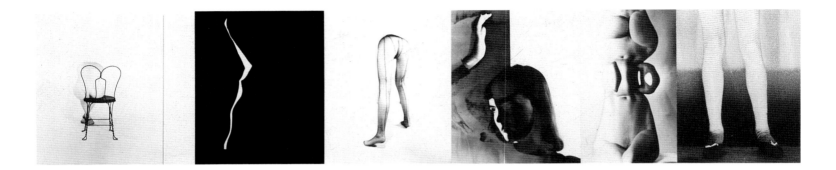

An installation photograph of Blumenfeld's section in 'In and Out of Focus', the Museum of Modern Art's group exhibition of 1947, curated by Edward Steichen and designed by Blumenfeld's friend, the Swiss designer and photographer Herbert Matter. By all accounts Blumenfeld was not particularly interested in gallery and museum exhibitions, preferring to reach the public through the printed page.

'Two Hundred Million Babbitts'

In 1955 Blumenfeld had a falling out with *Vogue*. The covers (having reached a high of twelve in one year) stopped abruptly, triggering a slow decline in his fortunes. Although assignments for *Vogue* did come his way until 1963, they were sporadic. Dayton, Helena Rubinstein and Elizabeth Arden, among others, would remain loyal clients well into the sixties, but a cornerstone of his edifice – his most visible and prestigious showcase – was beginning to crumble.

Why did Blumenfeld allow this to happen? He was at the peak of his career, in good health, successful in every way, and rich by the standards of any commercial photographer.

In part, it was because the world was passing him by. The fashion magazines thrived on novelty, and Blumenfeld's vision was no longer either new or unique. Now one could see 'Blumenfelds' in the work of others, like Constantine Joffe, John Rawlings and Serge Balkin. Younger photographers, with more sprightly visions to match, were on the rise: Richard Avedon, for example, Irving Penn and William Klein.

In addition, Blumenfeld was becoming too expensive and too difficult. Clients were tiring of his advice as to how *they* should be doing *their* jobs. His diatribes against 'arsedirectors' were less patiently received. Marina Schinz, his assistant from 1964 on, recalls him snapping at one such unfortunate during a sitting: 'I don't need a monkey to tell me what to do.'[77] Though the shoot was completed, the client never returned.

Part of the explanation for Blumenfeld's waning influence, however, lies in the man himself: his own conscious retreat. He had, after all, accomplished a number of things he had set out to do: firstly, to prove to himself that he had made the right decision, no matter what his parents had thought – it was indeed possible to make a living as an artist, and in a more profitable manner than any bourgeois careerist of their generation could ever have dreamed; secondly, to demonstrate to his critics in Holland and Germany that he had achieved the pinnacle of success as a photographer in spite of their damning prognoses; thirdly, to show that photography could be accepted as an art.

In spite of the 1955 watershed, there were still reserves to be tapped. *Harper's Bazaar, Seventeen* and *Cosmopolitan* continued to commission occasional work, and in 1963 the French company L'Oréal, Blumenfeld's last major client, took him on, for a high fee, as advisor-cum-photographer, and for a time his enormous posters for Dop Shampoo dominated the Paris Metro, just as they had filled the pages of *Votre Beauté* in the late 1930s. L'Oréal was particularly intrigued by Blumenfeld's film experiments (twenty-second-long potential advertisements timed precisely for television slots) which transposed into cinematic form many of his ideas and motifs from still photography. He had begun producing these films for the pleasure of trying his hand at another visual medium, while shrewdly keeping commercial possibilities open. The last of these experiments was highly complex, with five separate moving images projected simultaneously on the screen. Only his death a few years later put an end to this promising new direction.

'Un Talent comme Ecrivain'

However, what most involved Blumenfeld's creative energies during the later years of his life was his writing. He had always enjoyed composing poetry and short stories – twenty years of which were lost during World War II[78] – and through thick and thin he remained an inveterate letter writer. Cecil Beaton, always a grateful recipient of his friend's regular reports on the fads and foibles of the fashion world, found his letters extraordinary. After reading what *Harper's Bazaar* had to say about Blumenfeld when he joined the magazine in 1941, Beaton wrote to his friend: 'I read that the lens is your means of expressing yourself, but je trouve vos lettres extraordinaires et vous avez un talent comme ecrivain I find your letters have the same strength of character, point of view & taste, as in a different way, has Cocteau. I wish you would write your war experiences Do try.'[79]

Whether or not Beaton's encouraging words had originally planted the seed, it was at about the time that Blumenfeld parted with *Vogue* in the mid-1950s that he finally began producing such an account. It was to be called *Einbildungsroman* (a term which in typically Blumenfeld fashion has a double meaning: a *Bildungsroman* is a novel which traces the life of a character, while *Einbildung* means imagination; it was a way of saying that he acknowledged the idiosyncrasy of his own perspective). Sadly, he did not live to see the work in print, and only the persistence of his heirs managed to overcome initial publisher resistance to his unorthodox use of language and his savage wit.[80]

To call the work simply an autobiography is to do it an injustice. It reads far more like a novel, though it must be said that even its most implausible passages have been verified, at least in their general outlines, by family, friends and associates. What makes the book extraordinary, however, is not the content as

much as the form – that is, the way in which the events are described. *Einbildungsroman* is a semi-picaresque life-story, narrated in seventy-one brief chapters and written in sentences of such staccato-like cadences that they have been likened to jazz. Every page sparkles with acerbic wit and black humour, and the author revels in rhymes, puns, alliterations and double-entendres. In fact, in its rich, multi-layered composition it is not unlike his photography.

The author tells us at the outset that in his quest for self-realization, he identifies with Lynceus, famous for his sharp sight. Like the Argonaut, he is 'born to see, ordered to look'.[81] Powerless to do otherwise, armed only with the modern weapon of the camera, he follows his destiny, all the while buffeted about by forces he is unable to control or influence '. . . back and forth through languages, countries, wars, women, labyrinths, adventures, books, beauty, crap, wisdom, stupidity, lies, truths, keyholes Through the wonderful, hideous worlds of a cosmopolitan life.'[82]

Most of the book deals with Blumenfeld's European experiences, in particular his childhood in Berlin, the tribulations of two world wars, his doomed attempts at economic self-sufficiency, and his eventual success in Paris; by comparison, the American segment of his life is given short shrift and comes as something of an anticlimax, though it is entertaining for its character assassinations of notable figures of the fashion world. This imbalance could hardly be otherwise, since New York represented a safe haven from storm-wracked Europe, where the forces which impinged on him had life-and-death implications.

Yet the book's bias also betrayed the depth of his roots: he had always remained a transplanted European, albeit one who had managed a brilliant accommodation with an alien culture. While he was amused, intrigued and delighted by the more exuberant aspects of American life (jazz, the Marx Brothers, striptease, Janis Joplin), his emotional attachment was to European culture, *humanist* culture. In the United States he never found a substitute for Berlin's Café des Westens or Paris's Café de Dome, or mentors of the stature of Else Lasker-Schüler. Instead there was a nation of 'two hundred million Babbitts!'[83] He noted ruefully that many émigré European artists had foundered on the shoals of the New World; his old friend George Grosz, for example, had 'lost his art' in America.[84]

The most perspicacious critic of the book, the writer and poet Alfred Andersch, asked if the ire, indeed the *hate* Blumenfeld expressed so vehemently was justified.[85] Inasmuch as it was really directed 'at the people and the petite bourgeoisie responsible for two wars', Andersch concluded that it was entirely appropriate; given the light it sheds on nascent Nazism, the critic argued that the book transcended the genre of conventional autobiography and should be viewed as a valuable contribution to sociology.[86]

Home Life

Although work was at the centre of Blumenfeld's life, he always found time for his family. It helped that their West 67th Street apartment in the celebrated Hotel des Artistes was only a few blocks from the studio; Blumenfeld could have dinner at home and stroll back to his darkroom afterwards. For years, summer weekends were spent at the family beachhouse in Westhampton, Long Island, until a ferocious winter storm washed it away in 1963.

Lena, determined from their first days in New York not to play the role of housewife, had actively pursued her own career as a child psychologist. Lisette, the eldest of the children, had embarked on a career in fashion after leaving high school, holding a variety of jobs in New York including that of assistant in her father's studio. In the late forties she moved to Paris to pursue her interests in fashion and art, and later married an American painter, Paul Georges. Henry and Yorick, meanwhile, in spite of the total lack of interest their father had shown in their formal schooling, were at university. After studying at Harvard and Columbia, Henry, the older of the two, became a physicist. In 1956 he married Kathleen Lévy-Barnett, his father's agent at the time. Yorick studied history and literature at Harvard before embarking on a career as a writer and journalist.

Over lunches at his favourite restaurants – Café Arnold, next door to the studio, and the Oyster Bar at Grand Central Station – or over meals at home, Blumenfeld met with old friends and acquaintances like Richard Huelsenbeck, Walter Mehring and George Grosz, and shared memories of Dada days and the 'Café Megalomania'. Cecil Beaton, Alexey Brodovitch and Martin Munkacsi were also welcome guests at home or companions over lunch. Blumenfeld enjoyed the company, too, of the designer/photographer Herbert Matter, fashion photographers Norman Parkinson and James Abbe, Jr., the writer David Rousset, and the painter Richard Lindner, an old friend from Paris. Particularly close to Blumenfeld were the artist Ludwig Bemelmans, *Life* magazine's Alexander King, and Stuart Wells of the Dayton Company. And a day seldom went by when Blumenfeld did not talk to his stockbroker, Louis Berstman, with whom he shared a passion for numbers. Among close women friends were his ex-assistant Marella Caracciolo; Eileen Ford, founder of the model agency which bears her name; and Barbara Cushing Paley. He also had a soft spot for the two doyens of the cosmetics industry, Helena Rubinstein and Elizabeth Arden, though he mocks them mercilessly in his memoirs, where they feature as Queen Aphrodite Karbunkelstein and Ethel Boredom.

Relations between Blumenfeld and Lena were complicated in later years; Lena had always been a jealous wife and Blumenfeld's adoration of 'Woman', and more specifically two serious affairs he conducted, led to friction.

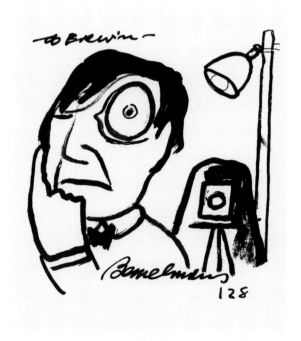

The artist Ludwig Bemelmans's homage to his great friend Erwin Blumenfeld, *c.* 1955. Blumenfeld's closest friendships tended to be with European émigrés.

In spite of this, however, a strong bond remained, and when in 1965 Lena was taken seriously ill in Vienna, where she was visiting her son Yorick, Blumenfeld went to see her as often as he could and wrote almost daily. Although an operation left her crippled, Lena recovered and eventually returned home. From then on, the two lived together only part of the time. Lena survived Erwin by twenty years, dying in 1989.

The Thread Breaks

Blumenfeld died on 4 July 1969 of a massive heart attack while on holiday in Rome. He had suffered a similar attack five years earlier, but had refused to modify his lifestyle, preferring an abrupt end rather than a slow, and perhaps humiliating, decline. Among his papers was found an 'account' of just such a death, dated fifteen days previously: '. . . Wet breath hammered my heart with fists, teeth almost stuck in my throat, bones crumbled, pearls of sweat fell before the swine, repulsive, phlegm-filled intestines left me, my eyes stared powerless into Nirvana, the thread broke, all was in the past, I was dead.'[87]

Homage to Blumenfeld

To the extent that Blumenfeld is known and admired today, it is more or less within the narrow, and often disparaged, confines of 'fashion photography'. His personal work – his Dada collages and drawings, his painting and his photography: portraits and nudes, novel renderings of sculptures and tapestries, studies of ecclesiastical architecture, cityscapes and landscapes – is familiar to very few people. This is partly a consequence of disruptions to his career; the negatives from his Amsterdam years were lost forever, while his French glass plates only narrowly avoided a similar fate.[88]

But even at the peak of his professional career Blumenfeld was able to exhibit or publish only a small selection of his personal œuvre. There was no substantial book or retrospective exhibition during his lifetime, merely features in magazines – the most extensive of which were illustrated with no more than half a dozen images – or group exhibitions showing a cursory selection. Although he had been able to communicate the *essence* of his vision, as he saw it, through the various fashion, photography and general circulation magazines at his disposal, he also admitted that much of his work never saw the printed page. 'There is work no one wants,' he told one critic.[89] This was not a complaint, however, since he believed that much of a creative photographer's work was a means to an end rather than an end in itself. Nevertheless, except perhaps for the early exhibitions in Amsterdam and Paris, the public was never given the opportunity of seeing the full array of his finest photography.[90]

Blumenfeld accepted that he was, and would be, known first and foremost as a fashion photographer. 'I started making pictures because I liked to,' he told an

Untitled, New York, *c.* 1960. Blumenfeld had a love–hate relationship with Manhattan. Here, in an original print (partially destroyed), he takes a dim view of the city's fitness for human habitation.

interviewer in 1950. 'Many years later, today, I receive interesting sums because I make pictures other people like I am not a model of frustration dashing madly about shouting ART Fact is, I eat regularly and rather well.'[91] Moreover, he liked the fact that in a pre-television age a magazine photographer exerted a powerful influence:

> The influence of photographers on the life of this world is much stronger than the Old Masters could ever have dreamt of. What we have in common with them is that a great magazine is a Maecenas to us, with all the advantages and disadvantages of such a situation. Every page is seen by millions of people and we are responsible for the tastes of tomorrow. Our pictures are the essence of a page and every page has to have its own face, its own spirit, to catch millions of eyes, as otherwise it is only a scrap of paper.[92]

However, one of the 'disadvantages' was expressed only in private: the compromise required of an artist in the service of commerce. His son Yorick recalls asking his father why a rather dejected-looking self-portrait of 1957-62 had been painted in red. Blumenfeld replied with typically self-deprecating irony that it had been inspired by the red light district of Amsterdam, and was a fitting colour for someone who had prostituted himself for the fashion world.[93]

While he was willing, on balance, to accept the pigeonhole into which he would be placed for posterity, it would have annoyed Blumenfeld to think that the world would ignore a substantial – and in his eyes *the* most important – part of his œuvre. He could acknowledge that his Dada work was the product of youthful exuberance, and that his oils probably amounted to 'Sunday painting',[94] but he firmly believed that his photography transcended the commercial uses to which it had been put. When, in later years, he decided to set the record straight by publishing a selection of what *he* considered to be his finest photographs (produced posthumously in 1979 as *My One Hundred Best Photos*[95]), only four images out of the hundred were of fashion.

There is no doubt that *My One Hundred Best Photos* overstated the case: none of the superb Parisian fashion imagery, and only one of the great American covers was featured. But it can still be argued – ironically, in view of his reputation – that his fashion work, particularly the American imagery, is the least interesting part of his legacy overall. Although he did create fashion images of great sophistication, there is much on the pages of *Harper's Bazaar* and *Vogue* that is mundane; the photographer was simply too constrained by the requirements of both fashion designers and magazine editors – that is, for clear depictions of the clothes – to be able to create the rich, mysterious atmosphere at which he excelled.[96]

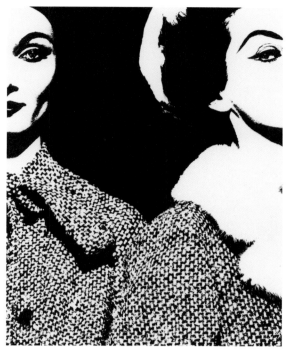

Fashions for Dayton's Oval Room, 1955. Blumenfeld's influence can still be seen in the work of many fashion photographers.

Half a century has passed since Blumenfeld was at the peak of his career. What can be said of his influence on other photographers, then and now? For years Blumenfeld 'covergirls' stared out from every newsstand in North America, and not infrequently from those in Britain and France. By 1955 most of the magazine-reading public in the United States had set eyes at least once on a Blumenfeld. Colleagues and aspiring fashion photographers had ample opportunity to analyse his techniques, or at least to draw inspiration from his approach. Irving Penn, for example, then setting out on his career, was struck by 'Blumenfeld's cleverness and graphic inventiveness.'[97]

Fashion photographers had to be prolific in order to survive and, faced with a deadline, none was above 'appropriating' an idea or an image he or she had seen elsewhere, Blumenfeld included. Undoubtedly, some of these appropriations were unconscious: it was more often than not a matter of a common visual culture. Serge Balkin, for example, made use of Blumenfeld's trademark profile/frontal motif for an assignment in *Glamour*,[98] while William Klein followed Blumenfeld's lead in creating a kaleidoscopic still life of shoes using mirrors. Various Klein images of women in hats, smoking, are also strikingly reminiscent of Blumenfeld imagery (pls. 3, 110), though with innovative twists of their own. And Blumenfeld's now iconic picture of Lisa Fonssagrives perched on the Eiffel Tower has had innumerable reworkings by such image-makers as Christian Moser, Thierry Mugler and Peter Lindbergh.[99]

The Blumenfeld spirit is particularly evident in the photography of Paolo Roversi and David Seidner. Roversi, who, like Blumenfeld, wanted to express 'the woman of the moment' has used double exposure, projected colour and 'bleached', high-key effects in the Blumenfeld style.[100] Seidner, perhaps more than any of his colleagues, felt a deep kinship with Blumenfeld, who through his example had shown that commerce did not necessarily rule out art, and that on the contrary there was a certain nobility in trying to bridge the divide. A number of the younger photographer's images show the influence of the master; one, indeed, is titled 'Homage to Blumenfeld'.[101]

Blumenfeld's work, with its magnificent transformations of the mundane, remains a touchstone not only for those photographers involved in the fabrication of the beauty myth, but also for those who share an abiding faith in photography's capacity to penetrate and then give form to the deepest recesses of the imagination.

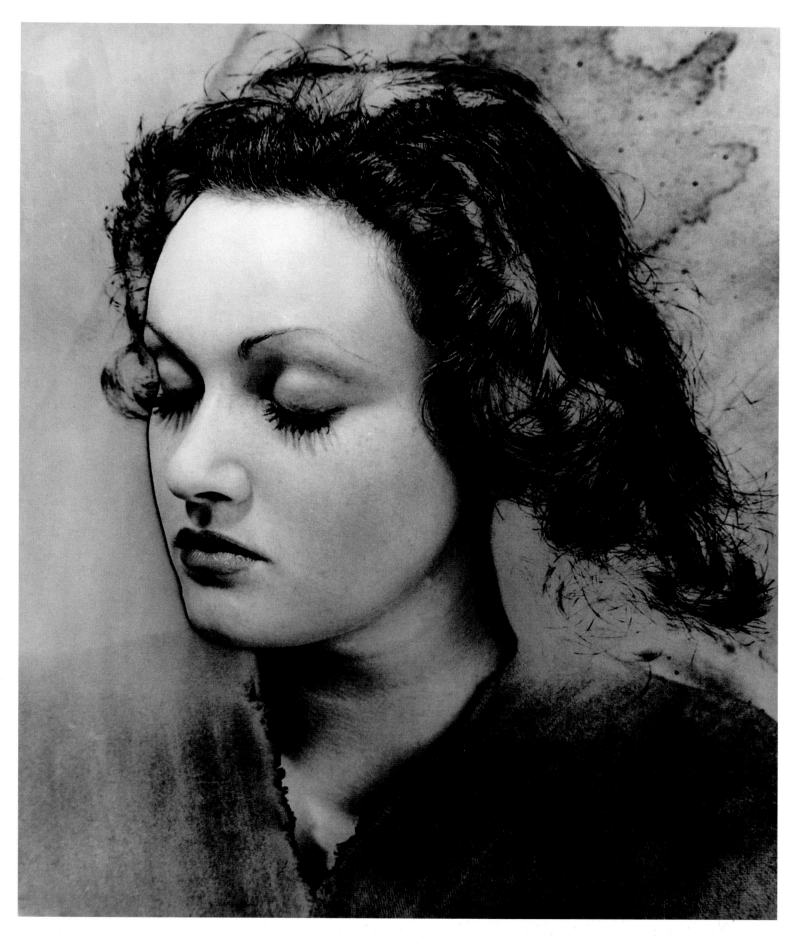

44 *Manina*, Paris, 1936

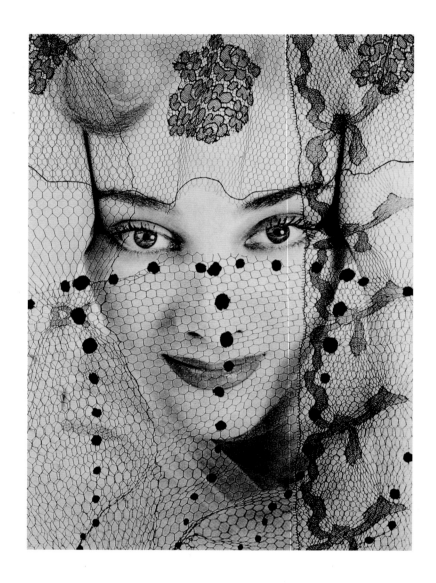

45 'Voilettes de Montezin', *Le Point de vue de Vogue*, French *Vogue*, Paris, February, 1939

46 *View from the Tower of Rouen Cathedral*, 1938

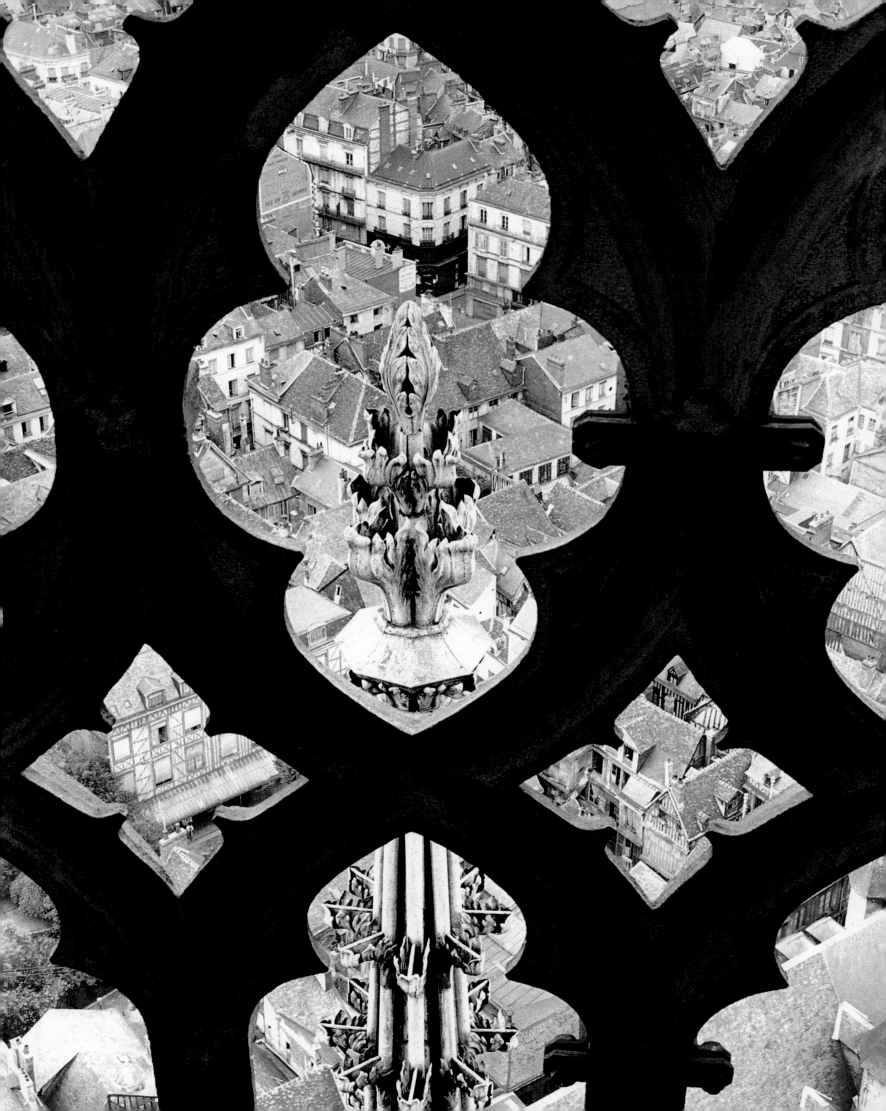

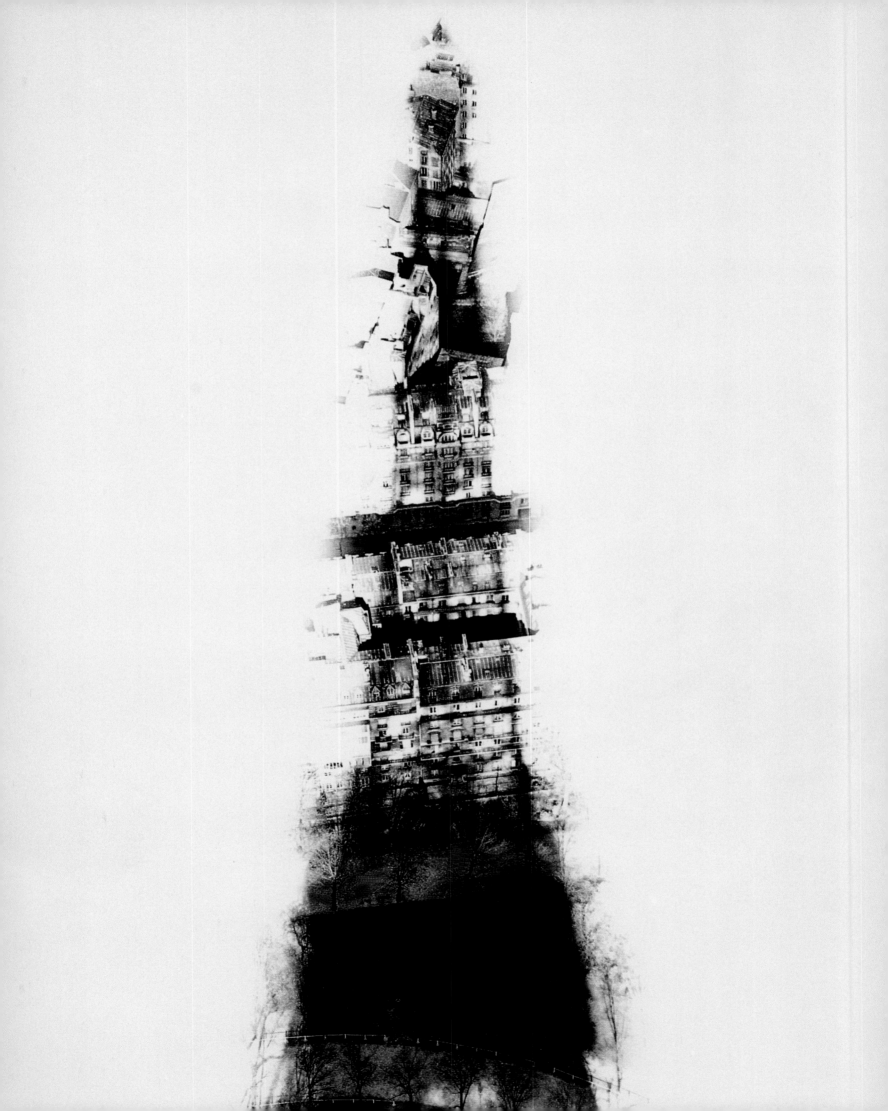

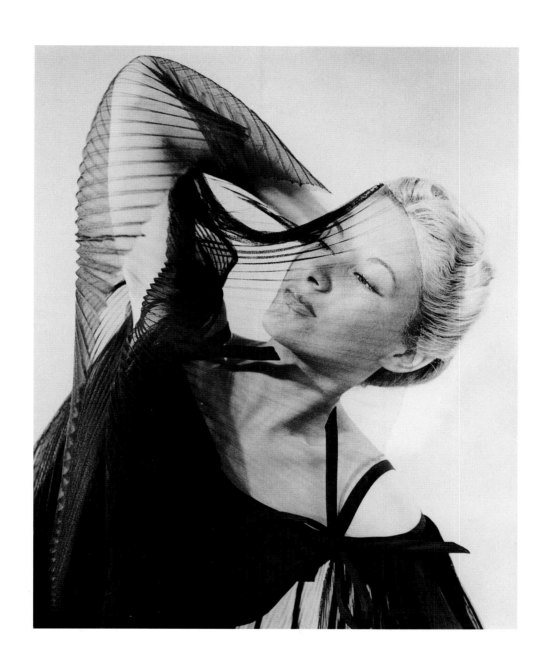

47 *Shadow of the Eiffel Tower, c.* 1938

48 Untitled fashion photograph, Paris, *c.* 1939

49 'Portfolio de Vogue: La Tour Eiffel':
'A white straw boater decorated with a bird, its wings outstretched.
By Rose Valois.' French *Vogue*, Paris, May 1939

50 Unpublished variant of an image from 'Portfolio de Vogue: La Tour Eiffel' in French *Vogue*, Paris, May 1939.
The published caption reads: 'Roomy dress in white surah with square motif painted in several colours.
By Lucien Lelong.' Model: Lisa Fonssagrives

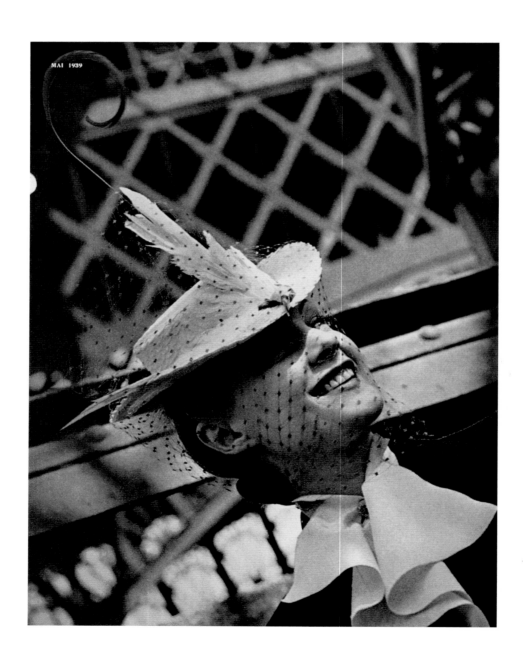

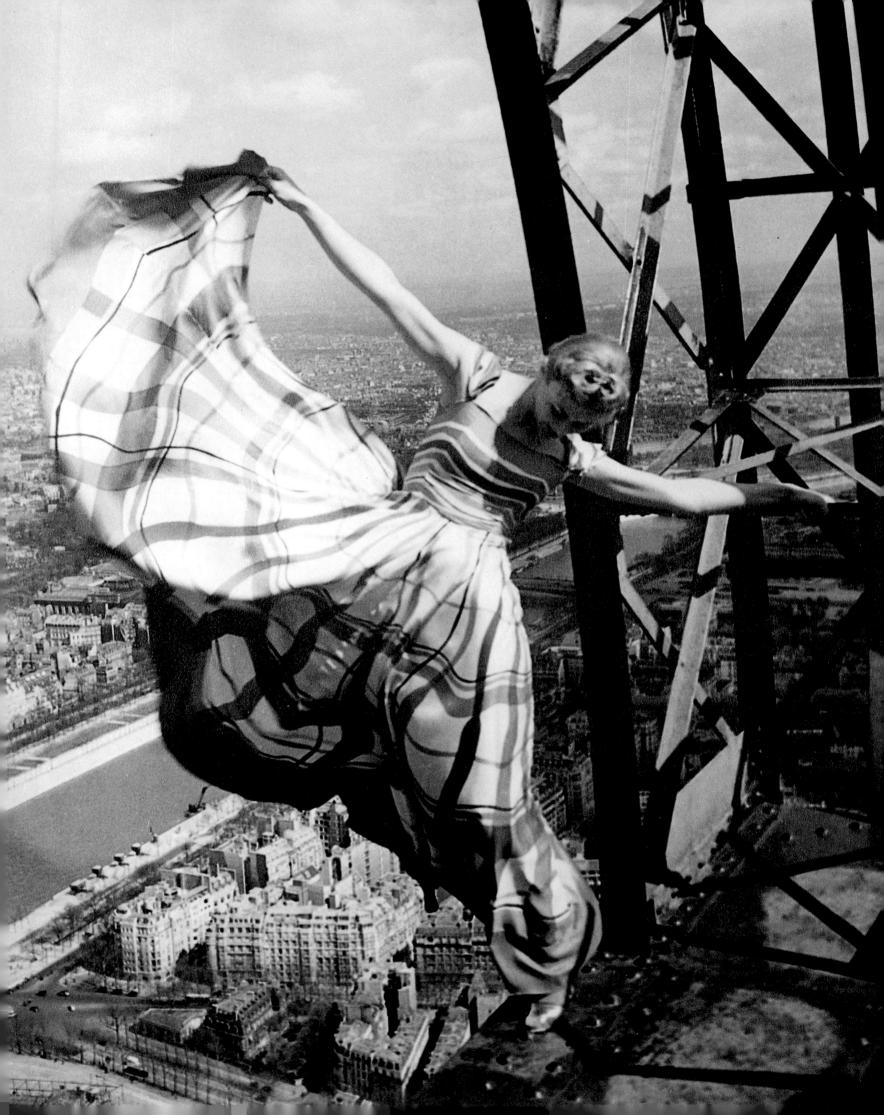

51 'Portfolio de Vogue: Materials.' French *Vogue*, Paris, February 1939.
Striped organdie by Chatillon Mouly Roussel

52 'Portfolio de Vogue: La Tour Eiffel':
'A high-necked dress in duchesse satin decorated with an appliqué of white bands. By Balenciaga.'
French *Vogue*, Paris, May 1939

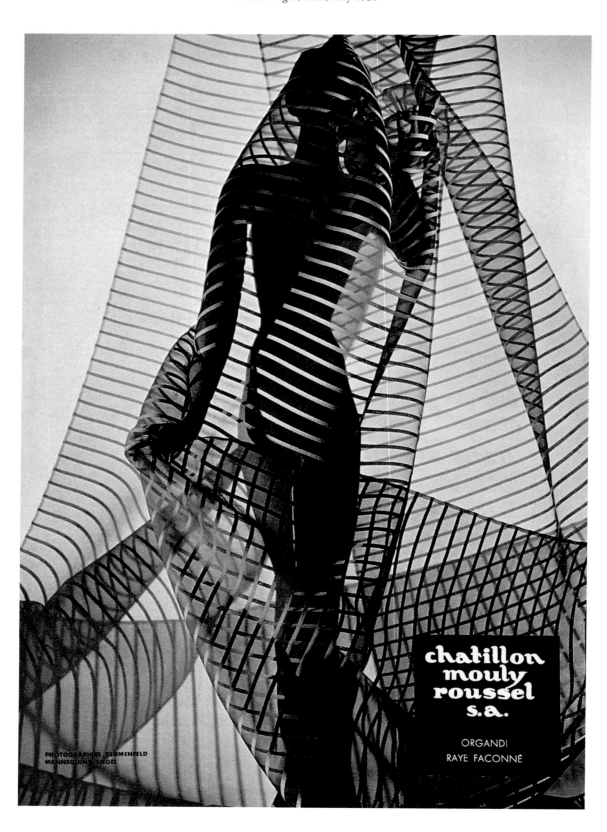

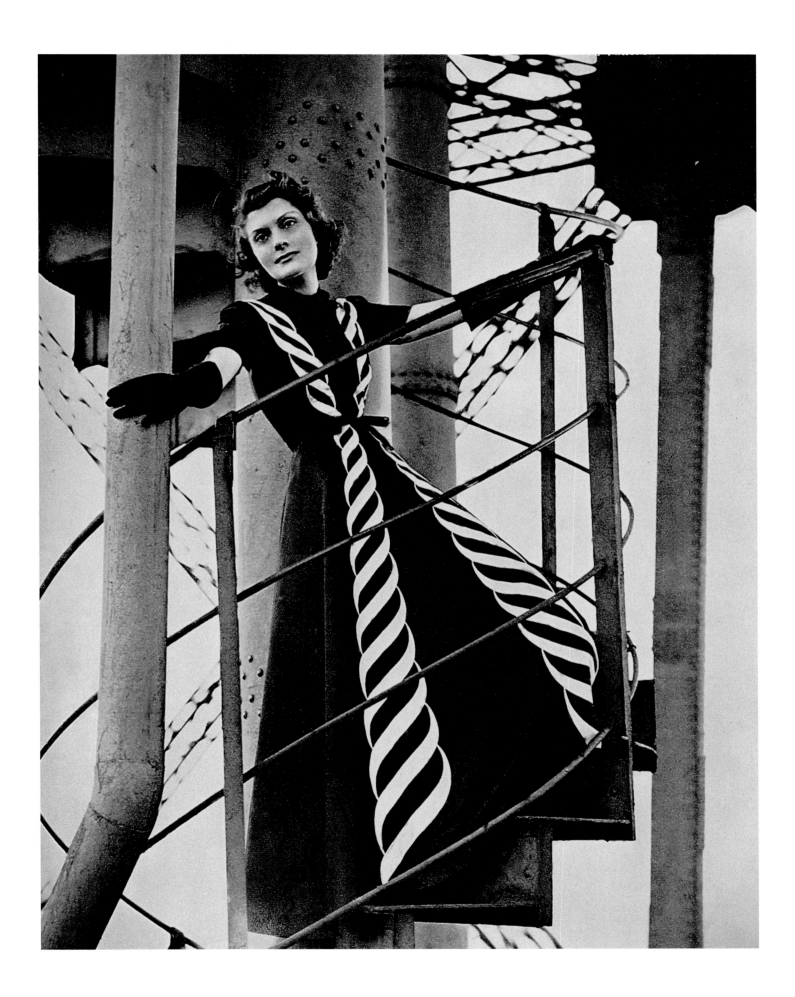

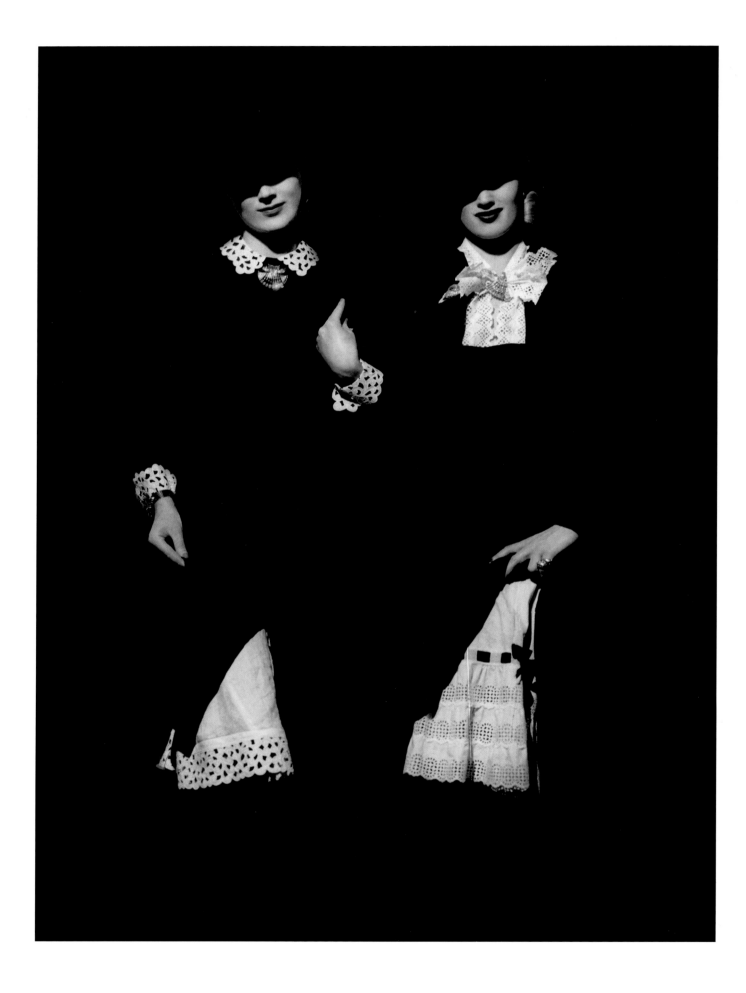

53 Fashions by Jean Patou (left) and Robert Piguet (right). French *Vogue*, Paris, October 1938

54 *Valeska Gert, Cabaret Performer*, Paris, *c.* 1938

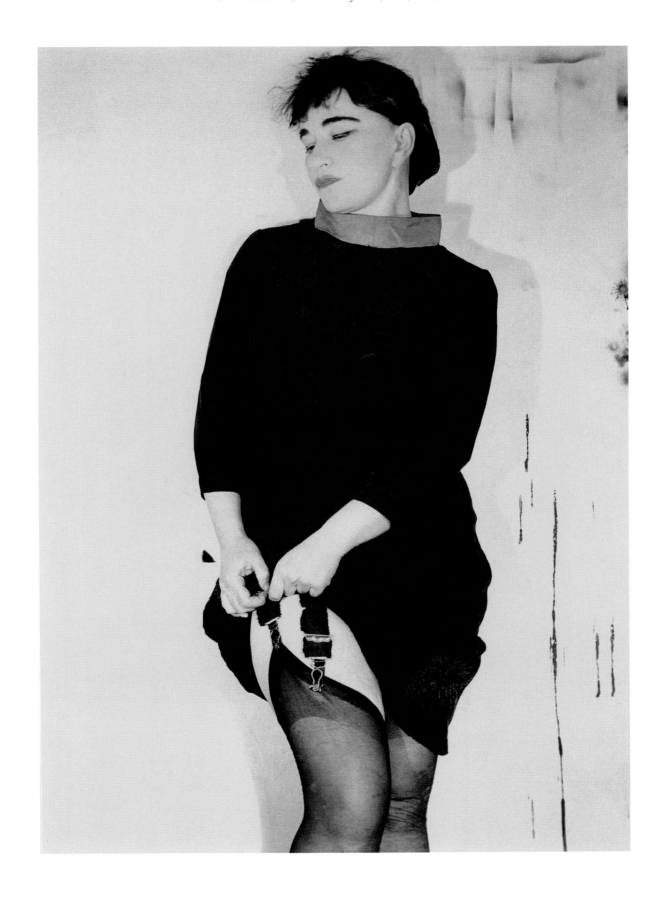

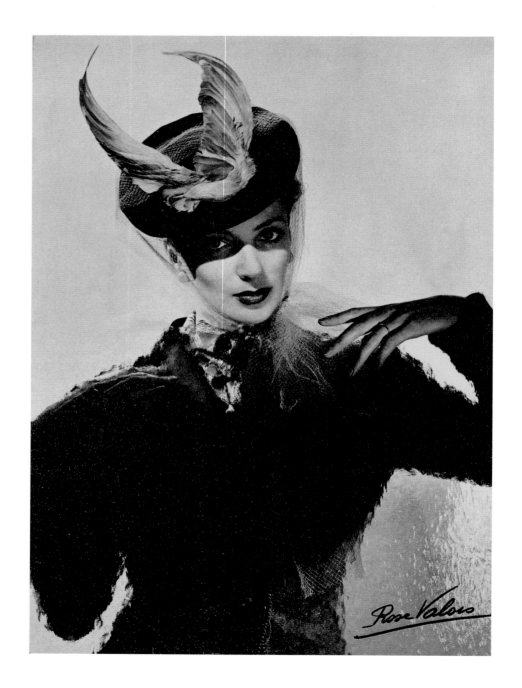

55 Fashion by Rose Valois, French *Vogue*, Paris, October 1938

56 Untitled fashion photograph, Paris, *c.* 1938

57 *Following pages* 'Poufs et Pirouettes.' French *Vogue*, Paris, November 1938.
Fashions (from top, clockwise):
Maggy Rouff, Marcelle Dormoy, Vera Borea, Bruyère

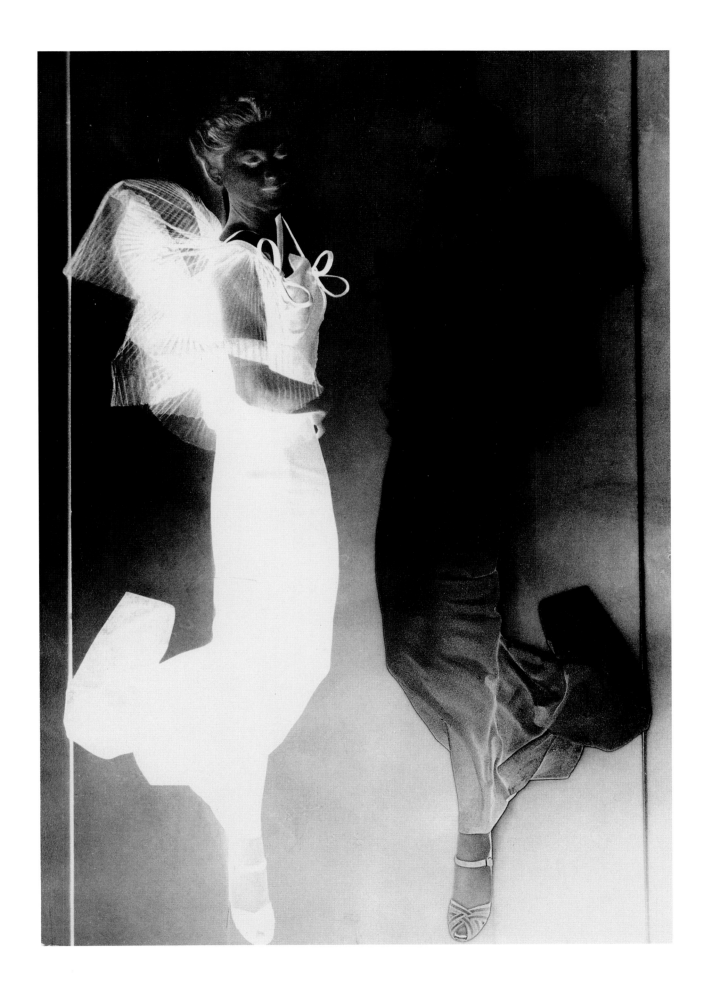

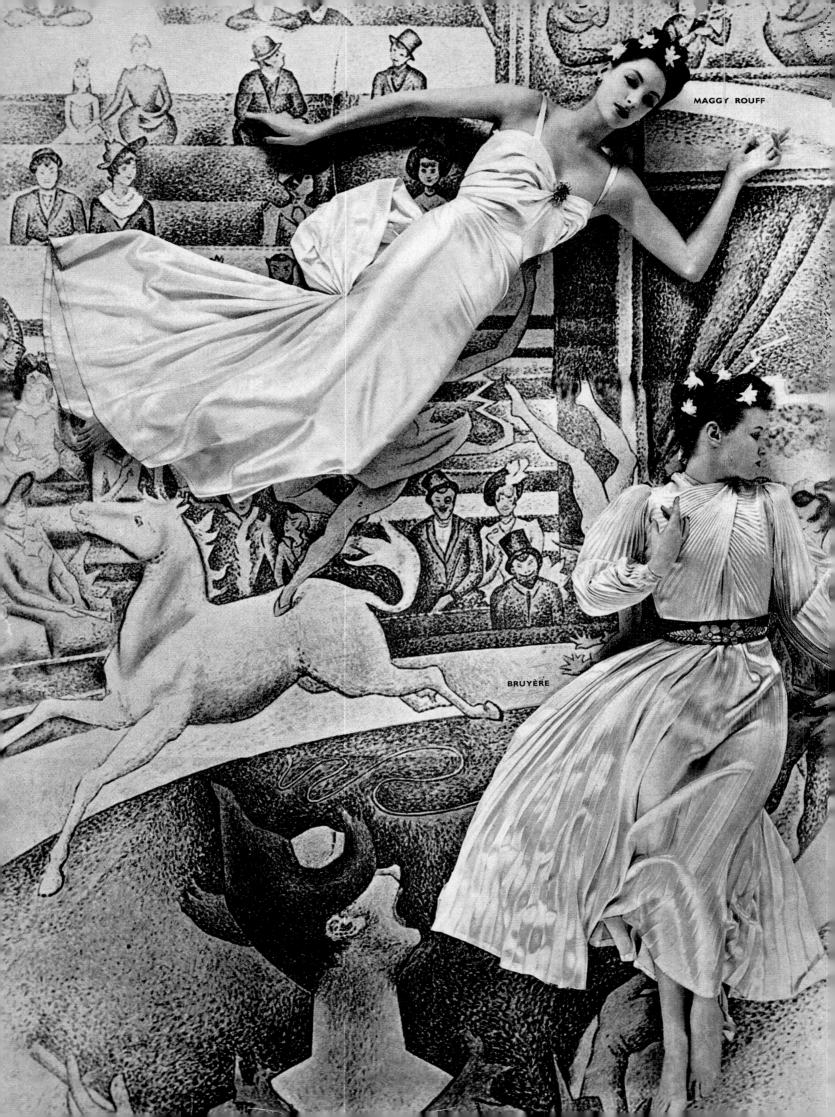

MAGGY ROUFF

BRUYÈRE

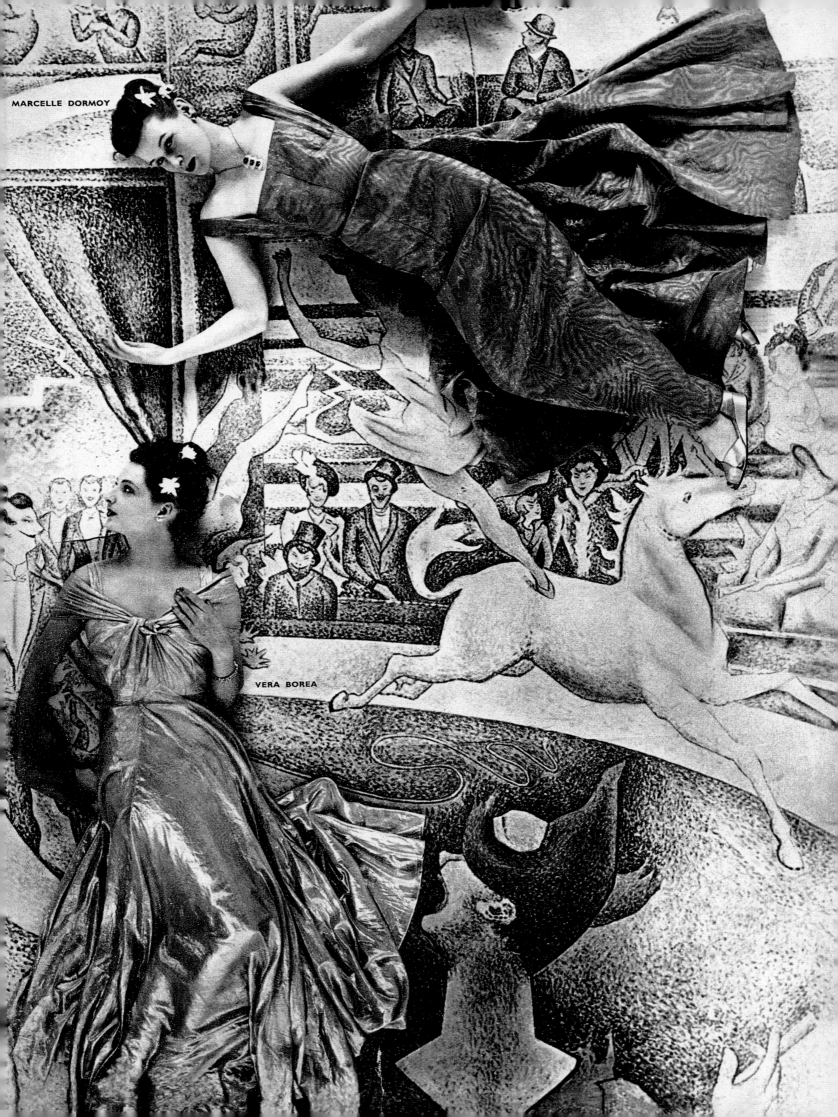

MARCELLE DORMOY

VERA BOREA

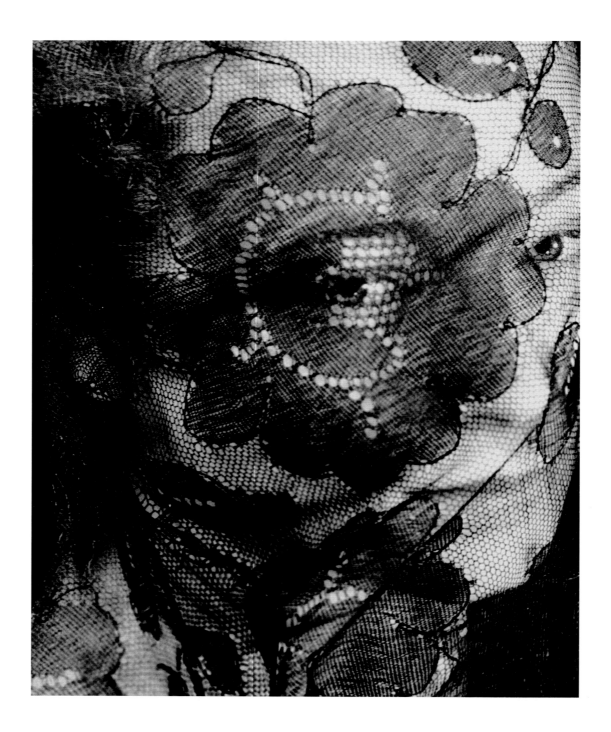

58 *The Spanish Veil*, Paris, 1937

59 Bicornes by Schiaparelli. Unpublished image for French *Vogue*, Paris, October 1938.
Models: Muth (left) and Lyla Zelensky (right)

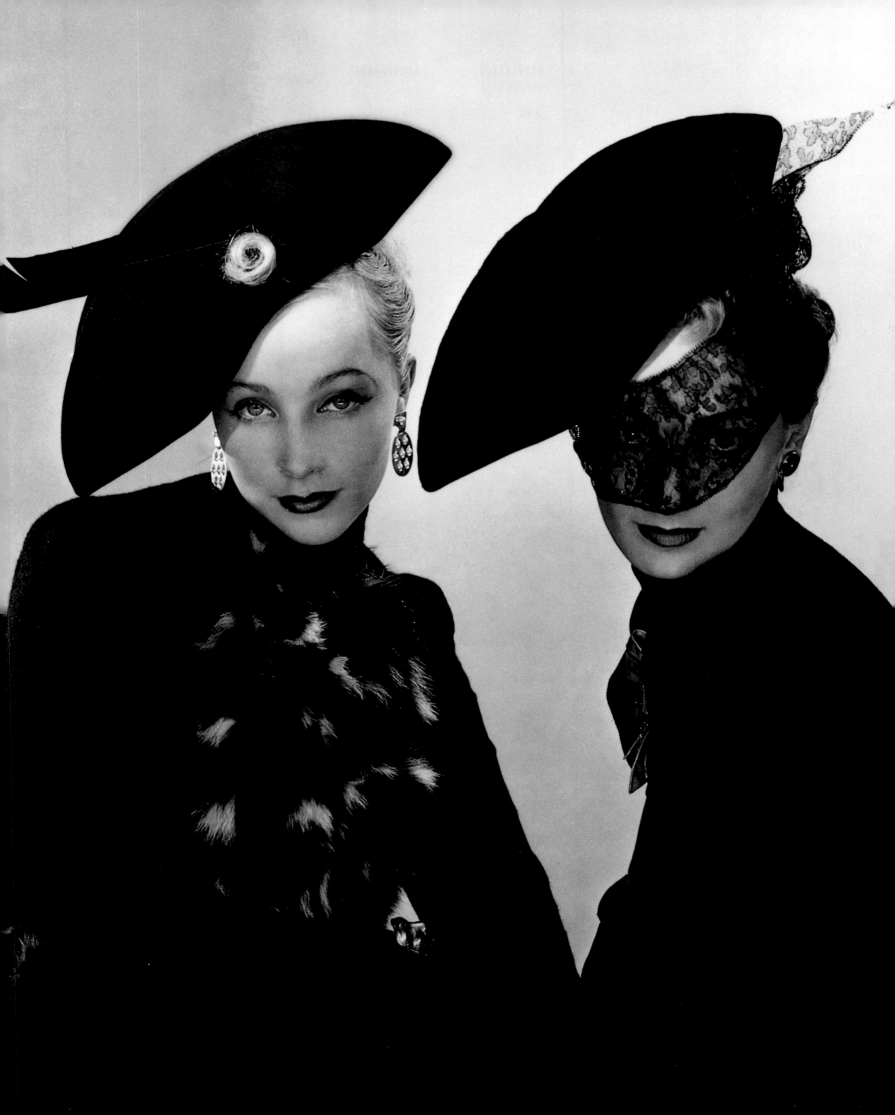

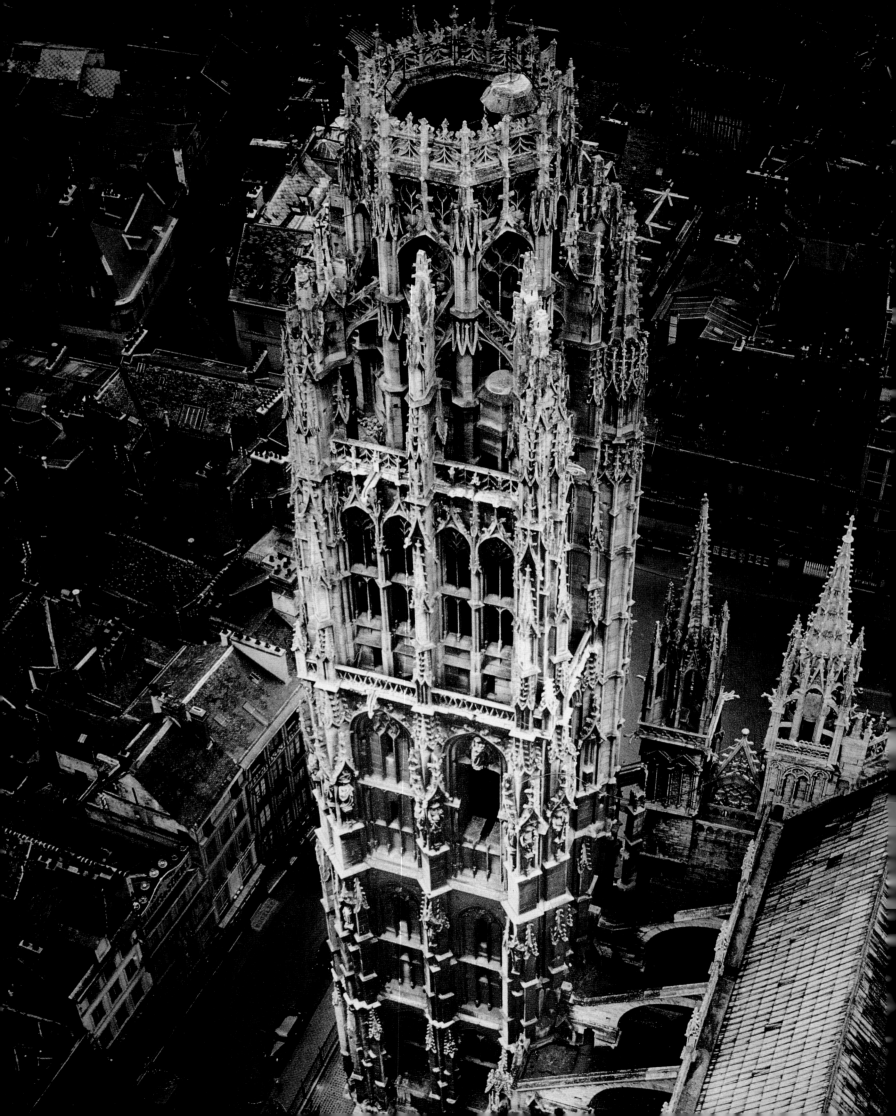

60 *Rouen Cathedral*, 1938

61 *Nude under Wet Silk*, Paris, *c.* 1937

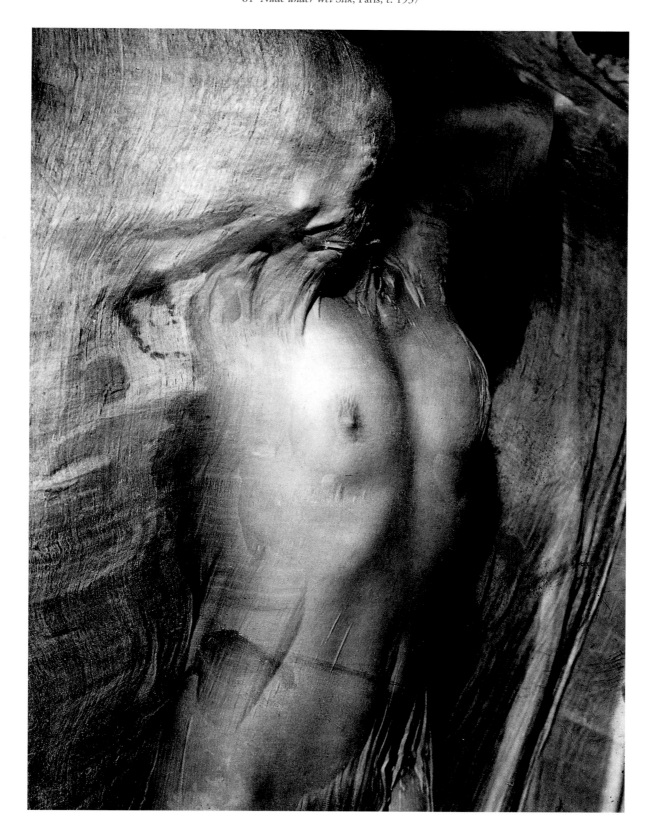

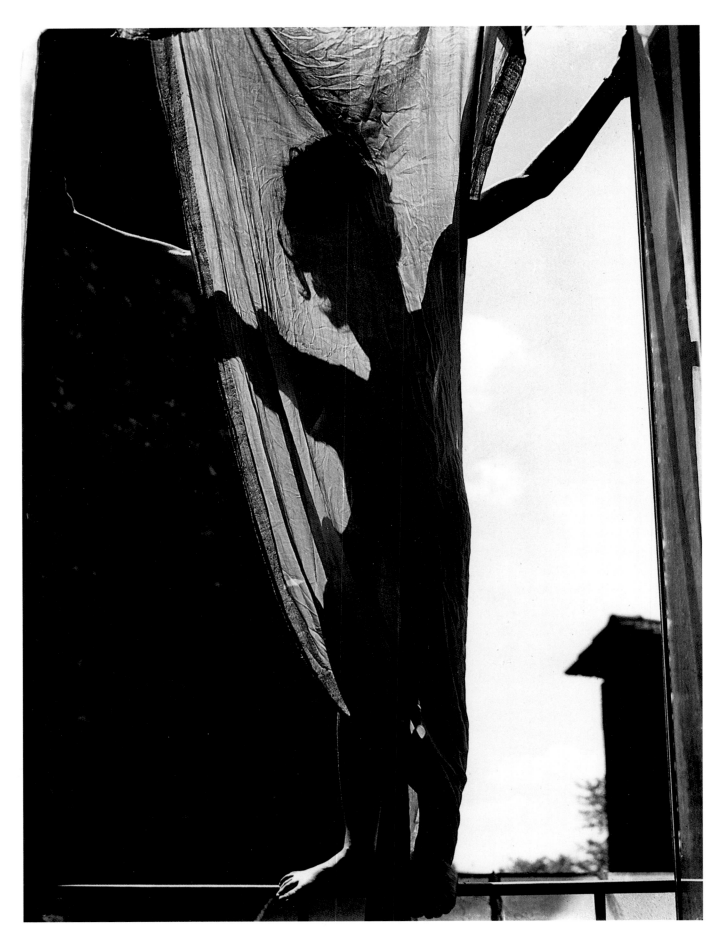

62 Untitled nude, Paris, *c.* 1937

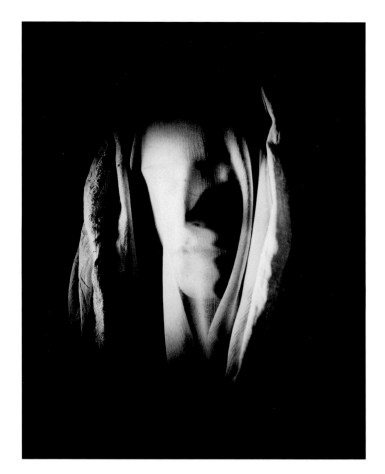

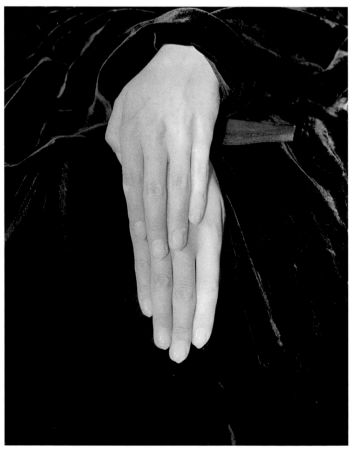

63, 64 Untitled, Paris, *c.* 1937

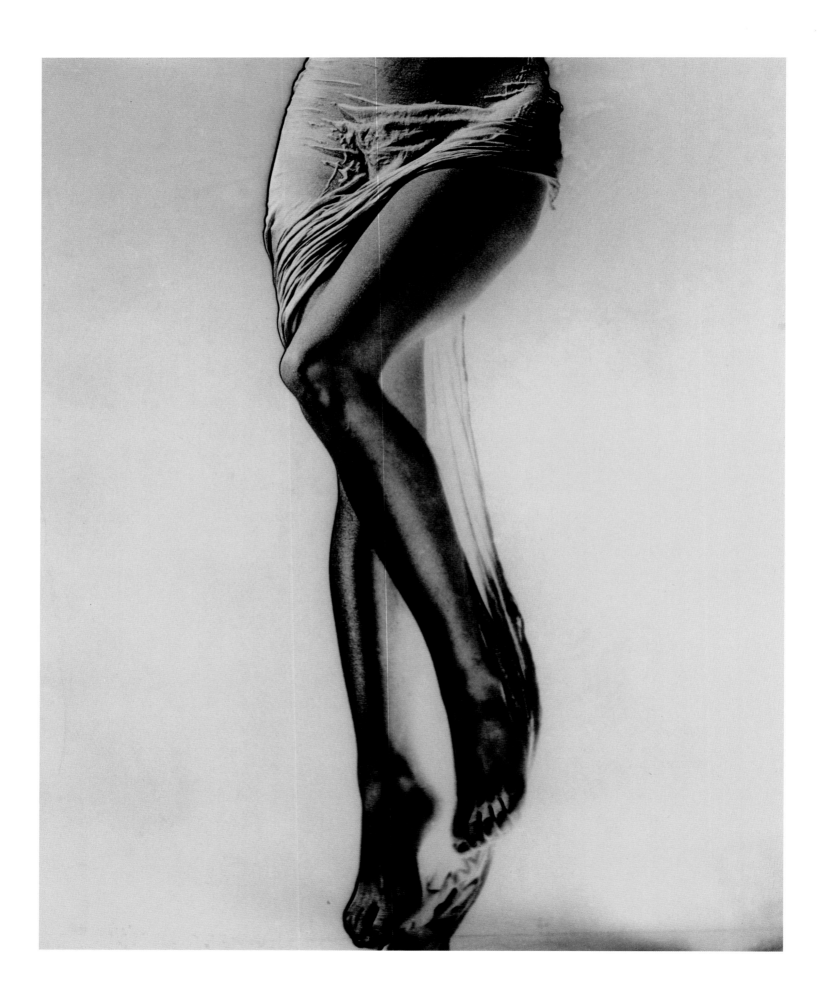

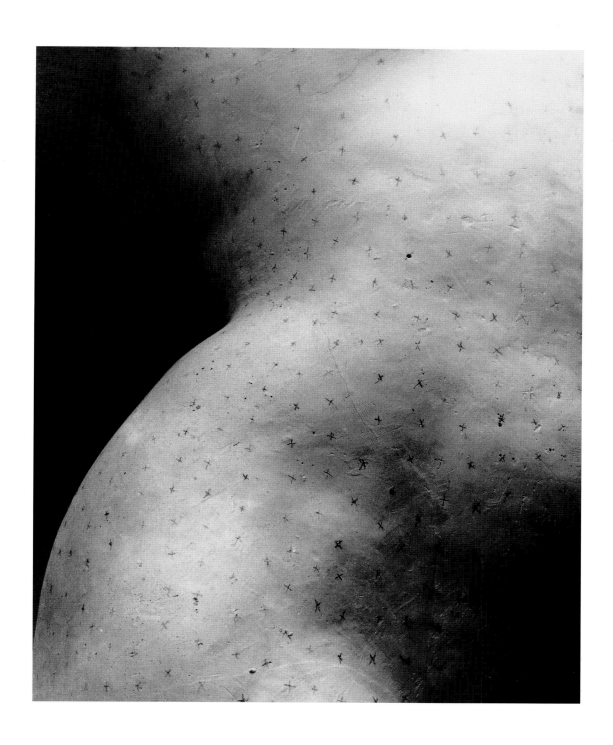

65 Untitled nude, Paris, *c.* 1937

66 Aristide Maillol sculpture, photographed for *Verve*, Paris, 1937

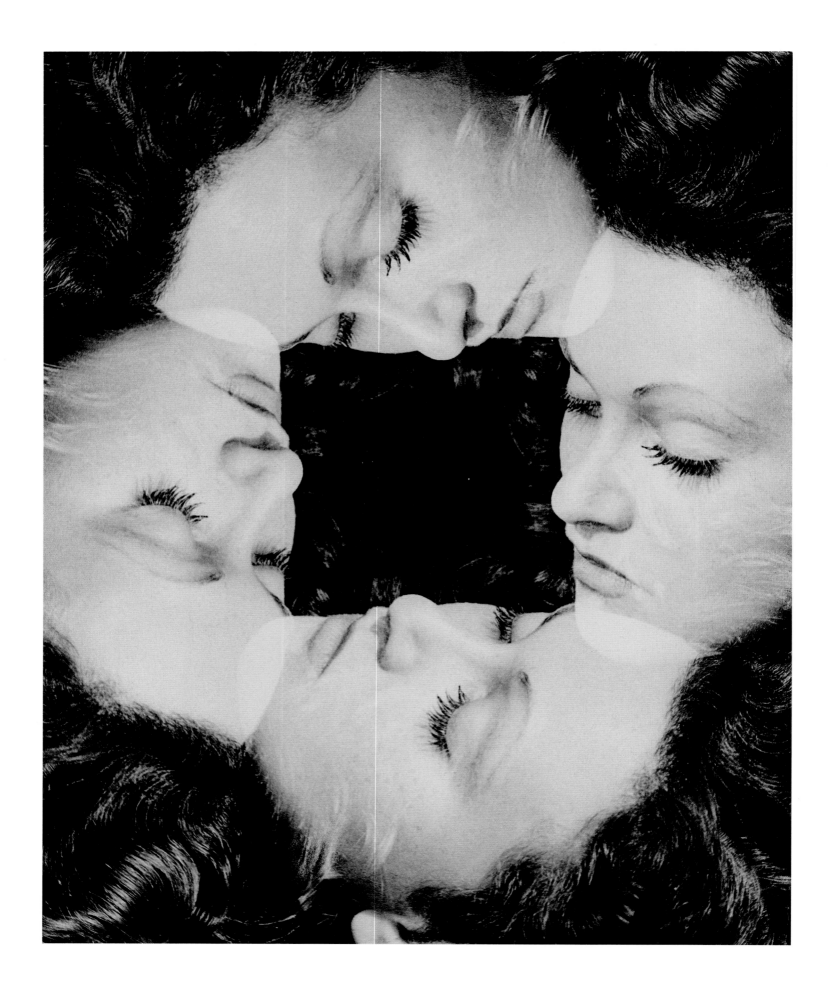

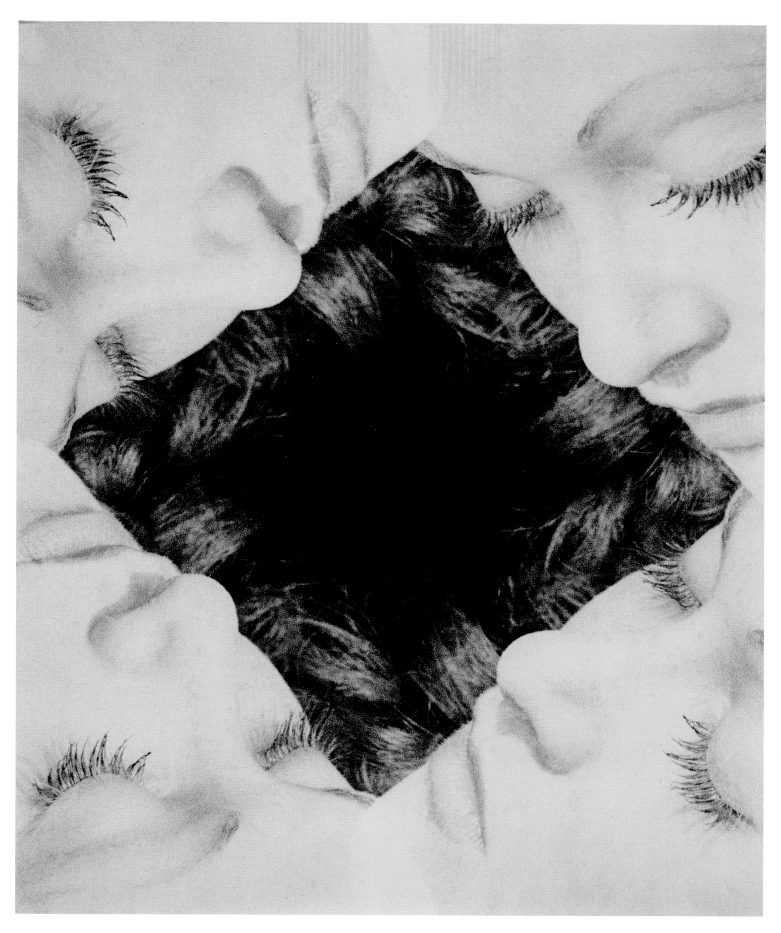

67, 68 *Buds*, Paris, *c.* 1937

69 *Rouen Cathedral*, 1938

70 *Meudon, France,* 1938

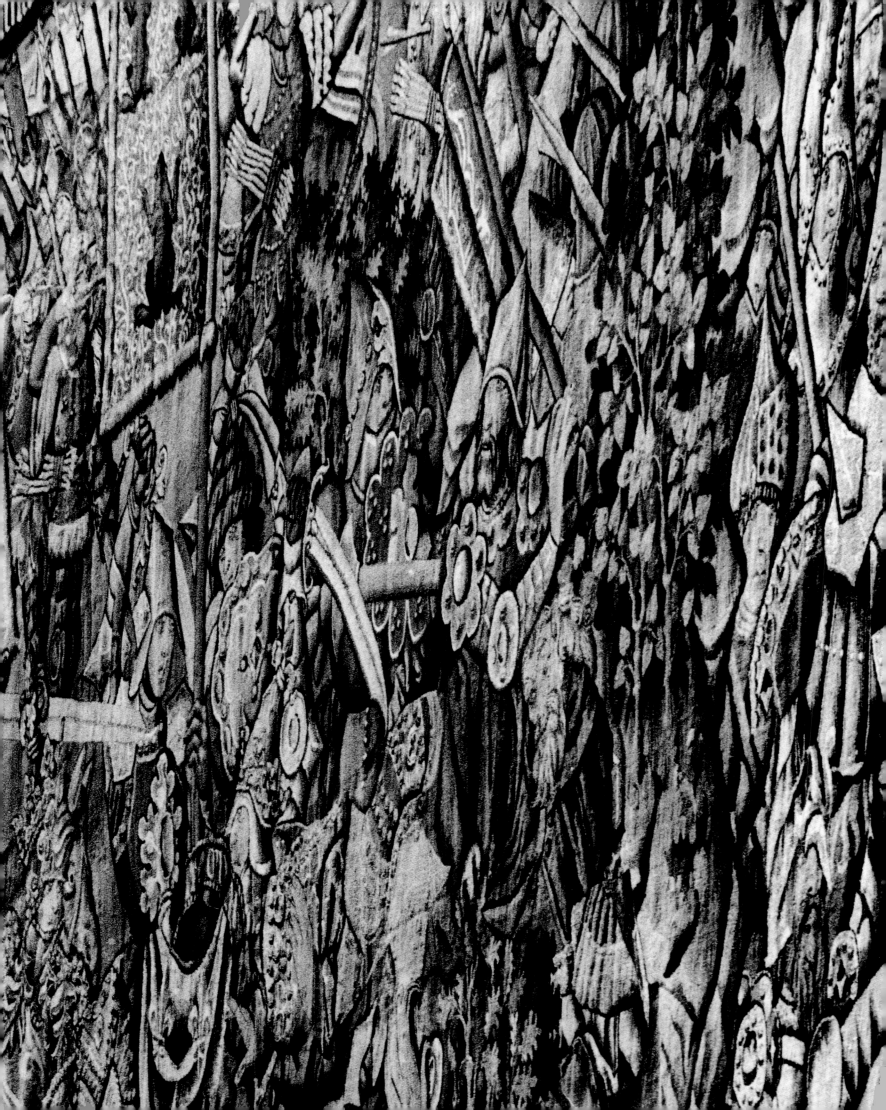

71 *La Bal des Sauvages*, Saumur, France, 1938

72 *Nude in the Mirror*, Paris, 1938

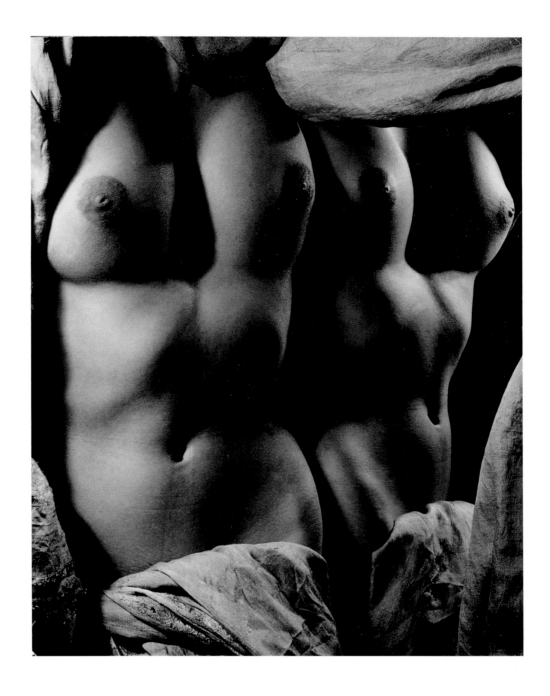

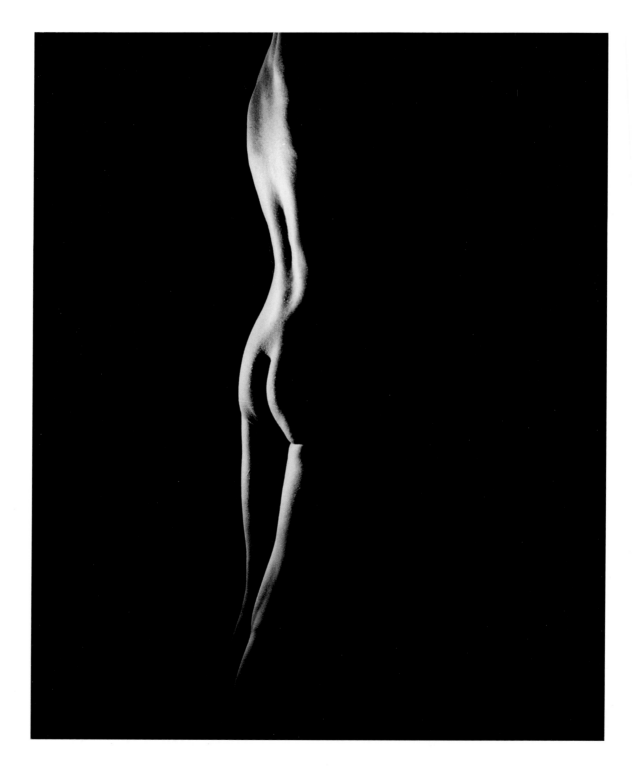

73 Untitled nude, Paris, *c.* 1937

74 *Interior of Rouen Cathedral*, 1938

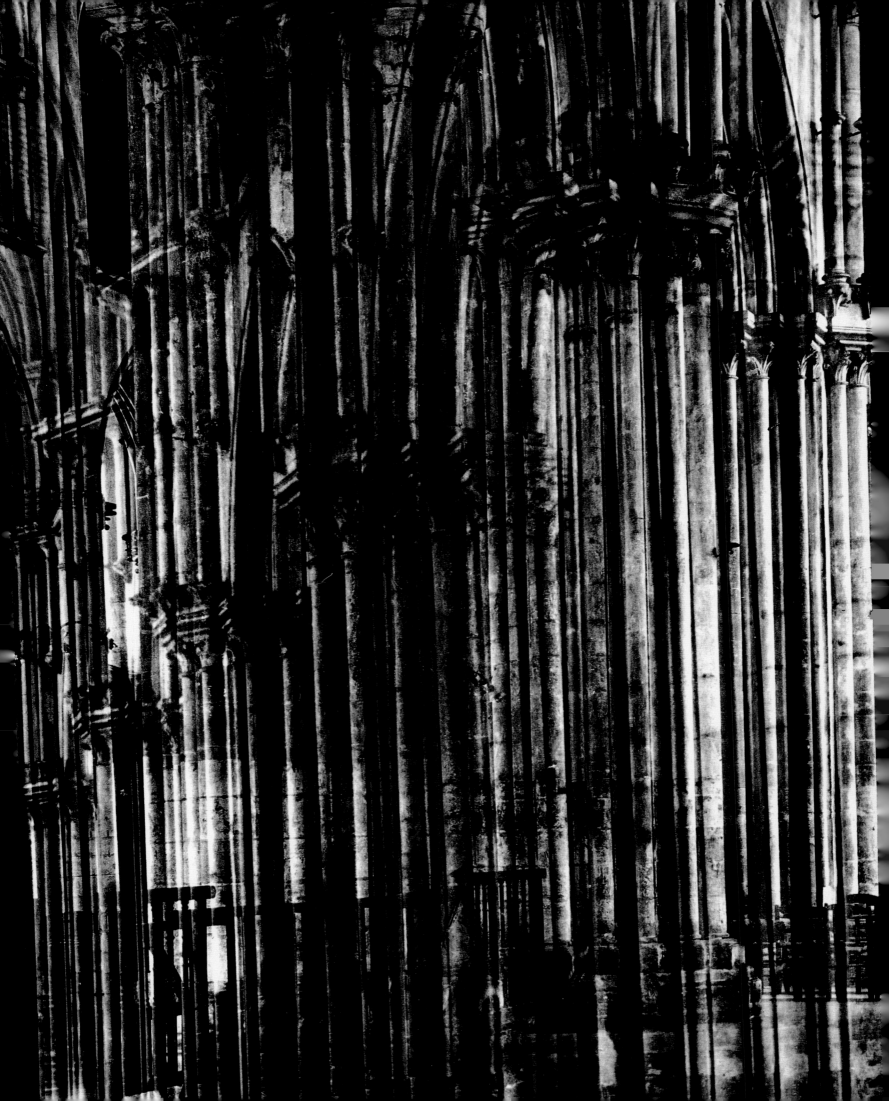

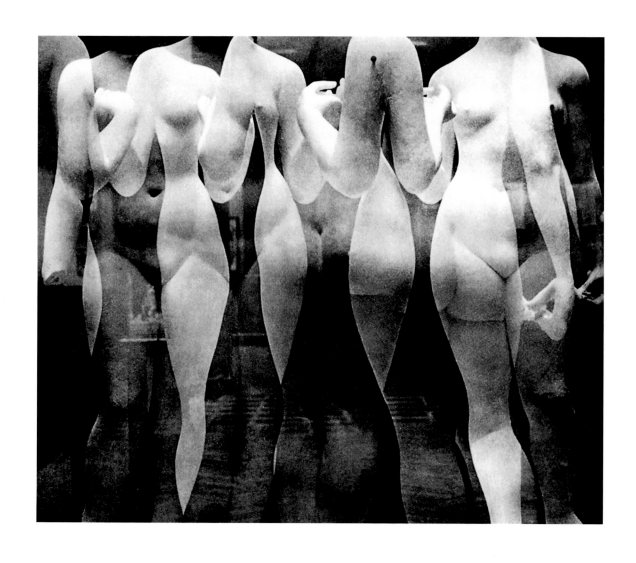

75 Aristide Maillol's *The Three Graces*, photographed for *Verve*, Paris, 1937

76 *Carmen, the Model for Rodin's* The Kiss, Paris, *c.* 1937

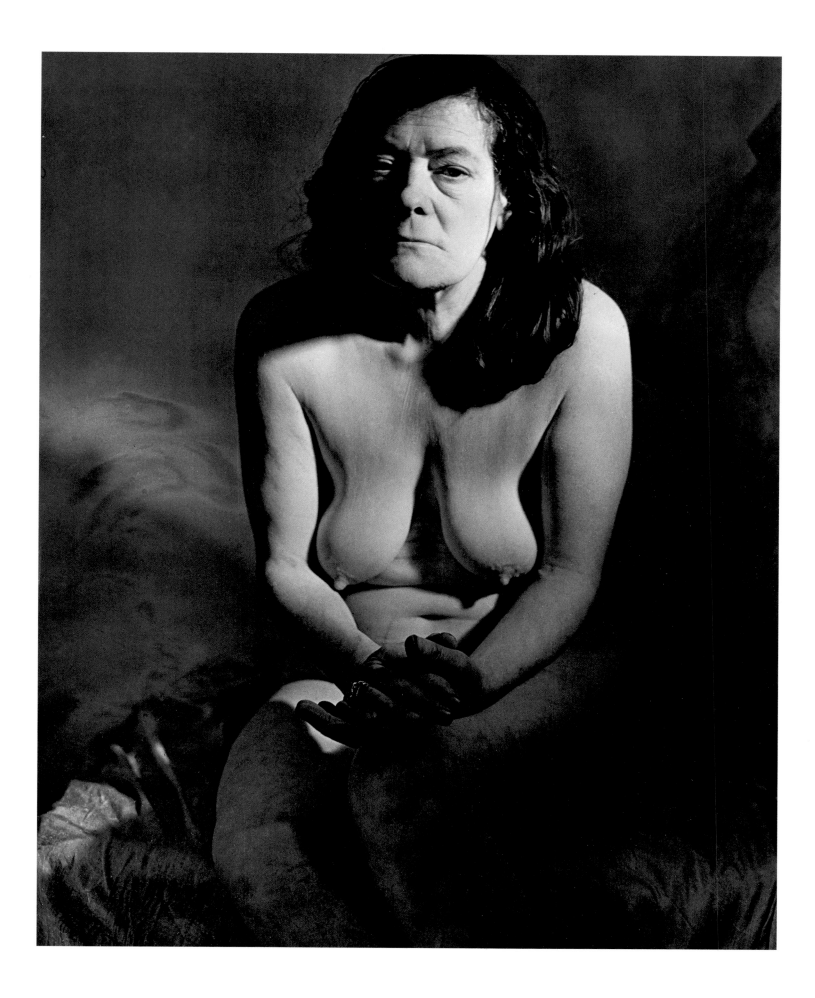

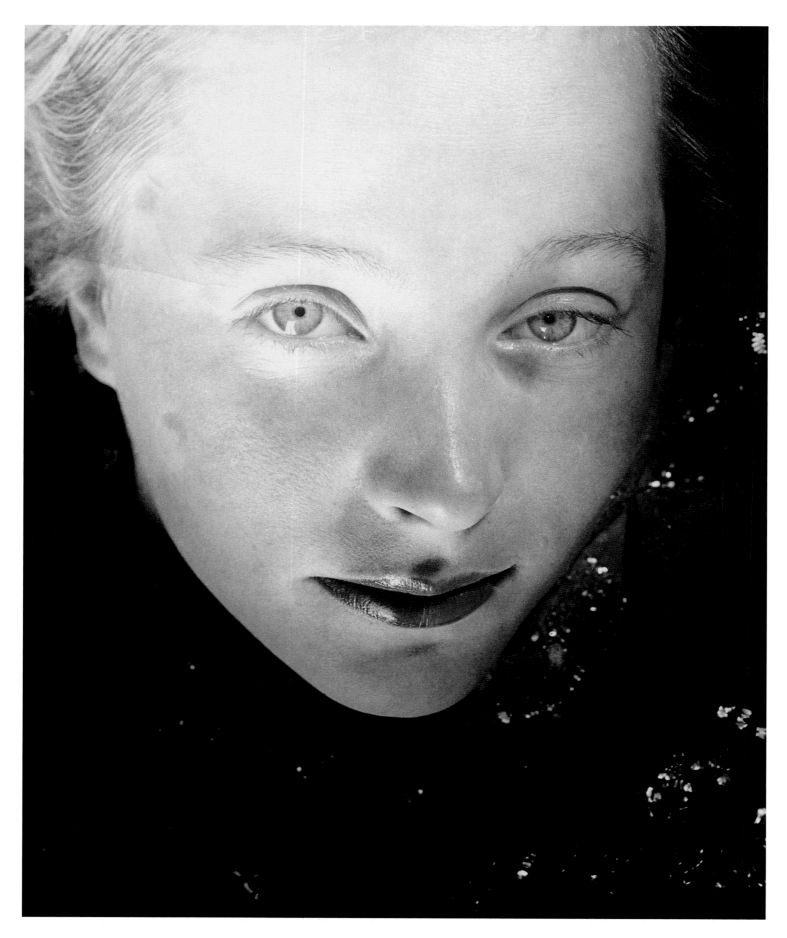

77 *Muth* (Blumenfeld's favourite model), Paris, *c.* 1938

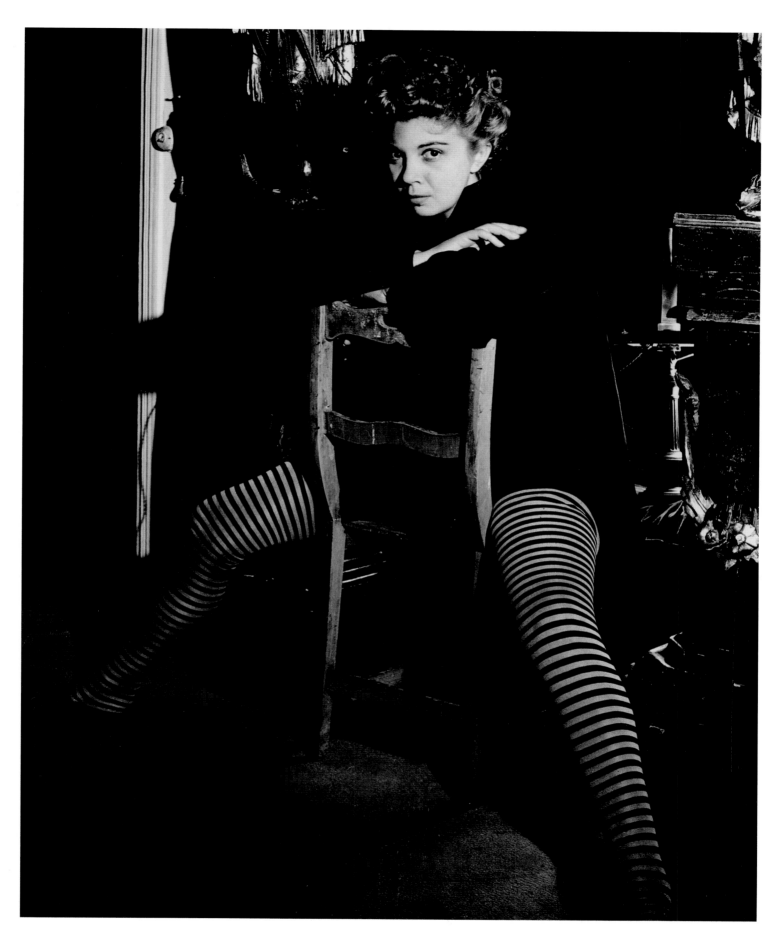

78 *Léonor Fini*, Paris, *c.* 1938

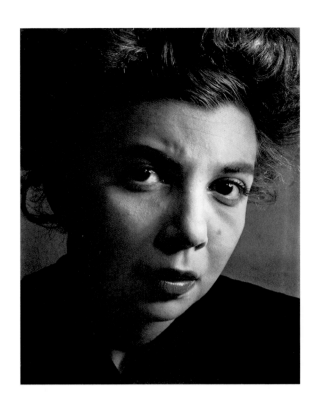

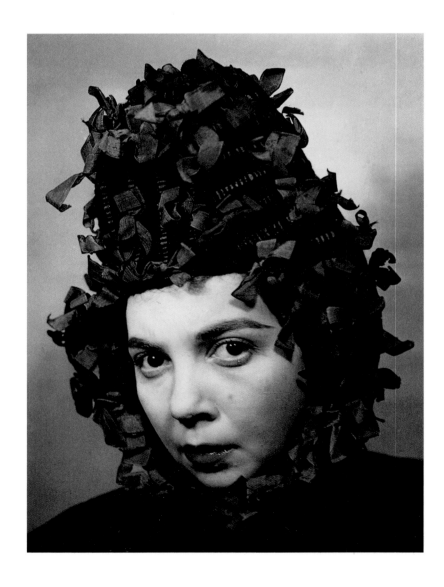

79, 80, 81 *Léonor Fini*, Paris, *c.* 1938

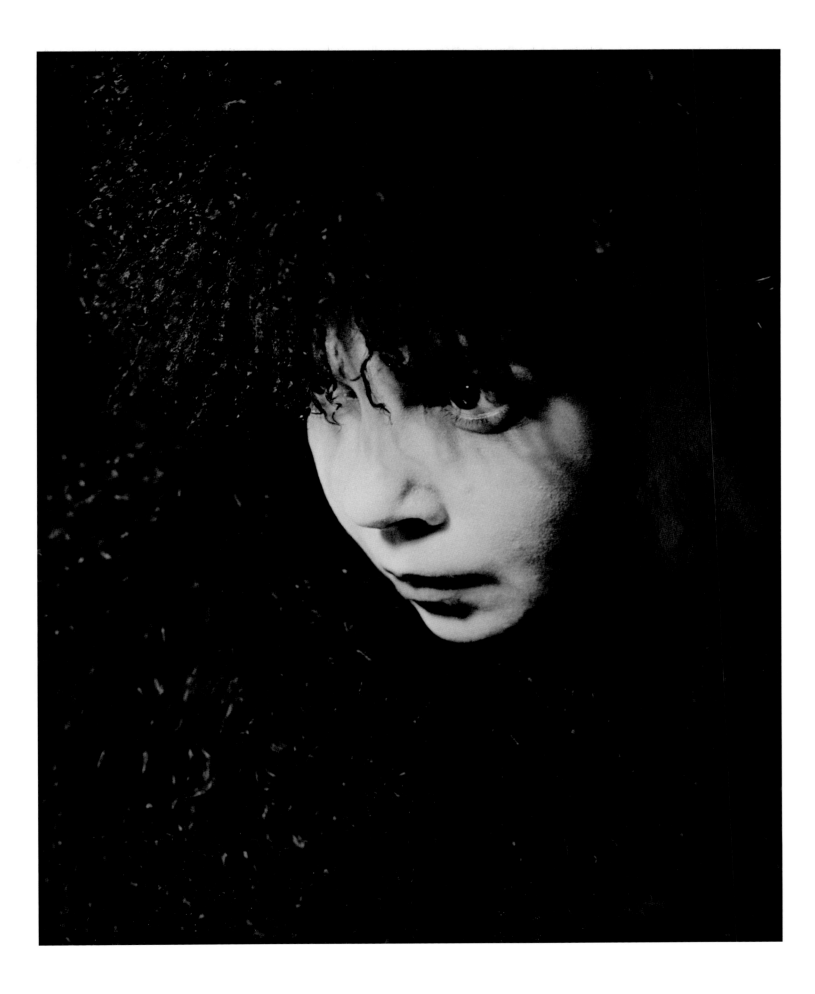

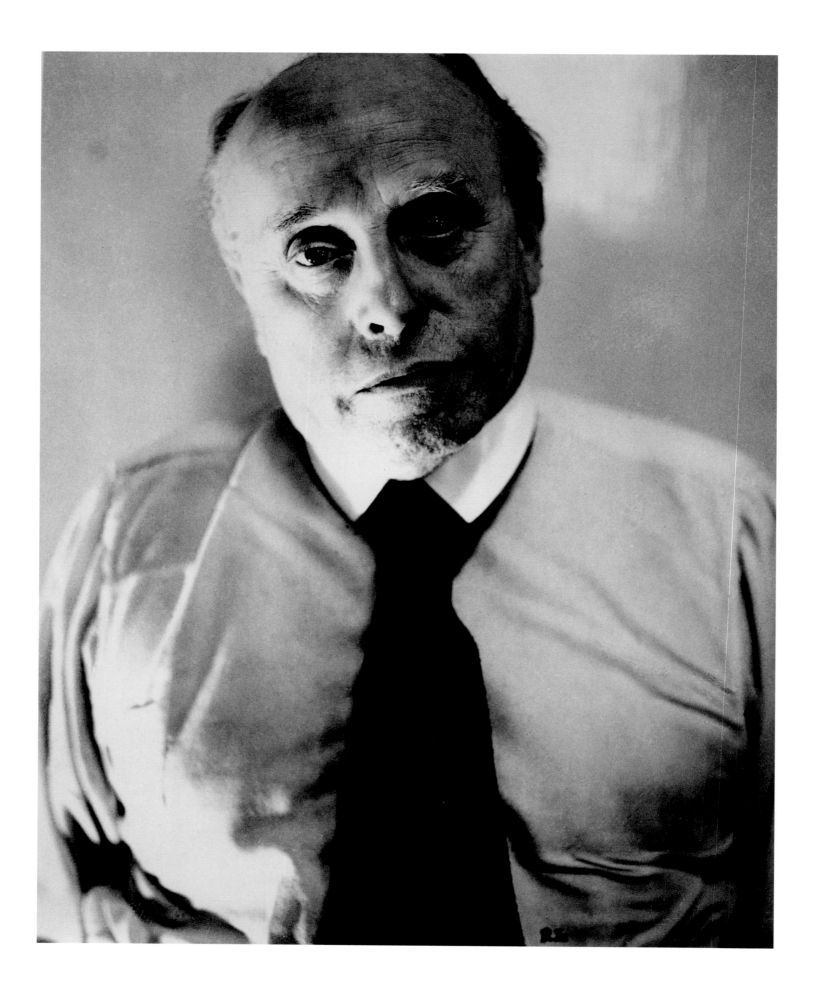

82, 83, 84 *Georges Rouault*, Paris, 1936

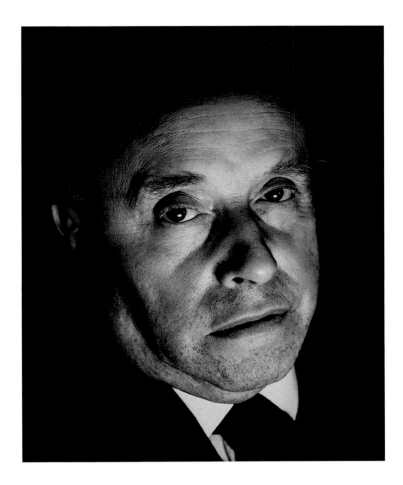

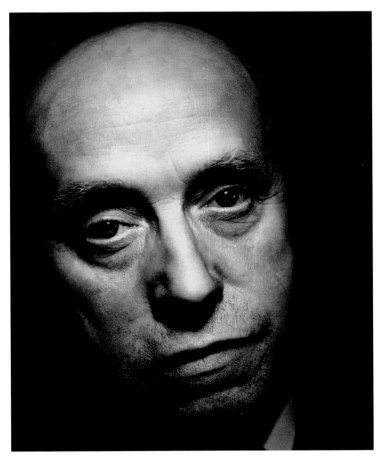

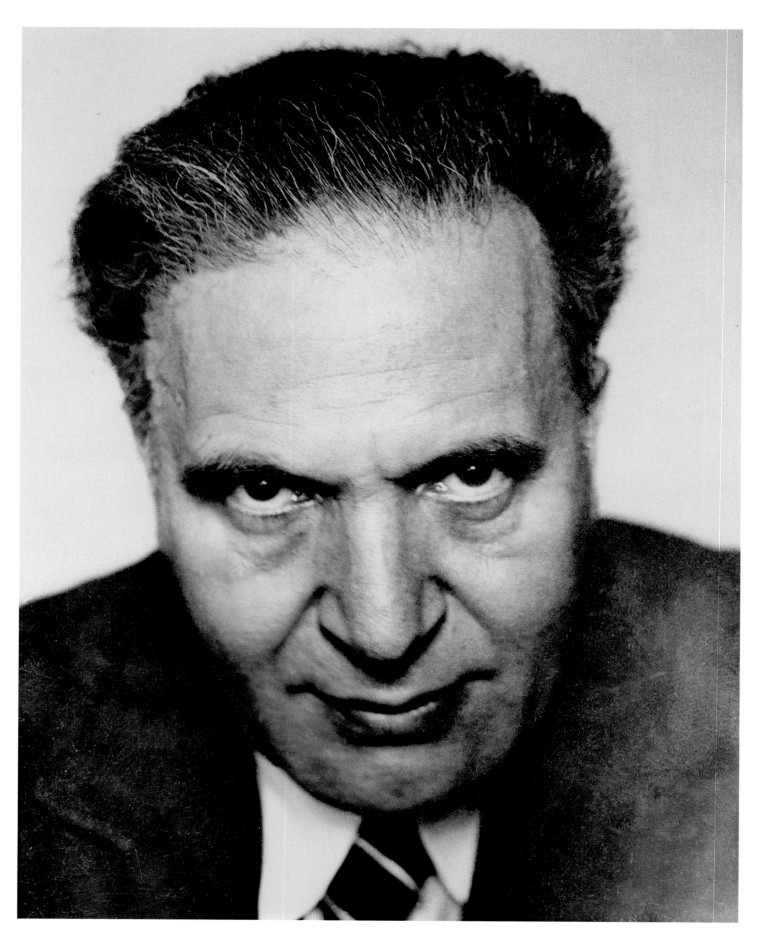

85 *Bruno Walter*, Paris (possibly Amsterdam), *c.* 1936

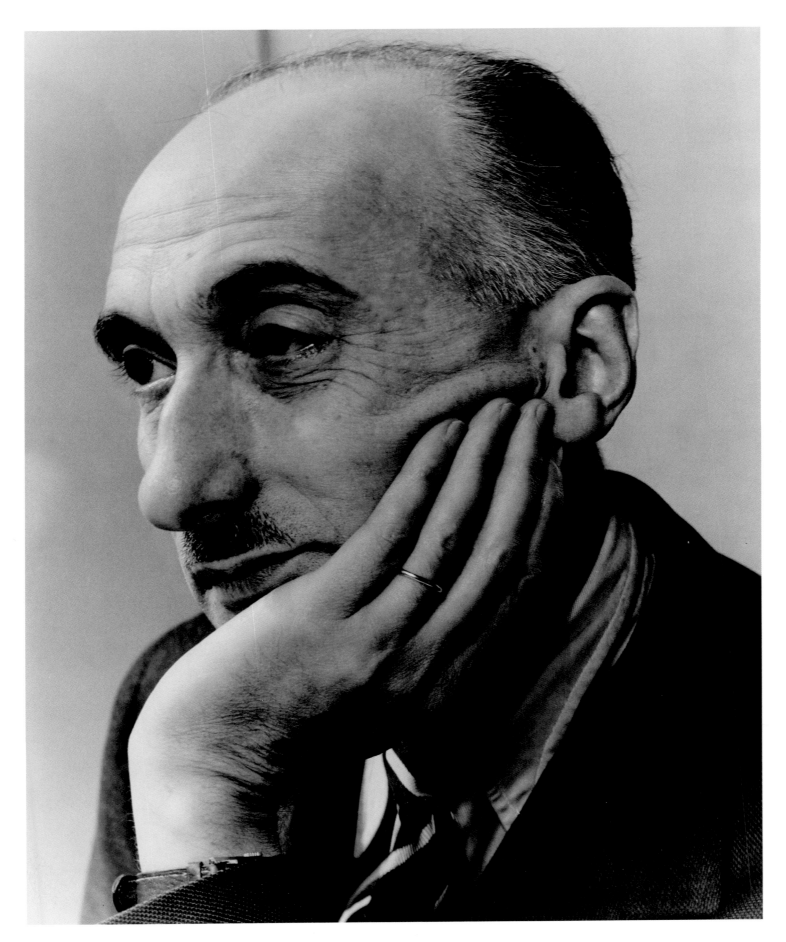

86 *François Mauriac*, Paris, *c.* 1937

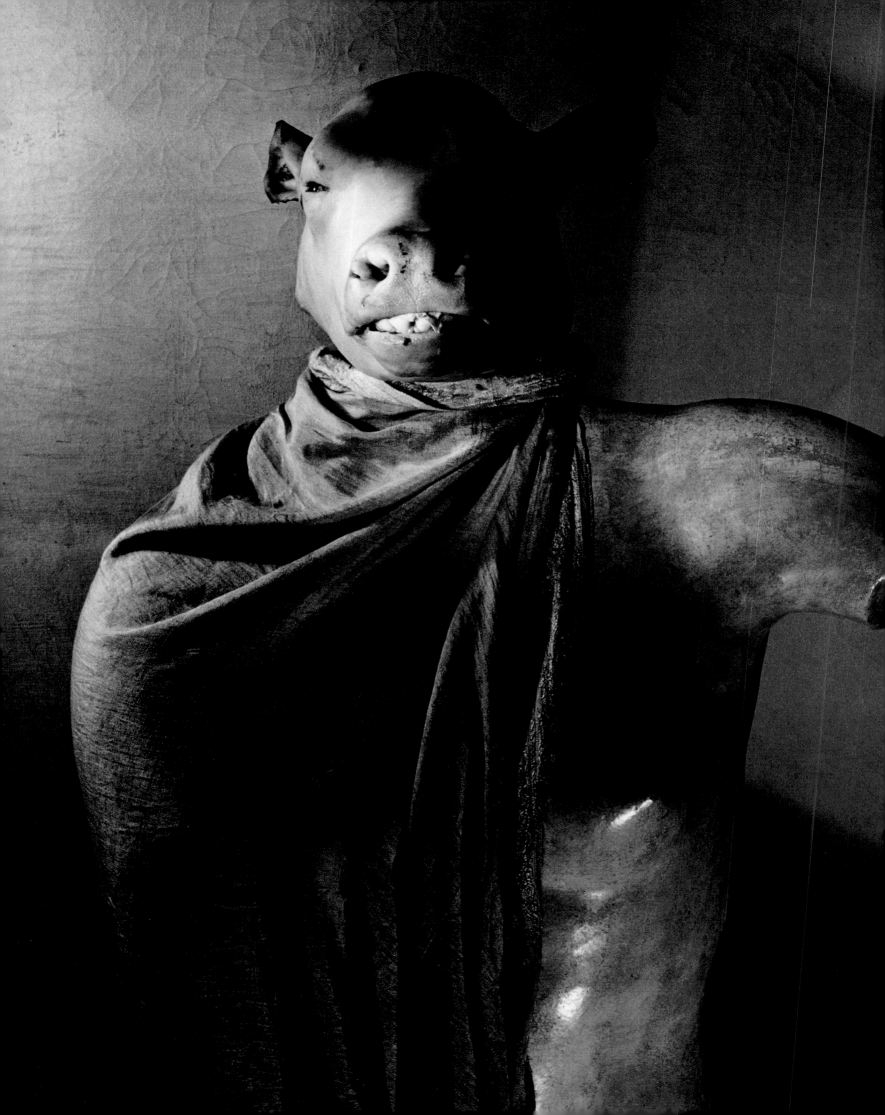

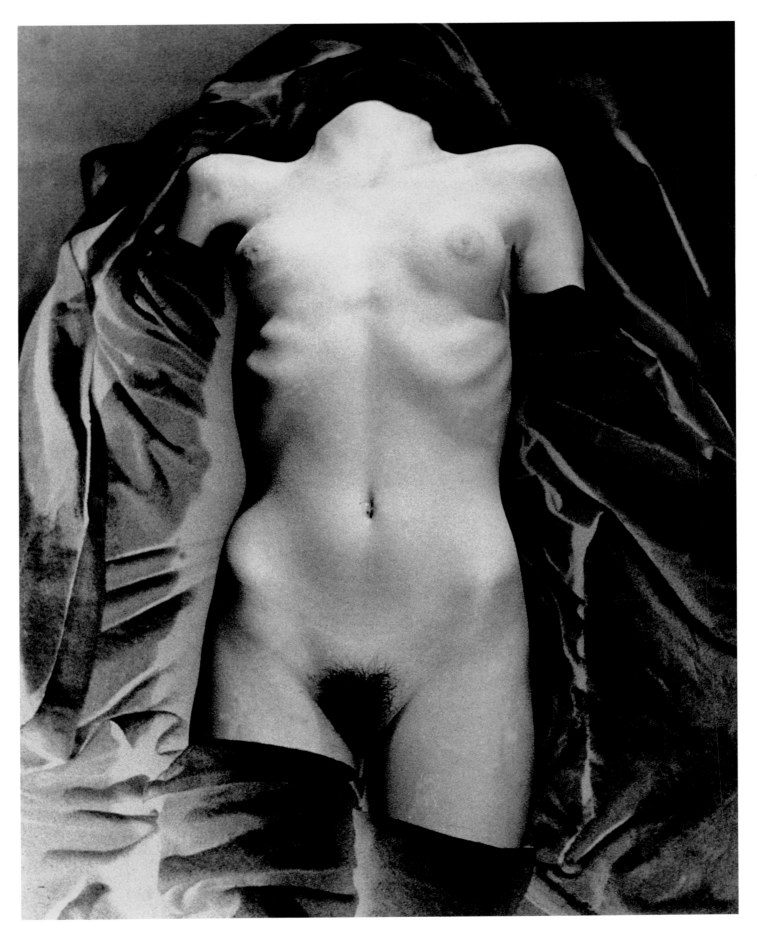

87 *The Dictator*, Paris, *c.* 1936

88 Untitled nude, Paris, *c.* 1936

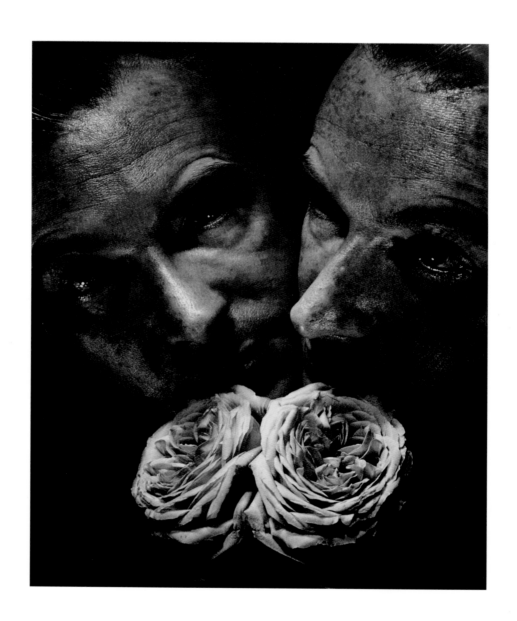

89 *Cecil Beaton*, Paris, *c.* 1938

90 *Marlene Dietrich*, New York, 1954 (Original print retouched for half-tone reproduction)

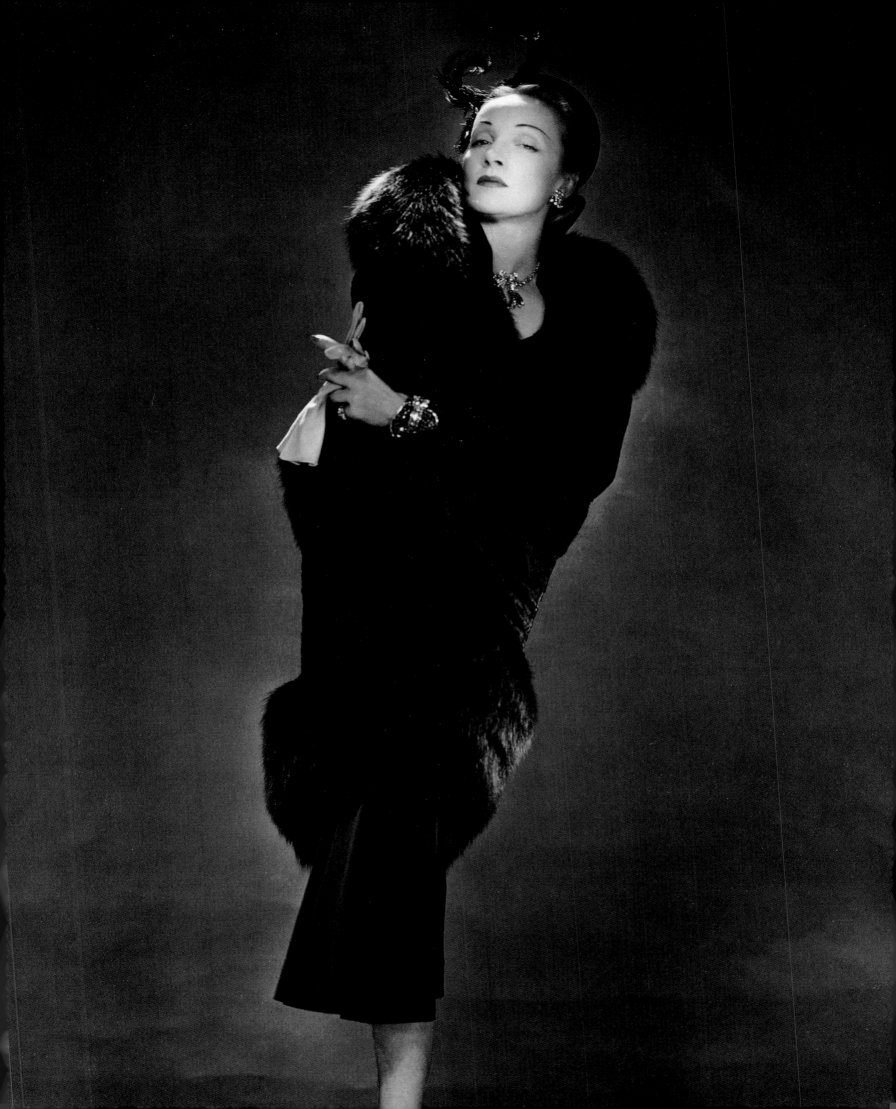

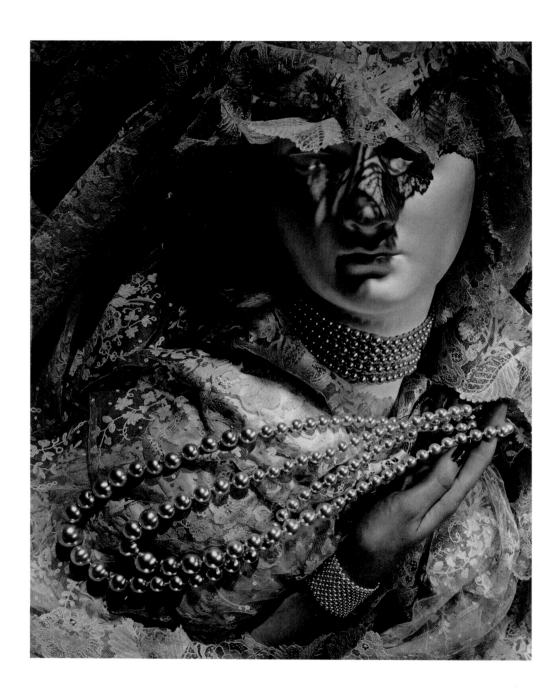

91 'Pearls of the Western World.' *Harper's Bazaar*, New York, February 1942

92 Unpublished variant of an image in American *Vogue*, New York, 1 August 1946.
The published caption reads:
'Feathers up: Crested Turban – Very Raja'. Hat by Walter Florell

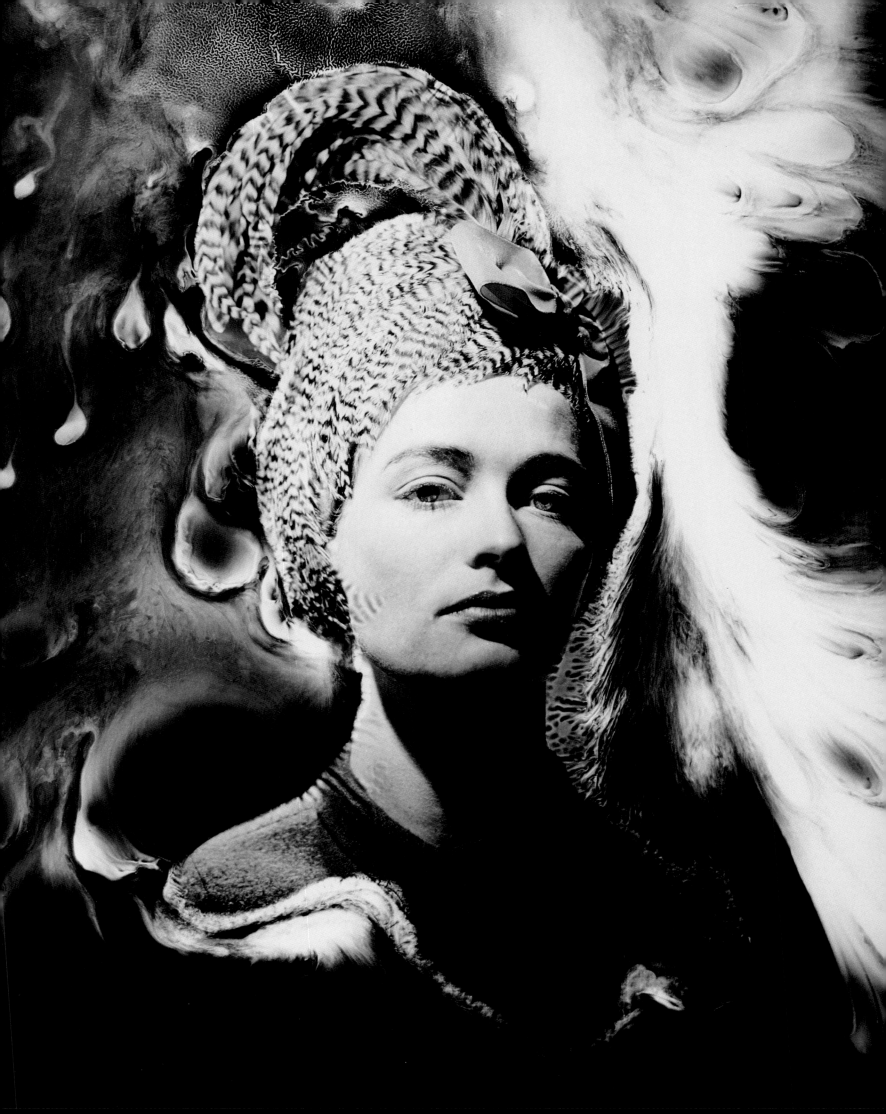

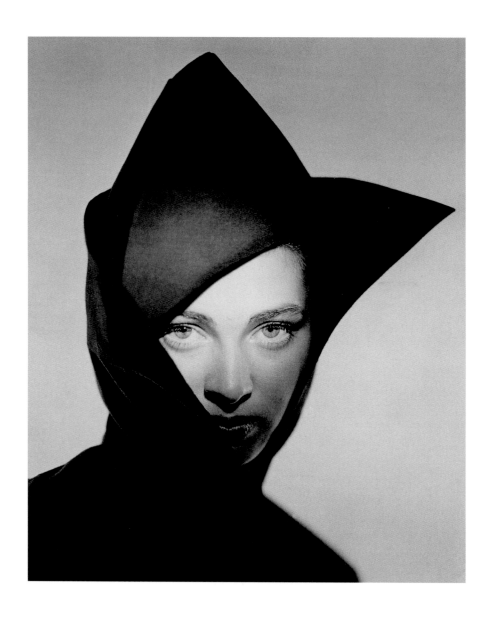

93 Untitled fashion assignment. Hat and jacket by John Frederics.
Unpublished variant of an image in American *Vogue*, New York, 1 September 1945.
The published caption reads: 'Eye-revealing hat and jut-collared jacket, both rayon faille.'

94 Untitled fashion assignment, New York, *c.* 1945

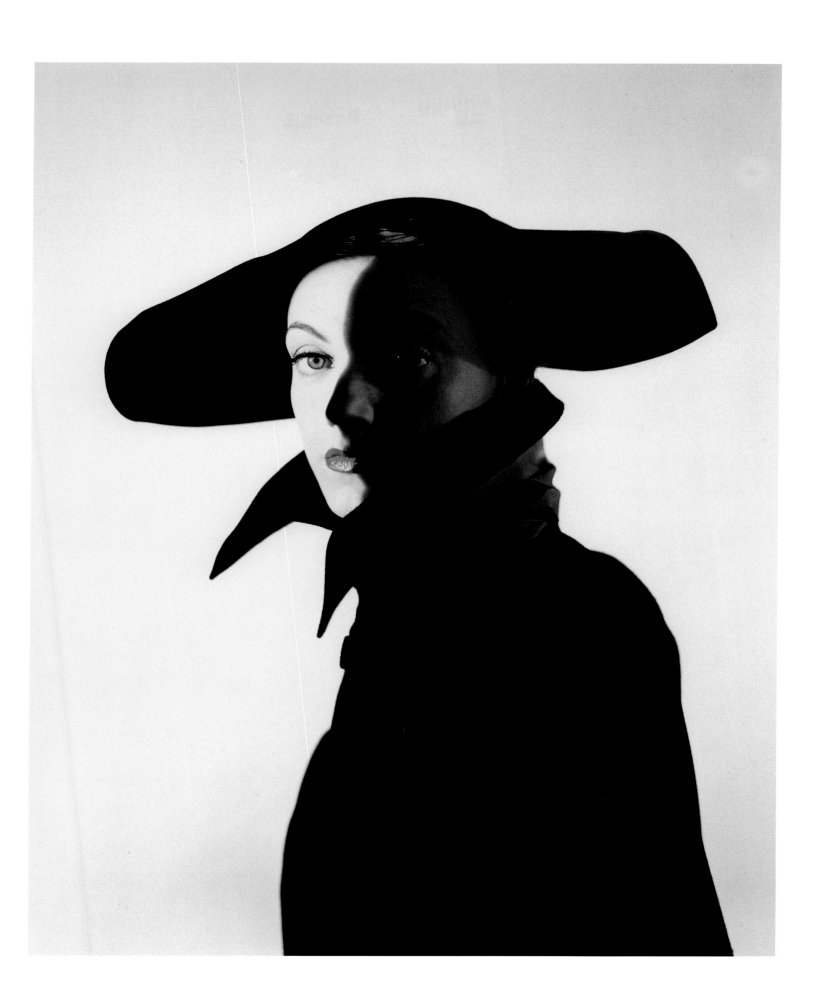

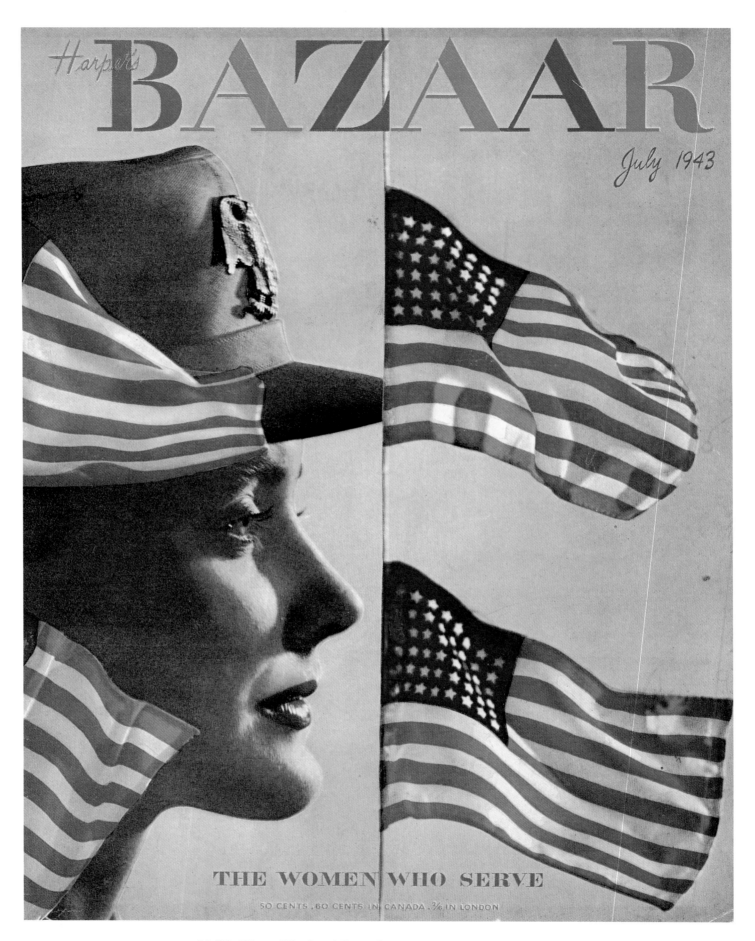

95 'The Women Who Serve.' Cover of *Harper's Bazaar*, New York, July 1943

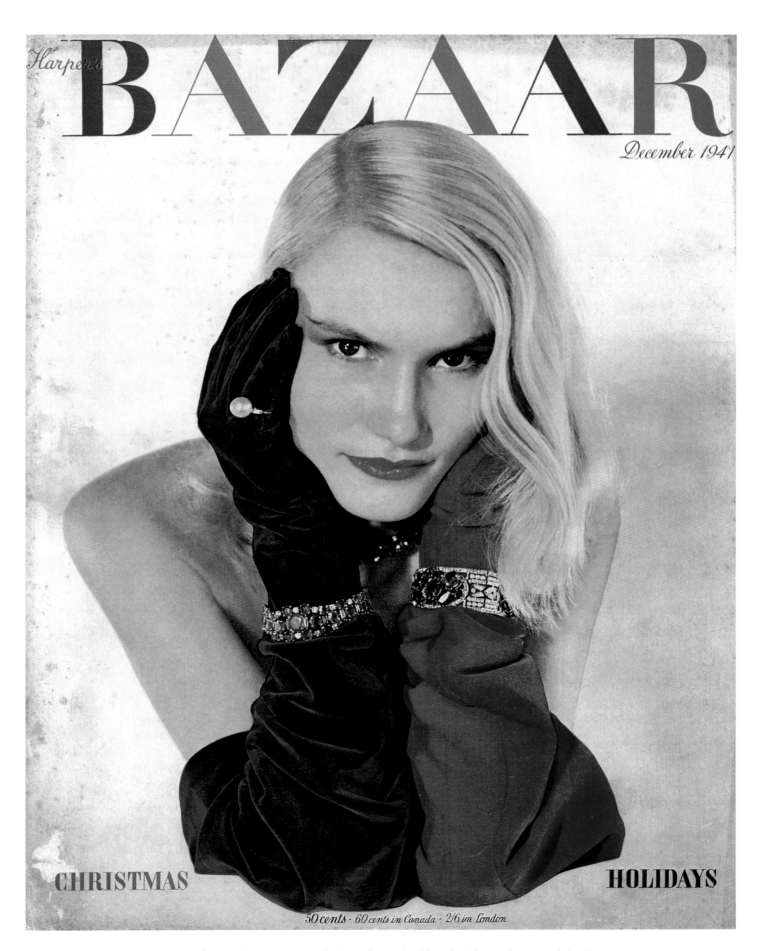

December 1941

CHRISTMAS

HOLIDAYS

50 cents · 60 cents in Canada · 2/6 in London

96 Cover of *Harper's Bazaar*, New York, December 1941. Gloves by John Frederics; jewels by Cartier

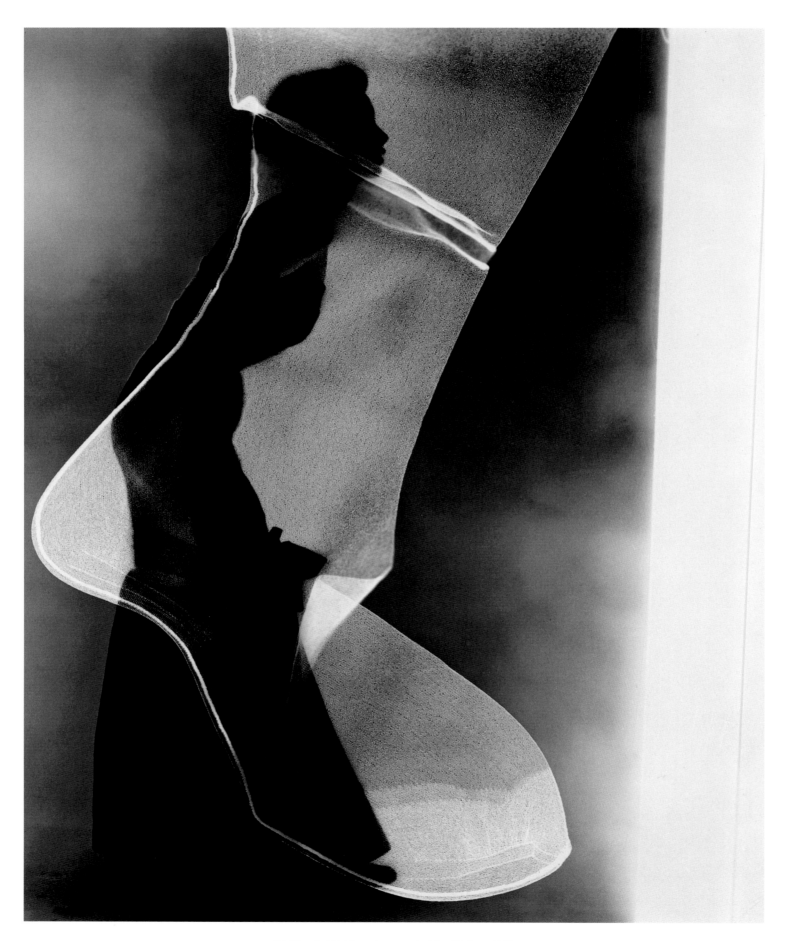

97 Untitled fashion photograph, New York, *c.* 1950

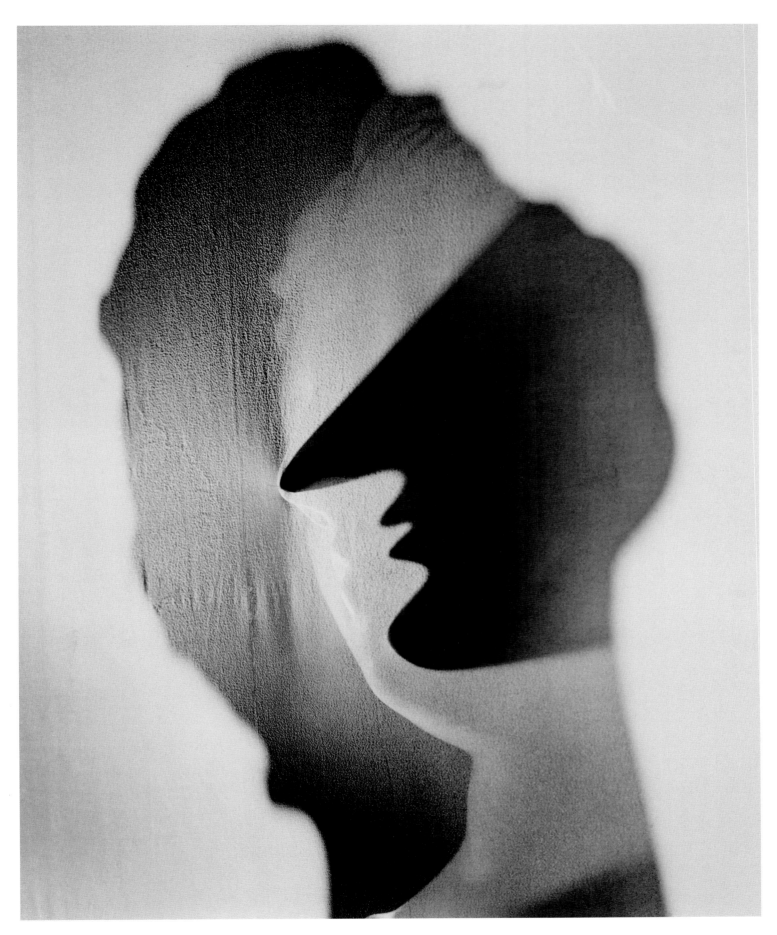

98 Untitled, New York, *c.* 1945

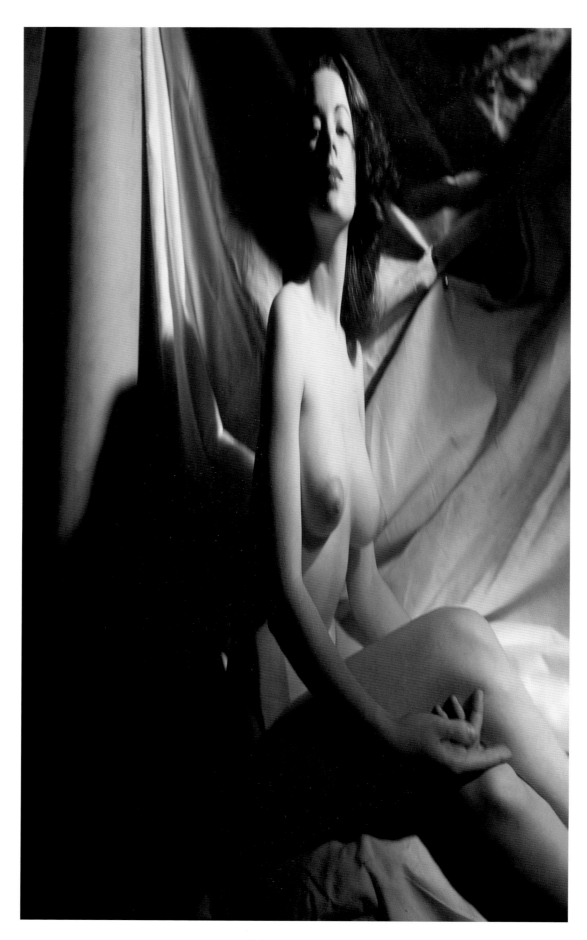

99 Untitled nude, New York, *c.* 1950

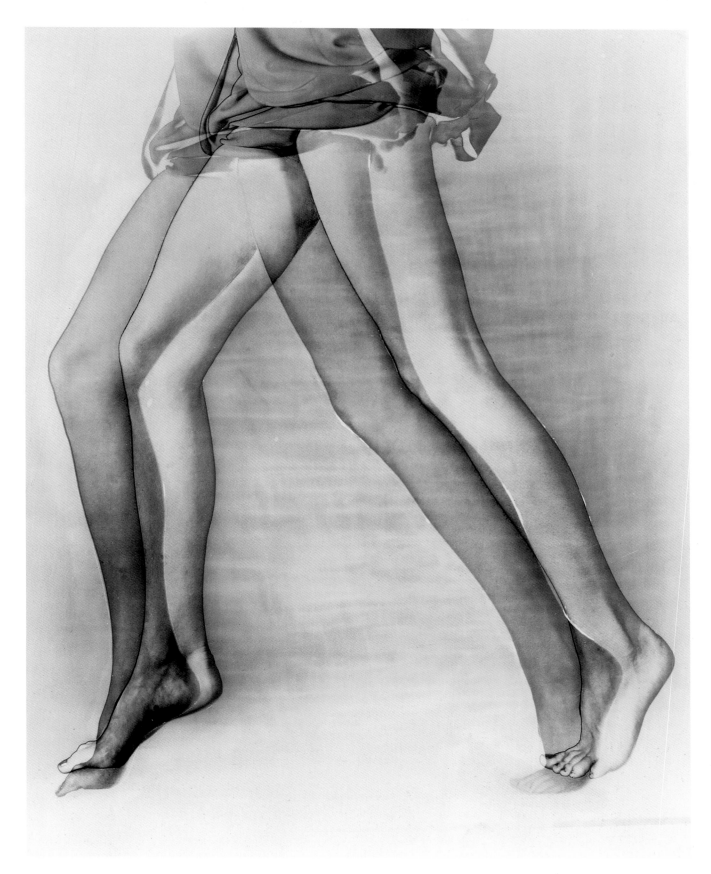

100 Untitled, New York, *c.* 1944

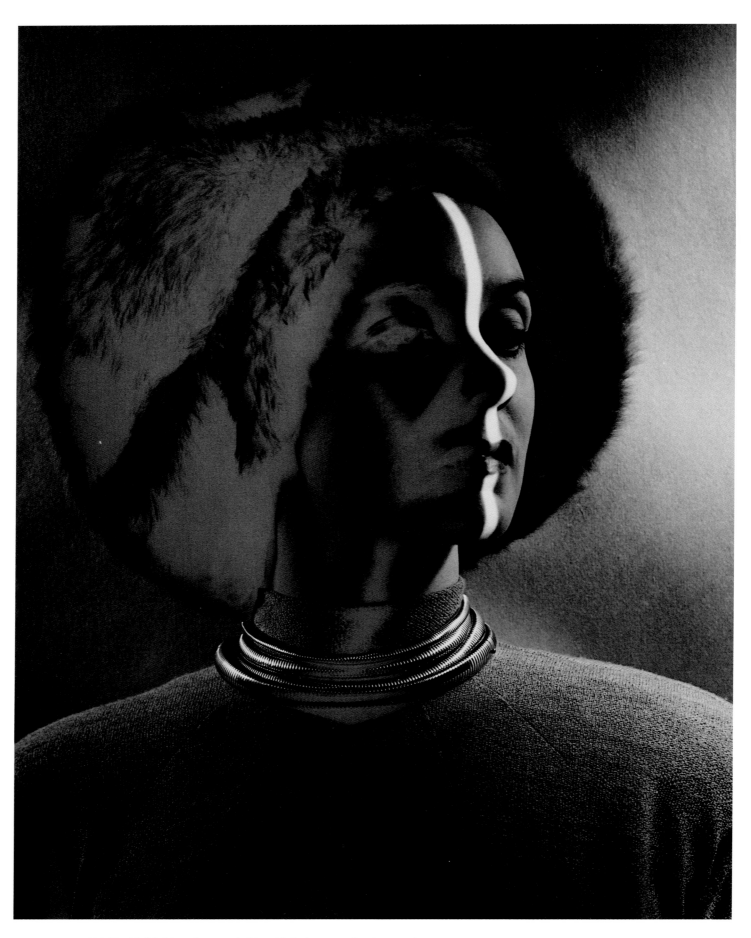

101 Untitled fashion photograph. Unpublished variant of a photograph in American *Vogue*, New York, 1 September 1945.
The published caption reads: 'Fashion is how you wear it. The hat is a big taupe pancake with the soft, ragged texture
of felt seen through a super magnifying glass . . . The new chic is in how you shape it . . . How you wear it.'

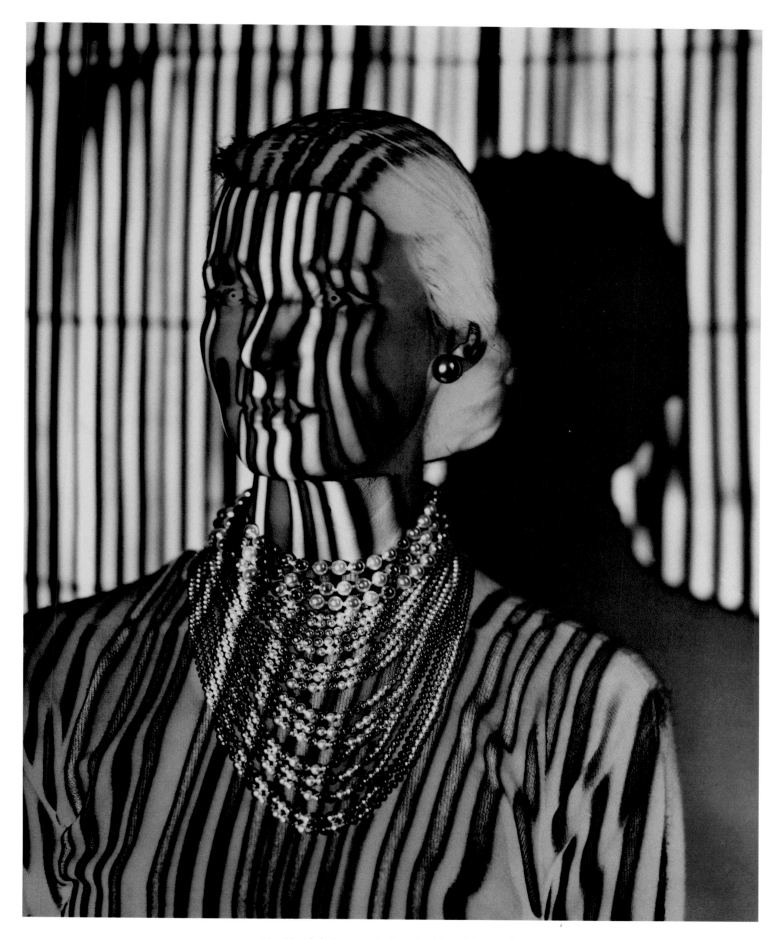

102 Untitled photograph of jewelry, New York, *c.* 1945

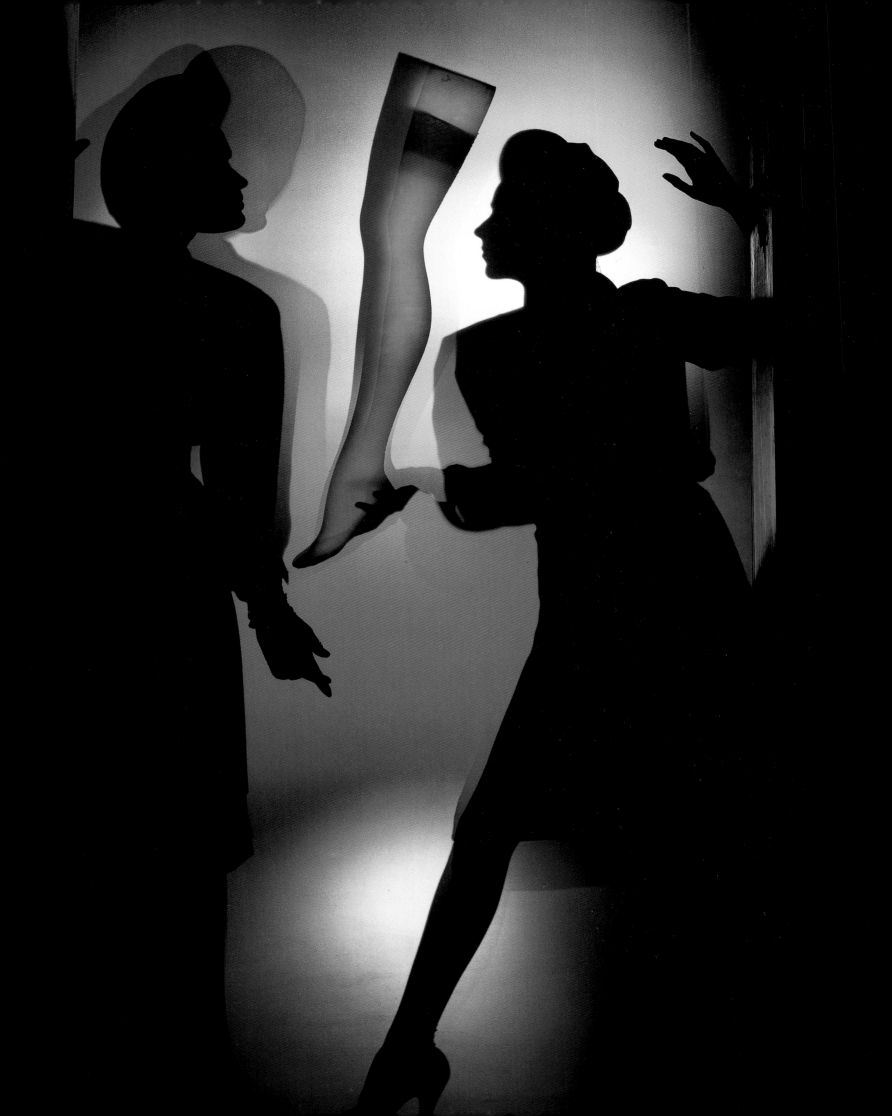

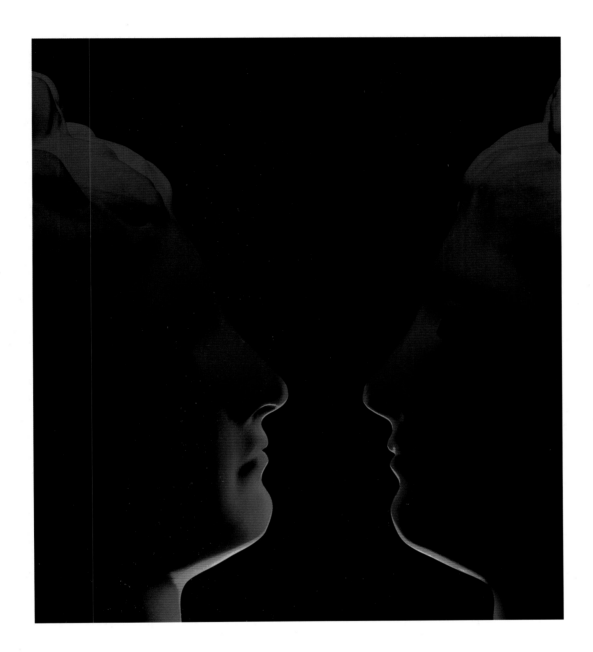

103 Untitled fashion photograph, New York, *c.* 1950

104 Untitled, New York, *c.* 1945

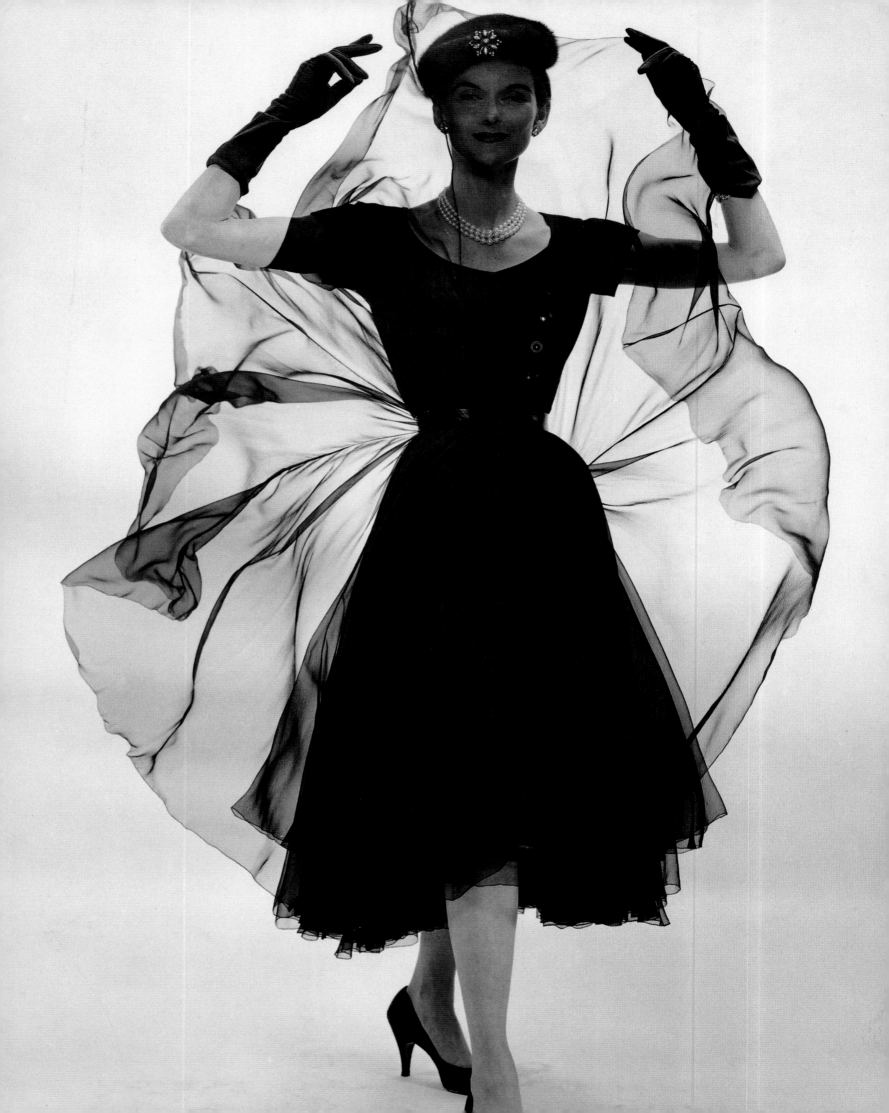

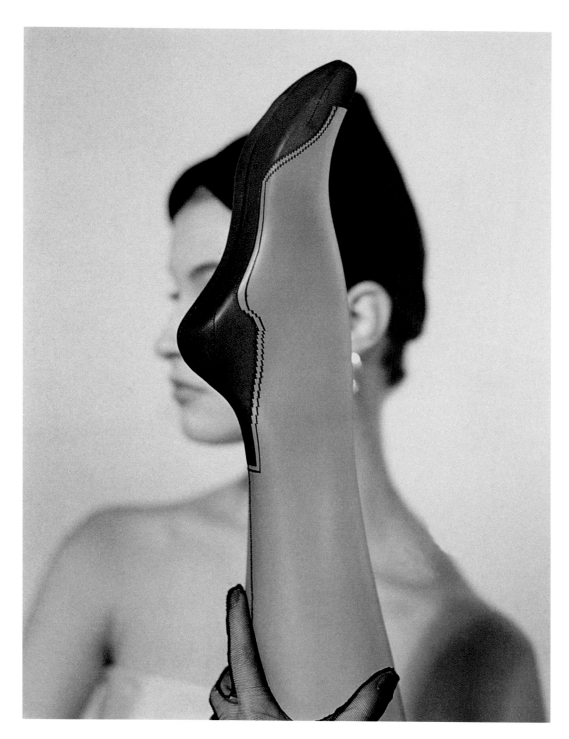

105 Untitled fashion photograph, New York, *c.* 1950

106 Untitled fashion photograph, New York, *c.* 1945

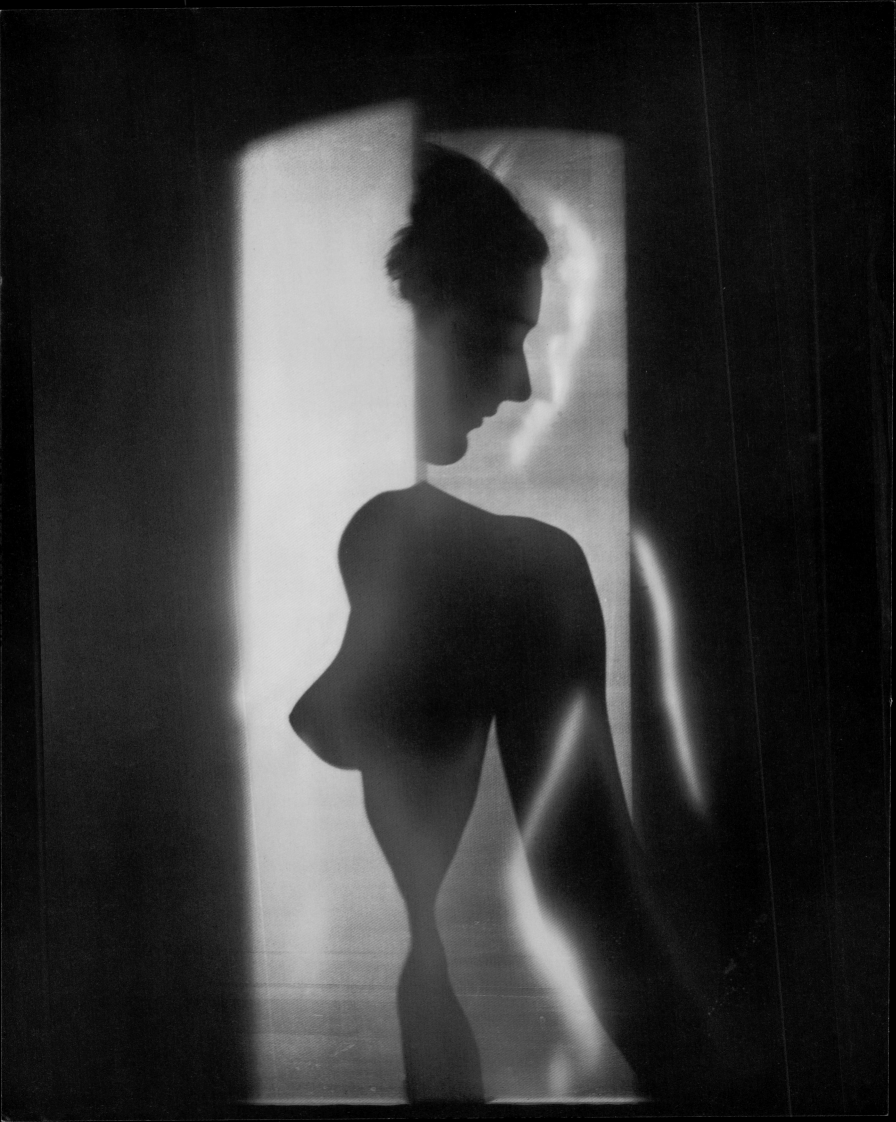

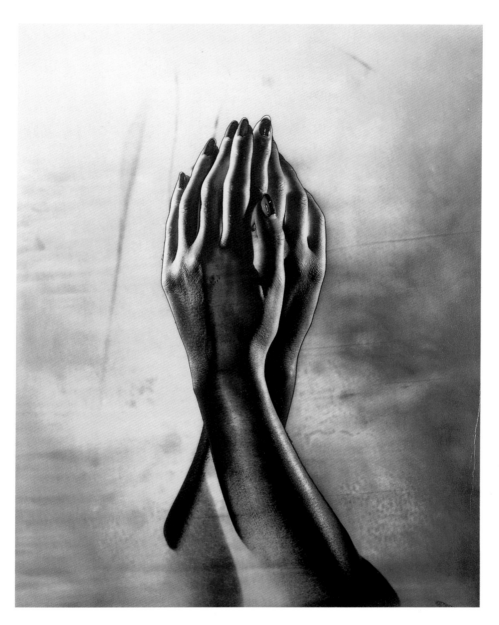

107 Untitled nude, New York, *c.* 1949

108 Untitled, *c.* 1950

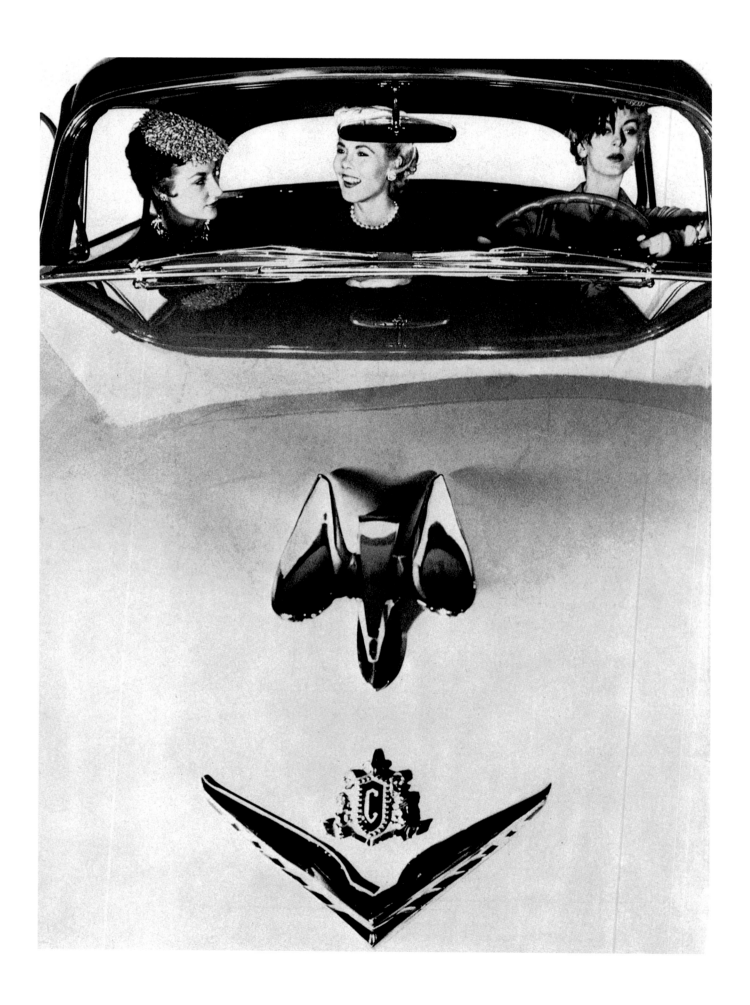

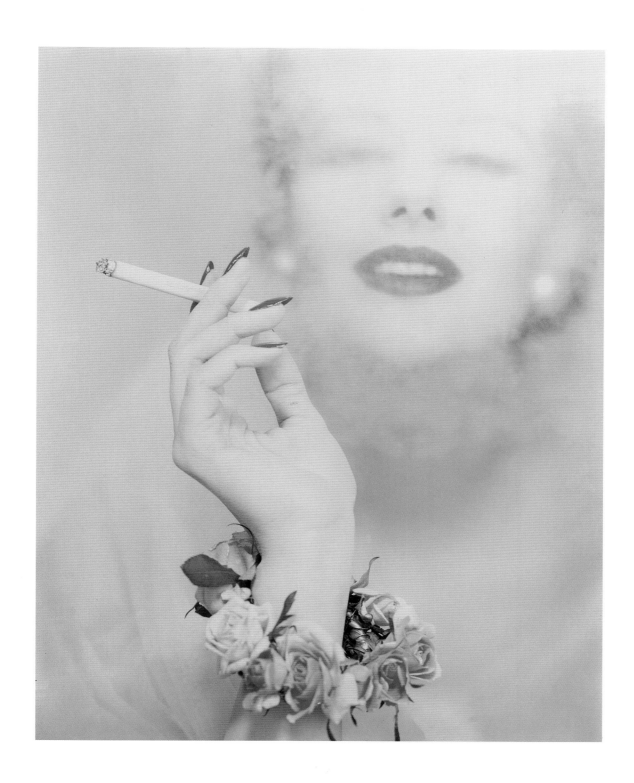

109 'Tip Sheet on the New Cars: The New Chrysler – a Powerhouse; their "New Yorker de luxe club coupe".
Hats from left: Mr John; Balenciaga copy; Mr John – at Bergdorf Goodman.' American *Vogue*, New York, 15 February 1954

110 Untitled photograph, New York, *c.* 1955

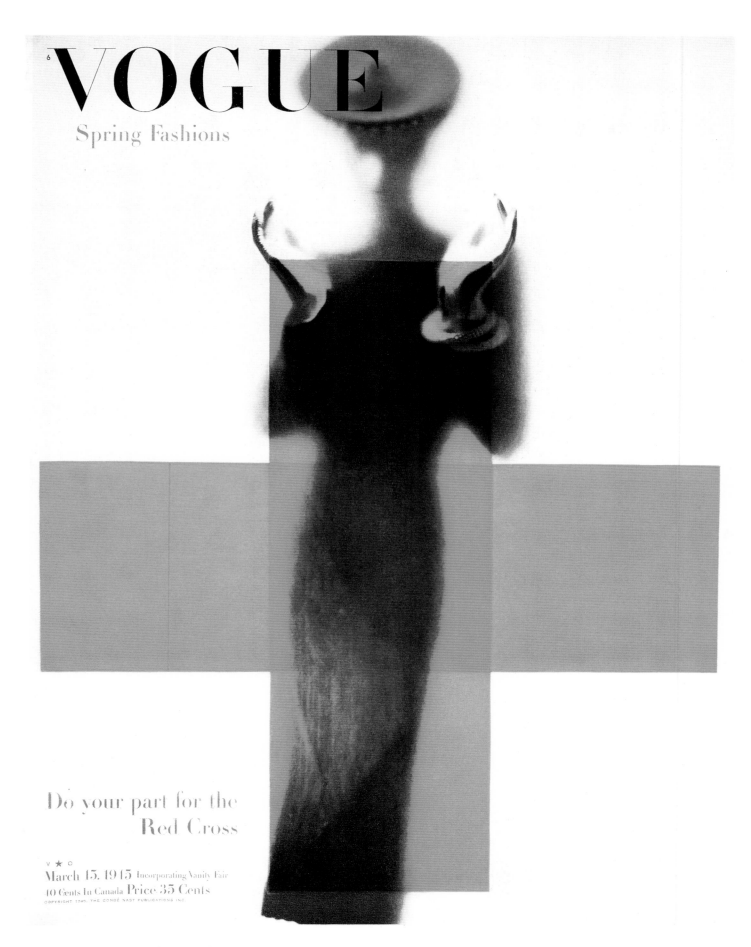

111 'Spring Fashions/Do Your Part for the Red Cross.' American *Vogue* cover, New York, 15 March 1945

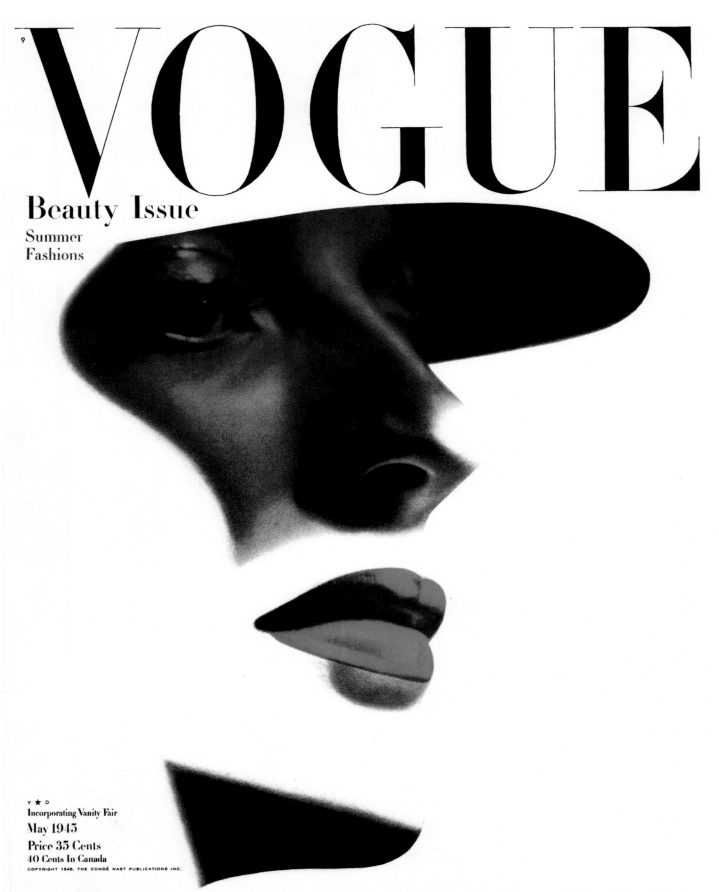

112 'Beauty Issue: Summer Fashions.' American *Vogue* cover, New York, May 1945

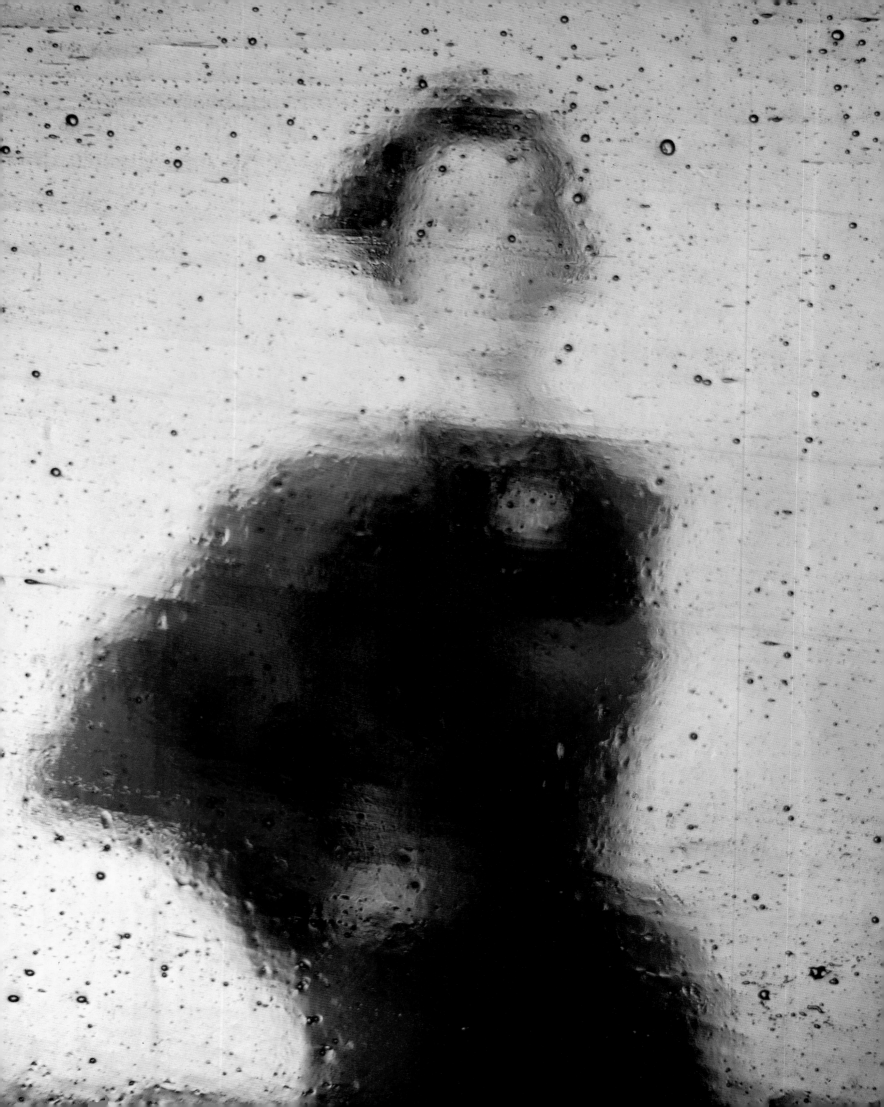

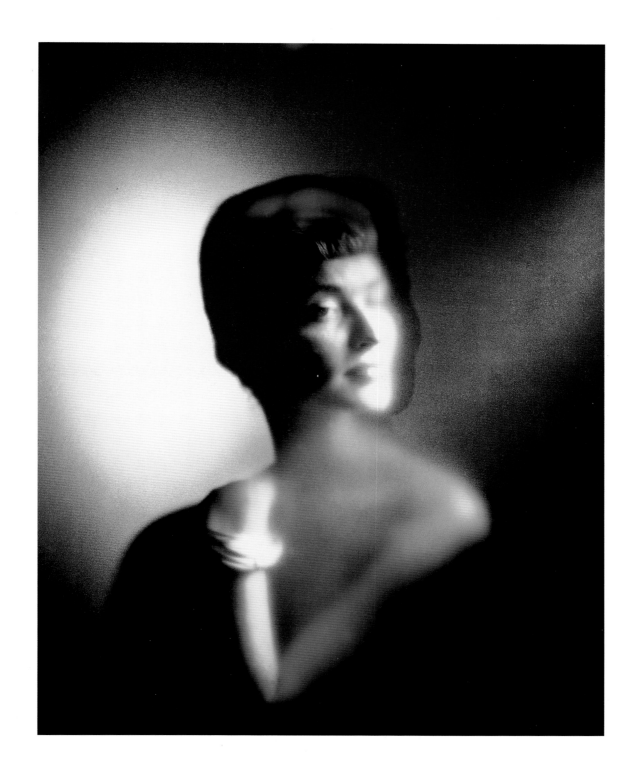

113 Untitled fashion photograph, New York, *c.* 1945

114 Untitled fashion photograph, New York, *c.* 1945

115 *Following pages* 'The Rest of Every Summer Costume: Illusion Shoes and Stockings.'
American *Vogue*, New York, 1 May 1952. McCallum Stockings; shoes by Julianelli

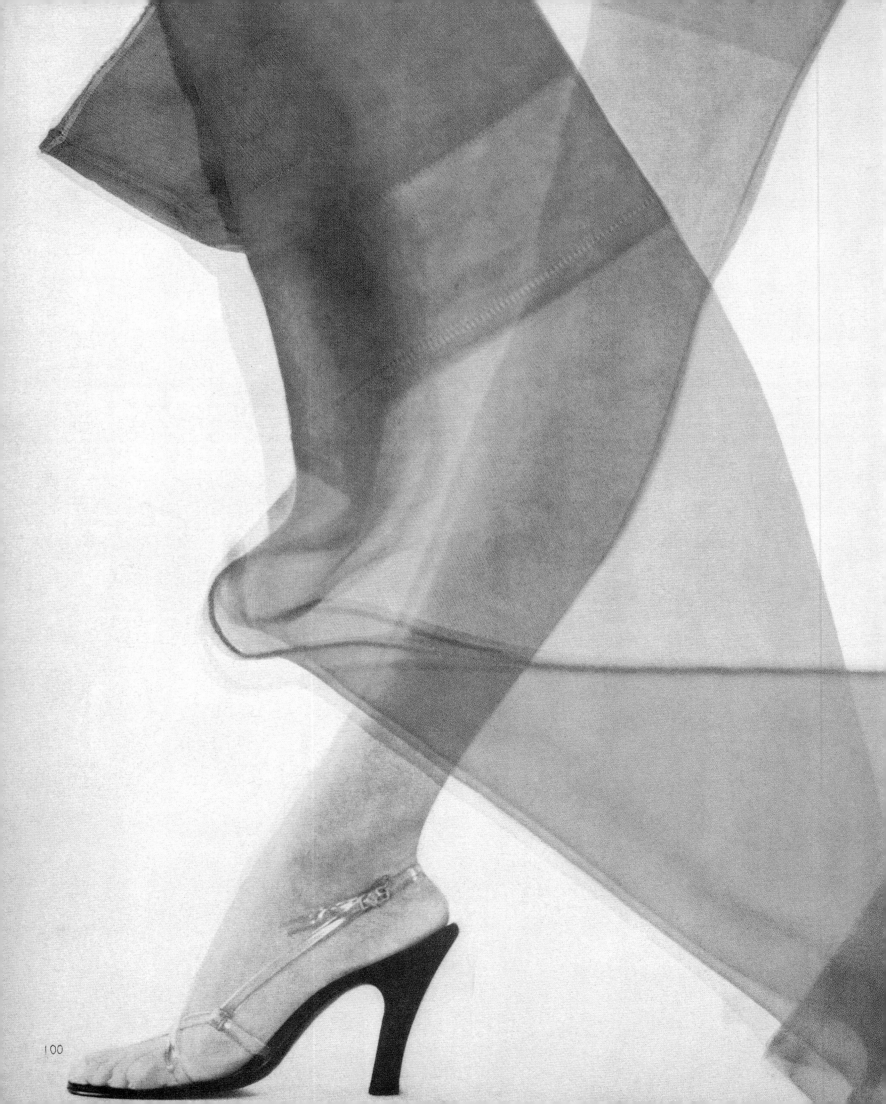

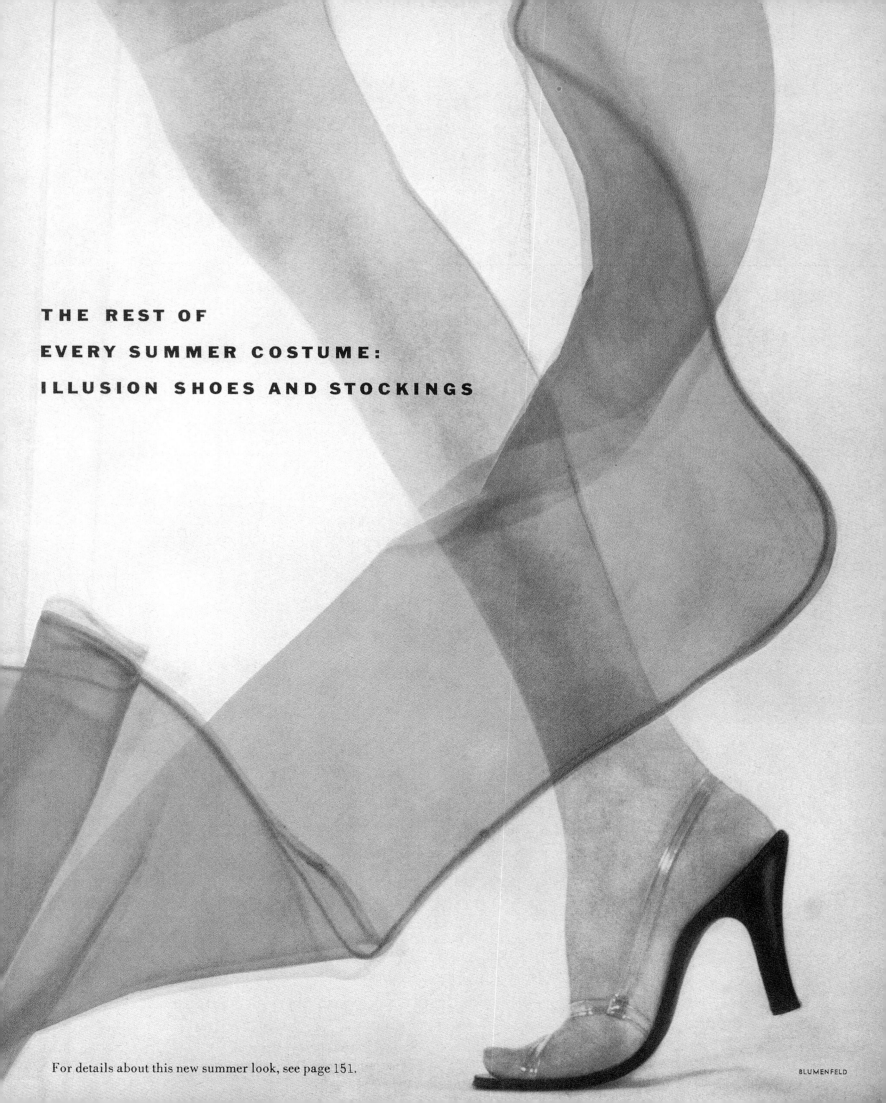

THE REST OF
EVERY SUMMER COSTUME:
ILLUSION SHOES AND STOCKINGS

For details about this new summer look, see page 151.

BLUMENFELD

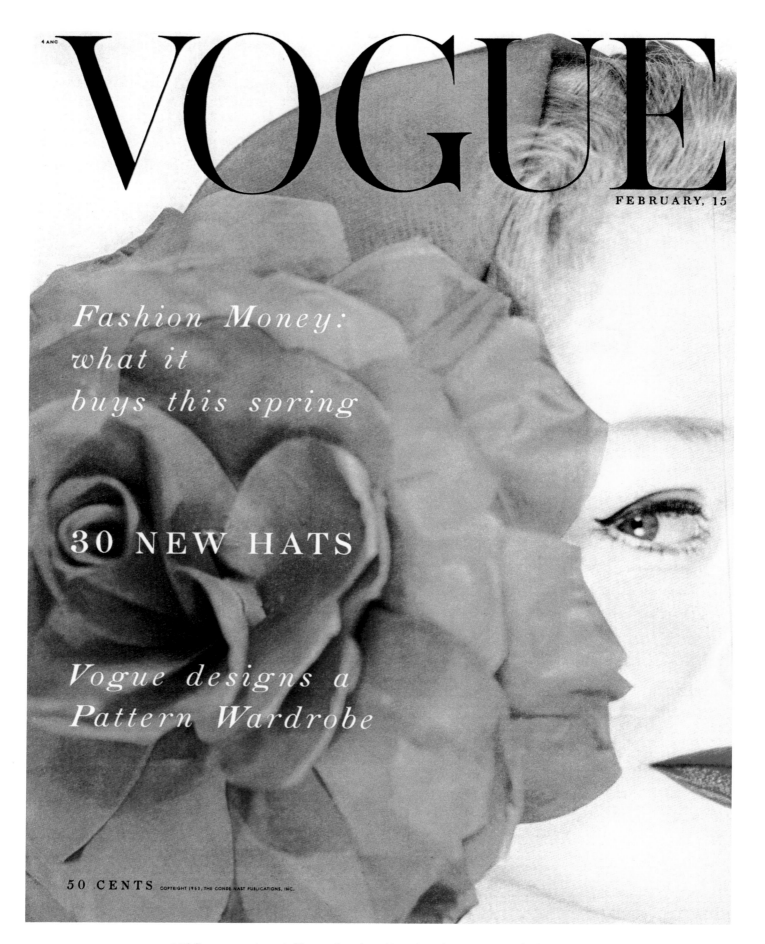

VOGUE

FEBRUARY, 15

Fashion Money: what it buys this spring

30 NEW HATS

Vogue designs a Pattern Wardrobe

50 CENTS COPYRIGHT 1953, THE CONDE NAST PUBLICATIONS, INC.

116 'A statement in capital letters about hats this spring – hats are going to be decorative.
This, in larger-than-life scale, is the John Frederics idea that started his whole series of silk chiffon rose hats in clear colours.'
American *Vogue* cover, New York, 15 February 1953

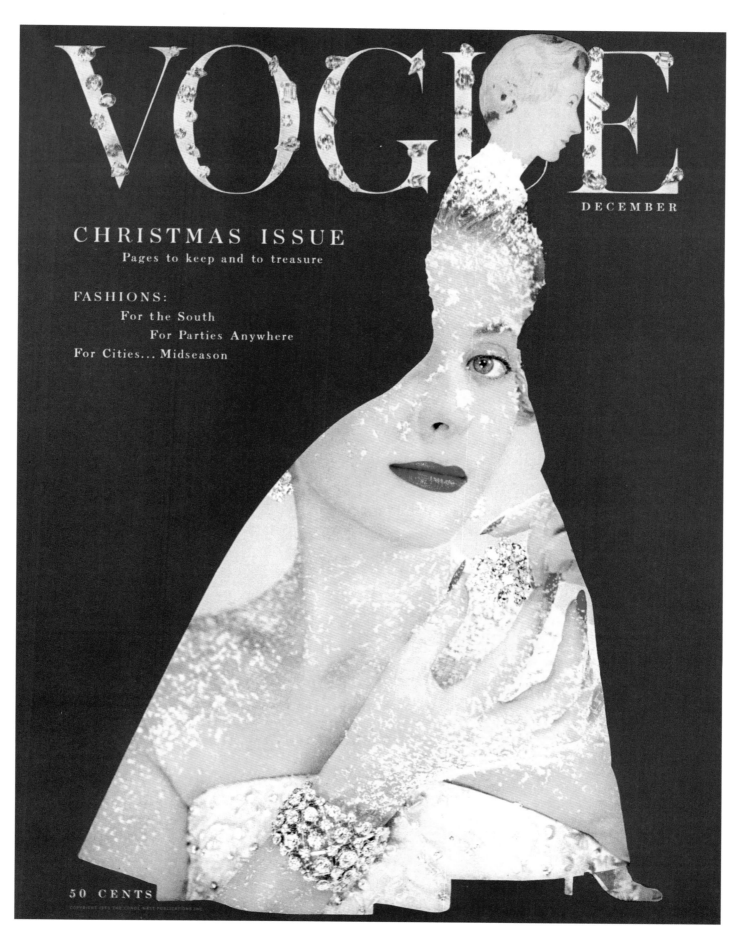

117 'Look at the picture in profile – it's an outline of the newest shape in evening dresses, the backswung line.
Look at it head-on, and see a fabulous bracelet, a wicker-work of diamonds by Harry Winston;
and colouring from a brilliant crayon, "Red Pencil" lipstick by Charles of the Ritz.'
American *Vogue* cover, New York, December 1953

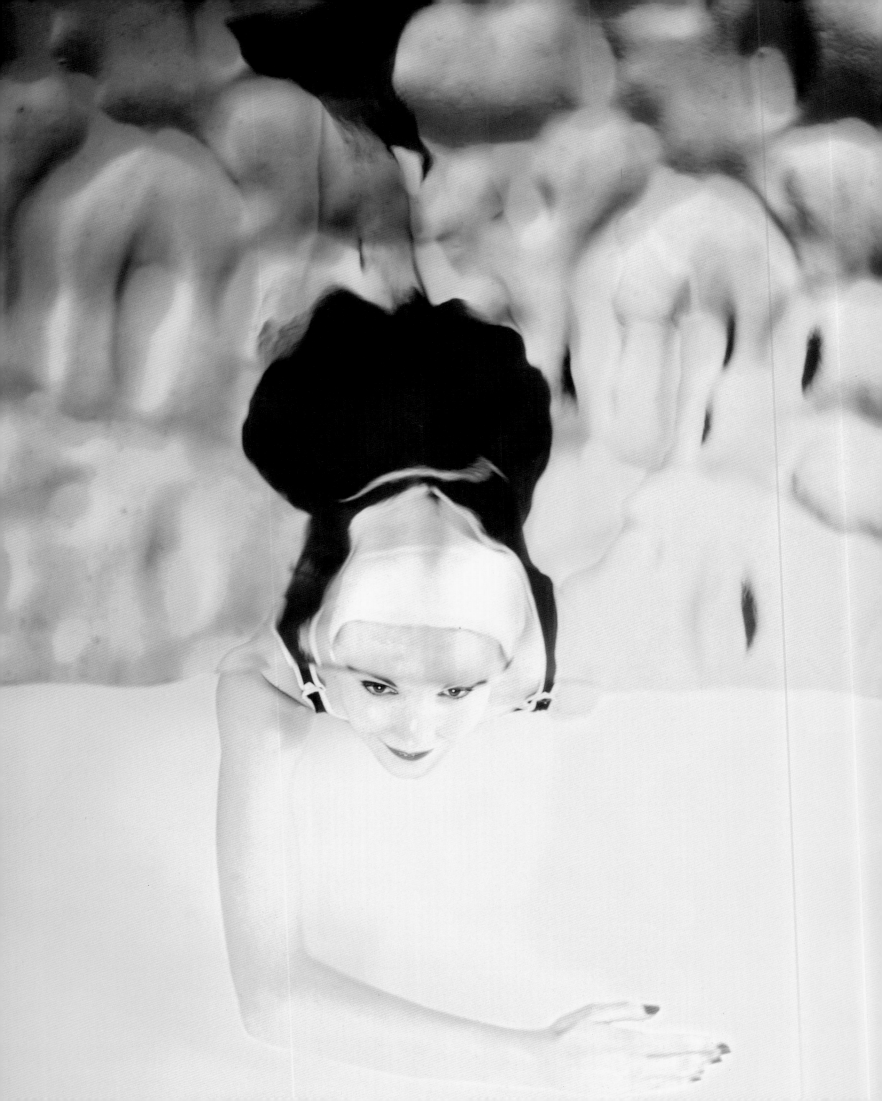

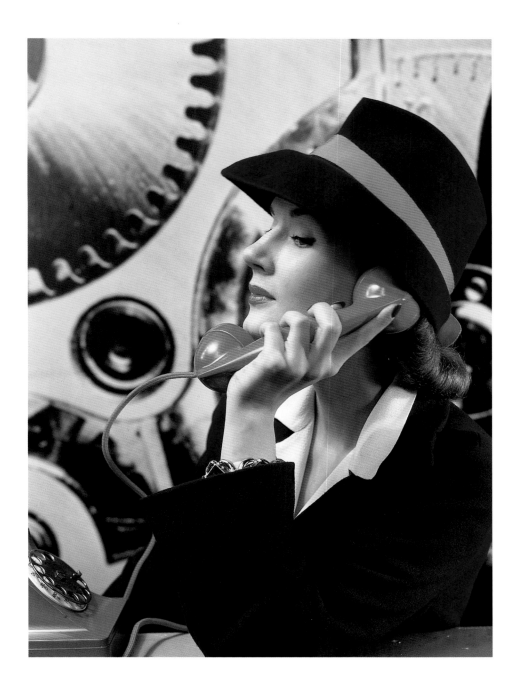

118 Untitled fashion photograph, New York, *c.* 1950

119 Untitled fashion photograph, New York, *c.* 1944

120 *Following pages* 'Legs in the Sunlight.' American *Vogue*, New York, July 1950.
Make-up: Germaine Monteil's Bronzé Beauty Balm; nail polish: Chen Yu's 'Coral Fan';
bamboo lipstick case: Lucien Lelong; sandal: Bernardo

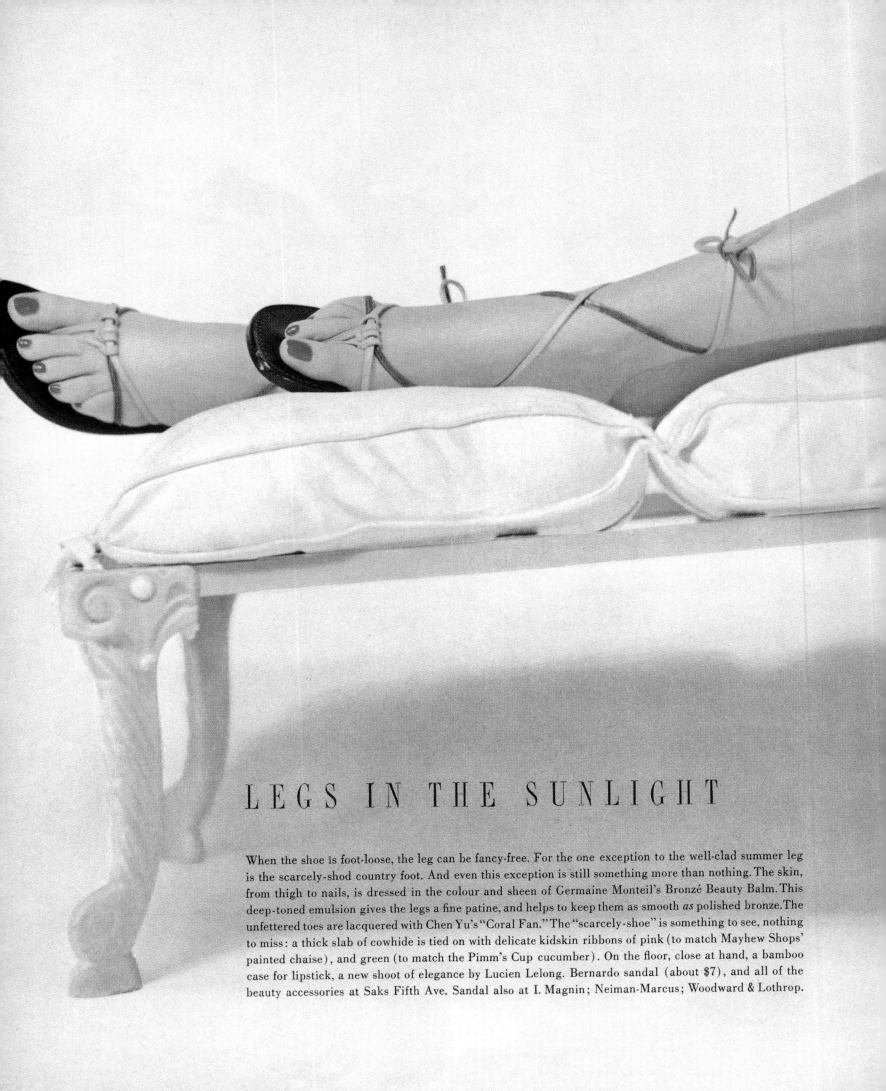

LEGS IN THE SUNLIGHT

When the shoe is foot-loose, the leg can be fancy-free. For the one exception to the well-clad summer leg is the scarcely-shod country foot. And even this exception is still something more than nothing. The skin, from thigh to nails, is dressed in the colour and sheen of Germaine Monteil's Bronzé Beauty Balm. This deep-toned emulsion gives the legs a fine patine, and helps to keep them as smooth *as* polished bronze. The unfettered toes are lacquered with Chen Yu's "Coral Fan." The "scarcely-shoe" is something to see, nothing to miss: a thick slab of cowhide is tied on with delicate kidskin ribbons of pink (to match Mayhew Shops' painted chaise), and green (to match the Pimm's Cup cucumber). On the floor, close at hand, a bamboo case for lipstick, a new shoot of elegance by Lucien Lelong. Bernardo sandal (about $7), and all of the beauty accessories at Saks Fifth Ave. Sandal also at I. Magnin; Neiman-Marcus; Woodward & Lothrop.

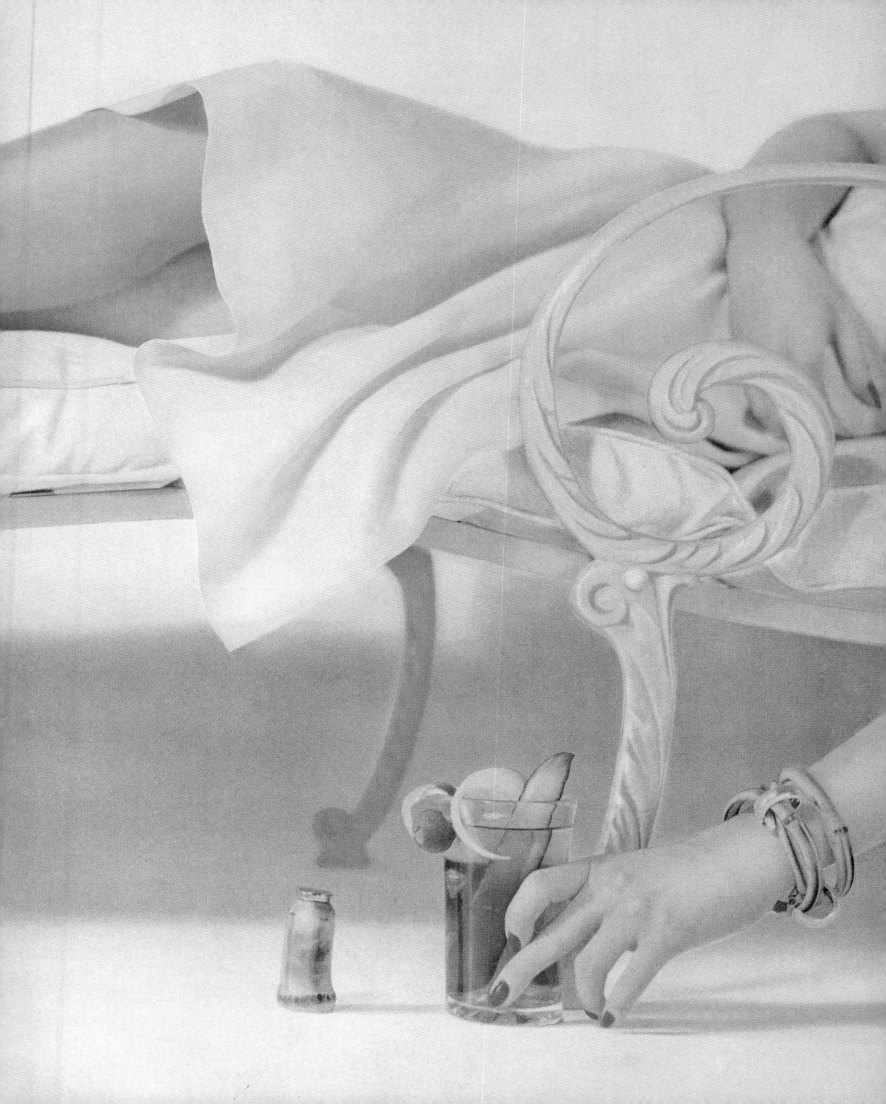

V O G U E

1951

NEW FASHION TIMETABLE

Fabric news to wear all year

Suit news to wear all year

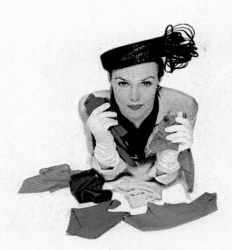

SPECIAL FEATURES:

Travel Headliners

"Laughter" by Christopher Fry

Memo on Germany

121 'One example of the 1951 timetable: The *white* faille suit – news, to wear now under furs, at five o'clock;
to take South; to wear to Sunday luncheons. Season unlimited, too, are the fresh-as-paint colours on the cover.
Suit, cotton-and-rayon; and straw hat, by Christian Dior – New York.'
American *Vogue* cover, New York, January 1951

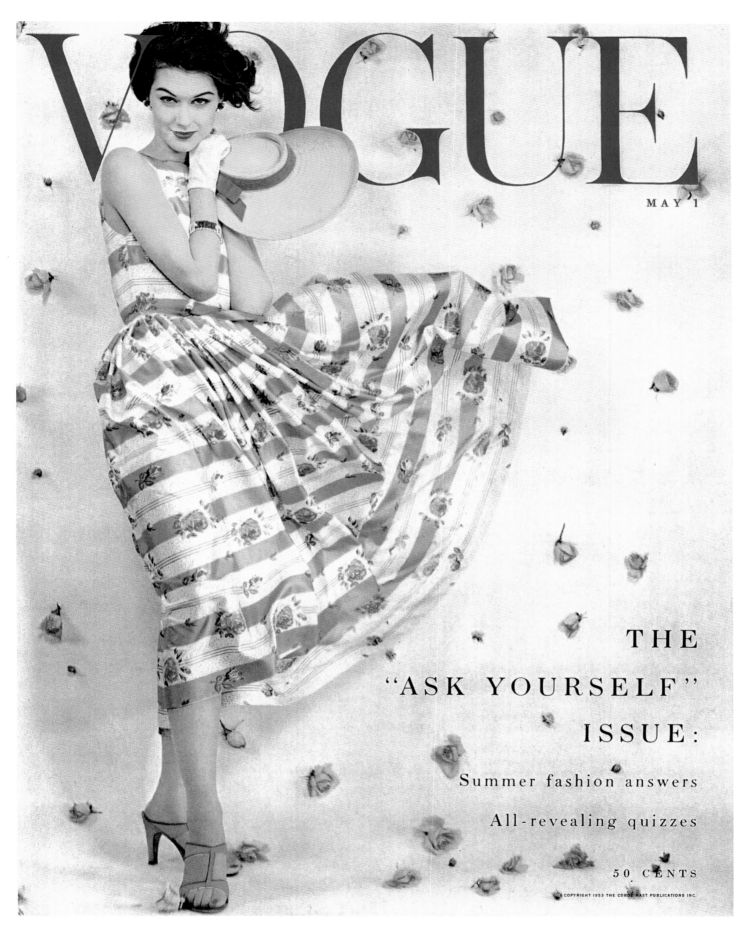

VOGUE

MAY 1

THE
"ASK YOURSELF"
ISSUE:

Summer fashion answers

All-revealing quizzes

50 CENTS

COPYRIGHT 1953 THE CONDÉ NAST PUBLICATIONS INC.

122 'The "Ask Yourself" Issue: Summer Fashion Answers.' American *Vogue* cover, New York, 1 May 1953
Fashions: Traina-Norell

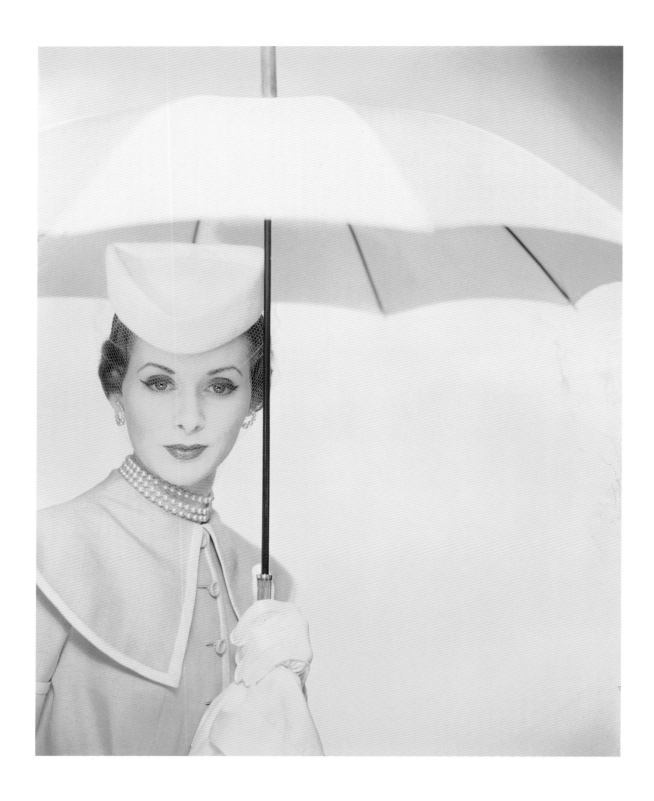

123 Unpublished variant of a cover image for American *Vogue* (see pl. 125), New York, 15 March 1950

124 Unpublished variant of an image for American *Vogue*, New York, 15 February 1954.
The published caption reads: 'Somewhat Cadillac: Somewhat Gold. Silk cushion-y cloche by John Frederics.'

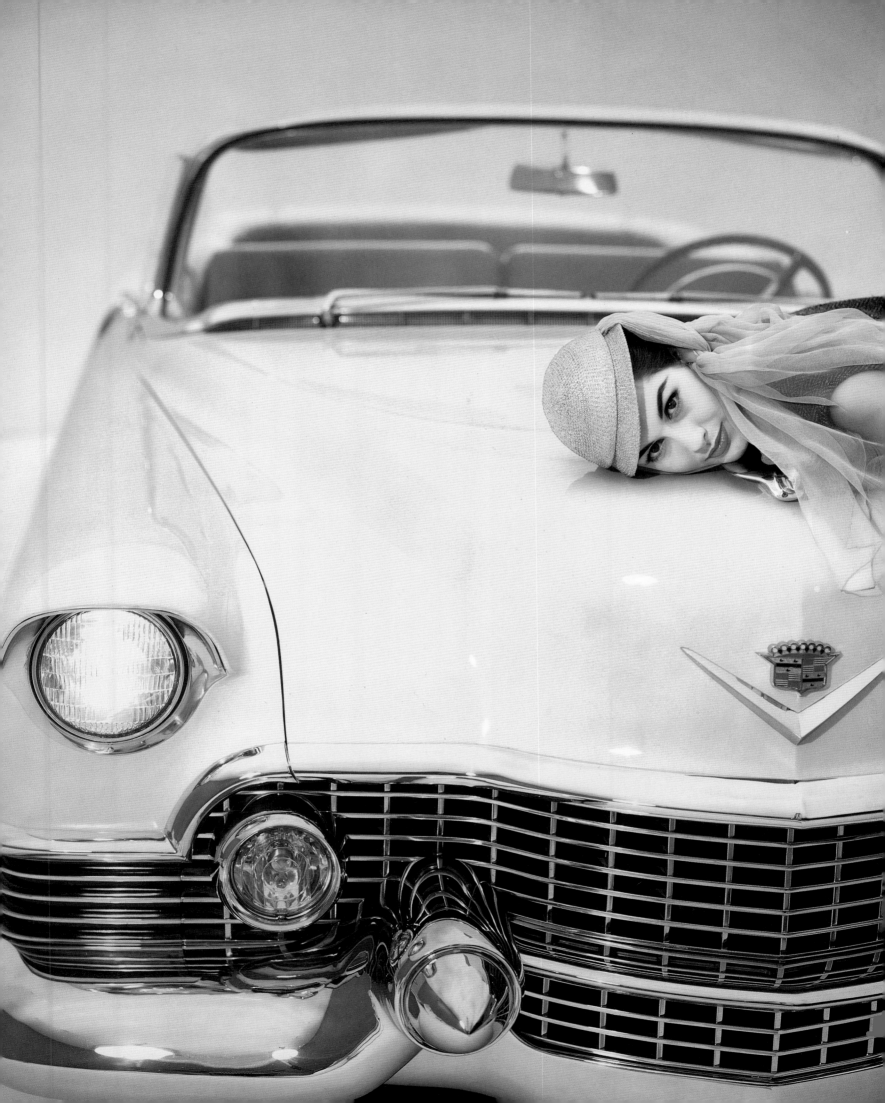

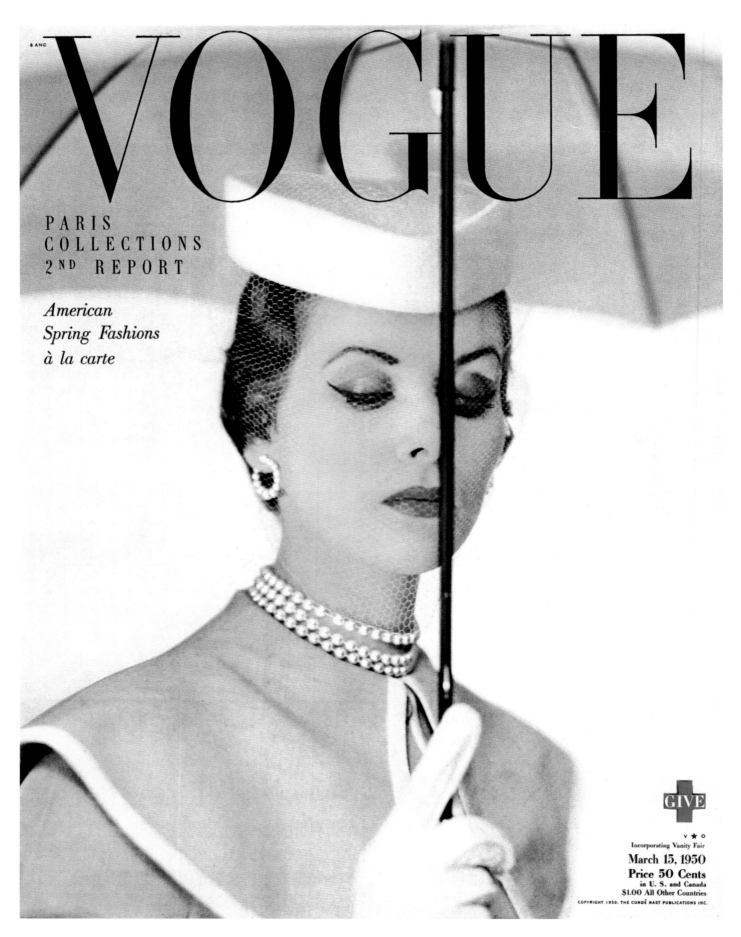

125 'The whiteness is the news, the delight . . . It is white that goes to the fingertips, to the umbrella overhead . . .
Velours tricorne by Mr. John, dress by Traina-Norell, Richelieu pseudo-pearls, lipstick by Harriet-Hubbard Ayer.'
American *Vogue* cover, New York, 15 March 1950

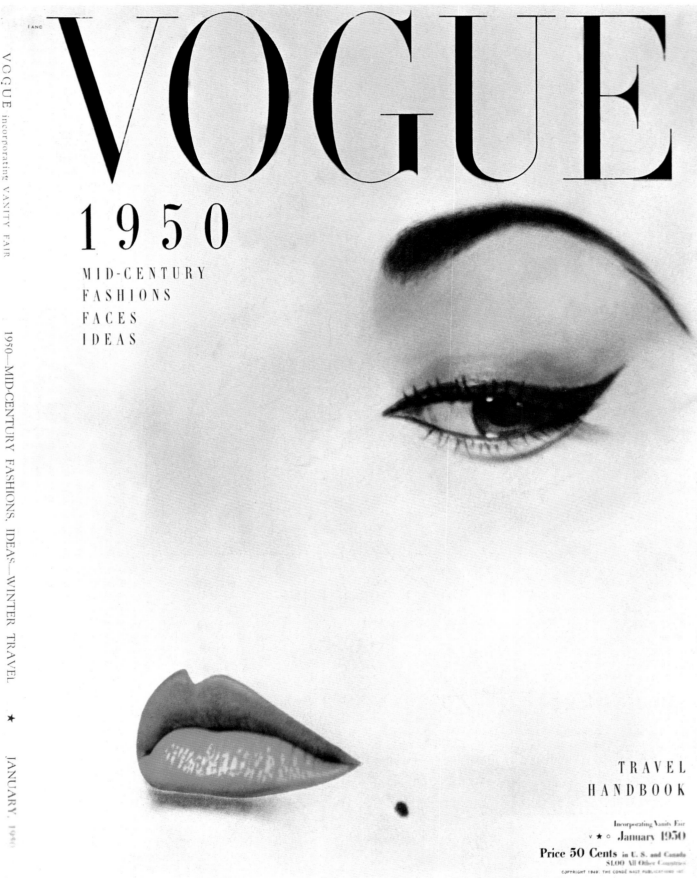

VOGUE

1950

MID-CENTURY
FASHIONS
FACES
IDEAS

TRAVEL
HANDBOOK

Incorporating Vanity Fair
v ★ ○ January 1950
Price 50 Cents in U. S. and Canada
$1.00 All Other Countries
COPYRIGHT 1949, THE CONDÉ NAST PUBLICATIONS INC.

126 '1950: Mid-century Fashions, Faces, Ideas.' American *Vogue* cover, New York, January 1950.
Image by Blumenfeld (retouched and hand-coloured by the *Vogue* art department)

127 Untitled fashion photograph, New York, *c.* 1952

128 'Mrs Schuyler Watts in pink silk chiffon.' *Harper's Bazaar*, New York, January 1942.
Dress and make-up by Germaine Monteil

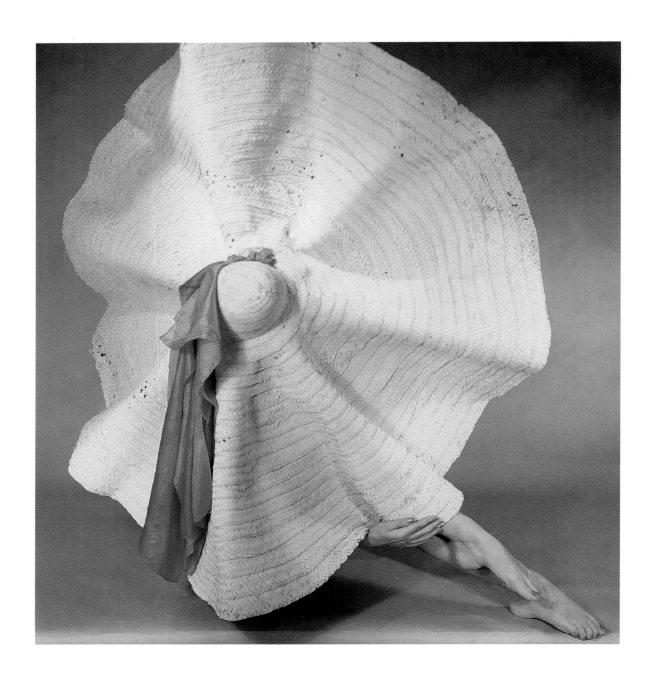

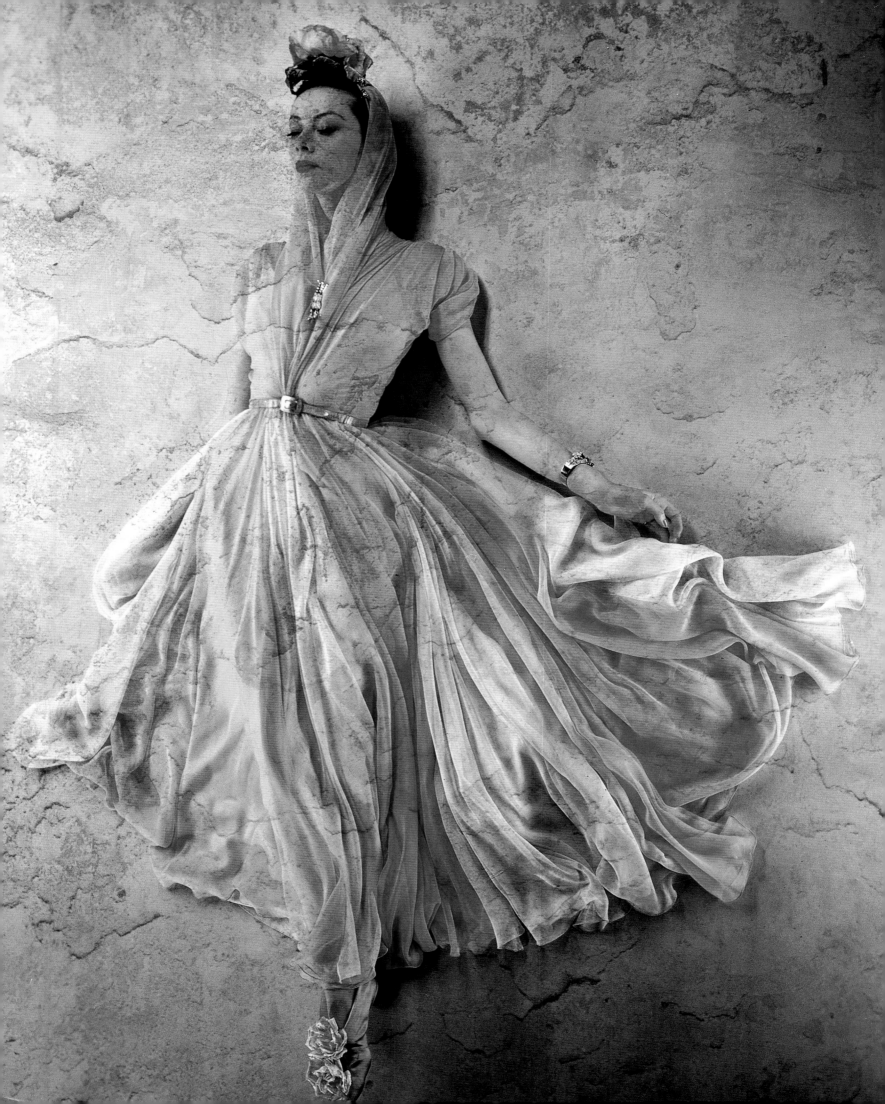

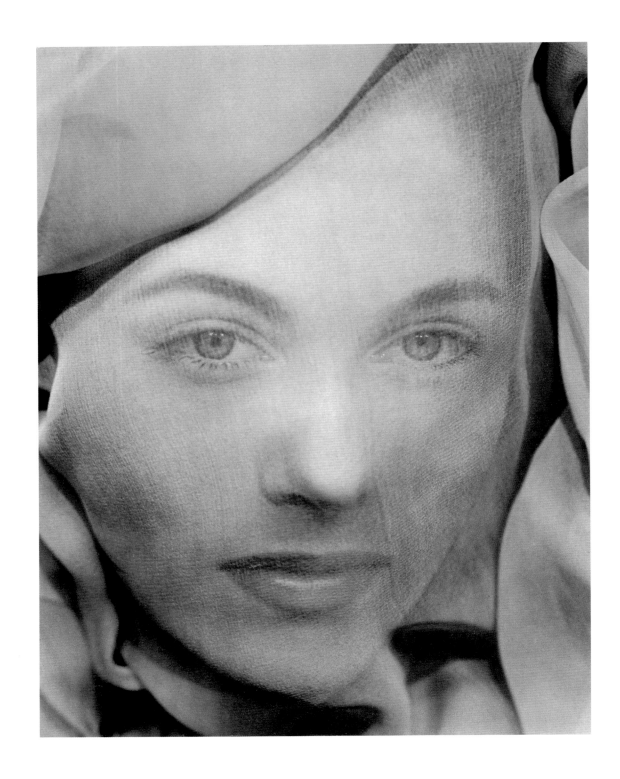

129 Untitled fashion test, New York, 1952. Model: Leslie Redgrave

130 'This face, wearing the mask of *Vogue* – whose is it? It might belong to any American woman.
For lipstick is her inevitable signature . . . Foundation and lipstick by Elizabeth Arden.'
American *Vogue* cover, New York, 15 October 1952. Dress by Jacques Fath

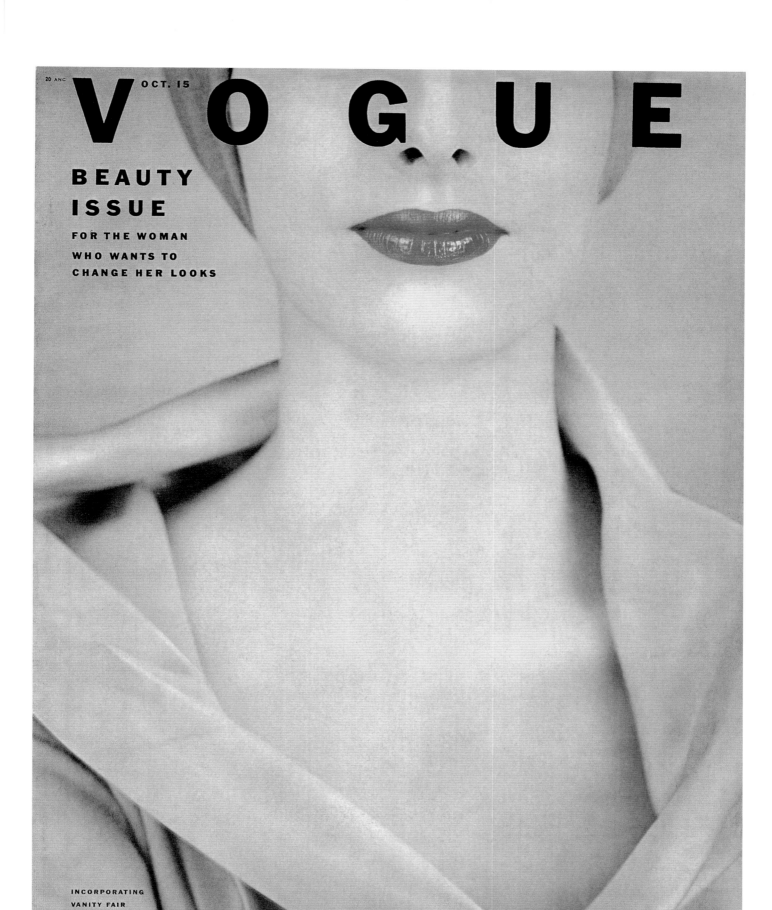

20 ANC OCT. 15

VOGUE

**BEAUTY
ISSUE**

FOR THE WOMAN
WHO WANTS TO
CHANGE HER LOOKS

INCORPORATING
VANITY FAIR
50 CENTS
COPYRIGHT 1952
THE CONDÉ NAST PUBLICATIONS INC.

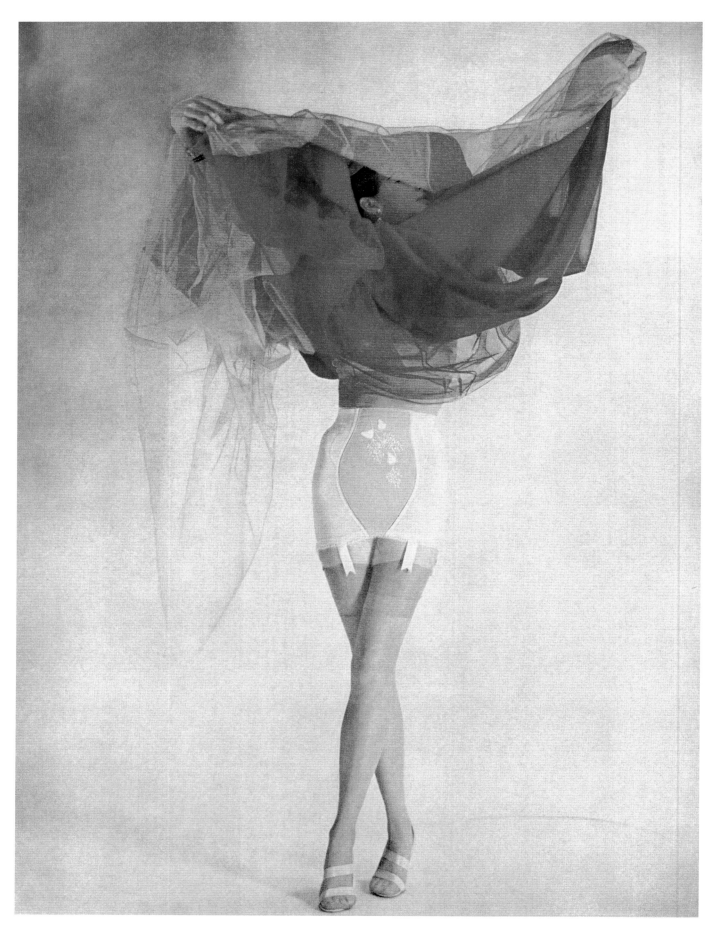

131 'Retouching the figure.' American *Vogue*, New York, 15 February 1953.
Girdle by Lily of France, organdie by Dior, stockings by Modeltex, satin sandals by Valley

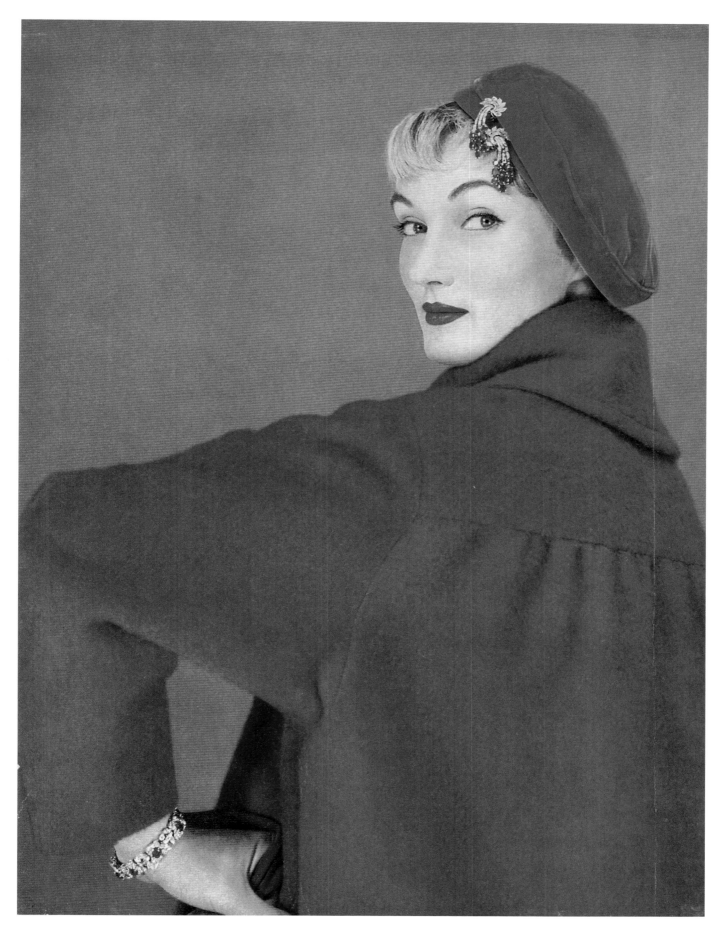

132 American *Vogue*, New York, September 1954. Velvet beret by Emme; fleece coat by Nettie Rosenstein

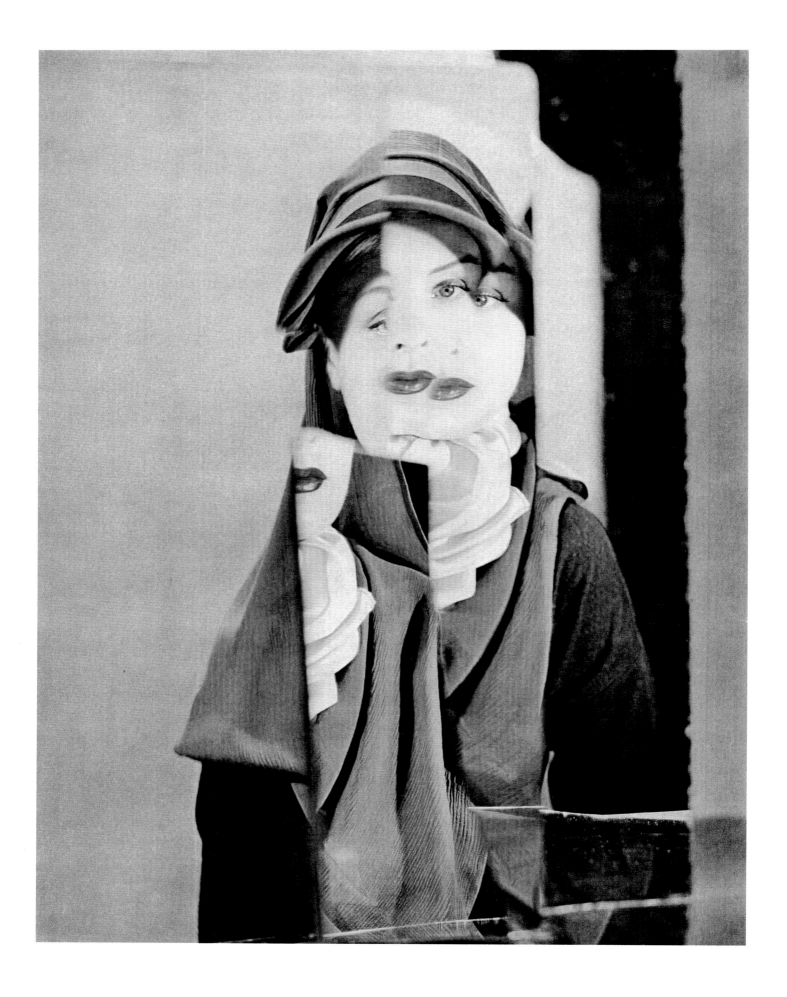

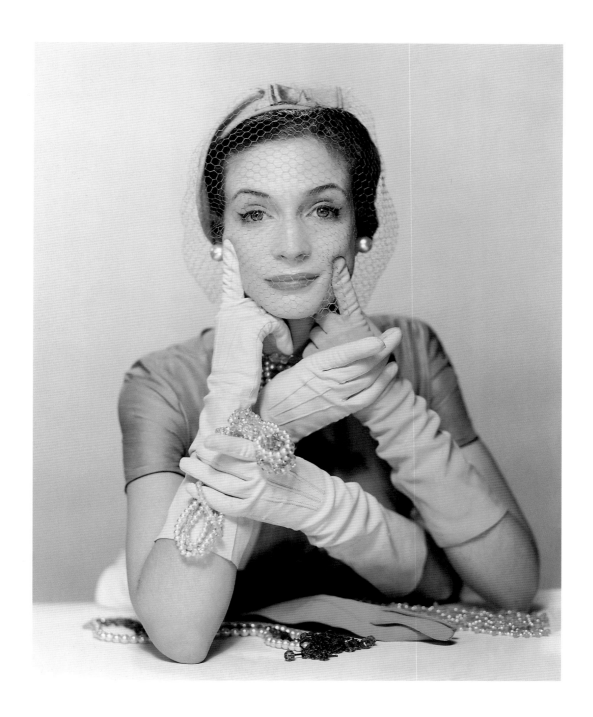

133 'What looks new: a milliner experiments with halftones in lipsticks and powders.'
American *Vogue*, New York, 15 March 1947. Make-up and hat by John Frederics

134 Untitled fashion photograph of hat, gloves and jewelry, New York, 1947

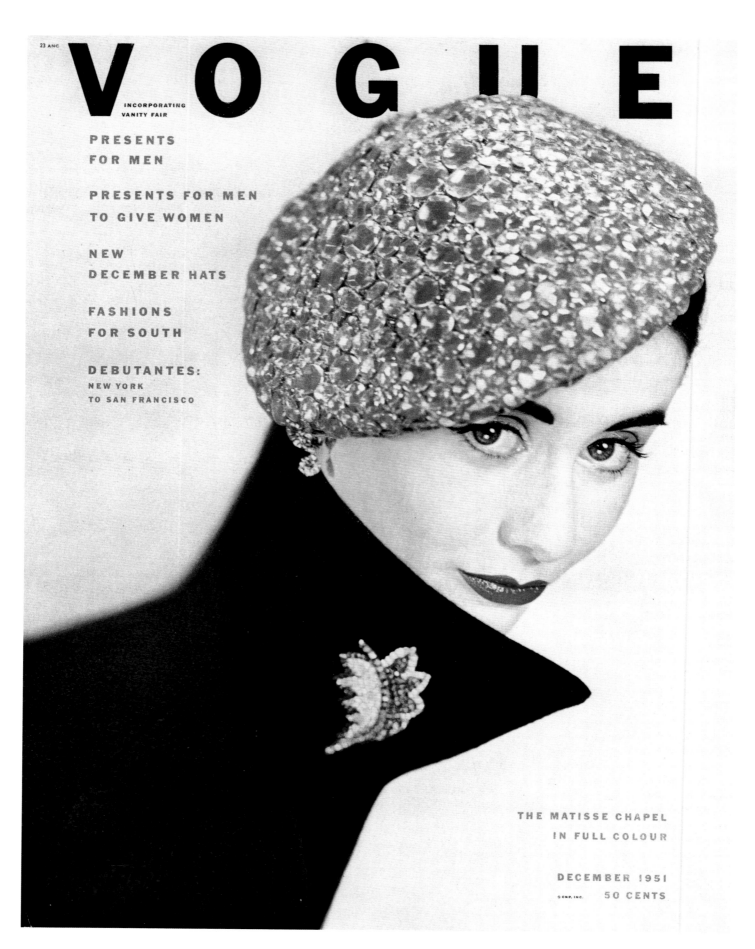

135 American *Vogue* cover, New York, December 1951.
Hat by Lilly Daché; jacket by Charles James; diamond and sapphire clip from Van Cleef & Arpels; cosmetics by Gourielli

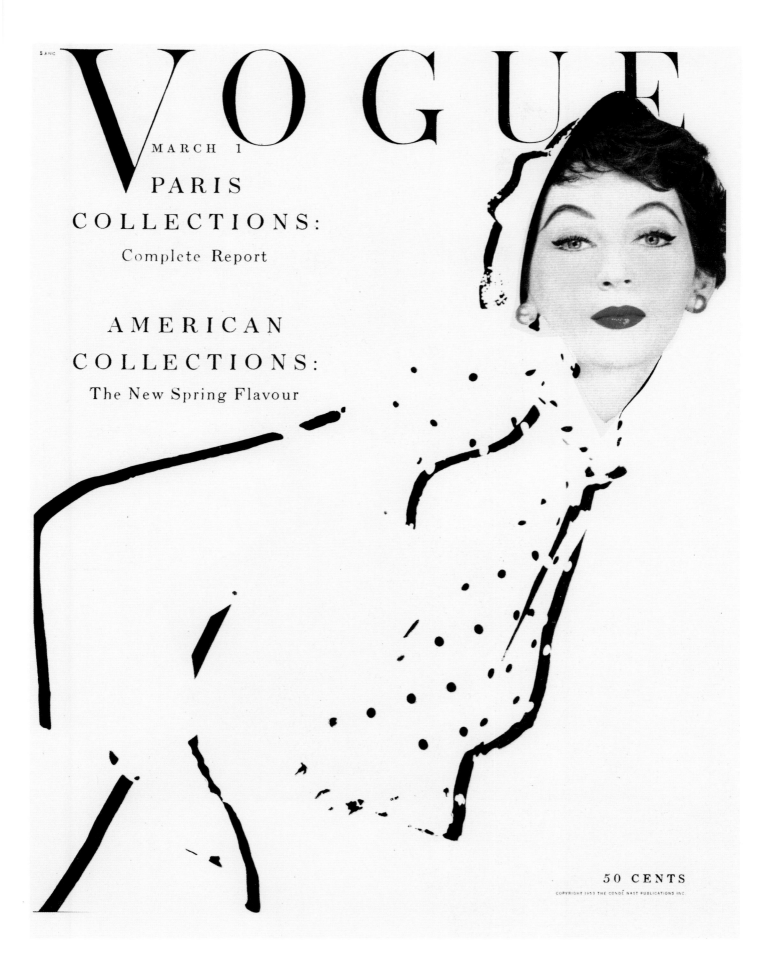

VOGUE

MARCH 1

PARIS
COLLECTIONS:
Complete Report

AMERICAN
COLLECTIONS:
The New Spring Flavour

50 CENTS

136 'American Spring Suits.' American *Vogue* cover, New York, 1 March 1953. Make-up by Yardley

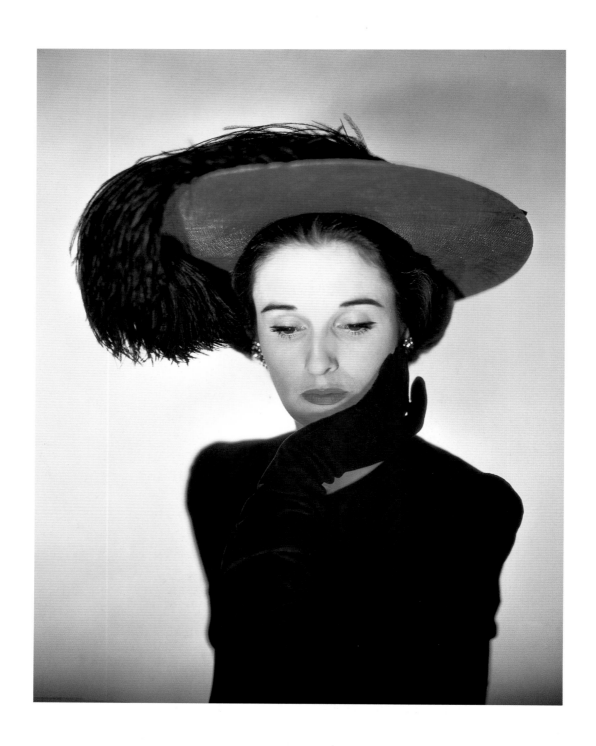

137 *Mrs Cushing Mortimer*, American *Vogue*, New York, February 1947

138 Christian Dior's 'Sargent Dress.' American *Vogue*, New York, 1 November 1949

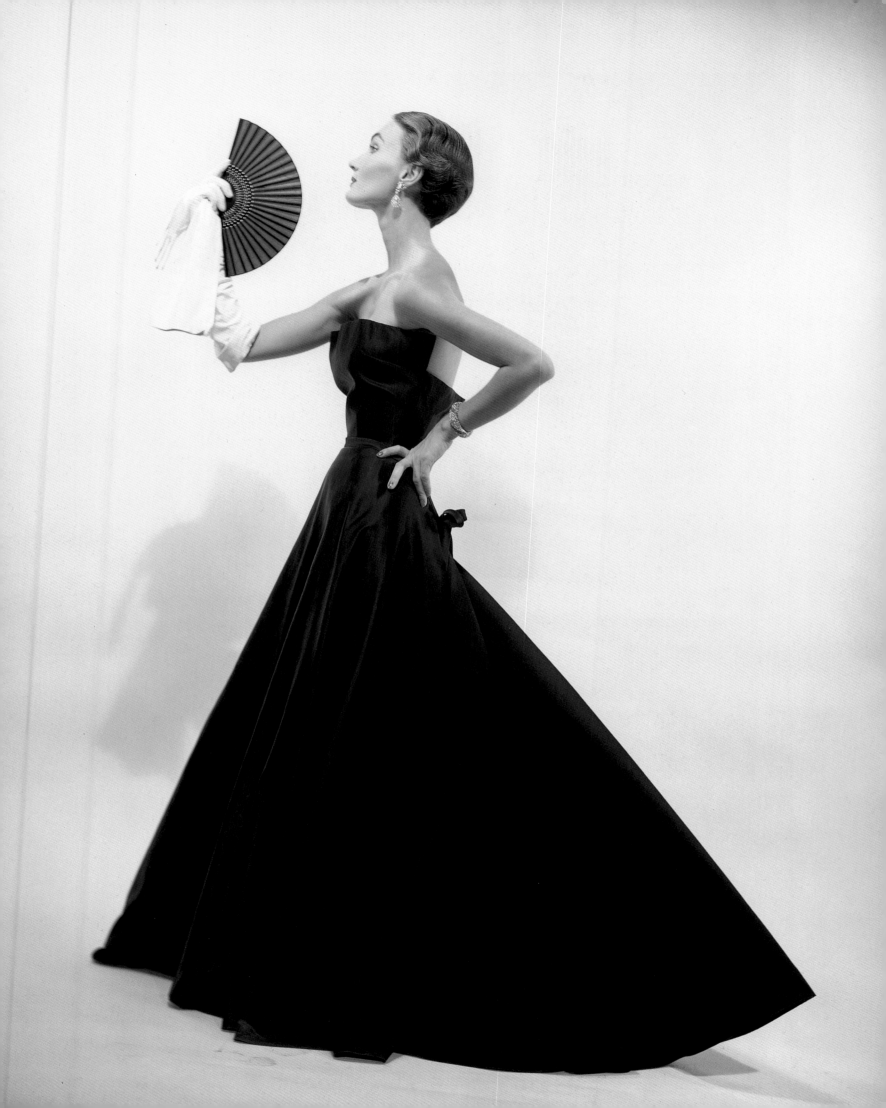

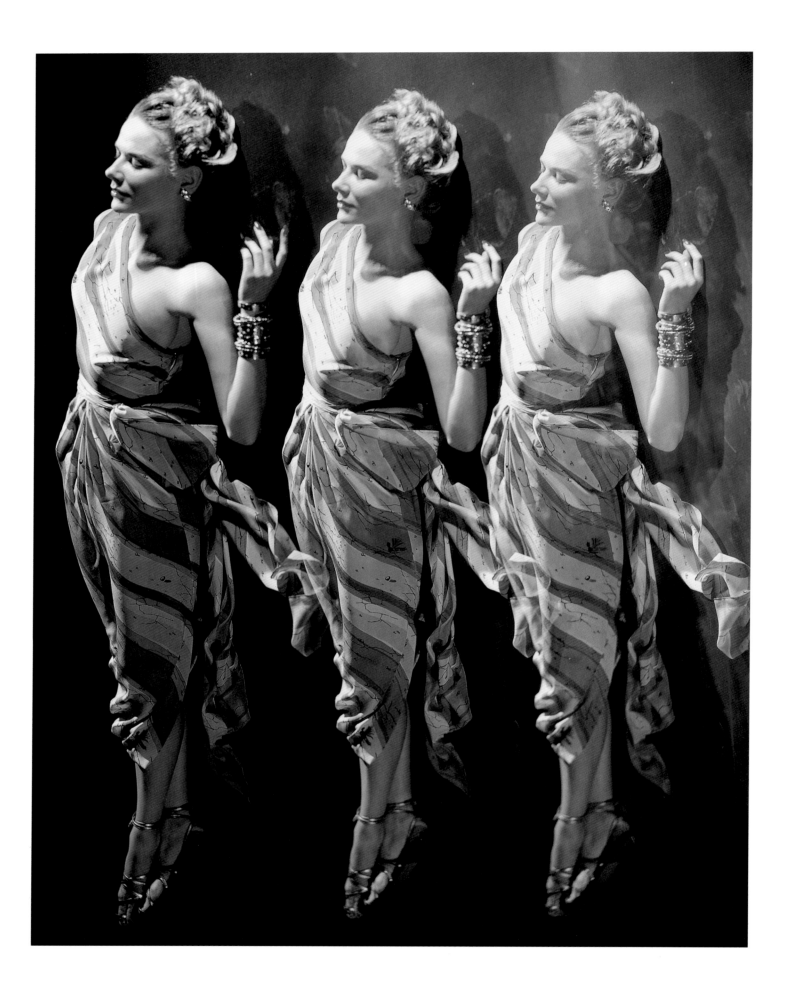

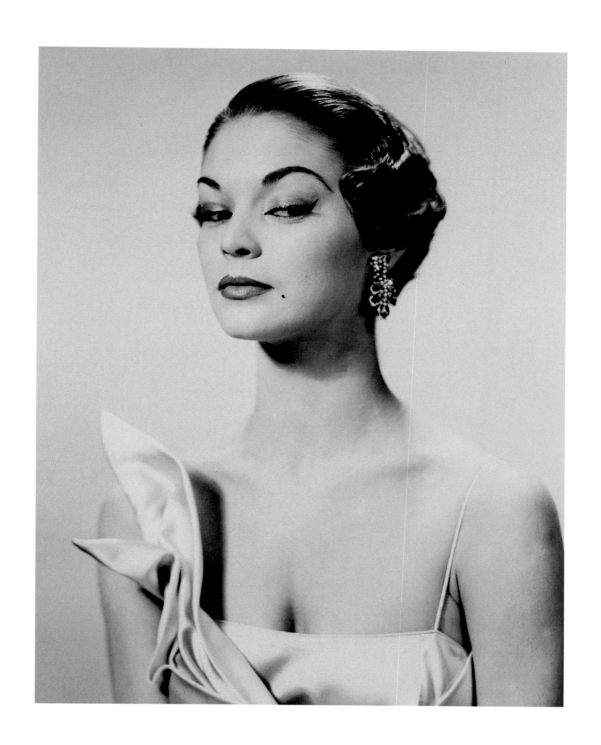

139 Dinner dress by Cadwallader (unpublished photograph), February 1947

140 Untitled beauty photograph showing make-up and coiffure, New York, 1949

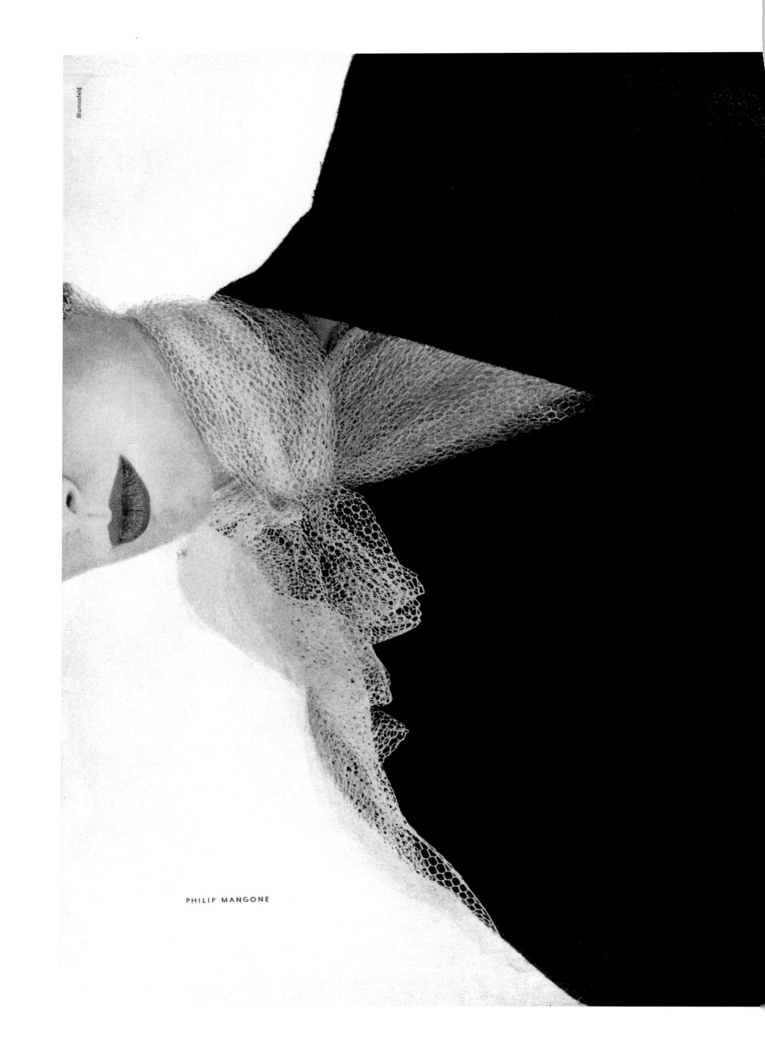

PHILIP MANGONE

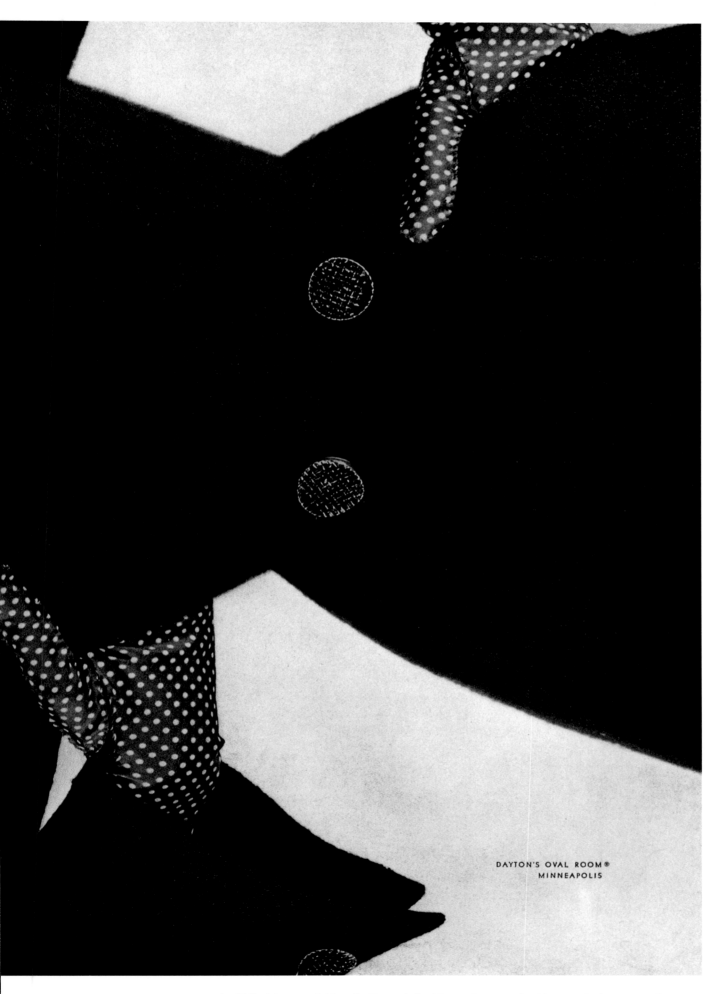

DAYTON'S OVAL ROOM®
MINNEAPOLIS

141 Philip Mangone fashions for Dayton's Oval Room, Minneapolis. Photographed in New York, *c.* 1955

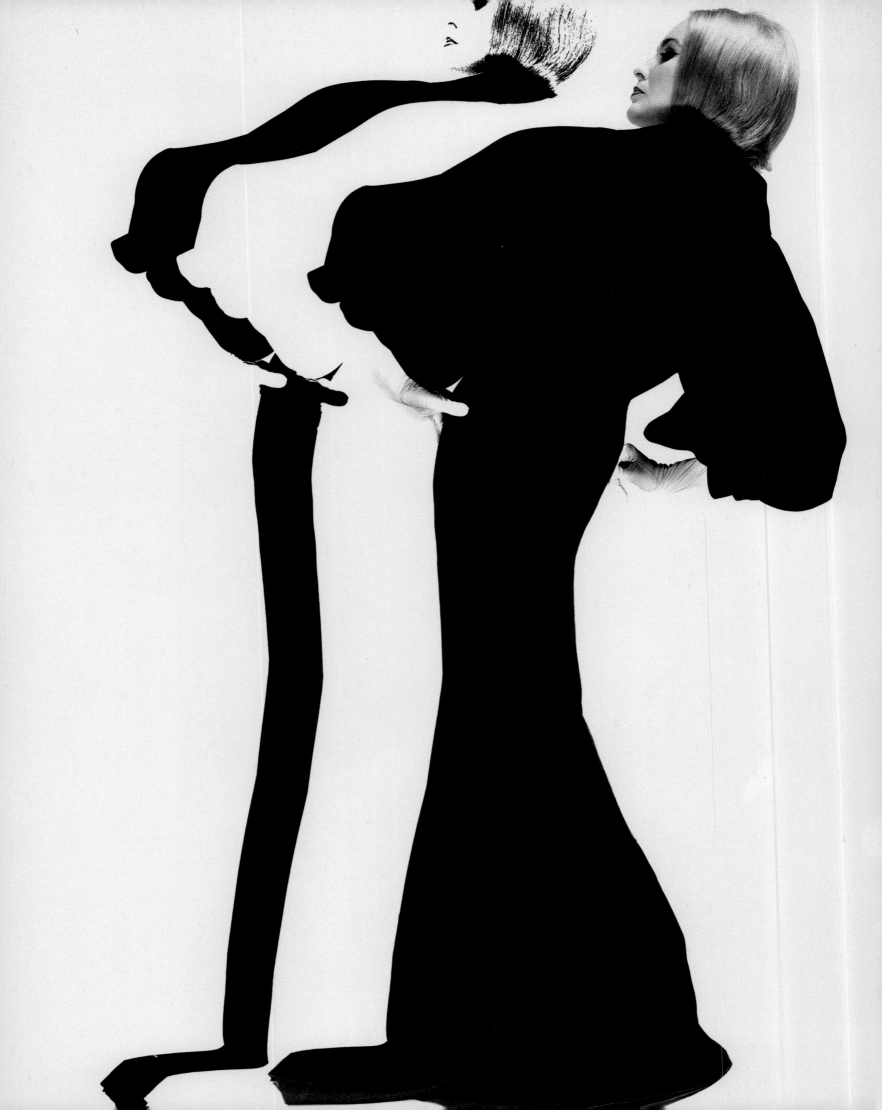

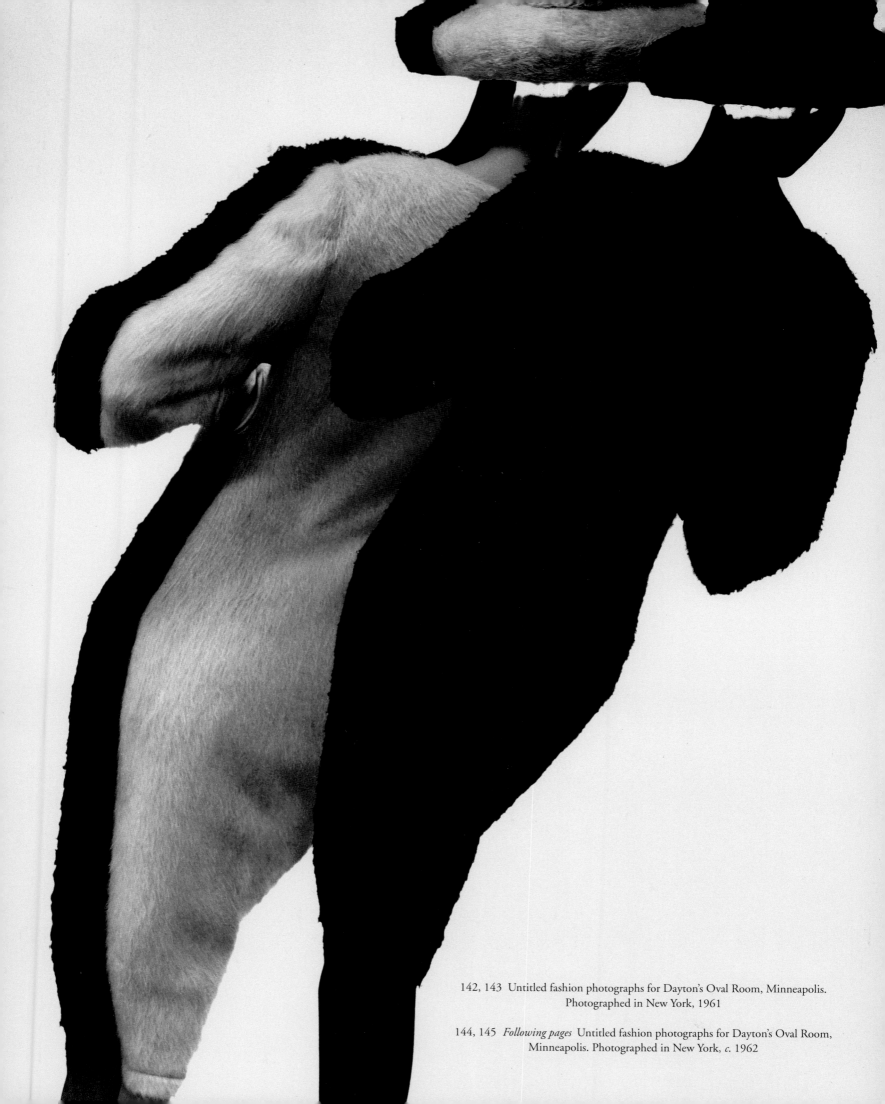

142, 143 Untitled fashion photographs for Dayton's Oval Room, Minneapolis. Photographed in New York, 1961

144, 145 *Following pages* Untitled fashion photographs for Dayton's Oval Room, Minneapolis. Photographed in New York, *c.* 1962

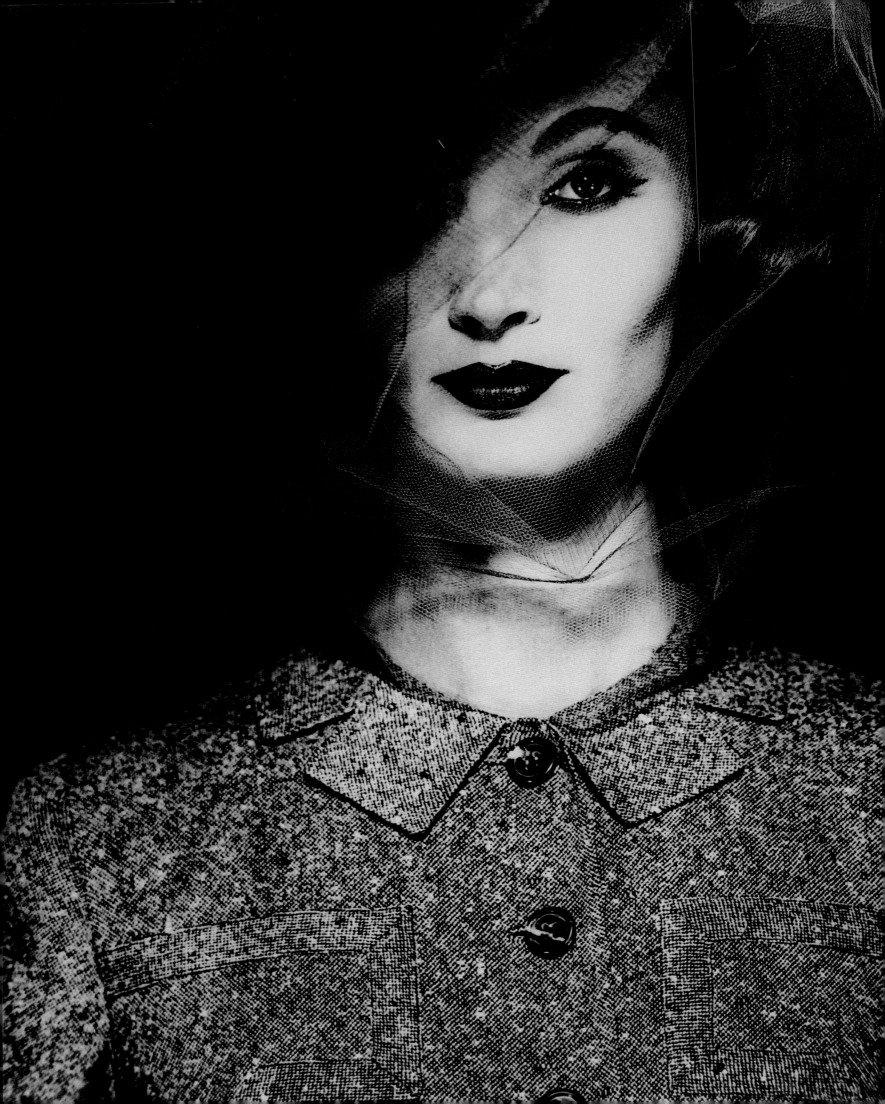

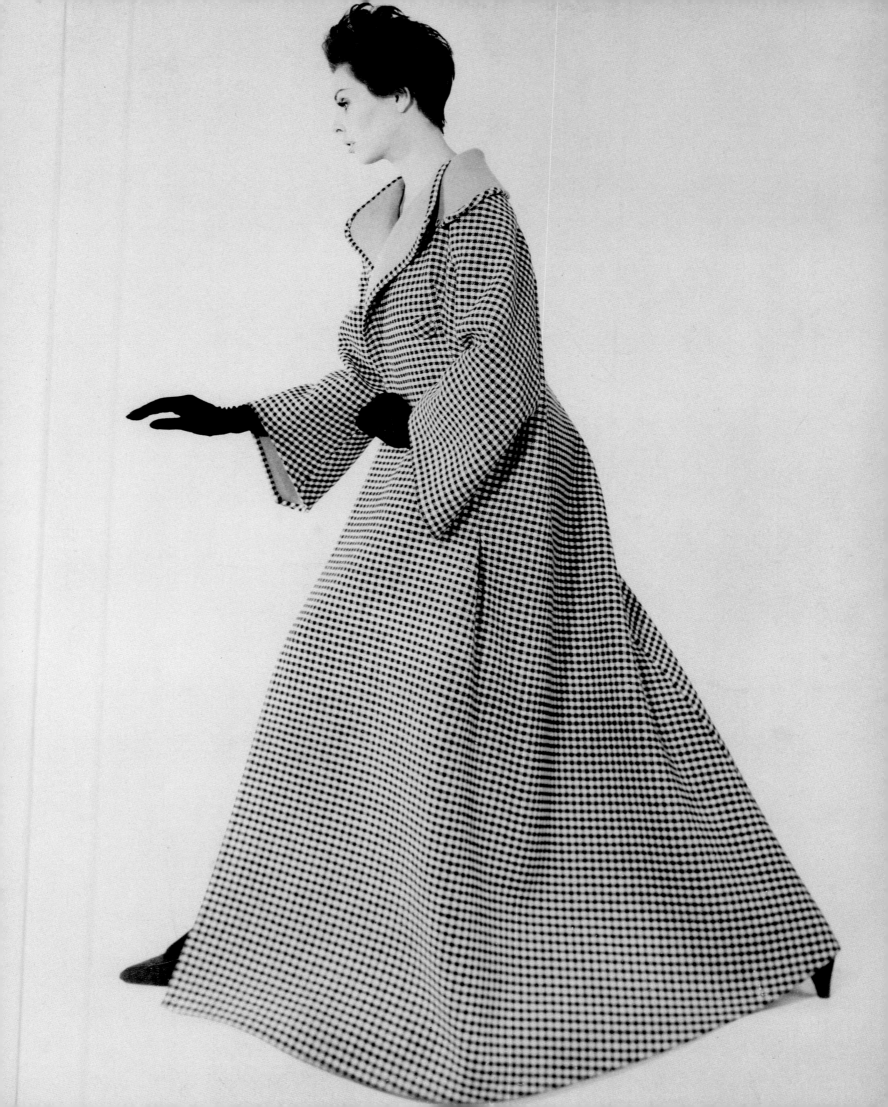

146 *Kathleen Blumenfeld* (a test shot), New York, *c.* 1956

147 *Juliette Greco*, for Columbia Records, New York, 1950

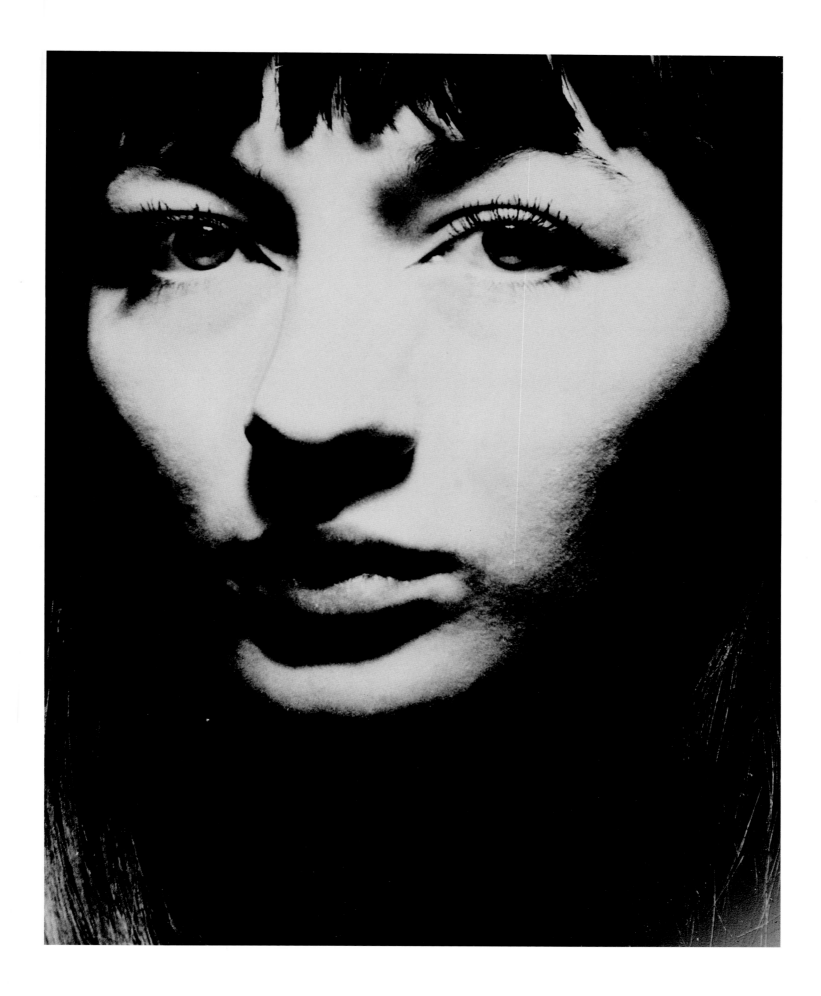

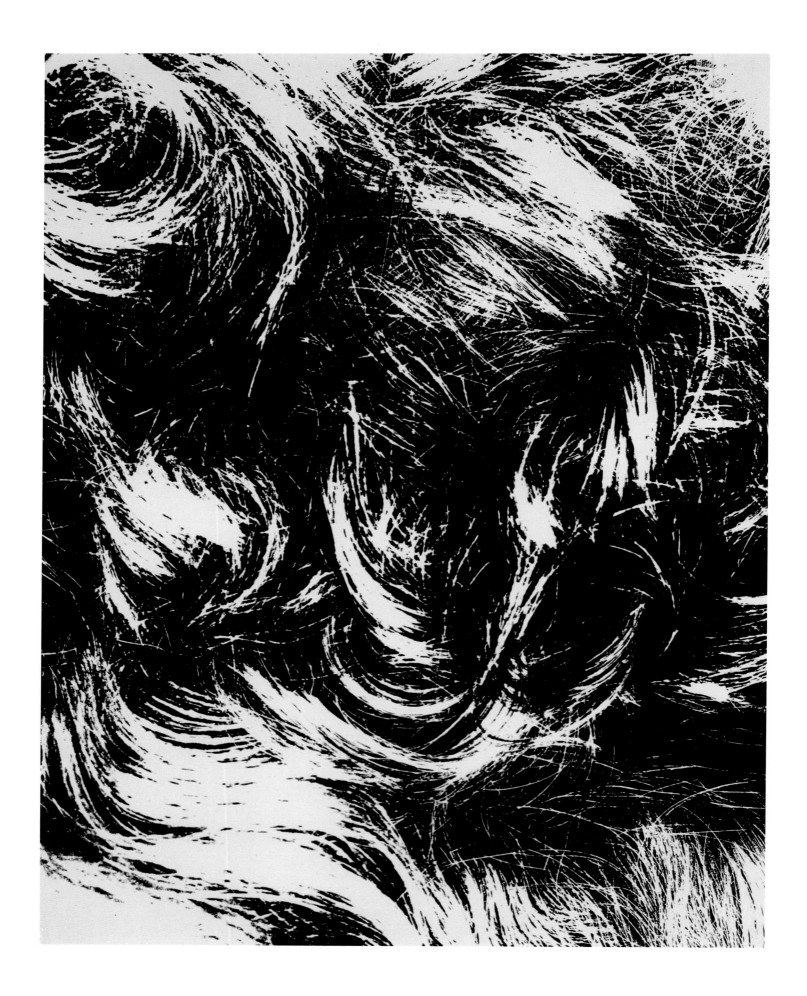

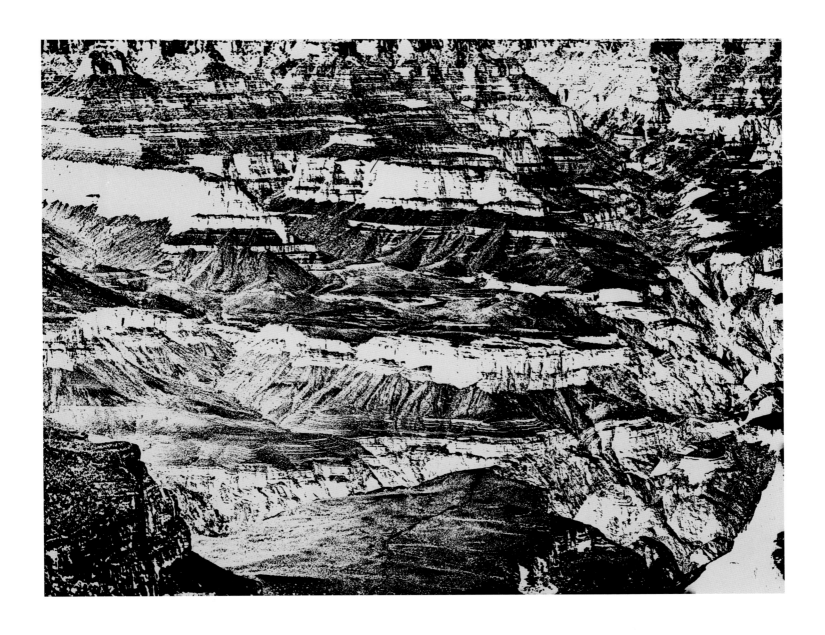

148 Untitled photograph of hair, New York, *c.* 1953

149 *Grand Canyon, Arizona*, 1953

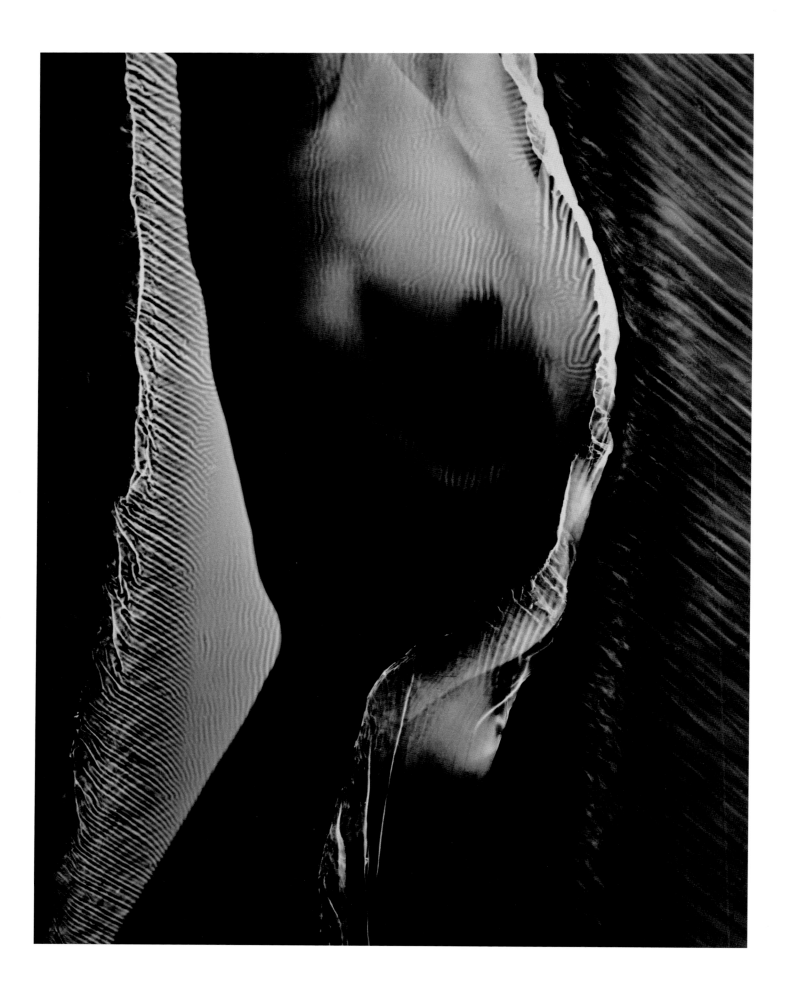

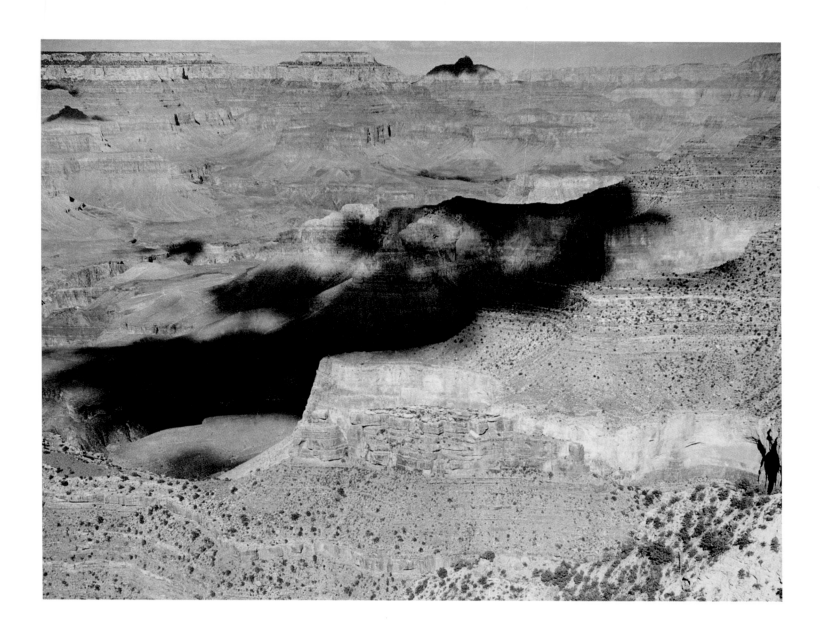

150 Untitled nude, New York, *c.* 1943

151 *Grand Canyon, Arizona,* 1953

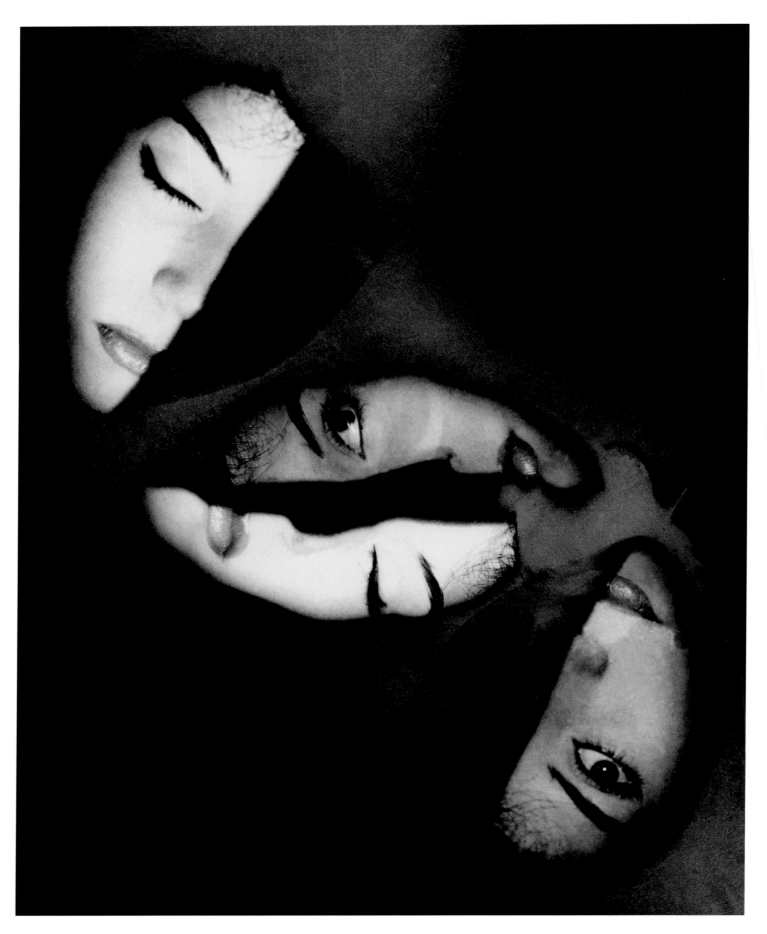

152 *Marua Motherwell*, New York, *c.* 1941

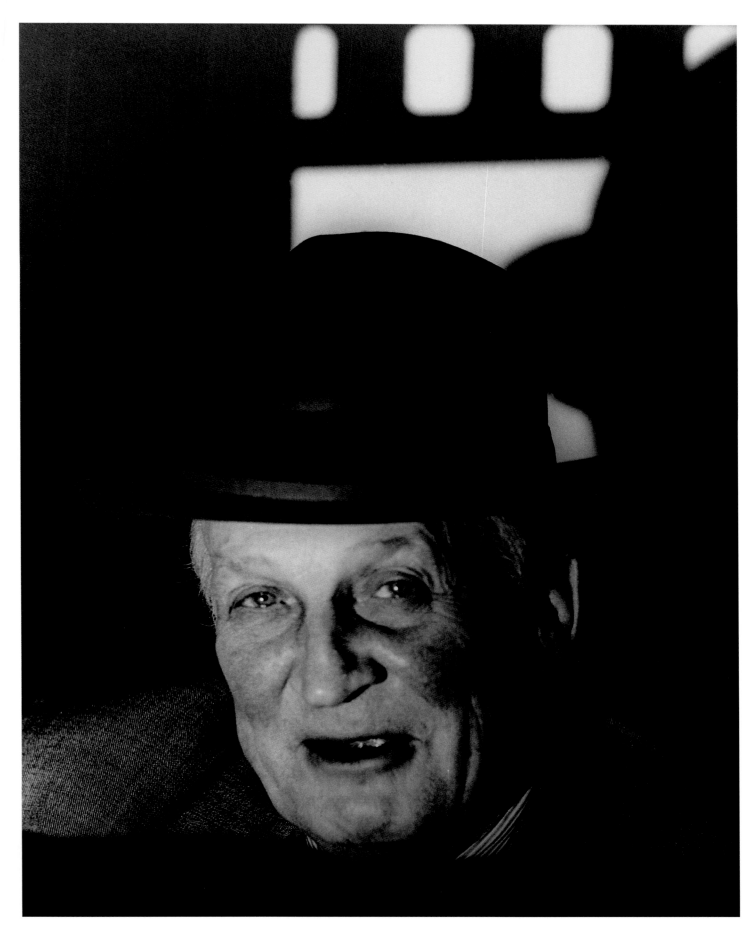

153 *The Filmmaker Robert Flaherty*, New York, 1946

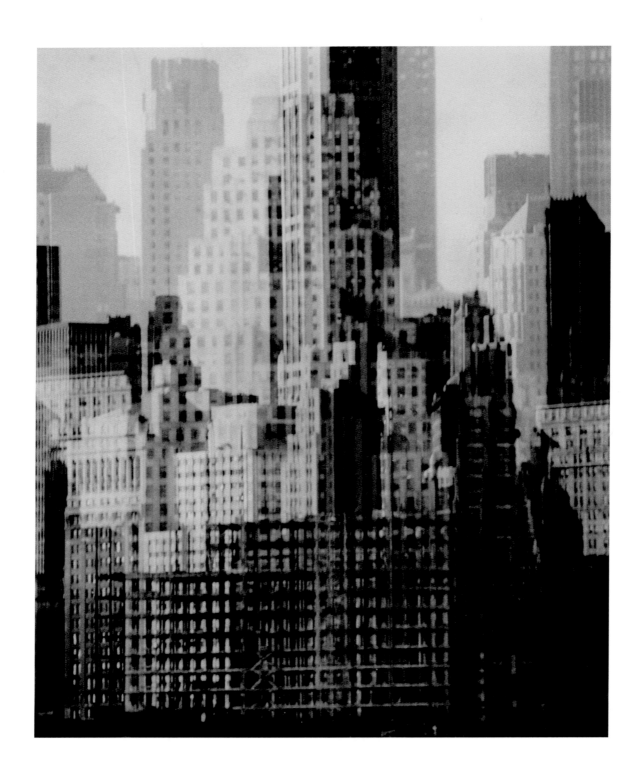

154 *New York City, c.* 1950

155 *Grand Canyon, Arizona,* 1953

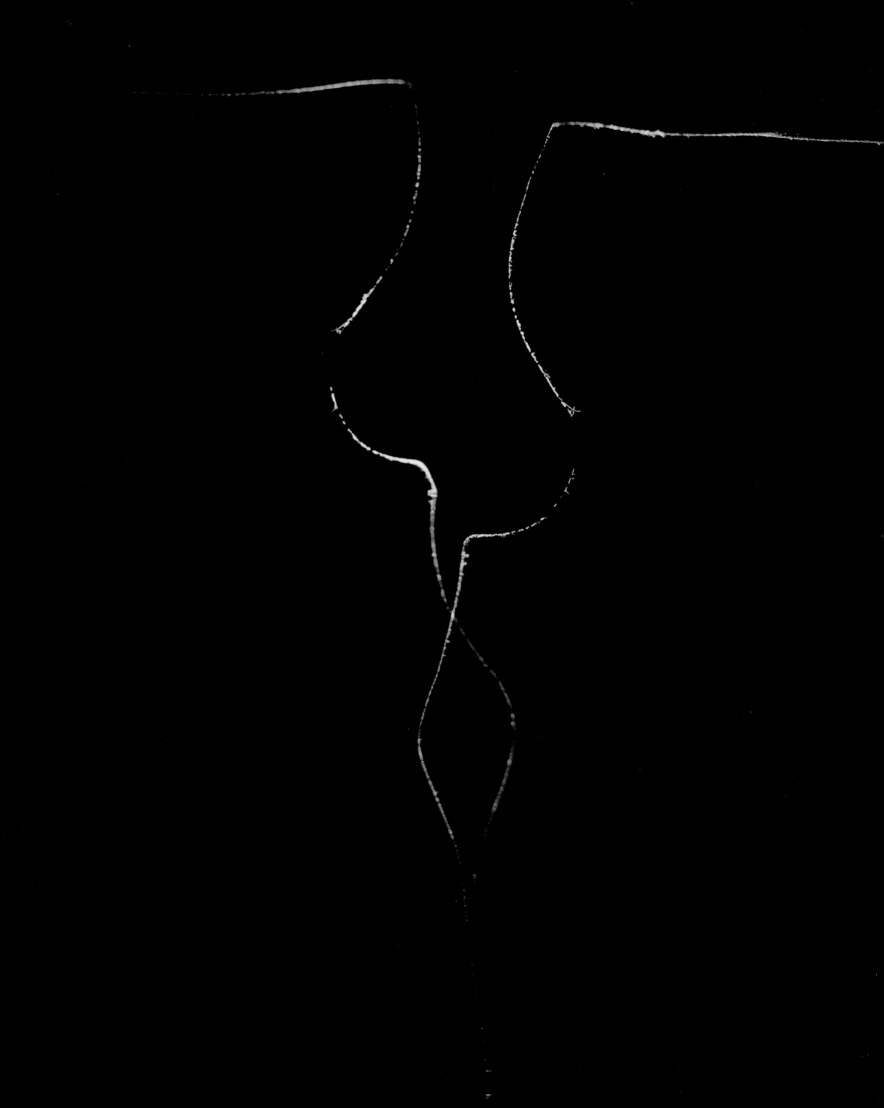

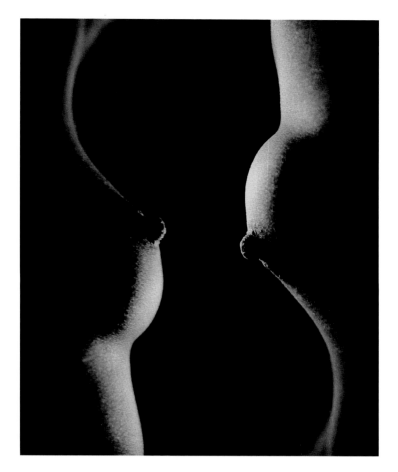

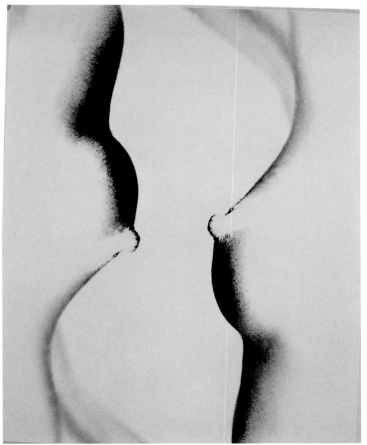

156 Untitled nude, New York, *c.* 1950

157, 158 Untitled nudes, Paris, *c.* 1937

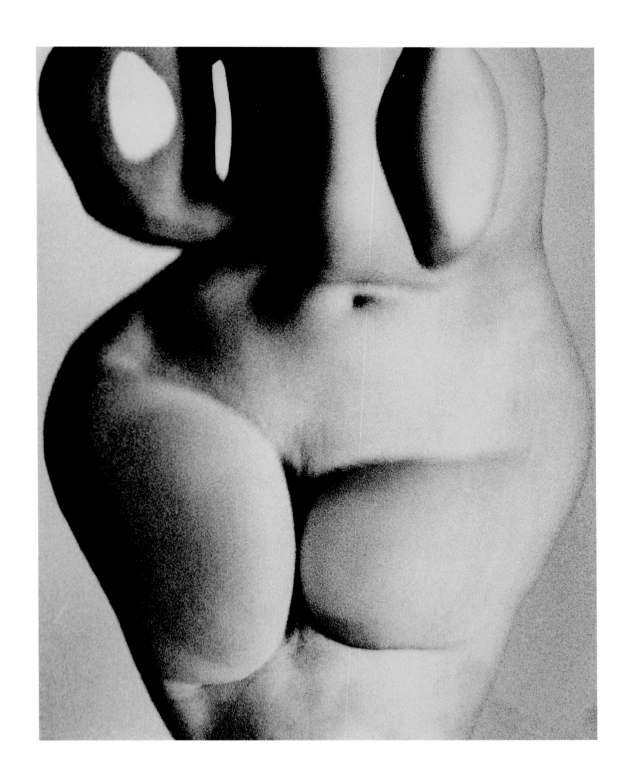

159 Untitled nude, New York, 1960

160 Untitled nude, New York, *c.* 1960

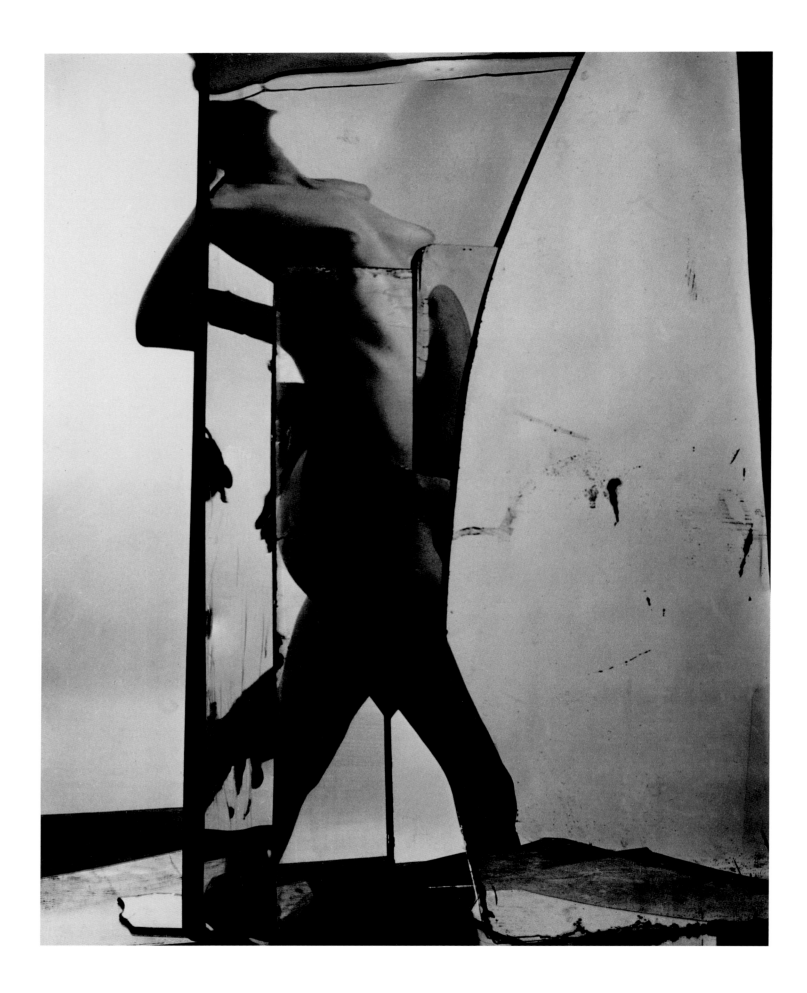

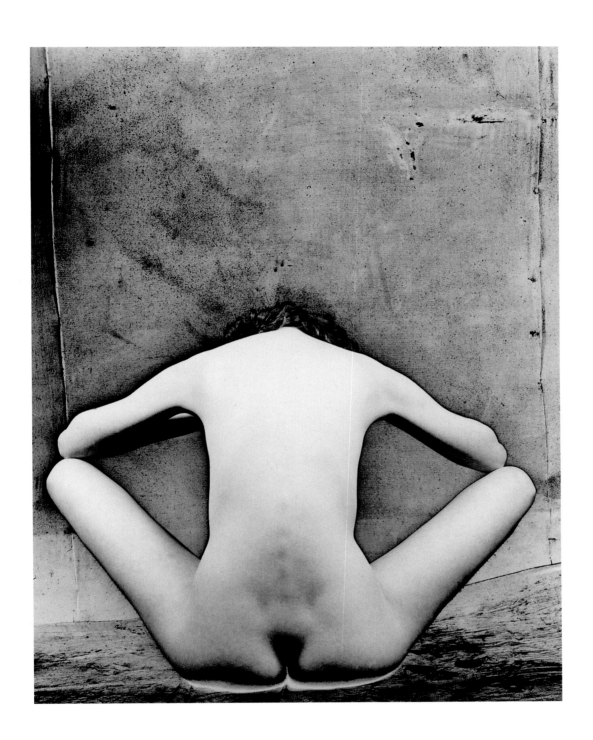

161 Untitled nude, New York, *c.* 1955

162 Untitled nude, New York, *c.* 1955

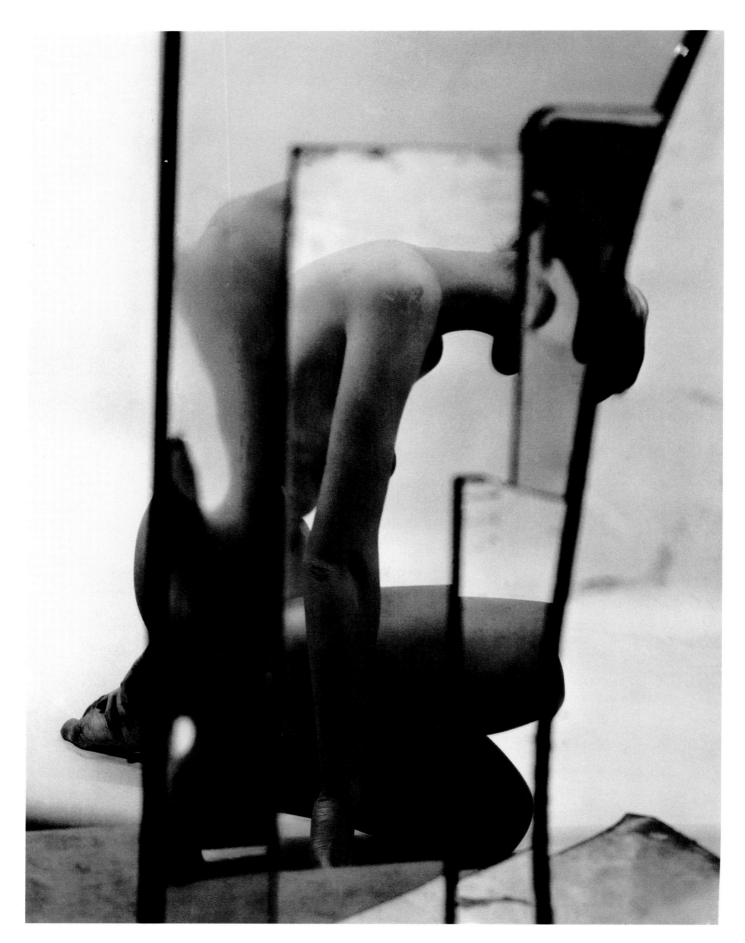

163 Untitled nude, New York, *c.* 1950

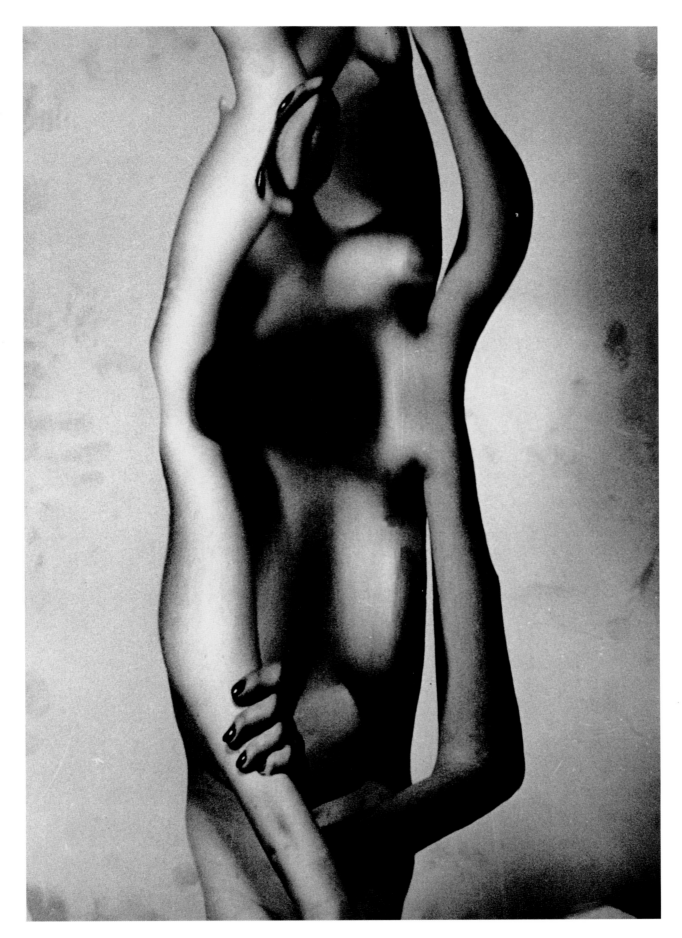

164 Untitled nude, New York, *c.* 1950

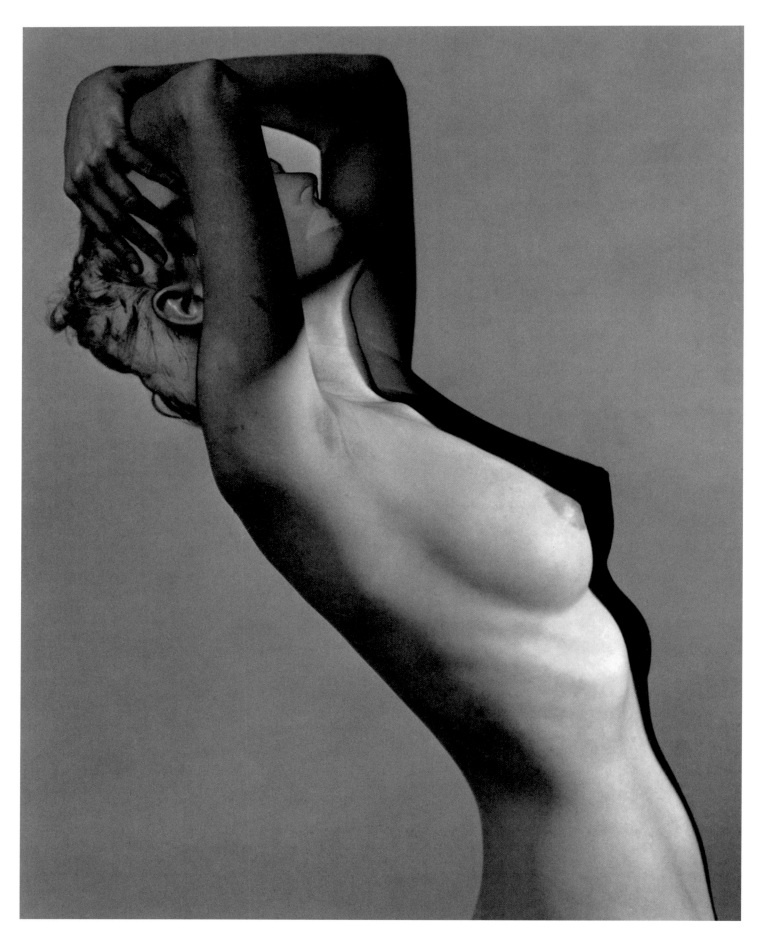

165 Untitled nude, New York, *c.* 1950

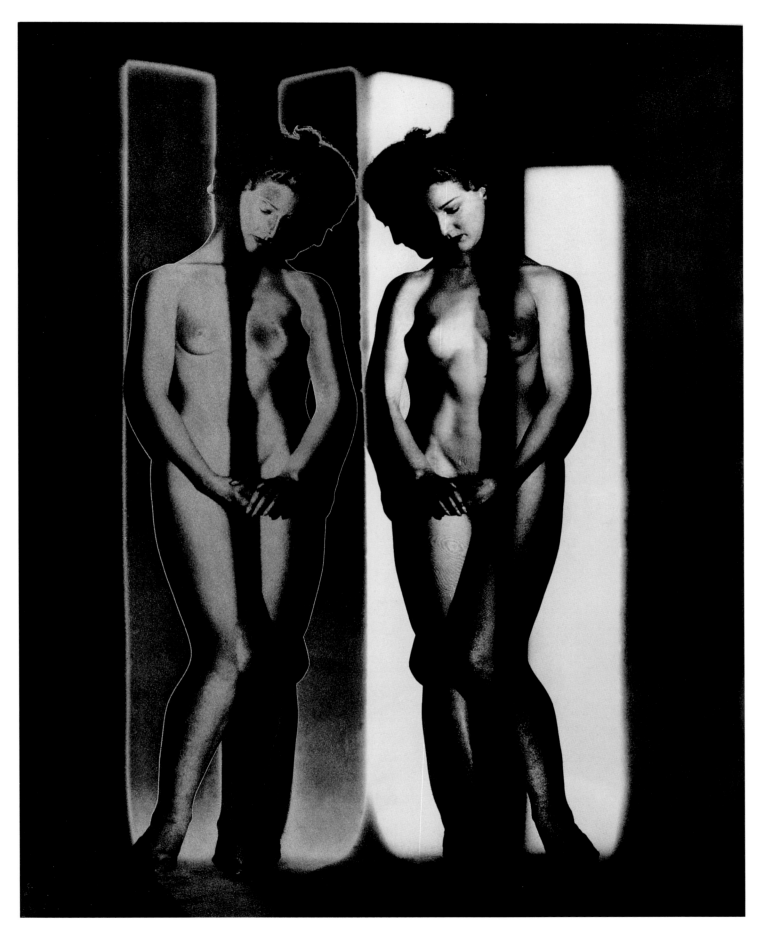

166 Untitled nude, New York, 1949

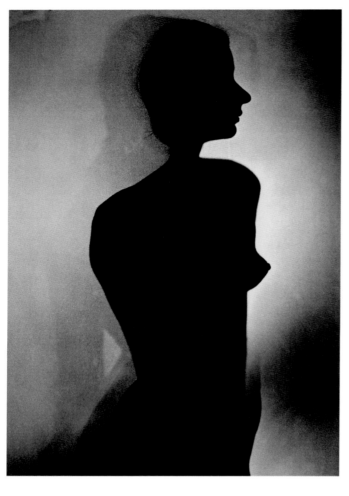
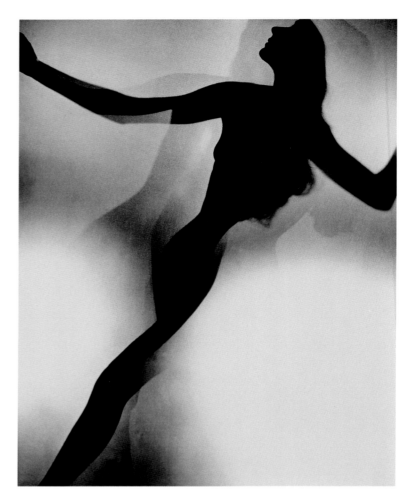
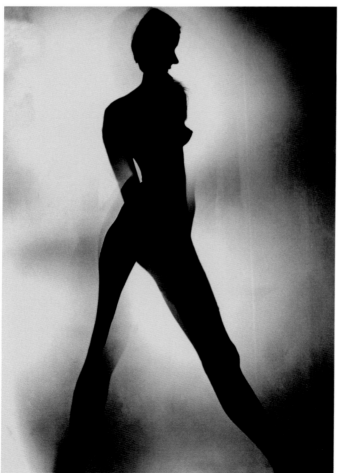
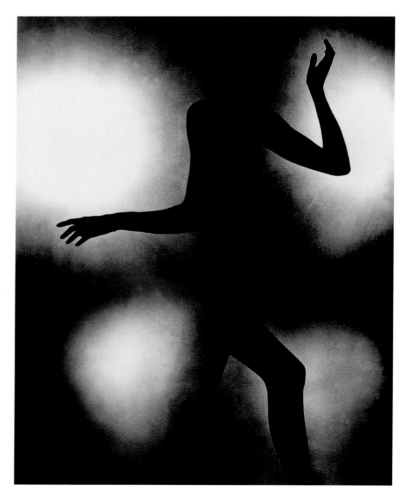

167, 168, 169, 170 Untitled nudes, New York, *c.* 1950

171 Untitled, New York, *c.* 1950

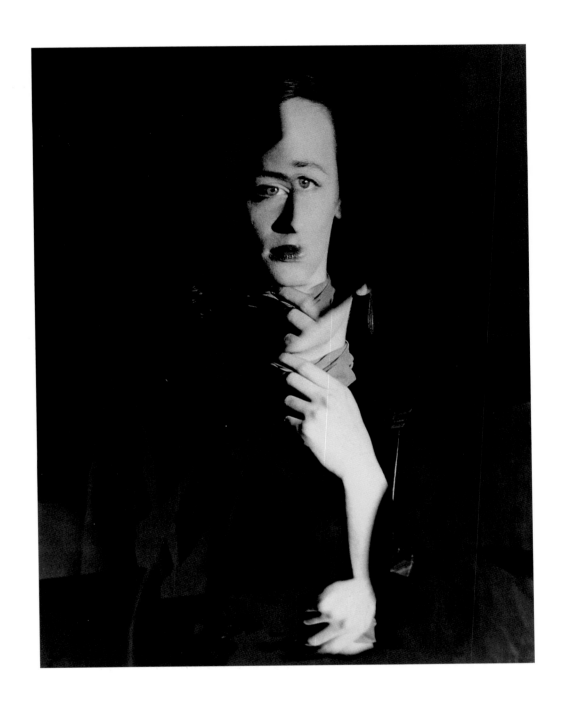

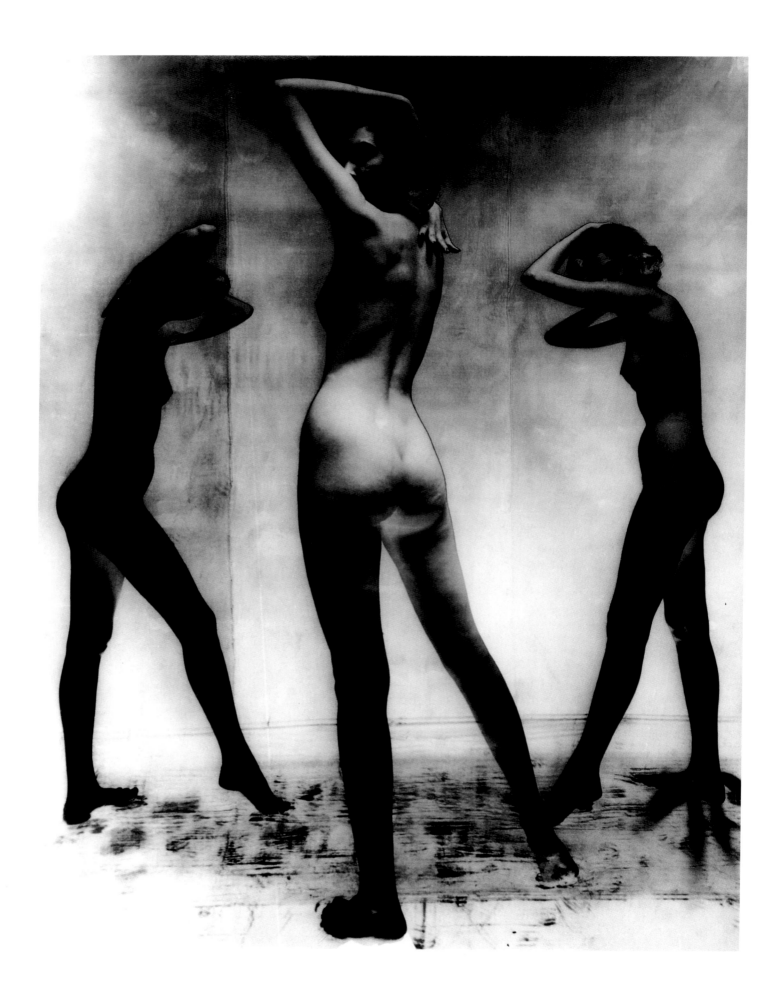

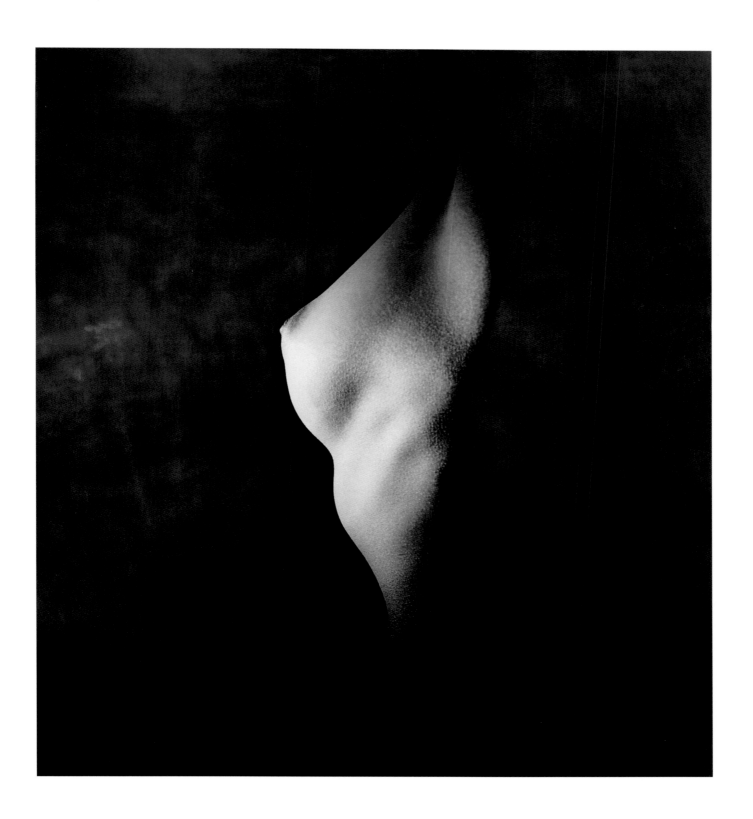

172 Untitled nude, New York, *c.* 1952

173 Untitled nude, New York, *c.* 1948

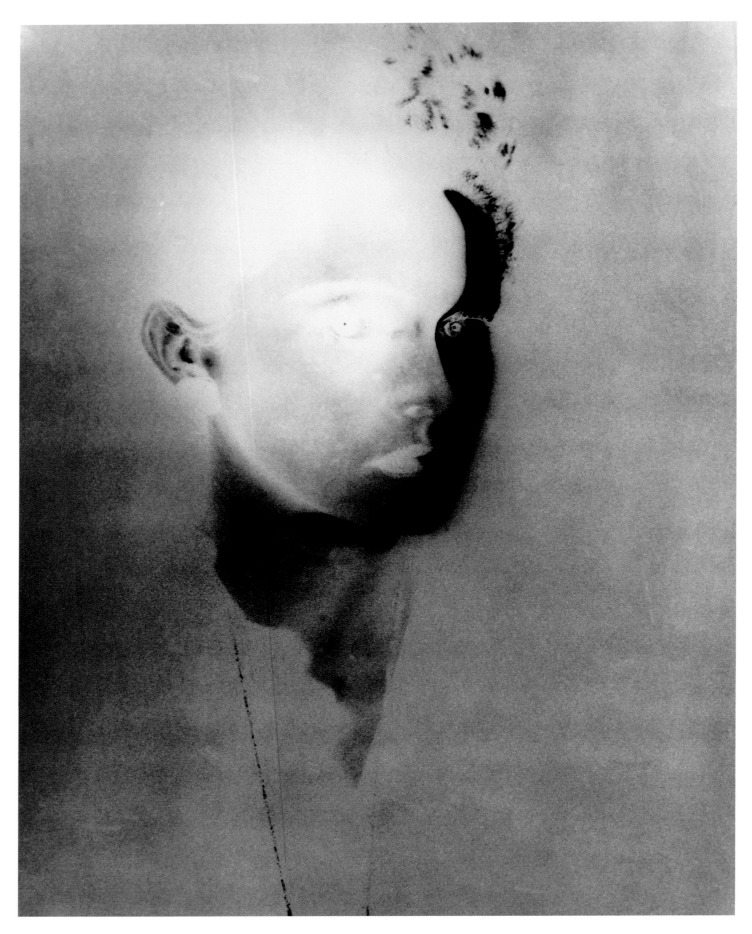

174 Untitled, New York, *c.* 1945

175 Untitled nude, New York, *c.* 1950

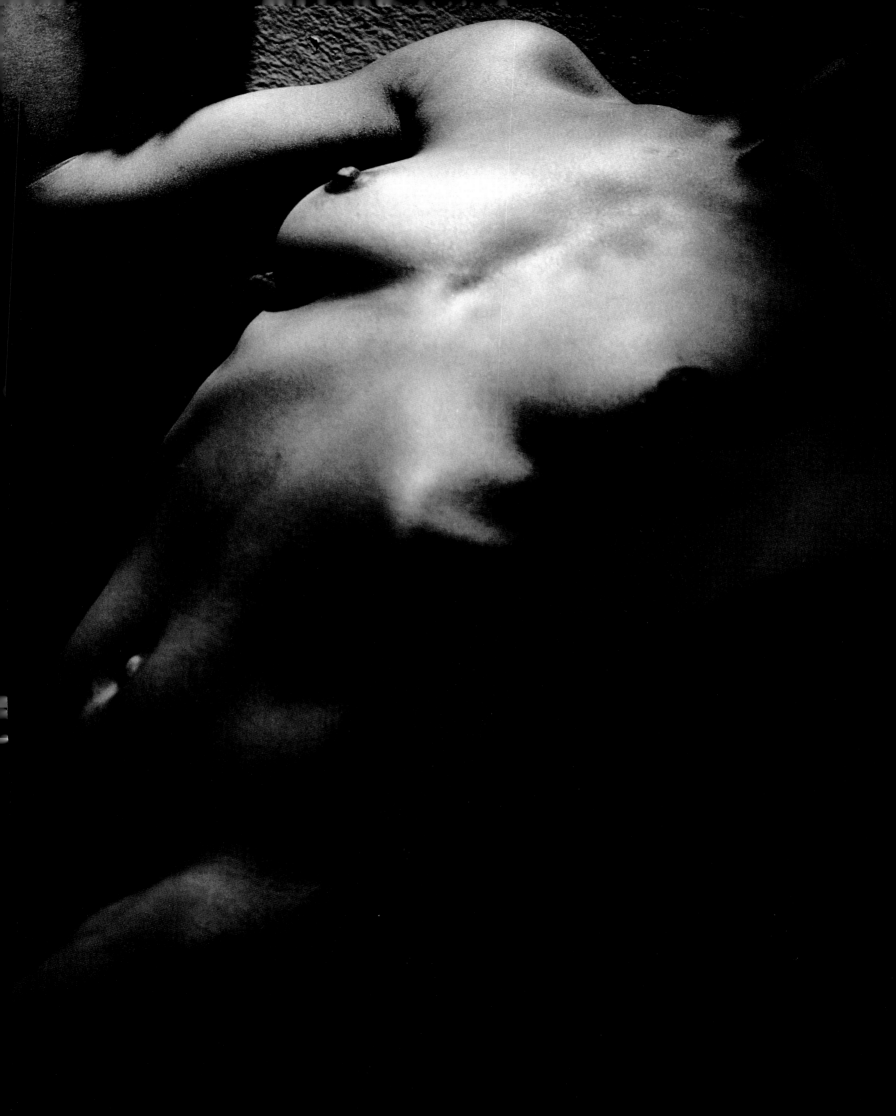

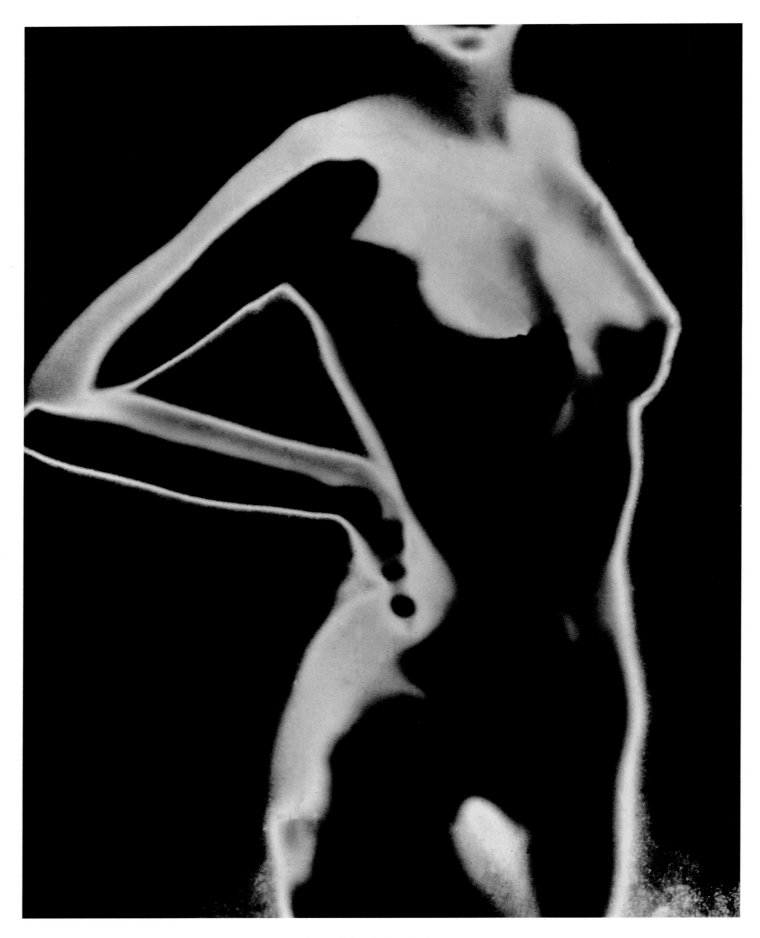

176 Untitled nude, New York, *c.* 1955

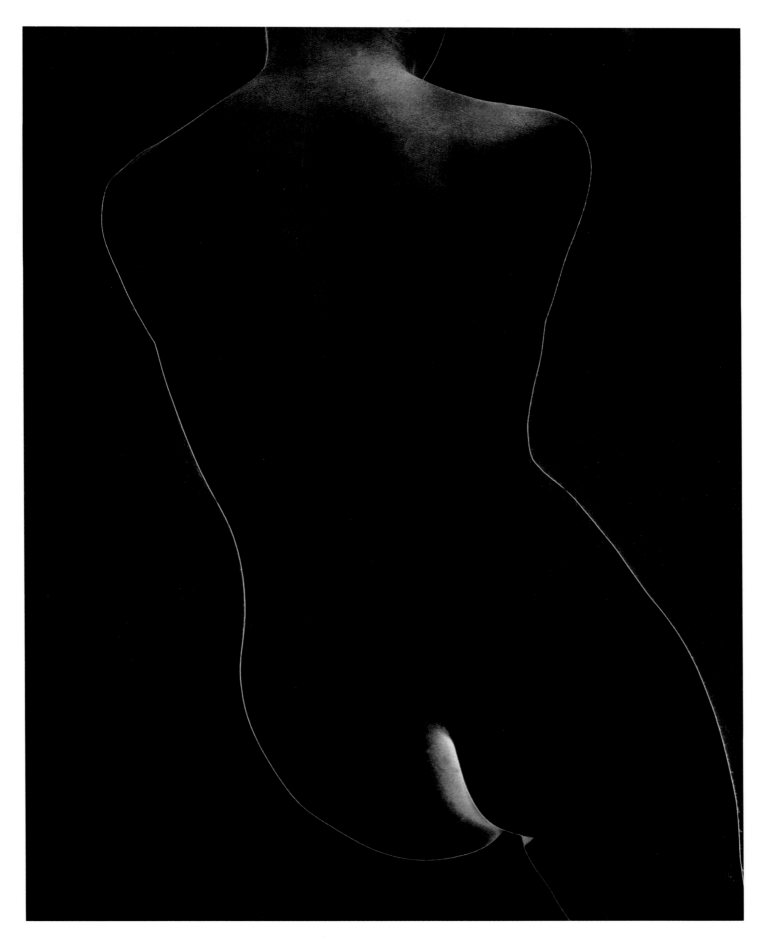

177 Untitled nude, New York, *c.* 1950

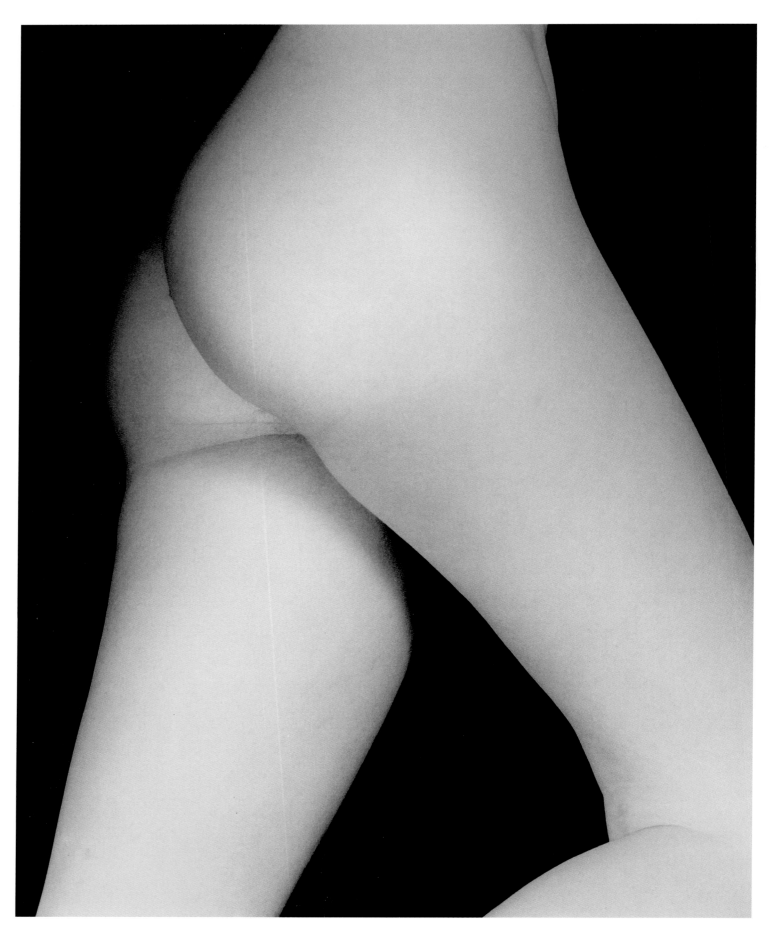

178 Untitled nude, New York, *c.* 1955

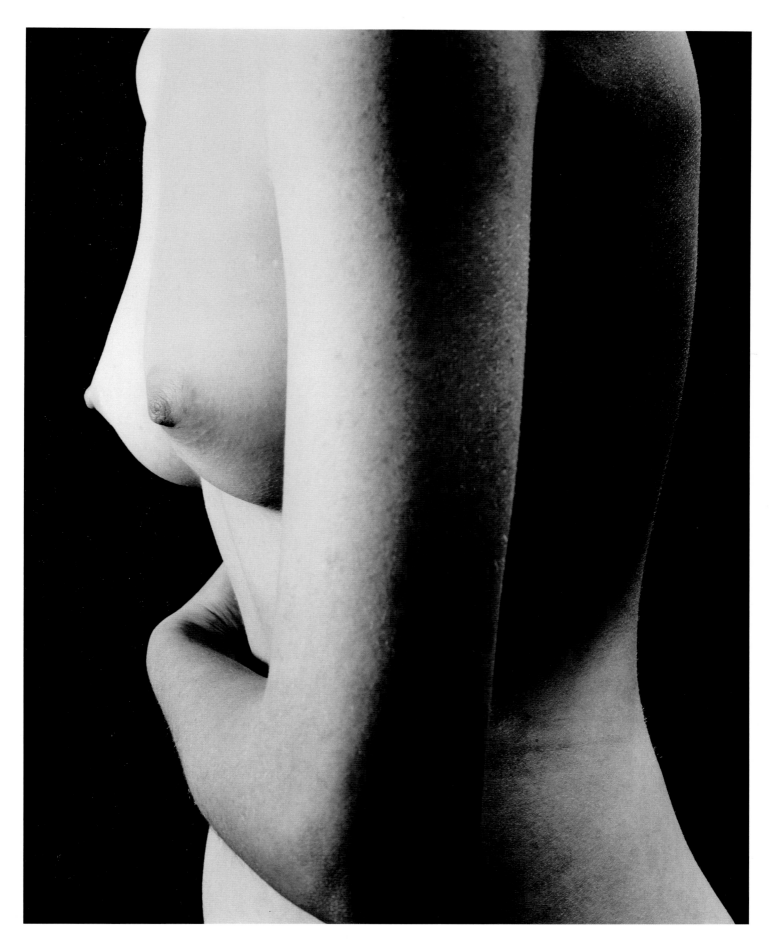

179 Untitled nude, New York, *c.* 1955

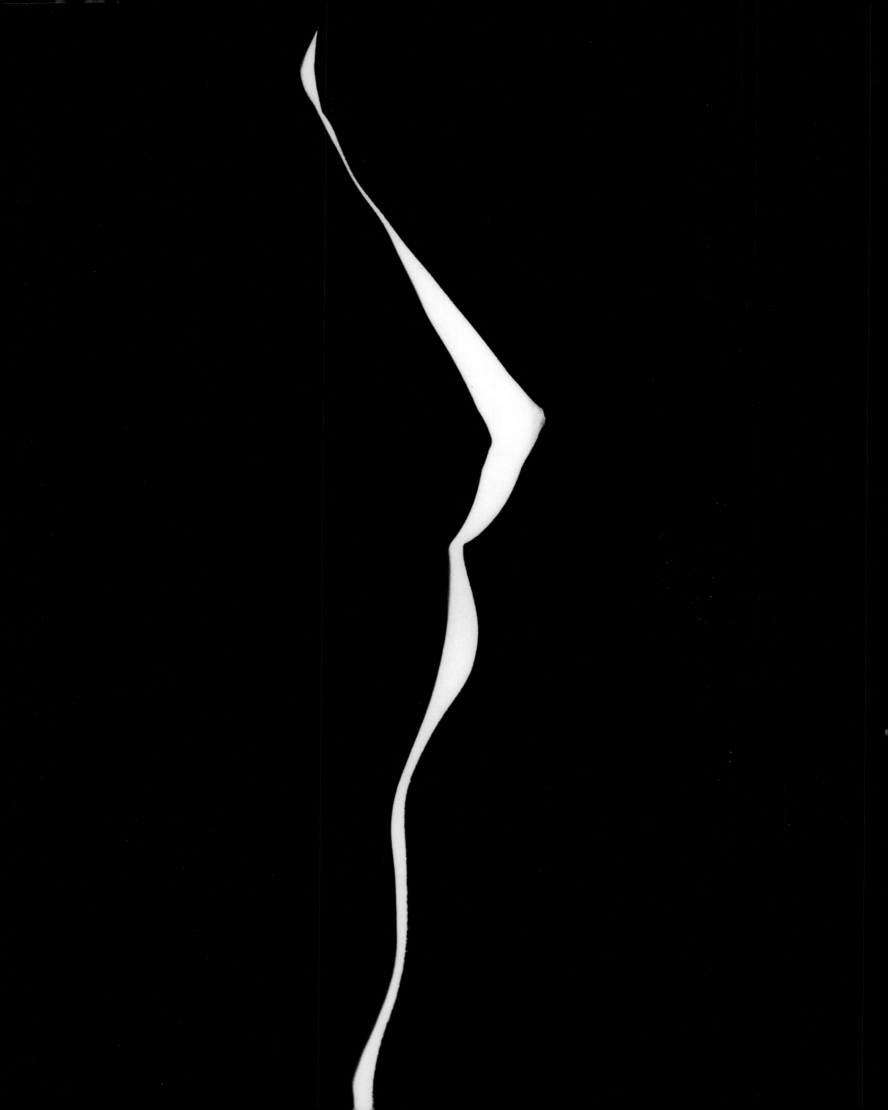

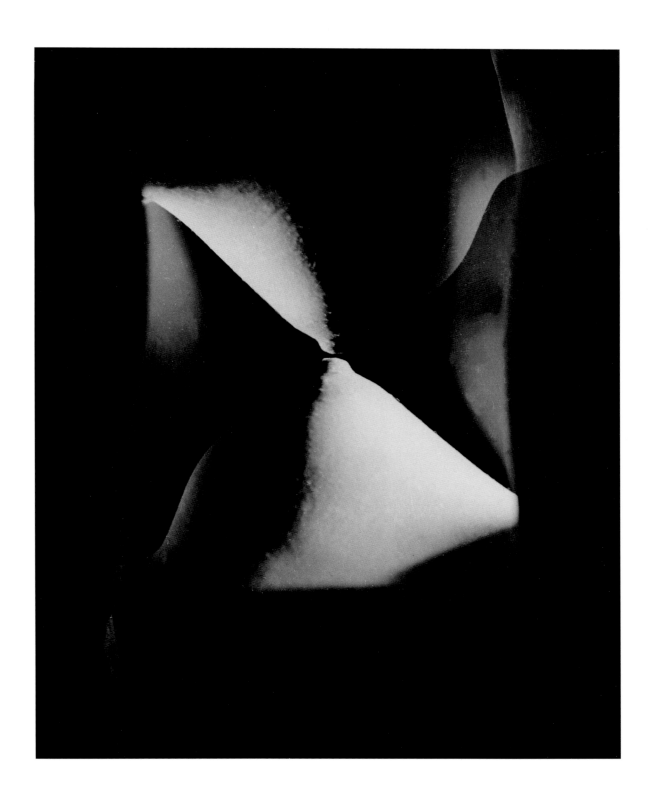

180 Untitled nude, New York, *c.* 1948

181 Untitled nude, New York, *c.* 1948

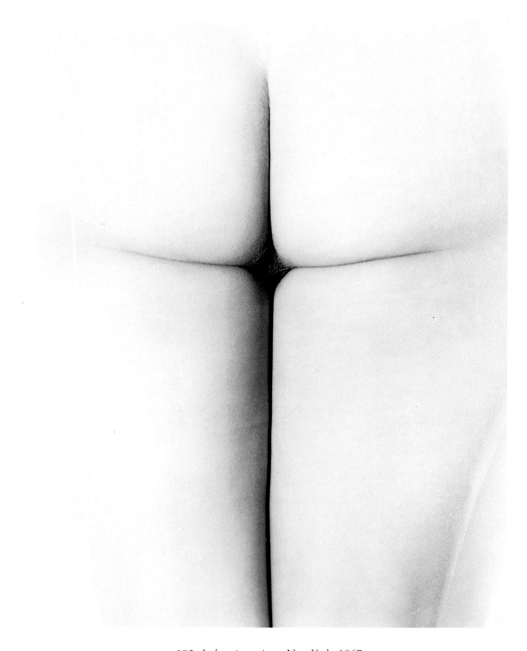

182 *In hoc signo vinces*, New York, 1967

Chronology

1897 26 January: Birth of Erwin Blumenfeld in Berlin, Germany, to Emma
(Cohn) and Albert Blumenfeld; second of three children
(Annie, b. 1894, and Heinz, b. 1900).

1899 *The Royal Academy in Berlin exhibits photography for the first time,
thereby sanctioning it as an art.*

1903 Enrolls at the Askanisches Gymnasium in Berlin. Meets Paul Citroen.
Alfred Stieglitz founds the review Camera Work, *soon to be followed by the
opening of the Little Galleries of the Photo Secession.*

1907 Takes up photography on receiving a camera as a gift.
Experiments enthusiastically with a chemistry set and a magic lantern.

1911 Photographic self-portrait as Pierrot, using a mirror to obtain
simultaneous frontal and profile views.

1913 Finishes his formal education and leaves with
secondary-school certificate.
Gives up thoughts of further education on the death of his father;
the family is virtually bankrupt.
Starts a three-year apprenticeship in the women's garment trade at
Moses & Schlochauer in Berlin.

1914 *Baron Adolf de Meyer hired as chief photographer at* Vogue.

1915 With his best friend from school, Paul Citroen, begins to frequent the
Café des Westens, favourite meeting place of the Expressionists; meets
a number of the key figures, including the poet Else Lasker-Schüler
and the artist George Grosz, who will become a lifelong friend.

1916 Meets Lena Citroen, cousin of Paul Citroen, with whom he has
conducted a lengthy correspondence; they become engaged soon after.
Writes poetry and draws, and plans to become an actor.

1917 Conscripted into the German army in March; sent as an ambulance
driver to the Western Front; wins the Iron Cross (Second Class) for
bravery; also serves for a brief interlude as a bookkeeper in the army's
'Field Brothel 209' near the Belgian border.

1918 On home leave in June plans to desert to Holland but is arrested and
imprisoned before he can put his plans into effect; released, he is
returned to his unit at the Front; there he learns of the death of his
brother, Heinz, near Verdun.
At war's end he returns briefly to Berlin; in December he goes into
self-exile in Holland in order to join his fiancée, Lena.
Paul Citroen goes to Amsterdam as the representative of Der Sturm.

1919–1922 Makes various attempts to secure a livelihood, including working for a
bookseller; joins Paul Citroen, who has set himself up as an art dealer,
but abandons this attempt when it becomes evident that there is
virtually no market in Holland for contemporary art.
Becomes 'a Sunday painter', makes collages and drawings, and
participates in the Dada movement along with Paul Citroen.
Photographs family and friends strictly as an amateur.
Continues to write poetry and also composes short stories.

1921 Marries Lena Citroen and honeymoons in Berlin.
Produces *Charlie*, his best known collage.

1922 *Man Ray invents his cameraless photographs which he calls 'Rayogrammes'.*
Birth of his daughter, Lisette.

1923 1 June: Goes into the leather goods business, opening a shop at
116 Kalverstraat under the name 'Fox Leather Company'.

1925 Birth of his son Heinz (Henry).

*Paul Citroen establishes a portrait studio business in Berlin with
the photographer Umbo.
Moholy-Nagy publishes* Malerei, Fotografie, Film.

1929 August: Arrested on Zaandvoort beach for allowing a strap of his
bathing suit to slip; this dashes chances of Dutch citizenship,
for which he has applied.
*Citroen settles permanently in Holland and takes up photography.
'Film und Foto', large-scale international survey of innovative contemporary
photography, Stuttgart.*

1930 *Man Ray makes his first solarizations.*

1932 Birth of his son Yorick.
Moves premises further down the street to 151 Kalverstraat and discovers
an operational darkroom on the premises; begins to photograph
female customers (for the most part portraits but also some nudes)
both out of rekindled interest in photography and with the idea of
making money.
Exhibits at the art gallery, Kunstzaal van Lier, Amsterdam.
Submits work to the Ullstein Verlag publishing house in Berlin for
appraisal, without success.

1934 Second exhibition of photographs at Kunstzaal van Lier.
Alexey Brodovitch becomes art director at Harper's Bazaar.
Still photographer on Jacques Feyder's *Pension Mimosas* (1935).

1935 Bankruptcy of Blumenfeld's leather goods store, Fox Leather Company.
Moves his portrait studio to the Keizersgracht.
His first few photographs are published in the French
magazine *Photographie*.
Exhibits at the Esher Surrey Art Galleries in The Hague.
His work is included in a group show organized by Paul Citroen at
the Nieuwe Kunstschool (New Art School) in Amsterdam, along with
Grosz, Umbo, Man Ray, Moholy-Nagy, Arp, Delaunay, Léger,
Mondrian, Schwitters and others.
Meets George Rouault's daughter Geneviève, a dentist, on a visit to his
shop; she arranges to exhibit his work in her waiting room
near the Opéra, Paris.

1936 Leaves Holland and settles in Paris with the aim of becoming a
professional photographer.
Geneviève Rouault helps him secure clients for portraits.
Photographs Georges Rouault and Henri Matisse,
among other well-known Parisians.
Takes on advertising work: Mon Savon, Dop Shampoo,
Pathé Marconi and other clients.
Exhibits his portraits at Galerie Billiet, Paris.
Rents a studio at 9, rue Delambre, where he continues with his
personal work in addition to his commercial activities.

1937 First magazine cover: *Votre Beauté* (February).
Photographs published in *Verve* (Winter 1937 and Spring 1938) and
again in the annual *Photographie* (also in 1938 and 1939); some 50
photographs are also sold to the U.S. magazine *Coronet*.
Makes one of his best-known images, *Nude under Wet Silk*
(possibly 1936).
Photographs Aristide Maillol's *The Three Graces* and other of
this sculptor's works.
Photographs Carmen, Rodin's female model for *The Kiss*.
His 1933 photocollage of Hitler is exhibited in a group show in Berlin
but is withdrawn following a protest by the German ambassador.

1938 Meets Cecil Beaton, who helps him secure a contract with *Vogue*;
the two become life-long friends.
First of many images appears in French *Vogue*, October 1938.
Photographs Rouen Cathedral.

1939	May: Takes his best-known Parisian fashion photograph, showing model Lisa Fonssagrives on the Eiffel Tower. Work for *Vogue* continues through June but contract with *Vogue* not renewed; sails to New York to investigate possibility of work for *Harper's Bazaar*, secures a contract with the magazine to cover Paris fashions. Returns to Paris on the eve of the war, but fails to make plans to flee. When war breaks out, interned in French camps, Montbard-Mernagne, Vernet d'Ariège and Catus, as an alien.
1941	Flees from France. Arrrives in New York, where he is immediately put under contract by *Harper's Bazaar*. Finds an apartment at the Hotel des Artistes, 1 West 67th Street, where he remains for the rest of his life. Shares the studio of Martin Munkacsi for almost two years. Maintains production of his personal work, with particular interest in the subject of the nude. First colour cover in December *Harper's Bazaar*. *Alexander Liberman begins his career at Condé Nast.* In the 1940s and 1950s his work will appear in *Look, Life, Coronet, Cosmopolitan* and *Popular Photography* in the USA and in many foreign publications, including *Lilliput* and *Picture Post* (UK) and *Graphis* (Switzerland).
1943	Secures a duplex studio at 222 Central Park South where he will remain for the rest of his life. His 1933 photocollage of Hitler is used as an Allied propaganda leaflet and is dropped in its millions over Germany by the American Air Force. *Irving Penn begins his career at* Vogue.
1944	Leaves *Harper's Bazaar* and begins work as a freelancer with *Vogue*, once again thanks to the intervention of Cecil Beaton. Over the next 15 years produces scores of *Vogue* covers and works for *Seventeen, Glamour, House & Garden* and a number of other mass-market fashion and photography magazines. Begins to build a lucrative business in the sphere of advertising, with such clients as Helena Rubinstein and Elizabeth Arden.
1944-1955	Produces dozens of cover images for Condé Nast and other magazines.
1945	*Richard Avedon begins his career under Alexey Brodovitch at* Harper's Bazaar.
1947	A selection of personal work included in 'In and Out of Focus: A Survey of Today's Photography', curated by Edward Steichen at the Museum of Modern Art, New York.
1948	Work included in 'Seventeen American Photographers' at the Los Angeles Museum (now the Los Angeles County Museum). Begins to travel extensively in Europe, North America, Mexico and the Caribbean.
1950	Produces what has become his most famous cover image, that of the January issue of *Vogue*.
1952	Begins long involvement as photographer for the Oval Room of the Dayton Department Store, Minneapolis, which gives him considerable creative freedom.
1954	Buys a house on the dunes at Westhampton Beach, Long Island, New York.
1955	Relationship with *Vogue* comes to an end; last of his *Vogue* covers (though he works for the magazine sporadically after this date). Starts work on his autobiography. Kathleen Lévy-Barnett becomes his agent; the business expands considerably. Buys his own colour printer for 'C-prints' but finds the colours unstable. *'The Family of Man' opens at the Museum of Modern Art, New York.*
1958	*Alexey Brodovitch leaves* Harper's Bazaar.
1962	Experiments with film out of interest and with an eye to commercial possibilities.
1963	Secures his final major client, L'Oréal. The Westhampton house is washed away in a storm.
1964	Marina Schinz becomes his assistant and begins to edit the autobiography.
1969	Completes the autobiography. Selects the images for his proposed book, *My One Hundred Best Photos*, and organizes the juxtapositions. Fatal heart attack when in Rome; he is buried there.

Notes

EB= An unpublished English translation by Nora Hodges of *Durch tausendjährige Zeit* by Erwin Blumenfeld.

Part I

1. EB, Chapter 41, 'Jadis et la Guerre', p. 2.
2. EB, Chapter 48, 'Furlough', p. 1.
3. EB, Chapter 50, 'Dishonourable Peace', p. 1.
4. EB, Chapter 11, 'Heinz', p. 2.
5. EB, Chapter 10, 'Grandpa Henry', p. 2.
6. Certainly many individuals other than his mother, most surprisingly his great friend and collaborator, Paul Citroen, received equally savage treatment in his memoirs. Traits which Blumenfeld *perceived* as complacency, vanity, pretension and, above all, hypocrisy, invariably provoked his venom.
7. EB, Chapter 6, 'Mama', p. 6.
8. *Ibid.*
9. EB, Chapter 7, 'Papa', p. 3.
10. *Ibid.*, p. 7.
11. EB, Chapter 27, 'The Mirror', p. 2.

12. EB, Chapter 28, 'Poetry and Prose', p. 2.
13. EB, Chapter 26, 'Theatre', p. 1
14. EB, Chapter 51, 'Holland', p. 10. *See also* Blumenfeld's portrait of Feyder, p. 82.
15. EB, Chapter 27, 'The Mirror', pp. 6-7.
16. EB, Chapter 20, 'Jadis et Daguerre', pp. 1-2.
17. EB, Chapter 20, 'Jadis et Daguerre', p. 2.
18. *Ibid.*
19. *Ibid.*
20. EB, Chapter 19, 'School', p. 6. Peter Gay writes: '[The Jew] seemed to [the German] clever, rootless, physically and psychologically mobile – a provocative assailant, the unpalatable antithesis of the cherished Teutonic ideal.' Peter Gay, *Freud, Jews and Other Germans*, Oxford University Press, Oxford, 1978, p. 20.
21. Stephen Kern writes: 'The *Volkische* gymnasts . . . were deadly in earnest. They were organized into quasi-military hierarchies and formed paramilitary clubs that were meant to prepare the German *Volk* for a test against its enemies who were preventing German political self-realization.' Stephen Kern, *Anatomy and Destiny: A Cultural History of the Human Body*, Bobbs-Merrill, New York, 1974, p. 222.
22. EB, Chapter 7, 'Papa', p. 2.

23. EB, Chapter 6, 'Mama', p. 6.
24. EB, Chapter 17, 'Wilhelmstrasse', p. 4.
25. Roy F. Allen, *Literary Life in German Expressionism and the Berlin Circles, Studies in the Fine Arts, The Avant-Garde, No. 25*, Bowker Publishing Company, Epping, Essex, England, 1983, p. 12.
26. EB, Chapter 5, 'Nomina Sunt Omnia', p. 1.
27. Allen (note 25 above) p. 16.
28. Blumenfeld continues: 'I am a citizen of certain parts of large cities.' EB, Chapter 19, 'School', p. 10.
29. 'Ajoutez à ce magnifique déploiement militaire, le petit état de siège dans lequel Berlin respire.' (Add to this magnificent military behaviour the slight state of siege in which Berlin exists.) Jules Laforgue, *Berlin: La Ville et la cour*, Edition de la Sirène, Paris, 1922, p. 21. Laforgue's writing was much admired in Expressionist circles.
30. *Meyers Konversations-Lexicon*, Berlin, 1874; quoted in Allen (note 25 above), p. 37. And Peter Gay writes that the Berliner was 'a born deflector of pomposity, self-importance, empty grandeur . . . serious about his humour and proud of it' – a description that fits Blumenfeld perfectly. Peter Gay, *Freud, Jews and Other Germans*, Oxford University Press, Oxford, 1978, p. 220.

31. EB, Chapter 8, 'Parental Dreams', p. 36.

32. EB, Chapter 34, 'M & S', p. 5.

33. Peter Gay, *Weimar Culture: The Outsider as Insider*, Secker and Warburg, London, 1969, p.4.

34. Walter Mehring, *The Lost Library: The Autobiography of a Culture*, Bobbs Merrill, New York, 1951, p. 136.

35. In their art the Futurists strove to depict life as it was felt or experienced, and not as it simply appeared to the eye, and this sat well with the Expressionists' inclination for the invisible over the visible and the unconscious over the conscious. By 1915 German artists were very familiar with Futurist ideas. Boccioni's book *Pittura scultura futuriste* (Futurist Painting and Sculpture), 1914, for example, was widely read in the Berlin circle. Blumenfeld acknowledged the Italian influence when he described his own postwar style as 'futurist dadaism'.

36. Quoted in David Britt, ed., *Modern Art: Impressionism to Post-Modernism*, Thames and Hudson, London, 1989, p. 132.

37. EB, Chapter 30, 'Joys of Discovery', p. 1.

38. Allen (note 25 above), p. 67.

39. Quoted in Allen (note 25 above), p. 24.

40. *'My Mount Olympus'*
Shakespeare Greek tragedy Marlowe
Molière Wedekind Strindberg
Mozart Monteverdi Purcell Bach Vivaldi Handel Gluck
Haydn Jazz Bosch Brueghel Grünewald Cranach Holbein
Greco Rembrandt Vermeer Chardin Goya Daumier
Van Gogh Gauguin Cézanne Degas Toulouse-Lautrec
Seurat Douanier Rousseau Futurists Cubists Dada
George Grosz
Early Gothic tapestries unknown masters
Villon Charles d'Orleans Scève Homer Ovid
La Fontaine Baudelaire Rimbaud Verlaine Apollinaire
Gryphius Claudius Heine Wilhelm Busch Morgenstern
Ringelnatz Struwwelpeter
Balzac Stendhal Flaubert Maupassant
Grimm's fairytales Poe Gogol Dostoievski Kafka
Casanova Montaigne Diderot Voltaire Swift Sterne
Egon Friedell: Cultural History of Modern Times
Lao-tse Schopenhauer Nietzsche Freud Plato
Sourire de Reims Greek-archaic
(from the Cyclades to the sixth century)
Egypt Maya Negro sculpture pre-Columbian
New York Paestum Cathedral of Laon
Melies Charlie Chaplin Buster Keaton
Marx Brothers Asta Nielsen
EB, Chapter 31, 'My Mount Olympus', p. 1.

41. EB, Chapter 30, 'Joys of Discovery', p. 4. Although Grosz and Blumenfeld remained friends for years, there are no references to Blumenfeld in Grosz's writings other than a letter, very much in the nonsense spirit, from him to Blumenfeld (5 May 1938). Herbert Knust, ed., *George Grosz, Letters 1913–1959*, Rowohlt Verlag, Berlin, October 1979, p. 271.

42. Henry Miller, *George Grosz: The Artist and Germany*, Nicholson and Watson, London, 1948, p. 34.

43. EB, Chapter 37, 'Thirteen Sees Black', pp. 198-199.

44. EB, Chapter 38, 'Outbreak of War', p. 4.

45. EB, Chapter 47, 'Forced Marches', p. 1.

46. EB, Chapter 41, 'Jadis et la Guerre', p. 10.

47. *Ibid.*, p. 2.

48. *Ibid.*

49. Blumenfeld seems to have held both his parents accountable for the weaknesses of their class and their generation. He wrote, 'The Bourgeoisie jabbered about inexorable progress due to the achievements of modern times; they invented the concentration camp in the Boer War; but they did not notice anything of the world revolution that was begun by Nietzsche, Van Gogh, Rimbaud, Strindberg, Wedekind, Freud, Einstein, Curie, Cezanne' (EB, Chapter 32, 'The Turn-of-the-Century', p. 1). Moreover, they refused to acknowledge the depth of anti-Semitic feeling in Germany, believing themselves to be modern and assimilated.

50. EB, Chapter 35, 'Papa's End', p. 8.

51. EB, Chapter 51, 'Holland', p. 4.

52. *Ibid.*

53. He therefore kept his German nationality and was persecute, by the French as a 'resortissant allemand' when the war broke out. Marina Schinz recalls that he often wondered what would have happened had he taken Dutch citizenship. In all

likelihood he would have been deported without warning and gassed. Thus his rejection by the Dutch proved in fact to have been a blessing in disguise.

54. Quoted in Marc Dachy, *The Dada Movement 1915–1923*, Editions Skira/Rizzoli, Geneva, 1989, p. 92.

55. Citroen spoke for himself and Blumenfeld in 'A Voice from Holland', in *Dada Almanach*, edited by Richard Huelsenbeck, Berlin, 1920. It warns their fellow artists to avoid Holland at whatever cost, as the bourgeoisie had triumphed there. *See* Gerard Forde, 'Dada in Holland', in *Paul Citroen and Erwin Blumenfeld* (exhibition catalogue), The Photographer's Gallery, London, 1993.

56. Quoted in Hendel Teicher, *Blumenfeld: My One Hundred Best Photos*, Zwemmer, London, 1981, p. 10.

57. George Grosz and Wieland Herzfelde, *Die Kunst ist in Gefahr* (Art Is in Danger), Königsten, Munich, 1981; a facsimile of the first edition of 1925. Blumenfeld wrote a short text (*c.* 1921), 'Charlie Chaplin, Friedrich Nietzsche, und Ich [and myself]', which proposed that 'the bourgeois world has thought up the epic of the tragedy of the clown, probably as revenge' (Die Spiesserwelt hat sich das Expos der Clownstragik ausgedacht, wahrscheinlich als Rache).

58. Letter from Blumenfeld to Tristan Tzara dated 3 April 1921. Bibliothèque Littéraire Jacques Doucet, Paris, translated by Gerard Forde.

59. Possibly inspired by the shops he had seen in Paris on his travels, or Bauhaus ideas Paul Citroen had brought to his attention.

60. EB, Chapter 20, 'Jadis et Daguerre', p. 3.

61. Helmut Gernsheim, *The History of Photography*, McGraw Hill, New York, 1969, p. 466.

62. Gernsheim (note 61 above), pp. 466-467.

63. *Photographisches Zentralblat*, was published between 1895 and *c.* 1910; *Die Photographische Kunst* from 1902 to 1912.

64. EB, Chapter 32, 'The Turn of the Century', pp. 3-4.

65. For an overview, *see* Maria Morris Hambourg and Christopher Phillips, *The New Vision: Photography between the World Wars*, The Metropolitan Museum of Art and Harry N. Abrams, New York, 1993.

66. For a wide-ranging anthology of such pictures, *see Arts et métiers graphiques*, No. 16, 1930, entire issue.

67. A letter Blumenfeld wrote to his children in 1928 gives every impression of a loving, if rather overwhelmed, father:

Dear Children,
My son [Henry] is a dictator. My daughter Queen of Tragedy.
Both their fathers are the husband of my dear wife,
my dearest. She is simultaneously the children's mother.
I find it hard to figure my place in this complicated
relationship . . .
As a matter of fact I am not as smart as I would like to believe,
but nevertheless I am much dumber than the good
friends that I do not possess.
My son is a handsome man, he is always elegant, always in a
good mood and he often likes to have fun.
No one can resist my daughter's blue eyes.
Her repertoire is endless, always she renews herself.
My son gives orders. Everybody obeys. And how he picks up on
things . . . dictator from head to toe . . . and heartbreaker.
I often ask myself. Where did these children get
these great gifts? . . .

Translated by Yorick Blumenfeld. The letter is in the collection of Yorick and Helaine Blumenfeld, Cambridge, England.

68. EB, Chapter 27, 'The Mirror', p. 7.

69. The art gallery at 126 Rokin had an adventurous and eclectic programme, with exhibitions of Dutch artists such as Fernhout, Raedecker, Hynckes and Citroen, foreigners like Beckmann, Grosz and Chagall, and Balinese, Maori, Pre-Columbian and African art.

70. 'Kunstfotos Erwin Blumenfeld', *Bedrijfsfotografie*, Amsterdam, June 1932, and 'Erwin Blumenfeld', in *De Groene Amsterdammer*, Amsterdam, 4 June 1932.

71. The anonymous reviewer went on to say that he admired Blumenfeld's 'cheek', and suggested that he go back to school or study photography with an established professional.

72. No records of the gallery's programmes exist in

Dutch archives. However, the Blumenfeld Estate has in their possession an undated invitation for a second show.

73. At Esher Surrey Art Galleries, The Hague.

74. 'Met de hartelijke groeten mit het gedachten concentratie kamp.'

75. Blumenfeld's virtual character assassination of Citroen in his memoirs is not easy to reconcile with the warm friendship (and correspondence) they shared over many years. *See* EB, Chapter 21, 'My Best Friend'.

76. EB, Chapter 52, 'Black Misery', p. 2.

77. 'Goodbye canals, goodbye ducks, goodbye rogues.' Paris was not the only destination which beckoned. Before settling there Blumenfeld considered an attractive offer to work in Russia and also considered moving to Ibiza, but the outbreak of the Spanish Civil War ruled out this option. (Lisette Georges, in conversation with the author.)

Part II

1. In addition to *Arts et métiers graphiques* and the annual *Photographie*, there was *Minotaure, Vu, Le Photographe* and *Photo-Illustration*.

2. In addition to *Vogue* and Paris-based work for the American *Harper's Bazaar*, there was *Femina, Excelsior, Votre Beauté* and *Paris Magazine*.

3. 'With my inclination toward alchemy, black-and-white magic, potassium cyanide, and metaphysical nonsense, combined with the commercial knowledge gained at M&S (Moses and Schlochauer, Berlin) and Brothers Gerzon (Amsterdam), I imagined that I would be able to conquer the *Ville lumière* as a fashion photographer.' EB, Chapter 53, Paris, p. 1.

4. EB, Chapter 53, 'Paris', p. 6.

5. André Lejard, 'Marcel Bovis: Photographe artisan', *Arts et métiers graphiques* 68 (May 1939): 49-53. Quoted in Maria Morris Hamburg and Christopher Phillips, *The New Vision: Photography between the World Wars*, The Metropolitan Museum of Art and Harry N. Abrams, New York, 1993, p. 126.

6. EB, Chapter 53, 'Paris', p. 1.

7. *Ibid.*, p. 8.

8. EB, Chapter 55, 'The Story of Beautiful Grimm', p. 1. Grimm was the name given to Muth by Blumenfeld.

9. *Ibid.*

10. 'Ce qu'il y a de plus profond dans l'homme c'est la peau.' *L'Idée fixe*, Gallimard, NRF, 1934.

11. 'On cherchait par la photographie psychologique le portrait définitif: On a découvert un nouvel aspect de la beauté.'

12. William L. Shirer, 'Hitler's Last Days', *Look* magazine, May, 1960.

13. Blumenfeld himself makes no mention of this episode in his memoirs, and there is no further documentation to substantiate Shirer's account. The work may have been shown that year in the Parisian exhibition, 'Art Cruel'. It is also possible that the image in question was included not in a group show but in Blumenfeld's exhibition at the Galerie Billiet.

14. EB, Chapter 54, 'Beautiful Helaine: Before and After', p. 1.

15. *Ibid.* 'The arsedirector: unsuccessful art photographers who seek their revenge everywhere for their lack of talent.'

16. No copies of these posters have been found by the author.

17. EB, Chapter 15, 'Taboos and Totems', p. 7.

18. EB, Chapter 22, 'L'Education sentimentale', p. 1. Walter Mehring has explained how this attitude was a typically German nineteenth-century intellectual sentiment; having 'solved' the great metaphysical conundrums (creation, force, matter, God, freedom of will and what was called 'the social question'), thinkers could now turn to the one remaining enigma: Woman. 'Salvation no longer existed, but thank God there was still sin. There was no longer an eternal, but there was still the eternal feminine.' Walter Mehring, *The Lost Library: The Autobiography of a Culture*, Bobbs Merrill, New York, 1951, p. 88.

19. Quoted in *La Révolution surréaliste* 1 (December 1924): 17.

'La femme est l'être qui projette la plus grande ombre ou la plus grande lumière dans nos rêves.'

20. 'Beauty is not pretty,' he told the authors H. Felix Kraus and Bruce Downes in 'Blumenfeld at Work', *Popular Photography*, October 1944. And in his memoirs he wrote: 'It is harder to wrest the beauty from a beautiful woman than to make an ugly one look beautiful. Helaine was beautiful, but goddesses want to look beautiful in a different way than I see them. It takes decades before they grow into their pictures. A good portrait has to wait. The model ages, the picture stays young.' EB, Chapter 54, 'Beautiful Helaine: Before and After', p. 3.

21. Maurice Bisset, 'Introduction', *Blumenfeld: My One Hundred Best Photos*, edited by Hendel Teicher, Zwemmer, London, 1981, p. 8.

22. *Blumenfeld: My One Hundred Best Photos* (note 21 above), p. 11.

23. EB, Chapter 53, 'Paris', pp. 1-2.

24. Martin Harrison, *Shots of Style* (Exhibition catalogue), Victoria and Albert Museum, London, 1985, p. 19.

25. EB, Chapter 56, 'In Vogue', p. 1.

26. Cecil Beaton, diary entry, April 1938. Sir Cecil Beaton Papers, Collection of St John's College, Cambridge, England.

27. 'Poufs and Pirouettes', French *Vogue*, November 1938, pp. 37-40.

28. Blumenfeld to Cecil Beaton, undated letter, October 1938, Collection of St John's College, Cambridge. Quoted in *Paul Citroen and Erwin Blumenfeld* (Exhibition catalogue), ed. Gerard Forde, The Photographer's Gallery, London (no pagination).

29. *Ibid.* For a Blumenfeld photograph of a Nina Ricci dress, *see* French *Vogue*, Paris, December 1938, p. 52.

30. *See* 'Des Joyaux Rêves' (jewelry Boucheron, Van Cleef & Arpels, mannequin by Siégel), French *Vogue*, Paris, February 1939, pp. 18-19.

31. Blumenfeld made clever use of models and mannequins in these images. He rearlit the mannequins so that they cast their shadows on a screen situated between them and the models. This projected a sinuous, larger-than-life shadow-form on the screen, which suggested the lithe profile which could be obtained by a woman wearing the corset, while simultaneously showing detail of the corset itself. This spread obviously intrigued a number of readers, as *Vogue* felt obliged to print an explanation the following month (April 1939): 'On several occasions we have been asked how we obtained the shadows unfortunately we omitted to mention that Mr Blumenfeld was able to obtain this curious effect thanks to the new and beautiful mannequins created by Maison Siégel'. ('De plusieurs côtés, on nous a demandé comment nous avions obtenu les ombres C'est par suite d'une omission que nous n'avons pas indiqué que M. Blumenfeld avait pu obtenir ce curieux effet, grâce aux beaux et nouveaux mannequins créés par la Maison Siégel.')

32. Blumenfeld in a letter to Cecil Beaton (note 28 above). Curiously, if we are to accept the memoirs at face value, Blumenfeld was not much distressed at this downturn. Indeed, he rather disingenuously maintains that *he* had had enough of *Vogue*. He reports being told by Michel de Brunhoff, the chief editor of the magazine, that had he been born a Baron and queer (i.e., like de Meyer), he would have become the greatest photographer in the world. ('Si vous étiez seulement né Baron et devenu pédé, vous serez le plus grand photographe du monde.') EB, Chapter 56, 'In Vogue', p. 2.

33. EB, Chapter 56, 'In Vogue', p.5.

34. EB, Chapter 57, 'Arrived', p. 1. Henry Blumenfeld remembers that from September 1936 through October 1939 the family lived at 9, rue Delambre, one floor below the studio. Blumenfeld had been poised to buy a beautiful apartment in the rue Verneuil but the outbreak of war prevented the sale. In conversation with the author.

35. EB, Chapter 62, 'Le Vernet D'Ariège', p. 1.

36. Recollection of Marina Schinz.

37. Cecil Beaton to Erwin Blumenfeld, undated letter, *c.* September 1941: 'C'est vrai les magazines américanes sont vides – jamais une idée nouvelle – sans esprit, sans originalité, sans intérêt. C'est triste.' 'It's true that the American magazines are empty – never a new idea – without spirit, without

originality, without interest – it's sad.'

38. 'Notes on the Contributors', *Harper's Bazaar*, October 1941.

39. The number of advertisers in national magazines rose from 936 to 2538 between 1939 and 1952, and the number of products advertised from 1659 to 4472. Gisèle Freund, *Photographie et société*, Paris, 1947. Quoted in Hendel Teicher (note 21 above), p. 30.

40. *See* 'Des Gants', French *Vogue*, June 1939.

41. Solarization is the partial reversal of tone in a photograph caused by extreme overexposure to white light, activating the unexposed silver. The process, discovered accidentally and put to aesthetic use by Man Ray, can create beautiful effects. It is obtained by the controlled flashing of light during the printing process. Blumenfeld wrote: 'I must say that the charm of solarization is that you can never predict the exact effect you will get finally. You know the direction in which you will go, but accident gets the stronger hand.' Typewritten, unpaginated notes for a lecture, dated July 1946, in the possession of Marina Schinz. There is no reference to where and when the lecture and demonstration was given, if indeed it was.

42. This produces a Seurat-like effect. Blumenfeld advised: 'To reticulate the film, don't harden it, but after development immerse the negative in a solution which is much hotter or colder than the developer and then place it in the hardener.' Lecture notes (note 41 above).

43. 'Blumenfeld', by Cecil Beaton. Unpublished and undated notes in the possession of Marina Schinz, New York.

44. Kraus and Downes (note 20 above).

45. Lecture notes (note 41 above).

46. 'Smuggled Art', *Commercial Camera*, December 1948, pp. 2-10.

47. Lecture notes (note 41 above).

48. *Ibid.*

49. Jacob Deschin, 'Imagination in Pictures: Blumenfeld Warns of the Dangers of Imitation', *New York Times*, 9 March 1947.

50. *Ibid.*

51. Letter from Cecil Beaton to Erwin Blumenfeld, 4 January 1943. Collection of Yorick and Helaine Blumenfeld, Cambridge, England.

52. Jane Mulvagh, *Vogue: History of 20th Century Fashion*, London, 1988, p. 185.

53. American *Vogue*, New York, 1 November 1949, p. 94.

54. *Alex, the Life of Alexander Liberman*, Dodie Kazanjian and Calvin Tomkins, Knopf, New York, 1993, p. 138.

55. Kathleen Lévy-Barnett (later Blumenfeld), then at *Vogue* as model editor, recalls Liberman telling her to treat Blumenfeld with kid gloves, that he was 'our prized possession, too temperamental, too difficult'. In conversation with the author.

56. In fact Blumenfeld had first made colour photographs years earlier: 'I had been taking colour since I was 13 and the possessor of my first folding camera. The pictures were transparencies made with the Miethe system, a dot process that nevertheless looked considerably more natural than either Kodachrome or Ektachrome. I remember that they had the softly lighted effect of British motion pictures.' As told to Mildred Stagg, 'Amateur's Workshop', *Popular Photography*, October 1959, p. 88.

57. Frank Crowninshield, 'Vogue, Pioneer in Modern Photography,' *Vogue*, 15 June 1941, p. 30.

58. Lecture notes (note 41 above).

59. *Ibid.*

60. *The Art and Technique of Colour Photography*, Condé Nast Publications, New York, 1951; Technical Note 183.

61. Lecture notes (note 41 above).

62. Marella Agnelli in conversation with the author.

63. Kraus and Downes (note 20 above), p. 89.

64. Kathleen Blumenfeld, in conversation with the author.

65. Jean Patchett, in conversation with the author.

66. Lecture notes (note 41 above).

67. Blumenfeld gave credit where it was due. Of one cover image which was largely the creation of the art department he wrote, 'Here I am innocent. I only contributed the photograph.' *The Art and Technique of Colour Photography* (note 60 above), Technical Note 176. And of the famous 'doe-eyed' cover of January 1950 he wrote, 'The full credit should go to the art

department and the engravers, who transformed a black-and-white photograph into a sensational cover' (Technical Note 187).

68. Lecture notes (note 41 above).

69. Kathleen Blumenfeld, in conversation with the author.

70. Kraus and Downes (note 20 above), p. 89.

71. *Pageant*, New York, October/November 1947.

72. *See*, for example: 'The World's Most Highly Paid Photographer', *The Strand*, London, April 1949; 'Great American Photographers' in *Pageant*, New York, October/November 1947; 'Erwin Blumenfeld', *Graphis*, Zurich, May 1946; 'Erwin Blumenfeld: My Favourite Model', *Lilliput*, London, September 1945; and 'Speaking Pictures', *Life*, New York, October 1942.

73. Lecture notes (note 41 above).

74. *Ibid.*

75. *Ibid.*

76. 'Glamour Portraits', directed by John Szarkowski, Museum of Modern Art, New York, 3 August to 19 September 1965. Quotation taken from introductory wall label.

77.

78. Recollected by Marina Schinz. These were hidden in a house in the south of France by Lena Blumenfeld while her husband was interned. Blumenfeld searched for them unsuccessfully on his release. Undated (1941) letter from Cecil Beaton to Blumenfeld (note 28 above).

79.

80. The autobiography was published first in French as *Jadis et Daguerre*, Robert Laffont, Paris, 1975; then in German as *Durch tausendjährige Zeit*, Verlag Huber, Frauenfeld, Switzerland, and Buch Klub Ex Libris, Zurich, 1978; by Deutscher Taschenbuch Verlag, Munich, 1980; in Dutch under the title *Spiegelbeeld*, De Harmonie, Amsterdam, 1980; and finally in German by Argon Verlag, Berlin, 1988. Jadis et Daguerre is a play on 'Jadis et naguère', meaning 'long ago and not long ago'.

81. EB, Chapter 3, 'Delivery', p. 3.

82. *Ibid.*

83. EB, Chapter 69, 'Americana', p. 2.

84. EB, Chapter 30, 'Joys of Discovery', p. 6.

85. Alfred Andersch, 'Refreshment through Hate,' *Times Literary Supplement*, March 1977, p. 269.

86. 'This family analysis thus widens and becomes sociology, while the satire becomes despair about a whole epoch.'

87. EB, Added posthumously to Chapter 72, 'Final Word', p. 2. (Found in Blumenfeld's typewriter by Marina Schinz.)

88. However, contact sheets from the Dutch period exist. Blumenfeld gave the glass-plate negatives of his French material to a friend before fleeing Paris; these were returned after the war.

89. Lecture notes (note 41 above).

90. However, *Popular Photography* reported in October 1944 that Blumenfeld was '. . . astonished that photography, after a full century of development, is still not considered suitable for the art market' (note 20 above).

91. Erwin Blumenfeld, 'Smuggled Art' (note 46 above), p. 2.

92. *The Art and Technique of Color Photography* (note 60 above) p. 170.

93. Yorick Blumenfeld in conversation with the author. However, this bleak assessment is disputed by Kathleen Blumenfeld and Marina Schinz, who insist that Blumenfeld was grateful for the patronage of the fashion magazines.

94. EB, Chapter 51, 'Holland', p. 8. 'At night at home, I became a Sunday painter with real feelings for colour and false contempt for design'.

95. Hendel Teicher (note 21 above), no page numbers.

96. It was a general criticism of fashion photographers by editors and designers. Norman Norell, for example, complained that 'the important part of fashion is often lost because the photographer gets involved in the model or the scene he is shooting – everything but the dress'. *Time* magazine, 3 December 1965, p. 66.

97. Letter to the author, 8 November 1995.

98. *See* 'Delicate Air', photographs by Balkin, *Glamour*, June 1950, pp. 72-73.

99. Lindbergh's semi-nude model on the tower, 'Paris 1989', is the most fascinating of these images – all the lightness and hope

of Blumenfeld are gone; the model's mood is dark as she contemplates the polluted city below. *See Aperture* 122, (Winter 1991): 97.

100. *See* 'Open and Closed Proposition: Shoes this Spring', photograph by William Klein, *Vogue*, 15 February 1955. *See also* Klein's famous picture of Evelyn Tripp, 1958 on cover, *In and Out of Fashion*, Random House, New York, 1954; and Albouy (hat with flowers), *Vogue*, May 1956.

For a number of contemporary photographers who have followed in Blumenfeld's footsteps to varying degrees, *see* Paolo Roversi, Javier Vallhonrat, Matthew Ralston, Peter Lindbergh *et al.* in 'The Idealizing Vision' (fashion photography), *Aperture* 122 (Winter, 1991), New York.

Martial Raysse, the French pop artist, took for one of his subjects in a series of works which parodied stereotypes of female beauty, Blumenfeld's 'doe-eye' *Vogue* cover

image of January 1950. *Seventeen (Titres journalistiques)*, 1962 (acrylic, assemblage and glitter on photographic base). *See* Sotheby's London, cover of exhibition catalogue, June 1994.

101. 'Homage to Blumenfeld' (Portrait of Prudence Walters), in David Seidner, *David Seidner*, Thames and Hudson, London, 1989.

Acknowledgments

This book, together with the exhibition which accompanies it, is a collaborative project involving many people and institutions. We wish to thank, first and foremost, the Blumenfeld family for their support and encouragement at every stage of the process, and their help with our research. We also appreciate the willingness of every member of the family to lend valuable original photographs as well as copy prints and transparencies, letters, reviews, and so on, for purposes of both book and exhibition. They also offered constructive advice and provided valuable insights. Lisette Blumenfeld Georges and her daughter Yvette Georges Deeton, Henry and Kathleen Blumenfeld, and Yorick and Helaine Blumenfeld are deserving of our profound gratitude.

We wish to thank the following galleries, museums and individuals for the loan of transparencies, prints and vintage magazines: Vince Aletti, New York; Berlinische Galerie, Berlin; Galerie Berinson, Berlin; Galerie Brusberg, Berlin; The Center for Creative Photography, Tucson, Arizona; Christie Citroen-Frisch, Wassenaar, Holland; The Condé Nast Publications Inc., New York; Gerard Forde, Rotterdam; Galleria Milano, Milan; Houk Friedman Gallery, New York; The J. Paul Getty Museum, Malibu, California; Kunsthaus, Zurich; Printenkabinet (Rijksmuseum), Leiden; Rachel Adler Gallery, New York; Elsa and Marvin Ross-Greifinger, New York; Arturo Schwarz, Milan; Horst Schwiemann, Berlin; Stedelijk Museum, Amsterdam; *Vogue*, Paris; and Zur Stockeregg, Zurich.

Vince Aletti, Gerard Forde, Christie Citroen-Frisch and Horst Schwiemann must also be thanked for their ideas and advice, much of which proved invaluable.

Many people at the above institutions have been most helpful and deserve our thanks, as do a number of other individuals who contributed in different ways: Marella Agnelli, Turin; Flip Bool, Amsterdam; Joan Juliet Buck, Paris; Jacklyn Burns, Malibu; Cindy Cathcart, New York; Veronique Chaubin, Paris; Karl Citroen, Amsterdam; Virginia Dodier, New York; Joan Gallant Dooley, Malibu; Diana Edkins, New York; Clare Ewing, Lausanne; Beppie Feuth, Amsterdam; Birgit Filzmaier, Zurich; Janos Frecot, Berlin; Barry Friedmann, New York; Suzanna Heman, Amsterdam; Edwynn Houk, New York; Fred Keith, New York; Guido Magnaguano, Zurich; Dr Herman J. Moeshart, Leiden; Colette Mouturat, Paris; Ruth Neitemeier, Berlin; Jean Patchett, New York; Irving Penn, New York; Eve Schillo, Los Angeles; Ingrid Streckbein, Berlin; Marcia Tiede, Tucson; Hripsime Visser, Amsterdam; and Frank Whitford, Cambridge.

We also wish to thank the staff of the Barbican Art Gallery for their enormous effort in organizing the exhibition, in particular John Hoole and Tomoko Sato.

William A. Ewing and Marina Schinz

Select Bibliography

Allner, W.H., 'Erwin Blumenfeld', *Graphis*, Zurich, May 1946.

Andersch, Alfred, 'Refreshment through Hate', *Times Literary Supplement*, London, 11 March 1977.

Bergius, Hanne, *Das Lachen Dadas: Die Berliner Dadaisten und Ihre Aktionen*, Anabas, Giessen, Germany, 1993.

Bernard, Sophie, 'Erwin Blumenfeld', *Photographies*, Paris, No. 66, April 1995.

'Blumenfeld à Beaubourg', *Photo*, Paris, No. 170, December 1981.

Blumenfeld: Dada Collages 1916–1931 (Exhibition catalogue), Israel Museum, Jerusalem, Fall 1981.

Blumenfeld, Erwin, 'My Favourite Model', *Lilliput*, London, September 1945.

--------, *Jadis et Daguerre*, Robert Laffont, Paris, 1975.

--------, *Durch tausendjährige Zeit*, Verlag Huber, Frauenfeld, Switzerland, 1978.

Blumenfeld, Henry, 'Erwin Blumenfeld', *Zoom*, Paris, July 1979.

--------, 'Il Dada Di Erwin Blumenfeld', *Zoom*, Milan, February 1982.

Blumenfeld, Yorick, 'Reflections in an Insatiable Eye', *American Photographer*, New York, February 1982.

Brockhuis, Carly, 'Obsessie als Kunst', *Foto*, Amsterdam, 9 September 1981.

Casanova, Nicole, 'Jadis et Daguerre: Une Folle Sensibilité', *Quotidien de Paris*, 25 June 1975.

Chaspal, Madeleine, 'Les Souvenirs d'Erwin Blumenfeld', *L'Express*, Paris, 24–30 March 1975.

Deloffre, Jacqueline, 'Ein Alptraum in Südfrankreich . . .', *Frankfurter Rundschau*, Frankfurt, 21 September 1985.

Deschin, Jacob, 'Imagination in Pictures: Blumenfeld Warns of the Dangers of Imitation', *New York Times*, New York, 9 March 1947.

--------, 'Viewpoint: Blumenfeld', *Popular Photography*, New York, December 1948.

Dister, Alain, 'Les Défis d'un Photographe', *Le Nouvel observateur*, Paris, 9 February 1995.

Dreyfus, Catherine, 'Les Mémoires d'un Oeil', *Le Nouvel observateur*, Paris, 21 April 1975.

'Erwin Blumenfeld', *Bedrijsfotografie*, Amsterdam, June 1932.

'Erwin Blumenfeld', *De Groene Amsterdammer*, Amsterdam, 4 June 1932.

Erwin Blumenfeld: Collages Dada 1916–1931 (Exhibition catalogue), Sonia Zannettacci Gallery, Geneva, 13 May–30 June 1981.

Erwin Blumenfeld: Dada Collage and Photography (Exhibition catalogue), introduction by Yorick Blumenfeld, Rachel Adler Gallery, New York, October 1988.

Erwin Blumenfeld. Dada Collages e Fotografie 1933–1968 (Exhibition catalogue), La Galleria Milano and Superstudio, Milan, 1989.

'Erwin Blumenfeld: Fotograaf en Voyeur', *De Stem*, Amsterdam, 27 April 1982.

'Erwin Blumenfeld: où le Monde Touche à l'Humain', *Schweizerische Photorundschau*, Visp, 25 November 1979.

'Erwin Blumenfeld: Smuggled Art', *Commercial Camera*, New York, December 1948.

Federspiel, Jurg, 'Das Leben vor dem Sterben des Erwin Blumenfeld', *Tages Anzeiger Magazin*, Zurich, 9 October 1976.

'Feminine Beauty Yesterday and Today', *Pageant*, New York, December/January 1947/48.

Ganne, Gilbert, 'Jadis et Daguerre', *Aurore*, Paris, 29 April 1975.

Grands Maîtres de la Photo: Erwin Blumenfeld, Les, *Photo*, Milan 1982 and Paris 1984.

'Great American Photographers', *Pageant*, New York, October/November, 1947.

Guérrin, Michel, 'L'Oeil et le Regard', *Le Monde*, Paris, 9 September 1993.

--------, 'La Femme Remodelée par Erwin Blumenfeld', *Le Monde*, Paris, 25 January 1995.

Guibert, Hervé, 'Erwin Blumenfeld à Beaubourg', *Le Monde*, Paris, 1 January 1982.

Haedens, Kleber, 'Du Balzac avec des Touches Céliniennes', *Journal du dimanche*, Paris, 27 April 1975.

Hall-Duncan, Nancy, *The History of Fashion Photography*, Chanticleer/Alpine, New York, 1979.

Heissenbuttel, Helmut, 'Der Hass als Gegengift', *Deutsche Zeitung*, Berlin, 1 January 1977.

Holme, C.G. (ed.), *Modern Photography*, The Studio, London and New York, 1937.

Jordan, Isabelle, 'Un Grand Photographe Raconte sa Vie', *La Quinzaine littéraire*, Paris, May 1975.

Juin, Hubert, 'Confessions Picaresques d'Erwin Blumenfeld', *Le Monde*, Paris, 19 April 1975.

Koetzle, Michaël, 'Licht und Schatten', *Photographie*, Paris, February 1989.

Koppens, Jan, 'Erwin Blumenfeld: 1897–1969', *Foto*, Amsterdam, October 1975.

Kraft, Martin, 'Zeitgeschichte in der Autobiographie', *Neue Züricher Zeitung*, Zurich, 23 November 1976.

Kraus, Felix, and Bruce Downes, 'Erwin Blumenfeld', *Popular Photography*, New York, October 1944.

Landmann, Salcia, 'Tausendjährige Zeit', *Rheinisher Merkur*, Cologne, No. 47, 19 November 1976.

Leclec'h, Guy, 'Erwin Blumenfeld', *Arche*, Paris, April 1975.

Liberman, Alexander (ed.), *The Art and Technique of Color Photography*, Simon & Schuster, New York, 1951.

Mahassen, Philippe, 'Les Collages de Blumenfeld', *Tribune des arts*, Geneva, 13 June 1981.

Mandel, Arnold, 'Une Vie', *Information juive*, Paris, 2–8 May 1975.

Martin, Richard, 'Blumenfeld', *The Idealizing Vision, Aperture*, New York, No. 122, Winter 1991.

Mauriac, Claude, 'Jadis, Naguère, Toujours', *Le Figaro*, Paris, 5 April 1975.

'Mit kalten Blick', *Stern*, Berlin, 5 January 1988.

Mouli, Raymond, 'Erwin Blumenfeld', *Zoom*, Paris, No. 30, May/June 1975.

--------, 'Expo: Blumenfeld', *Photo*, Paris, No. 98, November 1975.

--------, 'Bouche à Bouche', *Photo*, Paris, No. 206, November 1984.

Mulder, Hans, 'Een Productieve Reinigende Haat', *Urij Nederland*, Amsterdam, 12 July 1980.

Ollier, Brigitte, 'Erwin Blumenfeld', *Libération*, Paris, 17 January 1995.

Pam, Max, 'Erwin Blumenfeld, een joodse Céline', *H.P. Boeken*, The Hague, May 1982.

Paul Citroen and Erwin Blumenfeld, 1919–1939 (Exhibition catalogue), introductory essay by Gerard Forde, The Photographers' Gallery, London, September–November 1993.

Renko, J.P., 'Les Jeux d'Erwin Blumenfeld', *Tribune de Genève*, Geneva, 12 February 1979.

'Retour de Blumenfeld, Le', *Photo*, Paris, No. 92, May 1975.

Roth, Wilhelm, 'Erwin Blumenfeld, "Durch Tausendjährige Zeit"', *Volksblatt* Berlin, Berlin, 26 February 1989.

Schippers, K., and E.M. Querido, Holland Dada, Amsterdam, 1974.

Schwartz, Arturo, Almanacco Dada, Feltrinelli, Milan, 1976.

'Seventeen American Photographers' (Exhibition catalogue), Los Angeles Museum, 1948.

'Speaking of Pictures', *Life*, New York, 26 October 1942.

Stich, Sidra, *Anxious Visions: Surrealist Art*, Abbeville, New York, 1990.

'Study of Woman', *Vanity Fair*, New York, March 1992.

Teicher, Hendel, *Blumenfeld: My One Hundred Best Photos*, introduction by Maurice Besset, trans. Philippe Garner with Luna Carne-Ross, A. Zwemmer Ltd, London 1981.

Thomas, Mona, 'Sophisticated Ladies', *Beaux Arts*, Paris, September 1989.

Trefzger, Rudolf, 'Erwin Blumenfeld', *Der Alltag*, Berne, January 1986.

Uthmann, Jörg von, 'Uber Belichtet', *Frankfurter Allgemeine Zeitung*, 25 January 1977.

Werth, German, 'Vergangenheit als Gruselboutique', *Der Tagespiegel*, Berlin, 7 July 1977.

'World's Most Highly Paid Photographer, The', *The Strand*, London, April 1949

Sources of Illustrations

Notes on the photographs

1. Blumenfeld did not sign or date his images. Although a *negative* (when it exists) can be dated by period (i.e., Amsterdam, Paris, New York), the *print* may have been made much later. He habitually made new prints from old negatives, especially when he thought the original prints had been irretrievably lost. When negatives were sometimes recovered years later (as happened, for example, after the war), new prints were made from them. All these factors make it difficult to date Blumenfeld images with precision.

2. The Amsterdam images were produced between the early 1920s and 1936, but most probably between 1932 and 1936.

3. Blumenfeld made many prints from the same negative, with slight variations. Sometimes he merely reversed or inverted the image. Comparisons of Blumenfeld images in books, catalogues and magazines are therefore confusing.

4. Some images exist only in the form of the photographer's contact sheets; these are clearly noted in the captions.

All photographs are vintage gelatin silver prints unless otherwise stated.

pp. 16, 18, 19, 20. Modern gelatin silver copy prints. Courtesy: Collection of Henry and Kathleen Blumenfeld, Paris. p. 27. Vintage gelatin silver copy print. Courtesy: Collection of Christie Citroen-Frisch, Wassenaar, Holland. p. 28 *top*. Courtesy: Collection of Yorick and Helaine Blumenfeld, Cambridge, England. p. 28 *bottom*. Modern gelatin silver copy print. Courtesy: Collection of Horst Schwiemann, Berlin. p. 30. Modern gelatin silver copy print. Courtesy: Collection of Henry and Kathleen Blumenfeld, Paris. p. 32. Courtesy: Collection of Yorick and Helaine Blumenfeld, Cambridge, England. p. 33. Courtesy: Collection of Henry and Kathleen Blumenfeld, Paris. p. 34. Courtesy: Jared Blumenfeld, Cambridge, England. p. 35. Courtesy: Collection of Yorick and Helaine Blumenfeld, Cambridge, England. Transparency courtesy of the Rachel Adler Gallery, New York. p. 36 *top*. Courtesy: Copy print in collection of Gerard Forde, Rotterdam. p. 36 *bottom*. Courtesy: The Rachel Adler Gallery, New York, and the Galleria Milano, Milan. p. 37 *top*. Courtesy: Kunsthaus Zurich. p. 37 *bottom*. Courtesy: Collection of Arturo Schwartz, Milan. p. 38 *left*. Courtesy: Collection of Yorick and Helaine Blumenfeld, Cambridge, England. Transparency courtesy of the Rachel Adler Gallery, New York, and Galleria Milano, Milan. p. 38 *right*. Courtesy: Collection of Yorick and Helaine Blumenfeld, Cambridge, England. p. 39. Courtesy: Kathleen and Henry Blumenfeld, Paris. p. 41. Courtesy: Collection of Henry and Kathleen Blumenfeld, Paris. pp. 42, 43. Courtesy: Collection of Yorick and Helaine Blumenfeld, Cambridge, England. Transparencies courtesy of the Rachel Adler Gallery, New York. p. 44 *top*. Courtesy: Collection of Christie Citroen-Frisch, Wassenaar, Holland. p. 44 *bottom*. Modern gelatin silver copy print. Courtesy: Collection of Christie Citroen-Frisch, Wassenaar, Holland. p. 45. Courtesy: Collection of Henry and Kathleen Blumenfeld, Paris. p. 46. Collage. Courtesy: Elsa and Marvin Ross-Greifinger, New York. p. 47 *top*. Vintage silver print with coloured ink. Courtesy: Collection of Yorick and Helaine Blumenfeld, Cambridge, England. p. 47 *bottom*. Vintage manipulated silver print. Courtesy: The Stedelijk Museum, Amsterdam. p. 48. Courtesy: Marina Schinz, New York. p. 80. Courtesy: Collection of Henry and Kathleen Blumenfeld, Paris. p. 81. Modern silver gelatin print from original negative. Courtesy: Collection of Marina Schinz, New York. p. 82. Courtesy: Collection of Henry and Kathleen Blumenfeld, Paris. pp. 84, 85. Modern contact prints from original negatives. Courtesy: Collection of Marina Schinz, New York. p. 87. Modern gelatin silver print. Courtesy: Collection of Henry and Kathleen Blumenfeld, Paris. p. 88. Tearsheet. Courtesy: French *Vogue*, March 1939. p. 89. Tearsheet. Courtesy: Collection of Henry and Kathleen Blumenfeld, Paris. pp. 90, 91. Courtesy: Collection of Henry and Kathleen Blumenfeld, Paris. p. 92. Courtesy: Collection of Yorick and Helaine Blumenfeld, Cambridge, England. p. 93. Tearsheet.

Courtesy: Collection of Marina Schinz, New York. p. 96. Courtesy: Collection of Marina Schinz, New York. p. 98. Courtesy: Collection of Henry and Kathleen Blumenfeld, Paris. p. 101. Courtesy: Collection of Marina Schinz, New York. p. 102. Tearsheet. Courtesy: Collection of Henry and Kathleen Blumenfeld, Paris. pp. 103, 104. Courtesy: Collection of Henry and Kathleen Blumenfeld, Paris. p. 106. Courtesy: Collection of Marina Schinz, New York. p. 109. Courtesy: Collection of Henry and Kathleen Blumenfeld, Paris. p. 110. Courtesy: Yorick and Helaine Blumenfeld, Cambridge, England. Plates 1. Modern copy print. Courtesy: Collection of Henry and Kathleen Blumenfeld, Paris. 2, 3. Courtesy: Collection of Marina Schinz, New York. 4. Courtesy: Collection of Yorick and Helaine Blumenfeld, Cambridge, England. 5, 6, 7, 8. Courtesy: Collection of Marina Schinz, New York. 9. Proof from original gelatin silver print. Courtesy: Collection of Henry and Kathleen Blumenfeld, Paris. 10. Vintage gelatin silver contact print. Courtesy: Collection of Kathleen and Henry Blumenfeld, Paris. 11. Courtesy: Collection of Marina Schinz, New York. 12, 13. Vintage gelatin silver contact prints. Courtesy: Collection of Kathleen and Henry Blumenfeld, Paris. 14. Courtesy: Collection of Marina Schinz, New York. 15. Courtesy: Berlinische Galerie: Photographische Sammlung, Berlin. 16. Courtesy: Collection of Lisette Blumenfeld Georges, New York. 17. Vintage gelatin silver contact print. Courtesy: Collection of Henry and Kathleen Blumenfeld, Paris. 18. Vintage gelatin silver contact print. Courtesy: Collection of Henry and Kathleen Blumenfeld, Paris. 19. Vintage gelatin silver contact print. Courtesy: Collection of Henry and Kathleen Blumenfeld, Paris. 20. Courtesy: Collection of Marina Schinz, New York. 21. Courtesy: The J. Paul Getty Museum, Malibu, California. 22. Courtesy: Collection of Yorick and Helaine Blumenfeld, Cambridge, England. 23, 24, 25. Courtesy: Prentenkabinet der Rijksuniversiteit, Leiden. 26. Courtesy: The J. Paul Getty Museum, Malibu, California. 27. Vintage gelatin silver contact print. Courtesy: Collection of Henry and Kathleen Blumenfeld, Paris. 28. Courtesy: Collection of Yorick and Helaine Blumenfeld, Cambridge, England. 29. Courtesy: Collection of Lisette Blumenfeld Georges, New York. 30. Courtesy: Collection of Yorick and Helaine Blumenfeld, Cambridge, England. 31. Courtesy: Berliner Galerie: Photographische Sammlung, Berlin. 32, 33. Vintage gelatin silver contact prints. Courtesy: Collection of Henry and Kathleen Blumenfeld, Paris. 34. Courtesy: The J. Paul Getty Museum, Malibu, California. 35. Vintage gelatin silver contact print. Courtesy: Collection of Henry and Kathleen Blumenfeld, Paris. 36. Courtesy: The J. Paul Getty Museum, Malibu, California. 37. Courtesy: The Stedelijk Museum, Amsterdam. 38. Courtesy: Collection of the J. Paul Getty Museum, Malibu, California. 39, 40. Vintage gelatin silver contact prints. Courtesy: Collection of Henry and Kathleen Blumenfeld, Paris. 41. Vintage gelatin silver contact print. Courtesy: Collection of Lisette Blumenfeld Georges, New York. 42. Courtesy: The Stedelijk Museum, Amsterdam. 43. Courtesy: Collection of Yorick and Helaine Blumenfeld, Cambridge, England. 44. Courtesy: The J. Paul Getty Museum, Malibu, California. 45. Courtesy: Collection of Marina Schinz, New York; courtesy French *Vogue*, February 1939. 46. Courtesy: Collection of Marina Schinz, New York. 47. Courtesy: Collection of Lisette Blumenfeld Georges, Paris. 48. Courtesy: Collection of Marina Schinz, New York. 49. Tearsheet. Courtesy: French *Vogue*, May 1939. 50. Courtesy: Collection of Henry and Kathleen Blumenfeld, Paris. 51. Tearsheet. Courtesy: French *Vogue*, February 1939. 52. Tearsheet. Courtesy: French *Vogue*, May 1939. 53. Original gelatin silver print (copy print retouched). The black background was apparently added by the magazine rather than the photographer, but on whose instructions the decision was made is unclear. Courtesy: French *Vogue*, October 1938. Print courtesy of the collection of Marina Schinz, New York. 54. Courtesy: Collection of Lisette Blumenfeld Georges, New York. 55. Courtesy: French *Vogue*, October 1938. 56. Courtesy: Collection of Marina Schinz, New York. 57. Tearsheets from French *Vogue*, November 1938. 58. The title was probably invented by *Coronet* magazine when it published the image. Courtesy: Collection of Henry and Kathleen Blumenfeld, Paris. 59. Two variants of the image were published in December 1938 in French *Vogue*. Courtesy: *Vogue*, Copyright © 1938 (renewed 1966) by the Condé Nast Publications Inc., New York. 60, 61. Courtesy: Collection of Marina Schinz, New York. 62, 63, 64. Modern silver gelatin prints from original glass negatives. Courtesy: Collection of Marina Schinz, New York. 65. Courtesy: Collection of Marina Schinz, New York. 66. Courtesy: The J. Paul Getty Museum, Malibu, California. 67, 68. Courtesy: Collection of Yorick and Helaine Blumenfeld, Cambridge, England. 69. Courtesy: Collection of Marina Schinz, New York. 70. Courtesy: Collection of Lisette Blumenfeld Georges, New York. 71. Courtesy: Collection of Henry and Kathleen Blumenfeld, Paris. 72. Courtesy: Collection

of Marina Schinz, New York. **73.** Modern silver gelatin print from original glass plate negative. Courtesy: Collection of Marina Schinz, New York. **74.** Courtesy: Collection of Marina Schinz, New York. **75.** Modern silver gelatin print from vintage original. Courtesy: Collection of Henry and Kathleen Blumenfeld, Paris. **76.** Courtesy: Collection of Henry and Kathleen Blumenfeld, Paris. **77.** Courtesy: Collection of Marina Schinz, New York. **78.** Courtesy: Collection of Lisette Georges Blumenfeld, New York. **79, 80, 81.** Modern prints from original glass negatives. Courtesy: Collection of Marina Schinz, New York. **82, 83, 84.** Courtesy: Collection of Marina Schinz, New York. **85, 86.** Courtesy: Collection of Henry and Kathleen Blumenfeld, Paris. **87.** Courtesy: Collection of Marina Schinz, New York. **88, 89.** Courtesy: Collection of Henry and Kathleen Blumenfeld, Paris. **90.** Vintage gelatin silver print (retouched). Courtesy: Collection of Marina Schinz, New York. **91.** Courtesy: Collection of Marina Schinz, New York. **92.** Tearsheet. Courtesy: Collection of Marina Schinz, New York; *Vogue*, Copyright © 1946 (renewed 1974) by the Condé Nast Publications Inc., New York. **93, 94.** Courtesy: Collection of Lisette Blumenfeld Georges, New York. **95.** Original magazine cover. Courtesy: Collection of Vince Aletti, New York. **96.** Original magazine cover. Courtesy: Collection of Vince Aletti, New York. **97, 98.** Courtesy: Collection of Marina Schinz, New York. **99.** Modern colour transparency copied from original. Courtesy: Collection of Henry and Kathleen Blumenfeld, **100.** The legs of Lisette Blumenfeld, the photographer's daughter, who was at the time working for her father. Modern colour transparency copied from original. Courtesy: Collection of Henry and Kathleen Blumenfeld, Paris. **101.** Courtesy: Collection of Lisette Blumenfeld Georges, New York. **102.** Courtesy: Collection of Marina Schinz, New York. **103.** Modern colour transparency copied from original. Courtesy: Collection of Marina Schinz, New York. **104.** Modern colour transparency copied from original. Courtesy: Collection of Henry and Kathleen Blumenfeld, New York. **105.** Vintage gelatin silver print, mounted on cardboard. Courtesy: Galerie Zur Stockeregg, Zurich, Switzerland. **106.** Courtesy: Arizona Board of Regents: Center for Creative Photography, The University of Arizona, Tucson, Arizona. **107.** Modern colour transparency copied from original. Courtesy: Collection of Henry and Kathleen Blumenfeld, Paris. **108.** Courtesy: Collection of Henry and Kathleen Blumenfeld, Paris. **109.** Tearsheet. Courtesy: Collection of Henry and Kathleen Blumenfeld, Paris. Copyright © 1954 (renewed 1982) by the Condé Nast Publications Inc., New York. **110.** Modern colour transparency copied from original. Courtesy: Collection of Marina Schinz, New York. **111, 112.** Original magazine covers. Courtesy: Collection of Marina Schinz, New York. Copyright © 1945 (renewed 1973) by the Condé Nast Publications Inc., New York. **113.** Modern colour transparency copied from original. Courtesy: Collection of Henry and Kathleen Blumenfeld, Paris. **114.** Modern colour transparency copied from original. Courtesy: Collection of Marina Schinz, New York. **115.** Photographed from bound magazine. Courtesy: *Vogue*, Copyright © 1952 (renewed 1980) by the Condé Nast Publications Inc., New York. **116.** Original magazine cover. Courtesy: Collection of Henry and Kathleen Blumenfeld, New York. Copyright © 1945 (renewed 1973) by the Condé Nast Publications Inc., New York. **117.** Original magazine cover. Courtesy: Collection of Marina Schinz, New York. Copyright © 1953 (renewed 1981) by the Condé Nast Publications Inc., New York. **118.** Modern transparency copied from original transparency. Courtesy: Collection of Marina Schinz, New York. **119.** Modern colour transparency copied from original. Courtesy: Collection of Henry and Kathleen Blumenfeld, Paris. **120.** Photographed from bound magazine. Courtesy: *Vogue* Copyright © 1950 (renewed 1978) by the Condé Nast Publications Inc., New York. **121.** Original cover of magazine. Courtesy: Collection of the author. *Vogue*. Copyright © 1951 (renewed 1979) by the Condé Nast Publications Inc., New York. **122.** Original cover of magazine. Courtesy: Collection of Marina Schinz, New York. *Vogue* © 1953 (renewed 1981) by the Condé Nast Publications, Inc., New York. **123, 124.** Modern transparencies copied from original transparencies. Courtesy: Collection of Henry and Kathleen Blumenfeld. **125.** Original magazine cover. Courtesy: Collection of Marina Schinz, New York. *Vogue* Copyright © 1950 (renewed 1978) by the Condé Nast Publications, Inc., New York. **126.** Image by Blumenfeld (retouched and hand-coloured by the *Vogue* art department). Original magazine cover. Courtesy: Collection of Marina Schinz, New York. *Vogue* Copyright © 1950 (renewed 1978) by the Condé Nast Publications, Inc., New York. **127, 128.** Modern colour transparencies copied from originals. Courtesy: Collection of Henry and Kathleen Blumenfeld, Paris. **129.** Modern transparency from original transparency. Courtesy: Collection of Henry and Kathleen Blumenfeld, Paris. **130.** Original cover of magazine. Courtesy: Collection of Marina Schinz, New York. *Vogue* Copyright © 1952 (renewed 1980) by the Condé Nast Publications, Inc., New York. **131.** Tearsheet. Courtesy: Collection of Henry and Kathleen Blumenfeld, Paris. *Vogue* Copyright © 1953 (renewed 1981) by the Condé Nast Publications, Inc., New York. **132.** Tearsheet. Courtesy: Collection of Henry and Kathleen Blumenfeld, Paris. *Vogue*, Copyright © 1954 (renewed 1982) by the Condé Nast Publications, Inc., New York. **133.** Tearsheet. Courtesy: Collection of Henry and Kathleen Blumenfeld, Paris. *Vogue* Copyright © 1947 (renewed 1975) by the Condé Nast Publications Inc., New York. **134.** Modern colour transparency copied from original. Courtesy: Collection of Henry and Kathleen Blumenfeld, Paris. **135.** Original magazine cover. Courtesy: Collection of Marina Schinz, New York. *Vogue* Copyright © 1951 (renewed 1979) by the Condé Nast Publications, Inc., New York. **136.** Original magazine cover. Courtesy: Collection of Henry and Kathleen Blumenfeld, Paris. *Vogue* Copyright © 1953 (renewed 1981) by the Condé Nast Publications, Inc., New York. **137.** Modern colour transparency copied from original. Courtesy: *Vogue*, Copyright © 1947 (renewed 1975) by the Condé Nast Publications, Inc., New York. **138.** Modern colour transparency copied from original. Courtesy: *Vogue* Copyright © 1949 (renewed 1977) by the Condé Nast Publications, Inc., New York. **139.** Modern transparency copied from original transparency. Courtesy: Collection of Henry and Kathleen Blumenfeld. **140.** Courtesy: Collection of Marina Schinz, New York. **141.** Printer's proof. Courtesy: Collection of Henry and Kathleen Blumenfeld, Paris. **142, 143, 144.** Courtesy: Collection of Marina Schinz, New York. **145.** Courtesy: Collection of Henry and Kathleen Blumenfeld, Paris. **146.** Modern gelatin silver copy print. Courtesy: Collection of Henry and Kathleen Blumenfeld, New York. **147.** Courtesy: Collection of Henry and Kathleen Blumenfeld, Paris. **148, 149.** Courtesy: Collection of Marina Schinz, New York. **150.** Courtesy: Collection of Yorick and Helaine Blumenfeld, Cambridge, England. **151.** Courtesy: Collection of Lisette Blumenfeld Georges, New York. **152.** Courtesy: Collection of Marina Schinz, New York. **153.** Courtesy: Collection of Henry and Kathleen Blumenfeld, New York. **154.** Courtesy: Collection of Yorick and Helaine Blumenfeld, Cambridge, England. **155.** Courtesy: Collection of Lisette Blumenfeld Georges, New York. **156, 157, 158.** Courtesy: Collection of Yorick and Helaine Blumenfeld, Cambridge, England. **159, 160.** Courtesy: Collection of Marina Schinz, New York. **161.** Courtesy: Collection of Lisette Blumenfeld Georges, New York. **162.** Courtesy: Collection of Henry and Kathleen Blumenfeld, New York. **163.** Courtesy: Collection of Marina Schinz, New York. **164.** Courtesy: Collection of Yorick and Helaine Blumenfeld, Cambridge, England. **165.** Courtesy: Collection of Henry and Kathleen Blumenfeld, New York. **166.** Courtesy: Collection of Marina Schinz, New York. **167, 168, 169, 170.** Courtesy: (*from top left, clockwise*) Collection of Henry and Kathleen Blumenfeld, Paris; collection of Henry and Kathleen Blumenfeld, Paris; collection of Marina Schinz, New York; and collection of Henry and Kathleen Blumenfeld, Paris. **171.** Courtesy: Collection of Lisette Blumenfeld Georges, New York. **172.** Several versions of the image exist; unlike the others, this was printed in reverse. Vintage toned gelatin silver print. Courtesy: Collection of Marina Schinz, New York. **173.** Courtesy: Collection of Marina Schinz, New York. **174.** Courtesy: Collection of Henry and Kathleen Blumenfeld, Paris. **175.** Courtesy: Collection of Yorick and Helaine Blumenfeld, Cambridge, England. **176.** Courtesy: Collection of Henry and Kathleen Blumenfeld, Paris. **177, 178.** Courtesy: Collection of Marina Schinz, New York. **179.** Courtesy: Collection of Henry and Kathleen Blumenfeld, Paris. **180.** Modern gelatin silver print. Courtesy: Collection of Yorick and Helaine Blumenfeld, Cambridge, England. **181.** Modern gelatin silver copy print. Courtesy: Collection of Yorick and Helaine Blumenfeld, Cambridge, England. **182.** Courtesy: Collection of Marina Schinz, New York.

Index

Numbers in *italic* refer to text illustrations; numbers in **bold** refer to plates